VERMEER
OF DELFT

VERMEER OF DELFT

Complete edition of the paintings

Albert Blankert

with contributions by Rob Ruurs and
Willem L. van de Watering

PHAIDON OXFORD

Phaidon Press Limited, Littlegate House, St Ebbe's Street, Oxford
First published in Great Britain 1978

Originally published © 1975 as *Johannes Vermeer van Delft 1632–1675* by Uitgeverij Het
Spectrum B.V. 1975, second edition 1977
Published in the United States of America by E. P. Dutton, New York
English translation © 1978 by Phaidon Press Limited
ISBN 0 7148 1819 4
Library of Congress Catalog Card Number: 77-89295

Text printed in England by BAS Printers Limited
Plates printed in the Netherlands by De Lange / Van Leer N.V.

Introductory text translated by Gary Schwartz and Mrs Hinke Boot-Tuinman.
Edited by Ann Jensen, Henry Adams and Peter Sutton.

Catalogue and Documents translated by Mrs N. van de Watering-Köhler with revisions by
R. R. Symonds.

Contents

List of text illustrations

1. VERMEER'S LIFE
A master in Delft

Johannes Vermeer, for all his genius, lived the life of a small Dutch entrepreneur. Artists were typical members of the middle class of self-employed tradesmen, shopkeepers and craftsmen, who, in the seventeenth century, formed the backbone of Dutch society. Like most Dutch craftsmen they worked in an atelier at home, staffed by a few apprentices and servants, where they produced and sold their goods themselves. A few Dutchmen did business on a grand international scale. In contrast to the monarchies of the rest of Europe, the Dutch Republic was dominated, both politically and economically, by merchants and manufacturers.

Vermeer was born in Delft in 1632, the son of Reynier Jansz and Digna Balthasars. Recent research in the Dutch archives by Michael Montias sheds new light on Vermeer's family background. His mother, Digna Balthasars, had come from Antwerp. In 1615 she and Reynier Jansz were married in Amsterdam, where Reynier gave his occupation as '*Caffawerker*' (silk worker). They were married by an Orthodox Protestant minister, which indicates that Vermeer was born a Calvinist. The couple settled in Delft, where in 1620 the first of their two children was born, a daughter named Geertruy. Here in 1623 Reynier 'sold' all of his household effects, a transaction clearly undertaken to forestall bankruptcy. His possessions included no luxury items, except for sixteen paintings. The purchaser was none other than Reynier's father-in-law, who promptly made the effects over to him again 'as a loan'. From 1625 on, Reynier Jansz added *Vos* to his name, and in 1640 he occasionally gave his surname as *Vermeer*. While Vermeer's father often continued to call himself a silk worker, from 1629 on some documents refer to him as an innkeeper. He also apparently dealt in paintings. It is assumed that he was the 'Reynier van der Minne' who in 1631 entered the guild register as '*Meester Constvercoper*' (Master Art Dealer). And it is certain that he was involved in the sale of a painting in 1643. In legal documents his name accompanies those of various Delft painters with notable frequency.

Perhaps it was the art trade which brought the simple silk worker prosperity. In 1638 he was living with his family in the narrow *Voldersgracht*, a little canal lined with small houses, located just behind the fashionable houses which faced the *Marktveld* (Market Square). Most likely this is the same street which Vermeer depicted more than twenty years later in his painting *Het Straatje* (*The little Street*; Plate 9, see p. 38ff.). In 1625, while still only a silk worker, Reynier had wounded a soldier in a fight in an inn, and had been forced to go into temporary hiding. By 1641 he was prosperous

enough to purchase this inn, and the large house 'Mechelin' of which it was part, on the Market Square. He died in this house in 1652, a citizen of some substance.

Vermeer's mother, Digna Balthasars, always maintained close contact with her brother in Gorinchem. He was a 'military engineer' who constructed fortifications for the States' army. A document about fortifications which he built in Zeeland was drawn up in Delft on 23 April 1653. Of the two witnesses who signed the deed, one was 'Johannes Vermeer': this is the oldest known signature of the artist. Possibly Vermeer's interest in precise draughtsmanship was first stimulated by this uncle, the 'military engineer'.

It is clear from his father's involvement with the art trade that Vermeer must have become acquainted with the art of painting at an early age.* Reynier's relative prosperity enabled him to apprentice his son to a master painter. Such an apprenticeship lasted several years, during which time the master had to be paid for tuition, room and board. Only after a successful apprenticeship with a recognized master could an aspiring artist apply for admission to the Guild of Saint Luke and establish his own practice.[1]

Vermeer married Catharina Bolnes in April 1653, eight months before his admission into the painter's guild. She and her mother, Maria Tin, had lived in Delft since her mother's divorce from Catharina's father, Reynier Bolnes of Gouda. The bride was of a higher social class than Vermeer, and her mother owned considerable real estate in areas within and surrounding the city. Vermeer was marrying above his station, but rapid elevation (or descent) on the social ladder was not uncommon in seventeenth-century Holland—as the career of Vermeer's father indicates. Vermeer's prospective mother-in-law initially objected to the match, but acquiesced after the respected Delft painter Leonaert Bramer intervened, visiting her on Vermeer's behalf and no doubt testifying to his artistic (and financial) promise. Vermeer's bride was Catholic, and there are indications that at some point he also became a Catholic.[2]

In the year before Vermeer married his father had died. At the time of their marriage Vermeer and his new wife's address was the house 'Mechelin' on the Market Square. There is no evidence to indicate that Vermeer succeeded his father as innkeeper of the 'Mechelin'. Perhaps he and his family inhabited part of the huge house, while leasing the rest to be run as an inn. This may have provided him with a regular income to assist in the support of his wife and children, who eventually numbered at least eleven.[3] In the absence of such income it is difficult to imagine how he maintained the intense dedication and serene deliberation to which his works so eloquently attest.

* This data concerning Vermeer's parental background is derived from the first draft of an article by J. M. Montias, now published in *Oud Holland* 91, 1977, pp. 267–87. I am most grateful to Professor Montias for permitting me to make use of his material prior to its publication. He has meanwhile found new documents concerning Vermeer's grandparents and, most surprisingly, a document of 1653 signed in Delft by Vermeer and Gerard ter Borch. It was not known that ter Borch, who, after Vermeer, is the best known Dutch painter of interior scenes, was ever in Delft, let alone that the two artists actually knew each other. For all other documents concerning Vermeer see pp. 145ff.

A small œuvre

There is good reason to believe that Vermeer's artistic production was small. Three of his paintings are recorded in documents as the property of the painter's widow. Twenty-one more are listed in the catalogue of an áuction of paintings held in Amsterdam in 1696. Another five occur in auction catalogues from the end of the seventeenth and early eighteenth centuries. Remarkably enough, nearly all of these paintings can still be identified. Moreover, all but a few of the thirty-odd paintings now regarded as autograph works by Vermeer are mentioned in these few sources. This provides strong evidence that the Vermeers known today constitute nearly the entire *œuvre* of the master. His limited production is apparently due at least in part to his meticulous working method.

Vermeer's contemporaries rewarded his painstaking work with high prices. The French nobleman Balthasar de Monconys, who visited Delft briefly in 1663, testified to this fact. 'In Delft', he wrote, 'I saw the painter Vermeer, who did not have any of his works: but we did see one at a baker's for which six hundred livres had been paid, although it contains but a single figure for which six pistoles would have been too high a price in my opinion' (document 21).

The baker (apparently a more appreciative connoisseur than the French nobleman) was probably the 'Hendrik van Buyten, master baker' who shortly after Vermeer's death accepted two of his paintings from Catharina Bolnes as a guarantee for an unpaid bill of 617 guilders.[4]

An even greater patron of Vermeer than the baker van Buyten was the printer Jacob Dissius, a neighbour of Vermeer on the *Marktveld*. Dissius must have been a kind of Maecenas to the painter; the inventory of his possessions drawn up in 1682 includes no less than nineteen paintings by Vermeer. After 1682 he seems to have added two more works by the artist to his collection, for it is nearly certain that the twenty-one Vermeers auctioned in Amsterdam in 1696 were those that had belonged to Dissius.[5]

It is known that Vermeer bought and sold paintings by other artists (document 42), but to call him an 'art dealer' may be a misnomer. The Dutch middle class has never been reluctant to supplement their income with transactions in real estate, shares of stock, and paintings. Jan van Goyen, for example, left records of countless financial dealings—for instance in tulips, beer and real estate—which did not prevent him from finding time to produce an immense number of paintings.

The professions of artist and art dealer were not yet clearly differentiated. Vermeer always designated himself as a 'painter' in legal documents, but many painters listed themselves as 'dealer' (or 'merchant'). A recognized painter was also regarded as a connoisseur, as there was no distinct profession for art historians and art critics. In a legal controversy about the authorship of some works of art, Vermeer was called in to give expert testimony. Painters were also often consulted to appraise the value of works of art, for purposes of taxation, or in cases of inheritance.

The prosperity of Dutch painters has generally reflected the fluctuations of the economy. In the 'disaster year' of 1672, when a large part of Holland

was temporarily occupied by the French, many artists experienced financial difficulties as a consequence of the general economic crisis. A number of documents concerning Vermeer relate to his monetary problems at the time.

To escape the difficult financial situation in Holland, the elder and the younger Willem van de Velde, both marine painters, moved to England in 1672. Among those who were driven to bankruptcy or near-bankruptcy at the time were Vermeer's namesake, Jan Vermeer of Utrecht; the well-known portrait painter Bartholomeus van der Helst; and the Amsterdam art dealers Jacob van Neck and Gerrit van Uylenburgh—to mention only a few.[6] Vermeer was unable to escape the effects of the economic crisis. He leased the 'Mechelin' and moved his family in with his mother-in-law on the *Oude Langedijk*. This and subsequent reverses may have hastened his death. The burial of 'Jan Vermeer, painter, on the *Oude Langedijk*, leaving eight under age children', took place on 15 December 1675. He was forty-three years old when he died.

Vermeer's financial difficulties

After Vermeer's death his widow Catharina undertook a series of legal and financial actions, probably to prevent bankruptcy. These are recorded in extensive documents. We have already mentioned one of her manœuvres. On 27 January 1676, she pledged two paintings by her late husband to the baker Hendrik van Buyten, in lieu of payment of 'the sum of 616 guilder and 6 stuivers . . . owed to van Buyten for delivered bread.'

Two weeks later, on 10 February, Catharina contracted to sell '26 pieces, large paintings and small, for the sum of 500 guilders' in order to satisfy another of her shopping bills. It has often been maintained that these twenty-six paintings must have been works by Vermeer.[7] It seems most unlikely, however, that Catharina would have sold twenty-six of her late husband's works for the sum of 500 guilders, when only two weeks earlier the mere pledge of two of them satisfied a creditor with a 600 guilder claim. The documents suggest that she owned only a very few paintings by Vermeer, and that she took every measure possible to retain ownership of them. This would explain why, on 24 February, she sold 'a painting by . . . her late husband, representing the Art of Painting' (Plate 19) to her own mother, Maria Tin, 'in partial settlement of her debt'.

A few days later, on 29 February, an inventory was made of the contents of the house on the *Oude Langedijk*, probably because of a threatening bankruptcy. Catharina's property was listed separately from her mother's. It included some framed drawings, and twenty-four paintings—among them heads by Fabritius and Hoogstraten, 'a large painting of Christ on the cross', 'one containing a bass fiddle with a death's-head', and another representing 'Cupid'. The last three are surely the same paintings Vermeer depicted in the background of some of his own works (Plates 20, 25, 29).[8] Significantly, no paintings by Vermeer himself are mentioned.

None of these measures were effective: on 30 April the High Court of Delft declared Catharina bankrupt. She stated that she was 'charged with the care of eleven living children . . . Her husband, having been able to earn little or nothing in the years since the war with the King of France, was forced to

sell at a great loss the paintings he had bought and in which he traded, in order to feed the aforementioned children, thereby falling so deeply into debt that she was unable to satisfy all her creditors (who are not willing to take into consideration her great losses and bad luck caused by the war).'

In the autumn the biologist Anthony van Leeuwenhoeck, not yet famous for his work with the microscope, was appointed trustee of her estate. Angry objections were voiced to Catharina's prior disposal of paintings to certain creditors, such as her mother, which was interpreted as prejudicial to the interests of the other creditors. Despite strong protest, her mother was instructed to relinquish *The Art of Painting* (Plate 19) for sale at auction (documents 39, 52).

2. VERMEER'S WORK
Vermeer's early work

Despite the value of Vermeer's paintings, and their tremendous popular appeal, there has been little discussion of the artistic context in which his works were produced. As with any human achievement (or failure), Vermeer's paintings take on a richer meaning when they are examined in light of the options available to him in his place and time.

When Vermeer was a child, Delft was not a major centre of Dutch painting. Before 1650, the year when he turned eighteen, the new artistic currents originated in Amsterdam, Haarlem, Utrecht and Leiden. To be sure, Delft numbered among her painters some very capable craftsmen, such as Anthonie Palamedesz and Christiaen van Couwenbergh. But on the whole their work repeated developments which had originated elsewhere. Palamedesz, for example, painted a type of society picture—the so-called 'Merry Company' scene—which had originated in Haarlem and Amsterdam (Fig. 1). Van Couwenbergh produced figure paintings modelled on those of the Utrecht Caravaggisti (Fig. 2).

A notable exception was Leonaert Bramer (1596–1674), whom we have already mentioned in regard to his documented contact with Vermeer.[9] As a young man Bramer spent over ten years in Italy, where he developed a personal style which remained virtually unchanged from 1628, the year of his return to Delft, until his death in 1674. Bramer was skilled at painting groups of small lively figures, posed balletically against a dark background. He applied this formula impartially to a great variety of subjects—to Biblical, mythological and genre scenes (Fig. 4).

In the Delft of Vermeer's youth Bramer was the most admired local painter, and deservedly so. For this reason alone it is likely that Vermeer studied with him.[10] To be sure, Vermeer's style as we know it reveals no obvious debt to Bramer; however, it was not unusual in seventeenth-century Holland for a painter to develop a style quite different from that of his teacher, once he had mastered the rudiments of his craft. The lasting impact which Rembrandt exerted on the work of his pupils is, in fact, an exception to this general trend. Unfortunately, there is no definite proof that Vermeer apprenticed with Bramer, but Bramer's recommendation of Vermeer to his prospective mother-in-law in 1653 indicates that the two were on very close terms.

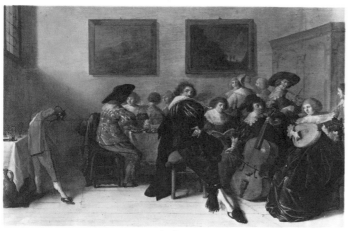

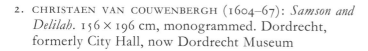

1. ANTHONIE PALAMEDESZ (1601–73): *Music after Dinner.*
47 × 73 cm., signed 1632. The Hague, Mauritshuis

2. CHRISTAEN VAN COUWENBERGH (1604–67): *Samson and Delilah.* 156 × 196 cm, monogrammed. Dordrecht, formerly City Hall, now Dordrecht Museum

4. LEONAERT BRAMER (1596–1674): *The Judgment of Solomon.* 78 × 100 cm., signed. New York, Metropolitan Museum of Art

3. JAN STEEN (1625/6–79): *Christ in the House of Mary and Martha.* 106 × 89 cm. Nimeguen, Private Collection

At the end of that year, on 29 December 1653, Vermeer was accepted as a master in the painter's guild in Delft. This indicates that he had completed his apprenticeship, and was entitled to sign and sell his own works. Accordingly, the thirty-odd paintings by Vermeer which are known—of which roughly two-thirds are signed—must have been produced between the beginning of 1654 and his death in 1675.

Fortunately Vermeer's *œuvre* has been preserved almost in its entirety. However, any outline of Vermeer's artistic development must be based almost entirely upon a stylistic consideration of the paintings themselves, for the master dated only three of his works, and external evidence is rare.[11]

Only three of Vermeer's paintings are dated: *The Procuress* dated 1656 (Plate 3), *The Astronomer* dated 1668 (Plate 23), and *The Geographer* dated 1669 (Plate 24). The two latter paintings are characteristic examples of the interiors for which Vermeer is so well known, while *The Procuress* bears little resemblance to these works. Its date, in fact, forms a turning point in Vermeer's development: as we shall discuss below, all the most characteristic Vermeers must date from after 1656.[12] The two paintings which are even less representative of Vermeer's mature style than *The Procuress*, *Christ in the House of Mary and Martha* (Plate 1), in the National Gallery, Edinburgh, and *Diana and her Companions* (Plate 2) in the Mauritshuis, The Hague, must thus date from between 1654 and 1656.[13]

The signature *VMeer* (with the *V* and *M* intertwined) on *Christ in the House of Mary and Martha* (Plate 1) first appeared in 1901, when the painting was in the possession of an art dealer. Its form corresponds exactly with the signature which appears on *The Procuress* (Plate 3). It is sometimes wise to treat with scepticism paintings whose signatures 'come to light' in the hands of art dealers, but in this case all doubts are dispelled by a lucky find: thirty years after the signature emerged, a painting by Jan Steen was discovered which was clearly derived from *Christ in the House of Mary and Martha*. Steen worked in Delft for a short time around 1655. He executed the painting in his own style, one which is distinctly different from that of Vermeer, and reworked the composition. Nevertheless, the pose of the three figures around the table is unmistakably adopted from Vermeer's picture (Fig. 3).[14]

In *Christ in the House of Mary and Martha* (Plate 1) three substantial figures join to form a monumental group. Unlike Vermeer's later work, with its glossy finish, the picture is broadly painted; the broken brushwork adds life to the painting's surface, vitalizing the otherwise solemn effect. Certain elements prefigure Vermeer's later development—for example, the unnatural brightness of the lighter passages, and the colour scheme based upon the primary colours, red, blue and yellow. The design of the carpet seen behind Mary strongly resembles that of the carpet in the foreground of the later *Girl asleep at a Table* (Plate 4) in New York. The downward gaze, which hides Martha's eyes from the viewer, is a device which Vermeer often repeated.

The second early painting by Vermeer, *Diana and her Companions* (Plate 2), was bought in 1876 by the Mauritshuis in The Hague as a signed work by Nicolaes Maes. When the painting was restored shortly thereafter, the signature of Maes disappeared and the letters *J Meer* vaguely emerged.[15] The painting was accordingly attributed to a little known master to whom very few paintings can be assigned: Jan Vermeer—of Utrecht. It was not until the discovery and acceptance of the signature on *Christ in the House of Mary and Martha* that *Diana and her Companions* was given its proper place in the *œuvre* of the young Jan Vermeer of Delft.

The arrangement of figures in *Diana and her Companions* is related to that in *Christ in the House of Mary and Martha*. Both pictures contain a prominent seated figure, a second figure at the feet of the first, and, uniting these two, the vertical form of a third figure standing behind them. *Diana and her Companions*, however, is more complex. Diana—identified by the crescent

moon on her forehead—is flanked by two additional figures. Moreover, one of these figures is seen from behind—which introduces a new element. On the whole, *Diana and her Companions* conveys a more stately effect than *Christ in the House of Mary and Martha*. Incidentally, the cropped figure and the rather abrupt ending of the composition at the right suggest that the painting may have been cut along the right edge.[16]

History painting

Christ in the House of Mary and Martha (Plate 1) is a Biblical representation, and *Diana and her Companions* (Plate 2) is a mythological one. Both belong to the category known in seventeenth-century art theory as 'history painting'. Although it may seem strange that the greatest master of Dutch genre painting began his career as a history painter, his choice of subject-matter, as well as his shift to genre painting, is quite understandable when considered in the light of broader developments in seventeenth-century Dutch painting.

Dutch painters in the seventeenth century, many of whom maintained a very high level of artistic quality, were the first to develop landscape, still-life, and interior scenes into independent branches of painting. But these Dutch masters—who were perfectly capable of creating new forms of art—apparently lacked the assurance necessary to develop an accompanying artistic ideology. They continued to pay tribute to the notion, imported from Italy, that the most noble form of art was history painting. This is understandable if we remember that the middle-class culture of Holland was a small island in a Europe still dominated by princes and courts.

A theory which elevated genre painting was not conceived until the nineteenth century, when the Dutch masters were first celebrated as the great recorders of 'everyday life'. This nineteenth-century conception, which we have inherited, clarified much about the Dutch school, but also obscured a great deal. Until recently scholars were unaware of the numerous symbolic and allegorical elements hidden in the art of 'everyday life'. Moreover, they failed to recognize that even in seventeenth-century Holland the history painter was still the acknowledged aristocrat of artists.

In Haarlem history painting flourished for over fifty years in the works of the so-called 'Academists'. If these painters have not received the attention from recent art historians that they deserve, it must be primarily because of a lingering prejudice against the subject-matter they chose to depict. The quality of their works is often of the very highest level, and their style is personal and distinguished.[17] Rembrandt devoted himself largely to history painting, as did most of his pupils, including Ferdinand Bol, Gerbrand van den Eeckhout and Aert de Gelder. Many ambitious and talented young artists, who eventually became specialists in one or another genre, began their careers, like Vermeer, as history painters. Among the earliest works of Emanuel de Witte, for example, now famous as a painter of church interiors, are several Biblical and mythological subjects.[18] The most important youthful work of Gabriel Metsu of Leiden, who later specialized in interior scenes, is *Christ and the Adulteress* of 1653 (Fig. 5). Its robust manner, somewhat ponderous draped figures, and bright colours placed against a dark background, have a definite kinship with the two early Vermeers.

5 · GABRIEL METSU (1629–67): *Christ and the Adulteress*. 135 × 164 cm., signed and dated 1653. Paris, Louvre

Vermeer's two early works indicate that he was aware of current trends in seventeenth-century Dutch history painting. In addition to Rembrandt and his pupils, another group of history painters was working in Amsterdam. Jacob Backer, Jan van Noordt, and Jacob van Loo are not much admired today, but their achievements should not be underestimated.[19] Their fluently composed and smoothly painted works have much in common with Vermeer's earliest two paintings. Vermeer seems to have been particularly interested in the work of van Loo. The figures in *Diana and her Companions* (Plate 2) closely resemble those in the background of van Loo's painting of the same subject (Fig. 6).[20] Similarly in *Christ in the House of Mary and Martha* (Plate 1) Vermeer adopts van Loo's lively arrangement of linear highlights which suggests the play of light over folds of fabric.[21]

History painting in Amsterdam was stimulated by the completion shortly after 1650 of the new Town Hall (now the Royal Palace) on the Dam. The city council decided to decorate its walls with large-scale historical scenes, and commissioned various painters of the city to depict subjects from the Old Testament, and from Roman and Batavian history.[22] One of the early commissions, for the ceiling of the 'Moses Hall', went to Erasmus Quellinus, a follower of Rubens from Antwerp.[23] Vermeer must have been aware of this exceptional honour which had been bestowed upon the Fleming. At the time when Quellinus was working in Amsterdam, Vermeer was painting *Christ in the House of Mary and Martha* (Plate 1). It so closely resembles Quellinus's

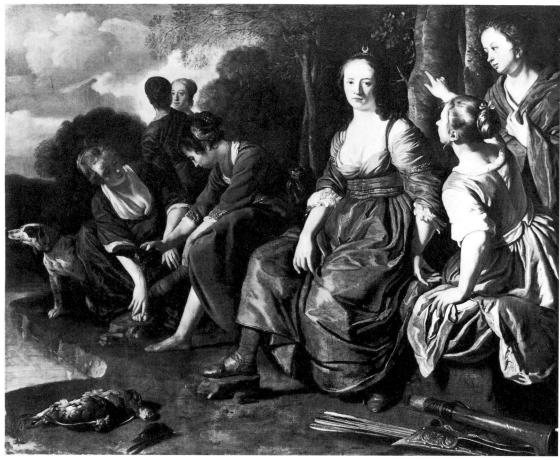

6. JACOB VAN LOO (1614–70): *Diana and her Companions*. 134 × 167 cm., signed and dated 1648. East Berlin, Bode Museum

7. ERASMUS QUELLINUS (1607–78): *Christ in the House of Mary and Martha*. 172 × 243 cm., signed. Valenciennes, Musée des Beaux-Arts

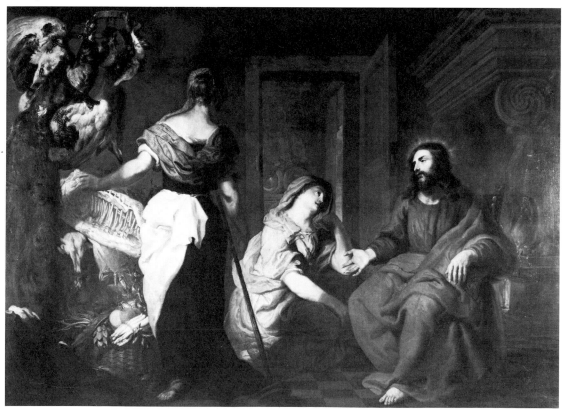

version of the subject—particularly in the figure of Christ—that we may assume that Vermeer knew of the work by the Flemish painter (Fig. 7).[24]

Vermeer's youthful work shows his desire—shared by many of his contemporaries—to create history paintings, which were considered the 'highest' achievement of the painter. Although Vermeer lived in Delft, he seems to have known and responded to developments in Amsterdam. Yet despite his ties with the work of other painters, his early paintings have traits which are quite unique in seventeenth-century Dutch painting. The exceptionally vigorous brushwork and deep colours convey a strongly Italianate impression, and differ markedly from the work of the Amsterdam history painters. The *facture* of *Diana and her Companions* (Plate 2) has even been compared to that of Titian. In spite of the overwhelmingly Italianate quality of these two works, there is no reason to believe that Vermeer visited Italy. He had every opportunity to study Italian art in Holland, where there was a flourishing trade in Italian painting.[25]

Vermeer was recognized as a connoisseur of Italian art. In May 1672 he was among the experts consulted to judge a disputed collection of paintings. Gerrit van Uylenburgh, an art dealer of Amsterdam, had sold a collection of paintings purported to be by Michelangelo, Titian and Raphael to the Elector of Brandenburg. A number of artists from Amsterdam and The Hague were summoned by Uylenburgh and attested to their authenticity. However, Vermeer and a fellow townsman, Hans Jordaens, who came to The Hague especially for this case, were among those who thought otherwise. Vermeer's pronouncement, which is the only statement on painting we have from him, is among the strongest. He declared that 'not only (are) the paintings no outstanding Italian paintings, but, on the contrary, great pieces of rubbish and bad paintings'.

Vermeer may have learned about Italian art from Leonaert Bramer, for although Bramer's style was influenced by his contemporaries from Haarlem and Utrecht, it was shaped primarily by the work of Domenico Feti, a master prominent during his ten year stay in Italy.

Bramer may also have inspired Vermeer's ambition to become a history painter—for nearly three-quarters of Bramer's *œuvre* consists of Biblical, mythological, and allegorical subjects.[26] It seems possible that a now lost 'large painting' by Bramer, representing 'the Magdalen washing Christ's feet', was a significant influence on Vermeer's early works.[27] The subject suggests a grouping of the main figures reminiscent of that found in both *Christ in the House of Mary and Martha* and *Diana and her Companions*.

The emergence of the Delft school

Except for the work of Bramer, Delft was artistically provincial in Vermeer's youth. But this was changed dramatically around 1650 by an influx and flowering of new talent, talent which included Adam Pynacker, Willem van Aelst, and Carel Fabritius.

Documents indicate that Adam Pynacker was living in Delft in 1649. One of the most important members of the Dutch Italianate school, Pynacker and his generation brought this tradition to its height of artistic accomplishment.[28] Italianate painting had begun a generation before, in the 1620s, with

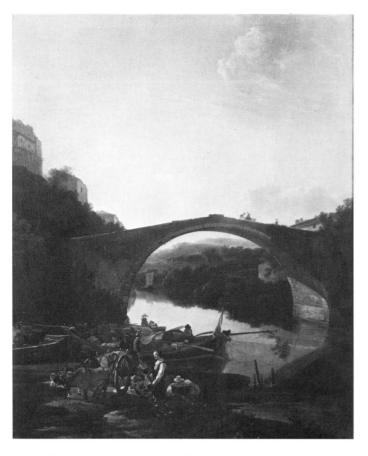

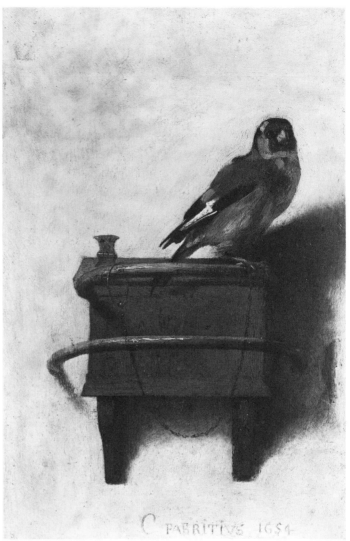

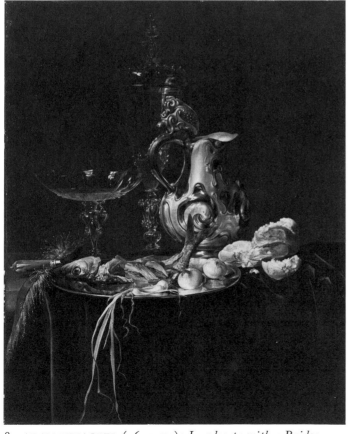

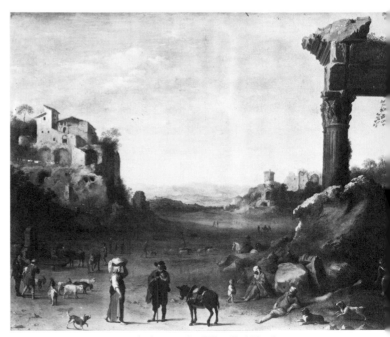

8. ADAM PYNACKER (1621–73): *Landscape with a Bridge*.
77 × 63 cm. Scotland, Private Collection

9. WILLEM VAN AELST (1625–after 1683): *Still-life*.
57 × 46 cm., signed and dated 1657. Copenhagen,
Statens Museum for Kunst

10. CAREL FABRITIUS (1622–54): *The Goldfinch*.
33 × 23 cm., signed and dated 1654. The Hague,
Mauritshuis

11. CORNELIS VAN POELENBURGH (*c.* 1590–1667): *Pastoral
Scene among Ruins and Castles*. London, Buckingham Palace

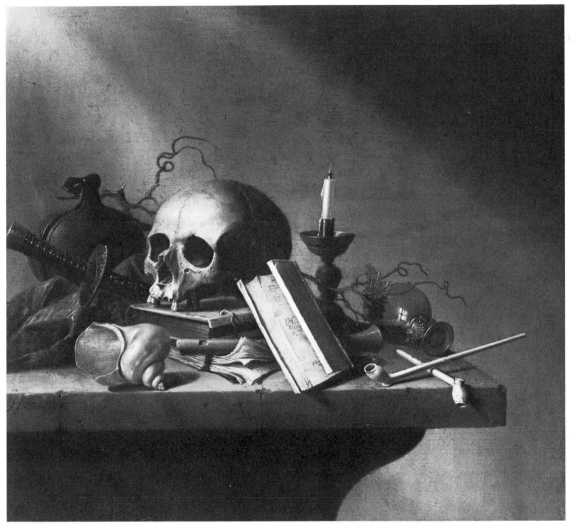

12. HARMEN VAN STEENWYCK (1612–after 1655): *Still-life*. 37.7 × 38.2 cm., signed. Leyden, Stedelijk Museum 'De Lakenhal'

Cornelis van Poelenburgh's detailed, brightly sunlit views of the Roman Campagna—landscapes picturesquely sprinkled with ruins, animals and tiny figures (Fig. 11). Pynacker's works of the fifties—which are recognizably derived from those of Poelenburgh—are arranged with a calculated balance of compositional features, which conveys an atmosphere of peace and harmony. Massive hillsides or ruins are viewed from close proximity, and closely knit groups of small figures add life to the scene (Fig. 8).

Even more important than Pynacker's delightful contribution to the Italianate landscape tradition were the innovations in still-life of Willem van Aelst, a master who was trained in Delft. Still-life painting in Delft before 1650 is exemplified by the work of Harmen van Steenwyck, whose competent, precisely worked compositions show tabletops laid with drinking cups, shells, books, and pipes, all decoratively arranged in curving patterns (Fig. 12). In the 1650s van Aelst transformed this formula. While retaining a precise rendition of texture, he replaced the everyday objects of van Steenwyck's tabletops with costly silverwork and exotic fruits (Fig. 9). Moreover, he drastically reduced the number of objects depicted, bringing them close to the viewer, and highlighting a single area. This gives his works a greater focus and stability than those of his predecessor.[29]

The most prominent artist to arrive in Delft during this period, and the one whose work was to have the greatest consequences for Vermeer, was Carel Fabritius, Rembrandt's most gifted pupil. He moved to Delft around 1650.[30]

Fabritius had begun his career as a history painter working in Rembrandt's style, but once in Delft he began to explore new artistic problems. Taking to heart Rembrandt's dictum, 'follow nature', Fabritius attempted to create as vivid an illusion as possible. The amazingly lifelike *Goldfinch*, painted in 1654, the year of Fabritius's death, is an example of such an early attempt at illusionistic painting (Fig. 10).[31]

Fabritius maintained close ties with Samuel van Hoogstraten of Dordrecht, with whom he had established a friendship while they were both apprentices in Rembrandt's studio. In the same year in which Fabritius painted *The Goldfinch*, van Hoogstraten created the earliest known true *trompe-l'œil* painting, and initiated a tradition which was to survive well into the nineteenth century.[32]

A *trompe-l'œil* painting—in the Netherlands they were often called 'cheaters'—depicts relatively flat, inanimate objects, against a flat, even background. Both the low relief and the lack of animation contribute to the effectiveness of the illusion. Since the objects are shown in a very shallow space, the viewer who moves in front of them does not readily perceive that they remain fixed in relation to the background, a clue which usually enables us to distinguish a painting from reality. Since the objects depicted are inanimate they do not induce any expectation of movement, and thus they convey an even more deceptive illusion than the living goldfinch represented by Fabritius (Figs 10, 13, 14).

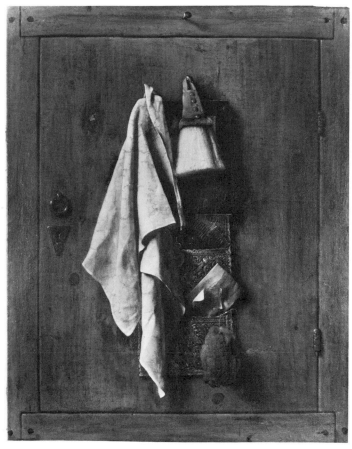

13. CORNELIS GIJSBRECHTS (active *c.* 1660–75). Picture representing the back of a picture. 66 × 86.5 cm. Copenhagen, Statens Museum for Kunst

14. SAMUEL VAN HOOGSTRATEN (1627–78). '*Trompe-l'œil*' painting. 90 × 71 cm., with inscription 'empfangen 12.2.1654 S. v. Hoogstraten, Wien'. Vienna, Akademie der bildenden Künste

In keeping with their fascination with perfect illusions, Fabritius and van Hoogstraten also experimented with effects of linear perspective. Most of Fabritius's *œuvre* has been lost: only one small panel, dated 1652, survives to testify to this aspect of his interests (Fig. 26). It depicts a view of the *Oude Langedijk* in Delft, with the *Nieuwe Kerk* (New Church) and the Town Hall in the background. The strange distortion of the perspective has led to speculation that the canvas might once have been attached to the back wall of a peep-box.[33] Although this is the only surviving painting of this type by Fabritius, van Hoogstraten's writings reveal that he also produced large perspective paintings.[34]

Van Hoogstraten's peep-box in the National Gallery in London offers an indication of what Fabritius's perspective paintings must have been like.[35] Such peep-boxes were apparently a Dutch invention. If one can overcome the traditional prejudice against artistic tricks, a peek through either of the holes in the ends of the box provides a delightful surprise: one experiences an almost perfect illusion of standing within a seventeenth-century interior (Figs 15, 16). Van Hoogstraten manages to combine in this box the illusion of space with a *trompe-l'œil* effect: since the interior of the box can only be viewed from a fixed point, through the peephole, the spectator cannot step aside and test the reality of the space.

(Van Hoogstraten's work from the 1650s, and also that of Nicolaes Maes, another pupil of Rembrandt from Dordrecht, displays such close ties with developments in Delft that it has sometimes been assumed that they lived there for a time. However, the close connections between their works and those of painters in Delft can be explained by the fact that Delft lies on the

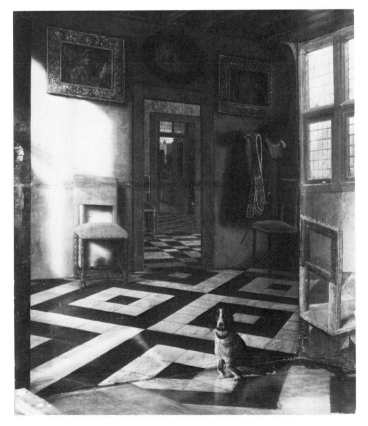

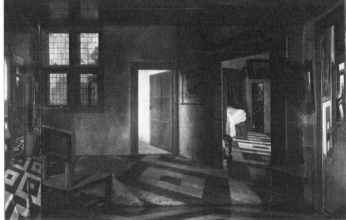

15 (*left*). SAMUEL VAN HOOGSTRATEN (1627–78). Perspective box. In order to photograph the inside of the box, one wall has been removed. Space and objects seem chaotic. Only when the onlooker himself watches through the peephole in the wall does everything fall into its proper place. London, National Gallery

16. The same box with the front side removed.

road from Dordrecht to Amsterdam. It is not far-fetched to assume that on trips to Amsterdam, Hoogstraten and Maes were in the habit of stopping in Delft to visit Carel Fabritius, another former student of Rembrandt. Such visits would have given them a first-hand acquaintance with the current artistic trends in the city.)[36]

Some ambiguous documents can be construed to indicate that Vermeer himself experimented with peep-boxes. In the auction of 1696, the *Woman weighing Gold* (Plate 15, see p. 153 below) is described as 'A young woman weighing gold in a box'. An archive document also associates a 'box' with paintings by Vermeer: a brief inventory drawn up at least as early as 1682 for the printer Dissius describes three paintings by Vermeer as 'in a box' (document 59). Some time ago H. E. van Gelder suggested that the word 'box' indicates a peep-box.[37] An alternative interpretation maintains that documents about works of other masters use the phrase 'in a box' to refer to the seventeenth-century practice of protecting valuable paintings by enclosing them in a box with doors.[38]

Van Gelder's hypothesis remains intriguing, for Vermeer seems to have desired to create a completely convincing depiction of reality. By placing his works in a peep-box, so as to control the line of sight exactly, he could have created a nearly perfect visual illusion. However, there are no special stylistic features in the *Woman weighing Gold*, the one painting definitely associated with a 'box' in documents, which separate it from Vermeer's other works and connect it with use in a peep-box.

These makers of peep-boxes and *trompe-l'œil* 'cheaters' were not the only artists in Delft to be interested in effects of spatial illusion and perspective. A group of painters of church interiors, who were active in Delft around 1650, were concerned with these same problems. Some of them also constructed peep-boxes,[39] and in their paintings they did everything possible to depict interior space as illusionistically as paint on canvas would allow.

Many years before, Pieter Saenredam, a hunchback of Haarlem, had taken the first step in the creation of illusionistic church interiors.[40] Unlike his predecessors, who created architectural fantasies, Saenredam depicted the interiors of existing Dutch churches. He bathed his views in an even light and clearly delineated all the architectural details (Fig. 18). Often he selected viewpoints which show a large area of the church. His desire for perfect accuracy is evident from the careful measurements and notations which appear on his drawings, and from his scrupulous adherence to the laws of perspective.

In one respect, however, Saenredam still adhered to tradition. Like his predecessors he always situated the picture plane exactly parallel to one of the walls of the building being represented. In contrast, the painters who were active in Delft around 1650 achieved a more natural effect by placing the picture plane at an oblique angle to the walls of the church. In his view of the *Oude Kerk* (Old Church) in Delft, for example, Emanuel de Witte did not attempt to show the entire building: he sought instead a more casual view of the interior, which gives us a glimpse through the church diagonally (Fig. 17). Despite the informality of the view de Witte's composition is by no means randomly conceived. Lights and darks are unobtrusively but carefully

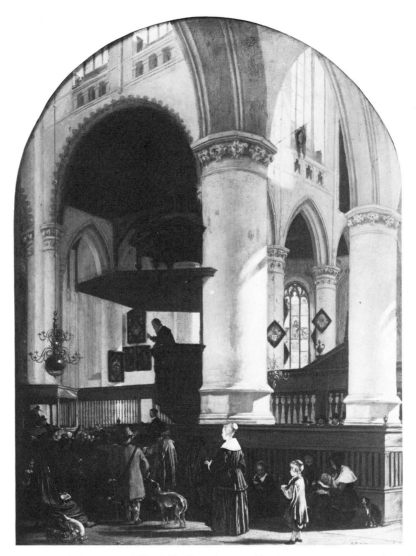

17. EMANUEL DE WITTE (1617–92): *The Old Church at Delft.* 61 × 44 cm., signed and dated
 1651. London, Wallace Collection
18. PIETER SAENREDAM (1597–1665): *The Church in Assendelft.* 50 × 76 cm., signed and dated
 1649. Amsterdam, Rijksmuseum

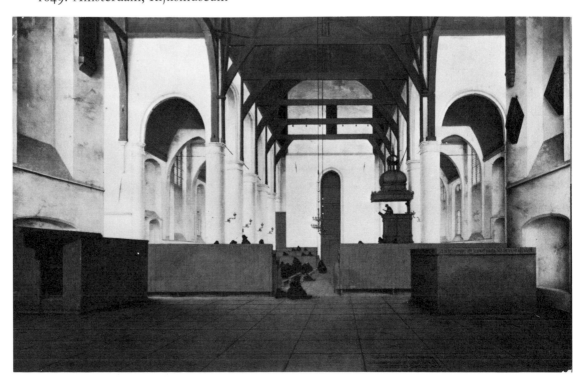

organized into a few large tonal areas: and the multitude of picturesque details is incorporated into the dominating rhythm of a few hefty columns, arches and choir screens.

Thus, by 1650 practitioners of many varieties of painting in Delft had come to share a common goal—that of making the most complete and convincing visual illusions possible.

Dutch interior scenes

Nearly all of Vermeer's paintings show interiors in which one or more well-dressed figures play an instrument, drink wine, or perform simple household tasks. In order to understand this aspect of Vermeer's art it is necessary to consider developments which took place outside Delft.

Before 1650 pictures of taverns, with drinking, gambling and quarrelling peasants, were popular. They were painted with superior artistry by Adriaen Brouwer, Adriaen van Ostade and others. After 1650, however, no major Dutch painter, with the solitary exception of Jan Steen, undertook to specialize in such unruly scenes. The talented new generation of genre painters preferred respectable households, staffed with elegantly attired ladies and gentlemen. Perhaps the upper-class costumes and furniture they depicted made genre painting seem more acceptable for masters who had, in many cases, begun their careers with a higher ambition—namely, history painting.[41]

Hidden symbolic allusions, generally of a moralizing nature, also gave genre painting a new respectability. This symbolism made it a close neighbour of allegory, which had always enjoyed a high position in the theoretical hierarchy of subject-matter. To the best of our knowledge the rowdy peasant scenes of Adriaen van Ostade had no such moralizing overtones.

Interiors with elegant ladies and gentlemen playing music and drinking wine—scenes nearly always laden with erotic overtones—were first painted by masters in Haarlem and Amsterdam. Willem (known as 'witty William') Buytewech, Dirck Hals, and Pieter Codde, invented and perfected this type of society painting in the 1620s and 1630s: they were soon joined by Anthonie Palamedesz of Delft. For the most part their paintings are limited to a single compositional scheme which they inventively varied. A characteristic example, Palamedesz's *Music after Dinner* in the Mauritshuis (Fig. 1), is composed of two monochromatic strips of floor and wall, which provide a neutral backdrop for a wide horizontal frieze of closely spaced figures. Palamedesz renders the shining costumes and the musical instruments with such skilful meticulousness that they seem almost real.

The formula first underwent a change when a new generation of talented young painters turned their attention to society painting around 1650. Prior to this time several of them had been exclusively history painters. Gerbrand van den Eeckhout, for example, whose work for the most part consists of Biblical scenes, painted a large number of elegant society paintings in the 1650s (Fig. 19). The somewhat older painter Jacob van Loo, who specialized in history paintings, executed a group of handsome interiors which also seem to date from shortly before 1650 (Fig. 20, compare Fig. 6).

19. GERBRAND VAN DEN EECKHOUT (1621–74): *Music-making Company*. 91 × 83 cm., signed and dated 1653. The Hague, on loan to the Gemeentemuseum, The Hague, Department of Musical Instruments

20. JACOB VAN LOO (1614–70): *The Concert*. 73 × 62 cm., signed and dated 1649. Present whereabouts unknown

Gabriel Metsu, who also was originally a history painter, converted around 1655 to genre themes representing ladies and gentlemen in interiors (Fig. 42).[42]

The greatest innovator in the field of genre painting was Gerard ter Borch (1617–81), who worked in the somewhat provincial town of Deventer in Overijssel. Before 1650 his work consisted of battle scenes and portraits. After that year, conscious, no doubt, of what van den Eeckhout and van Loo had done in the field of elegant society pictures, he became a specialist in genre. Ter Borch retained contact with the tradition established by Codde and Palamedesz, as is revealed by his sensitivity to the gloss of silk and satin, which he rendered with unequalled virtuosity (Fig. 21). But he enriched the genre tradition with a whole series of new motifs of his own invention, motifs which were to find a permanent place in the repertory of later masters.[43] Among other themes, a lady writing at a table, and a girl in front of the mirror were first painted by ter Borch (Fig. 44). As we shall see, they recur in the work of Vermeer (Plates 13, 20, 21, and 27).

In their scenes of elegant company van den Eeckhout, van Loo and ter Borch drastically reduced the number of figures, and enlarged these figures in relation to the overall space. They also replaced the light background of the earlier interiors with a dark one, thus concentrating the viewer's attention on the masterly balancing of light and shadow among the figures. These changes in elegant genre scenes reflect a more widespread stylistic shift in Dutch art of the period.

21. GERARD TER BORCH (1617–81): *Man and two Women.* 71 × 73 cm., about 1654. Amsterdam, Rijksmuseum

Around 1650 a group of gifted Dutch painters made decisive formal changes in subjects which had been practised with little change for decades. What van Loo and ter Borch did with interior painting is in many respects parallel to what masters like Adam Pynacker, Willem van Aelst and Emanuel de Witte accomplished in their respective fields of Italianate landscape, still-life, and church interiors. A typical work by one of their predecessors—Poelenburgh, Steenwyck, Saenredam or Palamedesz—shows a neat, evenly lit, horizontal arrangement of small objects, whether these be human figures, dishes and pipes, or church columns. The younger painters adopted the refined technique of their predecessors, but varied their compositional formula, selecting a vertical format, and employing a more casual grouping of large and small elements. Quite ingeniously de Witte, ter Borch and others brought a new visual unity to the placing of objects in space, the arrangement of outlines, and the division of light and shadow—problems which previously had been dealt with individually rather than in mutual inter-relationship. They attained a simpler, more natural, and at the same time more dignified effect than their predecessors. By the time Johannes Vermeer turned to specifically Dutch subjects, this new manner—which is often termed 'classical'—was a well established visual vocabulary.

Vermeer's The Procuress *and* Girl asleep at a Table

This emerging elegance and use of symbolism in genre painting were eventually to influence Vermeer decisively. But during the first few years of his career he remained out of touch with the innovative ideas circulating in Delft and elsewhere in Holland. While the subject of *The Procuress* (Plate 3) in Dresden, dated 1656, may reflect the success his colleagues were enjoying with erotic subject-matter, it owes nothing in style or composition to the work of the new generation of genre painters.

The depiction of a consistent interior space, a problem which was of central importance to the circle of Carel Fabritius and to the church painters of Delft, was not one to which the young Vermeer addressed himself in 1656. In *The Procuress* his figures are unclearly placed: the young woman seems to be seated behind a table which leaves no room for the lute held by the laughing young man to the left. Several writers have speculated that the latter figure may be the artist's self-portrait.[44]

In keeping with Vermeer's enthusiasm for monumental history painting, his style and technique relied not upon contemporary masters, but upon an earlier group of painters, the so-called Utrecht Caravaggisti. They had created comparable erotic scenes, on a large scale, with life-size figures. The theme of the procuress had been treated by several of them, including Theodoor van Baburen in a painting of 1622 in the Museum of Fine Arts in Boston (Fig. 22).

In both Baburen's and Vermeer's rendition of the subject a few half-length figures occupy the larger part of the picture. The composition and use of gesture in the two paintings are quite similar. This is more than mere coincidence, for Vermeer painted this very composition by Baburen into the background of two of his own paintings (Plates 17, 31), and a recently discovered document makes it highly probable that Vermeer's mother-in-law owned the picture (document 7). Accordingly, it is virtually certain that Vermeer used the general composition and poses of Baburen's *Procuress* as a model for his own. The motif of a carpet draped over a balustrade, which closes off the foreground of the composition, must have been borrowed from other works by the Caravaggisti of Utrecht.[45] Had Vermeer continued in this direction he might well have brought about a revival of this Utrecht type, which was rather outdated by the 1650s.

Despite his borrowings Vermeer's painting has some very original features. His conception is more quiet than that of his model. Baburen strongly accentuated facial expressions and emphatic hand gestures, while Vermeer minimizes animated movements. The peculiar beauty of Vermeer's picture is largely due to a warmth of colouring distinctly unlike that of the Utrecht school. The girl's face and yellow jacket are luminously highlighted against the muted dark tones of the background, and the glow of the red tapestry in the foreground.

The Procuress stands alone in Vermeer's *œuvre*; it cannot be placed in any trend or with any group. Yet it played a decisive role in his development, for it forms the chronological link between his early history paintings and the interior scenes—often imbued with erotic allusions—which were to follow.

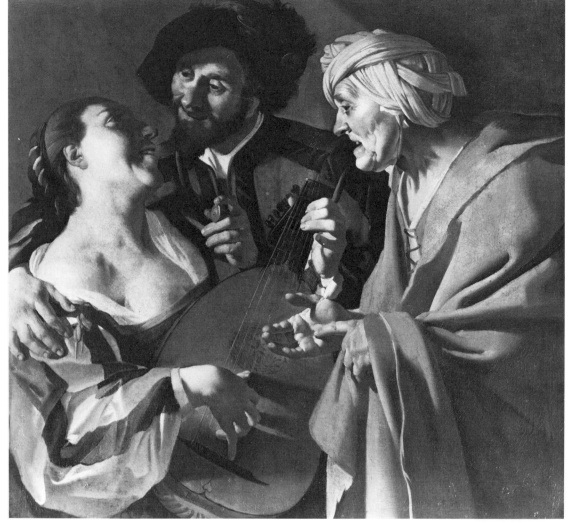

22. THEODOOR VAN BABUREN (*c.* 1595–1624). *The Procuress.* 101 × 107 cm., signed and dated 1622. Boston, Museum of Fine Arts

Girl asleep at a Table (Plate 4), in the Metropolitan Museum in New York, is Vermeer's first real attempt at genre painting. In many respects it recalls *The Procuress* (Plate 3): in its large size, in the dominance of red and yellow hues, and in the oriental carpet, which, more ostentatiously than effectively, closes off the foreground space. In neither *The Procuress*, nor the *Girl asleep at a Table*, is the relationship of the carpet to the table clearly indicated: the type and facial expression of the young ladies in both works are very similar. For these reasons the *Girl asleep at a Table* can be dated shortly after *The Procuress*, that is to say, about 1657.

Vermeer's new interest in pure genre painting led him to take another look at the masters in the circle of Carel Fabritius. The '*doorkijkje*' motif—the view from one room into another (see Figs 15, 16)—must have been derived from them; and the theme of the *Girl asleep at a Table* reminds us of a painting by Nicolaes Maes, dated to 1655, a time when he was closely associated with developments in Delft (Fig. 24).

In discussions of seventeenth-century painting the phrase 'genre painting' should be used with discretion. The seventeenth-century artist did more than present a picturesque view of an interior room—as was believed in the nineteenth century, when pure genre painting became popular. Nineteenth-

century critics read into seventeenth-century art the values of their own time; thanks to much recent research, we are now aware that the seventeenth-century painter frequently filled his pictures with symbolic and moralistic allusions.

Seymour Slive rightly reminds us that the *Girl asleep at a Table* is listed in the auction catalogue of 1696 (which we have previously mentioned) as 'A drunken girl sleeping at a table'. Slive argues that this early title should be taken literally, pointing out that wineglasses and a wine jug rest on the table, and that the girl's collar is not decently closed, as was proper at the time, but hangs indiscreetly open. Captions which accompany prints of the same subject from the period make it clear that such a depiction had moralizing implications. The image is meant to convey the idea that drunkenness is undesirable: it is more virtuous to walk the path of temperance and moderation.[46]

Aside from possible lost works, the *Girl asleep at a Table* is best regarded as the artist's initial imperfect attempt at genre painting. The perspective effects, which so intensely interested the other Delft masters, seem to have provided Vermeer merely with decorative additions to a composition originally conceived in a plane; the picture space is not defined at all clearly. The serene mood of the painting is due to Vermeer's concentration on a few broad and simple outlines. Strict verticals and horizontals—which foreshadow those in Vermeer's later works—make their first appearance.

Pieter de Hooch

As we have seen, Vermeer's work of the early 1650s reveals little interest in the contemporary developments which were revolutionizing Dutch painting. He did not participate in the successful campaign waged by his colleagues in Delft to find a thoroughly convincing mode of representing interiors. Nor, initially, did he show any awareness of the important compositional change which had taken place in genre painting, the shift to scenes dominated by a few large figures placed prominently in the picture space. It was not until around 1657 that he incorporated superficial adaptations of these innovations in the *Girl asleep at a Table* (Plate 4). But nothing in that painting leads us to suspect that its author would eventually develop a perfect synthesis of illusionism and 'classical' composition. It was an external impulse—the work of Pieter de Hooch—which stimulated Vermeer to attempt this synthesis.

De Hooch, Vermeer's senior by three years, originally trained in Haarlem under Nicolaes Berchem. Before about 1653, when he settled in Delft, he painted military scenes reminiscent of the work of the Amsterdam painters Codde and Duyster. He apparently began painting the interiors which constitute the greater part of his *œuvre* under the influence of the new milieu in Delft.

We do not know to what extent de Hooch had adopted the new Delft manner in the years before his earliest dated works, 1658.[47] Of his dated paintings those of that and the following three years are the most mature and accomplished we have from his hand. His artistic career seems to have been a long, arduous trek to a peak which he was able to sustain only briefly.

23. PIETER DE HOOCH (1629–after 1684): *An interior Scene*. 74 × 65 cm., monogrammed, about
1658. London, National Gallery

Shortly after 1660 the quality of his dated production began to decline. His
better undated works all resemble the works dated between 1658 and 1661;
there is no reason to assume that any of them were painted long before 1658.
About 1663 he moved to Amsterdam and eventually died in a lunatic asylum.

Imagine what a sensation one of de Hooch's early masterpieces of around
1658 must have caused (Fig. 23)! The lady with the wineglass and the two
gentlemen with whom she is coquettishly flirting are all displayed
prominently in the picture space, in a manner which reminds us of the work
of artists like ter Borch, Metsu, van den Eeckhout and van Loo (Figs 19–21).
But while these masters tend to focus attention on their figures by placing
them against a dark background, de Hooch dares to pose his figures in the
middle of a large, brightly lit chamber. Furthermore, the lines of the ceiling
beams, tile floor and window-frames conform exactly to the laws of linear

24. NICOLAES MAES (1634–93): *A sleeping Maid and her Servant.* 70 × 53 cm.,
signed and dated 1655. London, National Gallery

perspective, and the minute gradations of light reflected from walls and objects are recorded with the special sensitivity and precision which we associate with the work of painters from Delft.

We should not underestimate de Hooch's feat in successfully combining Delft's tradition of illusionistic interiors with the lively figures and tight internal unity found in genre painting. As early as 1655 Nicolaes Maes of Dordrecht had attempted the same synthesis (Fig. 24). Like van Hoogstraten, Maes was a former student of Rembrandt, who probably kept in touch with developments in Delft through acquaintance with Carel Fabritius. Though a talented painter, Maes failed where de Hooch succeeded. The figures in his painting threaten at any moment to slide off the steep floor; their expressions and gestures are excessively emphatic, and their outlines lack coherence. De Hooch was the first to place figures in interior space with perfect truth to life.

Vermeer's discovery of sunlight

Judging from a closely related group of four paintings, Vermeer was one of the first artists to recognize de Hooch's achievement. All four paintings convey a very de Hooch-like impression. While it cannot be proved, the four canvases seem to have been painted in 1658 and shortly thereafter, under the immediate impact of de Hooch's breakthrough.

The paintings differ completely in technique, colour and composition from all of Vermeer's previous work. His new goal was the placement of figures of palpable physical presence in brightly lit interiors. From the beginning it must have been apparent to Vermeer that he could improve upon de Hooch through greater simplification and concentration.

Soldier with a laughing Girl (Plate 5) in the Frick Collection in New York seems at first glance to be little more than a free copy of the left side of the de Hooch painting we have just discussed (Fig. 23). The woman in front of the table has now exchanged places with the man behind it, but the general composition is identical; even the map on the wall charts the same regions. However, Vermeer's depiction of the fall of sunlight from the left is brighter and less diffuse than de Hooch's, requiring an even greater virtuosity in rendering the minute gradations of value in both the bright and obscure passages. Such brilliant illumination in a painting was not considered advisable in the seventeenth century. Handbooks directed painters to work in studios with north light, or, if they could not avoid direct sunlight, to line their windows with oilpaper.

It seems that part of Vermeer's strategy for meeting this challenge was to paint the final canvas as much as possible from nature, an uncommon practice for the time. Even the most true to life works of a naturalist like Pieter de Hooch incorporate arbitrarily arranged elements. For example, de Hooch pictures the same house in two of his works, but places it in completely different surroundings, and changes various details. In one painting he depicts an untidy garden beside the house, in another three figures around a table (Figs 29, 30). The tiles in the foreground, the wall of the corridor, and the house seen through the little gateway all differ in the two pictures.

Vermeer worked otherwise. In the *Soldier with a laughing Girl* (Plate 5) and in two of the paintings related to it (*Girl reading a Letter at an open Window*, Plate 6, and *The Milkmaid*, Plate 7), he represented, very exactly, the same corner, of the same room, with the same window. Vermeer's faithfulness to nature is demonstrated by his representations of maps and globes, which are depicted with great accuracy, and which, in nearly all instances, can be precisely identified.[48]

This does not imply that Vermeer did nothing but record what meets the eye.[49] In strictly practical terms this was not possible for him. He wished to record all the nuances of the fall of light at a single moment. But his perfectionism obliged him to work for long periods over each painting—according to all indications he turned out no more than a few a year. Given the fickle Dutch weather, the intensity of light would change, constantly, in front of him.

To achieve his technical mastery, Vermeer limited his subjects in the years from 1658 onwards to a few objects in a small corner of a particular room. The hypothesis that he used a camera obscura seems very plausible.[50]

The *Girl reading a Letter at an open Window* (Plate 6) in Dresden provides a better idea of the growth of Vermeer's technique than the *Soldier with a laughing Girl* (Plate 5), which has a slightly abraded surface. If the latter painting represents a simplification of the format invented by de Hooch, the *Girl reading a Letter* carries that process even further. Only one figure remains; the visible surface of the left wall is halved; only the right part of the window is shown. He omits the wall map, allowing the light wall to function as an unbroken backdrop for the strictly ordered accents of window, figure, table, and curtain. Vermeer adjusts his treatment of objects according to their distance and texture, so that spatial relationships are rendered with crystalline clarity, and differences of texture are not so much visible as palpable. After discovering that sunlight spots in dark surroundings are perceived partly as splotches and dots of light, he duplicated this phenomenon in paint: in the *Girl reading a Letter* and the other pictures of the group he first uses his famous *pointillé* technique.

Art-historical conclusions are based on the accidents of survival. Fortunately, we know that Vermeer's *Girl reading a Letter at an open Window* (Plate 6) follows a compositional scheme already current in Delft, but we owe this conclusion entirely to a chalk sketch by Leonaert Bramer, which records a lost work by Adam Pick, a master who lived in Delft from 1642 until 1653. Bramer's drawing, which must date from before 1654, and one painting are all that remains of Pick's *œuvre* (Fig. 25).[51] From drawings Bramer made after paintings which still survive we know that he accurately rendered the composition of his models, but made no attempt to adjust his lively draughtsmanship to their style. Judging from the subject, Pick's painting may well have resembled a lost *Smoking Soldier* by Carel Fabritius.[52]

Thanks to the lucky survival of Bramer's drawing we know that by 1654 Pick (and perhaps other masters in Delft at the time, such as Carel Fabritius) had developed a compositional scheme which was a direct precursor of Vermeer's *Girl reading a Letter at an open Window*. Both Vermeer's painting, and the drawing after Pick depict a table with still-life objects, which closes off the foreground and which rests before a single figure who is placed against an unbroken background. Pick's composition, like that of Vermeer, is framed on one side by a drawn curtain.[53] But while works like the lost one by Pick provided Vermeer with a model for his *Girl reading a Letter*, he treated them in the same way that he treated de Hooch's paintings—he simplified them. Instead of Pick's extensive display of miscellaneous objects, Vermeer sets his table with a single bowl of fruit.

In an evenly lit space it is not an easy matter to imbue figures with life. The gestures and facial expressions of the figures in de Hooch's painting (Fig. 23) and the lively duo in Vermeer's *Soldier with a laughing Girl* (Plate 5) look frozen. In the real world figures move, but Vermeer's meticulous technique prevented him from creating an effective suggestion of movement. The practitioners of true *trompe-l'oeil* wisely circumvented this dilemma by depicting only inanimate objects (Figs 13, 14).

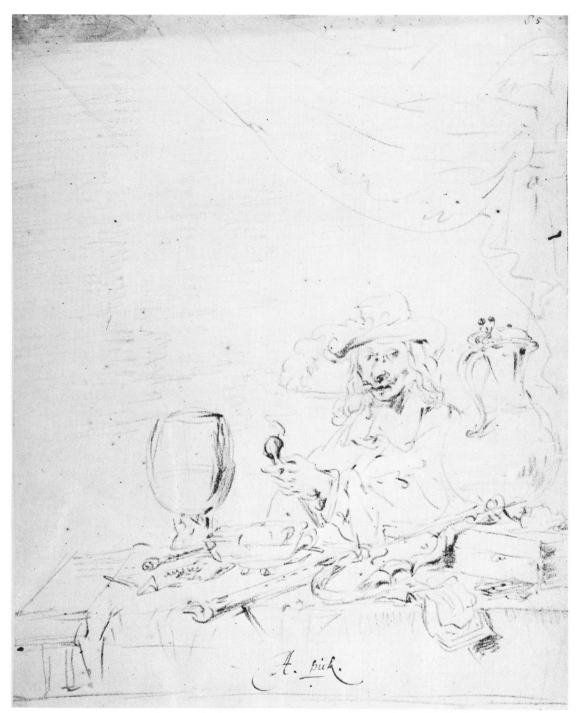

25. LEONAERT BRAMER after a painting by ADAM PICK (active *c.* 1650). Chalk drawing.
Amsterdam, Rijksprentenkabinet

Like the *trompe-l'oeil* painters, Vermeer desired a completely illusionistic
effect, but in addition he wished to depict figures. In many of his works he
solved this problem of motion by placing figures in circumstances where we
expect no activity from them. The only motion we should expect from a girl
standing quietly reading a letter would be the almost imperceptible
movement of her eyes—and the girl in Vermeer's painting glances
downward, hiding her eyes from us. The lowered gaze is a device Vermeer
first used in *Christ in the House of Mary and Martha* (Plate 1), and he was to
use it repeatedly thereafter to transform the women in his paintings into still-
life.

If this painting in Dresden (Plate 6) shows a greater concentration and simplicity than the one in New York (Plate 5), *The Milkmaid* (Plate 7) in the Rijksmuseum in Amsterdam is an additional step towards the same goal, and represents the culmination of Vermeer's work in this direction. This last painting cannot be much later than the *Girl reading a Letter at an open Window*: it has the same cool clarity and bright colours, and again the scene is laid in the same corner of the same room. Vermeer applies the *pointillé* technique in the highlit areas more daringly than before—particularly in the loaves of bread on the table. Even more significant is the reduced contrast between foreground and background. The silhouette of the seated soldier in the *Soldier with a laughing Girl*, and the curtain to the right in the *Girl reading a Letter at an open Window* are somewhat obvious *repoussoirs*. Vermeer abandoned this device in *The Milkmaid* and moved closer to the subject. We now see only a small fragment of the window, and the solid figure of the milkmaid, who dominates the whole picture.

In *The Milkmaid* Vermeer lovingly dwells on the fabrics, crockery and metal, the structure of the plaster wall, and the light that plays over them all. The effect is one of spontaneous naturalism, but he avoids any disjunction of forms or disorder of colour by means of a calculated organization of light and shadow, of large and small forms, and of curved and straight lines. A diagonal line running from upper left to lower right would separate a predominantly illuminated area from one predominantly cast in shadow. Only the flat, neutral wall in the background is evenly lit. The patches of light and shadow between the empty wall surface and the busy foreground are connected by the massive vertical of the milkmaid herself. The eye-catching still-life on the table, which defines the foreground area, also catches the light, but it is snugly anchored by the area of shadow around it.

The first change which Vermeer effected in the composition of de Hooch's interior scenes was to reduce the number of figures to one or two, and to remove them to a corner. Thus he was able to concentrate on a few closely observed objects, which he varied from painting to painting. This is how he achieved the incredible mastery displayed in *The Milkmaid*. Only after working on these limited problems did Vermeer attempt to compete with de Hooch on his own ground. *The Glass of Wine* (Plate 8) in Berlin is the first example of such an attempt. Its general composition recalls de Hooch more directly than any of the paintings we have discussed thus far. For the first time Vermeer exactly follows him in placing a man and a woman in a spacious interior (Fig. 23). He has not surrendered any of the masterful rendition of textures which he had perfected in the *Soldier with a laughing Girl* (Plate 5), *Girl reading a Letter at an open Window* (Plate 6), and *The Milkmaid* (Plate 7), for even in the smallest details *The Glass of Wine* clearly differentiates between the polished wood, nubby carpeting, and smooth silk. This vivid sense of texture is in sharp contrast to de Hooch's work. When we examine de Hooch's painting in London we can hardly distinguish the individual materials of the carpet, clothing, and other objects. At the same time, even in this complicated composition, Vermeer preserves a sense of unity and inner logic. In its sobriety and quiet harmony *The Glass of Wine* far surpasses anything accomplished by de Hooch.[54]

Vermeer's city views: The little Street *and the* View of Delft

Carel Fabritius and the masters in his circle not only made illusionistic renderings of interiors but of exteriors as well. We have already mentioned the only surviving painting of this type by Fabritius himself (Fig. 26). A curious, rather awkwardly designed painting by Daniel Vosmaer of Delft may reflect Fabritius's larger works in this style (Fig. 27). Like the paintings of Fabritius, Vosmaer's work combines a contrived perspective with a real view of Delft. A number of paintings by Vosmaer and his fellow townsman Egbert van der Poel show Delft as it looked after the explosion of the powder magazine there on 12 October 1654 (Fig. 28). Among the victims of this dreadful disaster, which left the greater part of the city in ruins, was Carel Fabritius.

These Delft paintings from the 1650s, along with representations by Saenredam and Jan Beerstraten of the old Amsterdam Town Hall, which was destroyed by fire in 1652, are the first true city views known to us.[55] The *vedute* as a popular genre did not develop until later, when it was practised with great success by such masters as Jan van der Heyden, the Berckheyde brothers and, in the eighteenth century, by Venetian artists.

Pieter de Hooch, in a series of works painted around 1658, the same years in which he rejuvenated the painting of interiors, was the first to capitalize on the potential of exterior views. A canvas such as de Hooch's *Courtyard of a House in Delft* (Fig. 30), dated 1658, provides impressive evidence of his achievement. Only the existence of paintings like this can explain why Vermeer decided to direct his vision out-of-doors.

Vermeer was no more a mimic of de Hooch's models of exterior painting than he had been of the latter's interior scenes. In place of de Hooch's box-like constructions of spatial compartments in his *Courtyard*, Vermeer's *The little Street*, ('Het Straatje', Plate 9) in the Rijksmuseum depicts a continuous

26. CAREL FABRITIUS (1622–54): *View of Delft*. 15 × 32 cm., signed and dated 1652. London, National Gallery

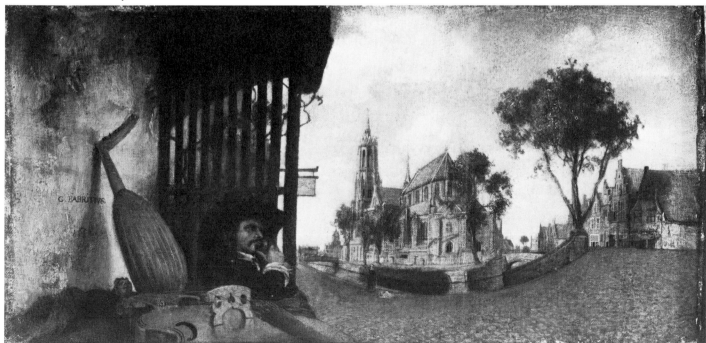

27. DANIEL VOSMAER (active *c.* 1650–66): *View of Delft.* 90 × 113 cm., signed and dated 1665. The Hague, Dienst voor 's Rijks Verspreide Kunstvoorwerpen, on loan to Museum Prinsenhof, Delft

28. EGBERT VAN DER POEL (1621–64): *View of Delft after the Explosion of the Powder House in 1654.* 36 × 49 cm., signed and dated 1654. London, National Gallery

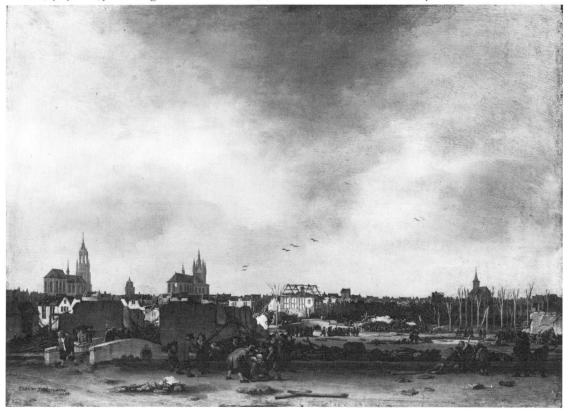

wall, pierced by an occasional doorway. De Hooch succeeded in imbuing his *Courtyard* with a degree of naturalism unrivalled by his contemporaries. Vermeer achieved still more refined effects through his brighter colouring and meticulous modelling, which are combined with his *pointillé* technique.

As in the case of his genre paintings, Vermeer probably reached this perfection by painting directly from nature. De Hooch's deceptively natural *Courtyard of a House in Delft* is actually a composition of his own invention, as is indicated by his use of the same porch in another painting, with quite different surroundings (Figs 29, 30). Vermeer's *The little Street* (Plate 9), on the other hand, is probably an absolutely exact transcription of a view from the rear window of Vermeer's house, on to the street where he had lived as a child.[56]

29. PIETER DE HOOCH (1629–after 1684): '*The Courtyard of a House in Delft.*' 66 × 56 cm., monogrammed and dated 1658. On loan to the National Gallery of Scotland

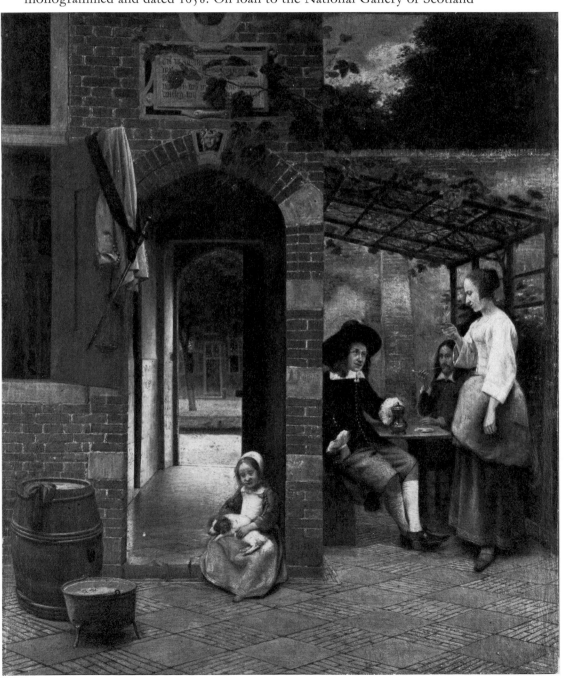

City views apparently originated from the desire to record buildings which had perished or were threatened: we have already noted that some of the earliest Dutch views of this type—by Vosmaer, van der Poel, Beerstraten and Saenredam—depicted buildings which had been destroyed. Vermeer's *The little Street* belongs to this same tradition, for some of the houses in the painting (the one on the right, and the gate beside it) were demolished in 1661 to make way for the new quarters of the painters' guild.

It is likely that Vermeer only made his painting when the buildings in it were threatened with destruction. The demolition provides a plausible incentive for the painting, and the date of 1661 fits in well with Vermeer's stylistic development. The simplicity of *The little Street* (Plate 9) resembles

30. PIETER DE HOOCH (1629–after 1684): *'The Courtyard of a House in Delft.'* 73 × 60 cm., monogrammed and dated 1658. London, National Gallery

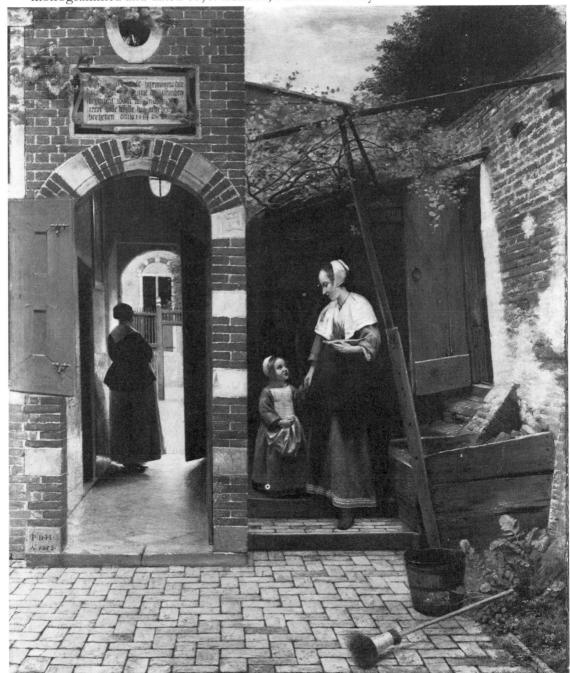

The Milkmaid (Plate 7), a work which probably also dates from a few years after 1658. *The little Street* confidently displays the sort of artistic mastery which was achieved in *The Milkmaid* only after a long period of experimentation. We can only guess at the appearance and date of a lost 'View of Some Houses in Delft' which is mentioned in the auction of 1696, but there is every reason to believe that Vermeer did not attempt to rival de Hooch's exterior views until after he had mastered genre painting.

In the city views as with his interior scenes, Vermeer developed from relatively modest compositions to more ambitious ones. The success in a small format of *The little Street* probably encouraged him to attempt an outdoor painting of larger scale—his *View of Delft* (Plate 10) in the Mauritshuis, The Hague. It is an altogether astonishing achievement. While some paintings strike us forcefully on one occasion, only to leave us unimpressed the next, the *View of Delft* is endlessly fascinating.

Many authors have compared its vibrant luminosity with the work of the French Impressionists. However, the *View of Delft* bears an equal affinity with the painstakingly exact city views of Dutch *vedute* painters of the late seventeenth and eighteenth centuries. It is, in fact, a topographical view—a precise rendering of the *Schiekade* in Delft, between the Rotterdam and Schiedam gates, viewed from across the Schie River. The very house from which Vermeer worked can be identified.[57] As in other paintings he seems to have painted directly from nature with the aid of a camera obscura.

Vermeer's obsession with topographical accuracy was not unique. The Delft archives tell of a 'Great Picture Map of Delft' which was started for the city government in 1675, only a few months after Vermeer's death. Large sums were spent for this compilation of exact renderings of buildings in Delft, all made on the spot. The project included not only an illuminated ground plan, but also a drawing (for which 72 guilders were paid) representing 'the profile of the city drawn most fastidiously from nature, without sparing time or effort'.[58]

Vermeer's achievement in the *View of Delft* was to combine just this sort of topographical exactitude with a magical sensitivity to the play of light. While some later artists have achieved great accuracy in the realm of either objective or perceived reality, Vermeer's synthesis of the two is unequalled.

Further refinement, and the influence of Frans van Mieris

The Soldier with a laughing Girl (Plate 5), the *Girl reading a Letter at an open window* (Plate 6), *The Milkmaid* (Plate 7), *The Glass of Wine* (Plate 8), *The little Street* (Plate 9), and the *View of Delft* (Plate 10) were evidently painted in rapid succession in the years from 1658 to 1661. In technique they form a distinct group within Vermeer's *œuvre*. All exhibit the same solid, emphatic modelling. Close inspection also reveals an uneven paint surface, marked by lumps and small areas of impasto, particularly in the brighter passages.

In his later paintings—the date of transition in style is probably about 1662—Vermeer abandons the very explicit and pasty modelling of these early works in favour of a smoother paint surface, a more restrained and less individualized treatment of texture, an increasingly subdued lighting, and a generally greater refinement.

Woman and two Men (Plate 11) in Brunswick is an early example of this new departure. Though it repeats many of the features of *The Glass of Wine* (Plate 8) in Berlin, it replaces the layered application of paint employed in that picture with more delicate modelling. The pronounced contrast of form and texture of the Berlin painting—the contrast of the glossy chair and the rough carpet, for example—are avoided in the Brunswick piece. Fashion changes in the clothing of the figures suggest that *Woman and two Men* is several years later than *The Glass of Wine*.[59] Apparently Vermeer had spent the intervening time working on city views, and only belatedly returned to the format of *The Glass of Wine*.

Woman with a Water Jug (Plate 12), in the Metropolitan Museum, is also a transitional piece. Its brilliant lighting recalls Vermeer's work of 1658–61, but its refinement of technique places it with his later work.

Although the delicate modelling of this new phase has an affinity with Gerard ter Borch's style of the 1650s (see Fig. 21), a more direct influence on Vermeer was the work of Frans van Mieris the Elder, the most gifted pupil of the Leiden *Feinmaler* ('precision painter') Gerard Dou. Of precocious talent, by 1658, at the age of twenty-three van Mieris was producing works of comparable quality to those of Pieter de Hooch, who was six years his senior. Van Mieris drew inspiration from ter Borch as well as benefiting from his training under Dou and from the example of the Delft interior painters. During his lifetime his work fetched high prices, and his fame lasted until the nineteenth century, when with the advent of Impressionism his meticulous style fell out of favour.[60]

In so far as external influences could shape Vermeer's very personal development, van Mieris's art was of primary significance. This is illustrated by his *Duet* of 1658 (Fig. 31)—a fine example of his work, in which large figures are placed against a light background with an elegance which is reminiscent of ter Borch. Both the theme of van Mieris's *Duet*, and his arrangement of figures and objects (the chair in the right foreground, for example) presage features which would soon appear in Vermeer's art (see Plates 16, 19). Even such a detail in the *Duet* as the red gown with brocade trimming, worn by the girl at the clavecin, is repeated precisely—in regard to colour, fashion and the way it is rendered—in Vermeer's *Woman and two Men* (Plate 11).

Vermeer was influenced by van Mieris somewhat later than by de Hooch—not until sometime after 1660. This is hardly surprising, for since van Mieris worked in Leiden, his work was surely less accessible than that of Vermeer's fellow townsman de Hooch. In addition, it was only in about 1660, and the years which followed, that van Mieris perfected his distinctive style—with its glossy, velvet-soft modelling, and its vividly sculptural apprehension of form (Fig. 36).

The 'three women'

Vermeer's *Woman and two Men* (Plate 11) and *Woman with a Water Jug* (Plate 12) are followed by seven paintings which are still more refined and mature in execution and yet clearly precede Vermeer's late style, which commences in about 1667 (see p. 53). As a group these paintings fit roughly in the years

31. FRANS VAN MIERIS (1653–81): *The Duet.* 32 × 25 cm., signed and dated 1658. Schwerin, Staatliches Museum

from 1662 to 1666, but their individual sequence is difficult to determine; the various arguments in favour of one or another chronology tend to confound one another. The problem remains alluring, for in this period Vermeer was at his artistic zenith.

The *Woman with a Pearl Necklace* (Plate 13) in Berlin, *Woman in blue reading a Letter* (Plate 14) in Amsterdam, and the *Woman weighing Gold* (Plate 15) in Washington demonstrate once more Vermeer's manner of re-employing a basic scheme in several pictures (each of which, in this instance, is almost equally perfect).[61] In each of these three paintings a horizontal, formed by a table covered partly with a carpet and laid with a few objects, sets off the

prominent vertical of a woman standing nearly in full length. The stress on horizontal and vertical is repeated in the accessories of each scene—by the seat and back of a chair in the foreground (Plates 13, 14); or by the right-angle of a map (Plate 14) or painting on the back of a wall (Plate 15). Within this simple framework Vermeer outlines forms with unrivalled delicacy.

In attempting to evoke the mood of these paintings writers have despaired at the limits of language and the tools of art-historical description. 'Pure poetry', 'solemnity', and 'subdued harmony' are phrases typically invoked. The effect which these vague terms seek to convey is not difficult to sense. But in order to understand more precisely how Vermeer achieved it we should compare his paintings with the work of his contemporaries, which served him as a starting point—for example with van Mieris's *Duet* (Fig. 31), itself a 'classic' painting. In contrast with the restful, perfectly balanced poses of Vermeer's three women in Berlin, Amsterdam and Washington (Plates 13, 14, 15) van Mieris's clavecin player arches her back with obvious effort, introducing a note of tension in the composition. Vermeer's women (whose repose is enlivened only by the accents of hands and profile) are described with smooth, almost uninterrupted outlines, while van Mieris's contours seem mobile and disrupted. Vermeer's only animating note is the graceful outline of the carpet, and the table filled with objects. He veils the entire area at the left with shadow, while van Mieris clutters the left side of his composition with music paper, a parrot, and other paraphernalia.

In the *Woman in blue reading a Letter* (Plate 14) Vermeer exploits the same motionless but evocative motif which he had used earlier in his painting in Dresden (Plate 6). In the *Woman with a Pearl Necklace* (Plate 13) and the *Woman weighing Gold* (Plate 15) he manifests an even more subtle expressive skill, in selecting a moment of immobility which exploits the tension between rest and action. The woman with a pearl necklace is shown pausing to study herself in the mirror, as she debates whether or not to tie the ribbons of her necklace; the woman weighing gold is caught in an instant of suspended attention as the pans of her scales come to rest.

For all their shared features the three paintings are not mechanical repetitions of a single prototype, as is so often the case with the work of Vermeer's contemporaries. Rather, Vermeer developed in each an entirely new lighting and colouring.

Woman with a Pearl Necklace (Plate 13) possesses a silvery light, with predominating tones of muted yellow and white.

The *Woman in blue* (Plate 14) has more diffuse illumination, and a blue ground which suffuses the whole surface. Because this is the only Vermeer with such a strong overall tonality, it is likely that the blue is more exaggerated now than when the picture was originally painted. In other paintings by Vermeer the original green (a colour obtained by mixing yellow and blue) has turned blue as the yellows in the mixture have oxidized (a change sometimes referred to as 'blue-green disease'). The queer and inappropriate blue vegetation in *The little Street* (Plate 9) and the *View of Delft* (Plate 10), and the blue laurel wreath in *The Art of Painting* (Plate 19) are examples of this green-to-blue shift. It is likely that the blue in the *Woman in blue* was also originally balanced by green and yellow passages.

The theme of the *Woman weighing Gold* (Plate 15) had earlier precedents in Delft. Leonaert Bramer painted the subject more than once, although unfortunately none of these works has survived; they are known only through the descriptions in eighteenth-century sales catalogues.[62] A painting in a style related to Bramer's, by Willem de Poorter of Haarlem, probably reflects the spirit of Bramer's treatment of the theme (Fig. 33). It can hardly be coincidence that the general format of de Poorter's painting resembles that of Vermeer's work.

Vermeer's contemporaries undoubtedly were quick to recognize the connection between the action of the woman and the painting on the wall behind her, which depicts the Last Judgement—the fatal day when all souls will be weighed. The mirror is a frequently employed symbol of vanity while the gold on the woman's scale and the strings of pearls on the table represent the transience of earthly wealth which will have no value on the Day of Judgement; only the alloy of the soul will have weight.[63] With characteristic subtlety, Vermeer hid the representation of St Michael weighing souls behind the woman's head.

'Companion of joy, balm for sorrow' (Plates 16, 17, 18)

Without doubt the splendid *Music Lesson* (Plate 16) in Buckingham Palace is a later work than the three paintings of women we have just discussed (Plates 13, 14, 15). To be sure, it has occasionally been dated earlier. Some writers, apparently impressed by the similarity of the rich treatment of the carpet in the foreground to the carpet in the *Girl reading a Letter* (Plate 6) even date it before 1660. But the *Music Lesson* has none of the experimental and transitional qualities we have noted in the *Girl reading a Letter*. As in the three paintings of women (in Berlin, Amsterdam and Washington), action and repose are in a perfectly balanced tension, and individual forms, sensitively rendered, are integrated into an overall geometric order. However, the structure of the *Music Lesson* is considerably more complex than the previous paintings. Given the complexity of the new undertaking, it is quite understandable that Vermeer borrowed such motifs as the conspicuously displayed carpet from his earlier manner.

'Musica Laetitiae Comes Medicina Dolor[um]' (Music: Companion of Joy, Balm for Sorrow).[64] Written in capitals on the cover of the clavecin, this text may express Vermeer's ambitions for painting as well as music. A lively, forceful rhythm guides our glance over the opulently covered table in the foreground, the upright chair, and the viola da gamba lying on the floor; it does not dissipate when our gaze reaches the rectangular back wall, for the rhythm is picked up by a series of clearly indicated oblong forms set against the wall and parallel to it—a mirror, a painting, and the clavecin. The carefully calculated movement into depth, and the carefully placed rectangles in the background all contribute to a single impression—that of a commodious, box-like space which scrupulously obeys the laws of perspective.

The spatial arrangement evokes one of the finer pictures of Pieter de Hooch (see Fig. 23); the subject-matter evokes Frans van Mieris (see Fig. 31). But in contrast to van Mieris's *Duet* Vermeer shows his performer from

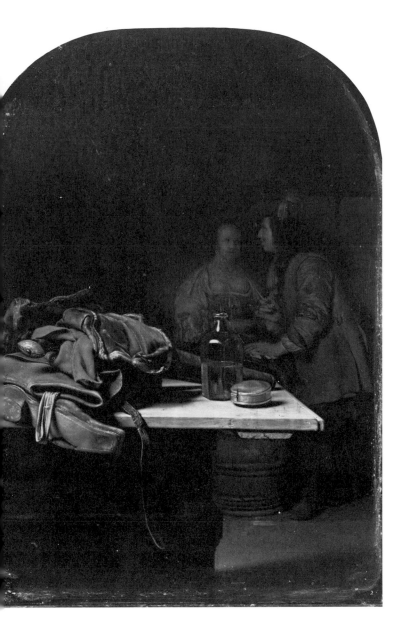

32. FRANS VAN MIERIS (1635–81): *Interior*. 27 × 17 cm.,
signed and dated 1666. Munich, Alte Pinakothek

33. WILLEM DE POORTER (1608–after 1648). *Woman
weighing Gold*. 46 × 41 cm., signed. Raleigh, North
Carolina Museum of Art

behind so that her active hands are not visible. Her face is seen only at one
remove, reflected in the dimly lit mirror. Thus we do not expect movement
either from her, or from the quietly listening man.

The huge table in the immediate foreground makes a striking contrast
with the diminutive figures at the back of the room. But there is a parallel for
this surprising effect, in a painting by Frans van Mieris from the same period,
in which the contrast of scale is even more pronounced (Fig. 32). This seems
to confirm that Vermeer and van Mieris were in contact during these years.

The general arrangement of the *Music Lesson* (Plate 16) recurs in *The
Concert* (Plate 17) in the Isabella Stewart Gardner Museum in Boston, which
presents a more circumscribed view and omits the ceiling and the side walls
of the room. Now it is the man who is seen from the back: a woman singing
is seen in three-quarters view, and the woman at the harpsichord is viewed in
profile. This time her hands are clearly visible. It is unclear whether *The
Concert* is earlier than the *Music Lesson* or a later variation of it.

The *Girl with a pearl Ear-ring* (Plate 18) in the Mauritshuis is even more difficult to place in sequence than *The Concert* (Plate 17) in the Gardner Museum. Vermeer concentrates on the glance the girl casts over her left shoulder as her eyes meet ours. Her shining eyes, moist lips, and the modelling of her face and dress succeed in convincing us of their perfect naturalness. But if we compare the painting with a work by Frans van Mieris from about 1658 (Fig. 34), a work which may even have provided Vermeer's source of inspiration, Vermeer's tendency to idealize is very apparent.

Van Mieris dresses his model in clothes of the current fashion, and conscientiously differentiates the nearly palpable textures of velvet, fur and cotton. Vermeer, by contrast, avoids specifics: his girl wears an apparently fanciful costume of a single, indeterminate fabric. While van Mieris delicately models the plasticity of the face, indicating all its imperfections and idiosyncrasies, creating the effect of a portrait, Vermeer only indicates the rhythmic beautiful contour of the face, and keeps detail to a minimum. (The line of the nose is, in fact, invisible; the bridge of the nose and the right cheek simply flow into each other, forming a single area of absolutely even colour.) In no other painting by Vermeer do we see so clearly how his truthfulness to nature was coupled with a desire to represent it in its ideal state.

The Art of Painting (Plate 19)

In 1661 construction of new quarters for the Delft Guild of Saint Luke was begun on the *Voldersgracht*, directly behind Vermeer's house. The classicizing façade of the new building—which unfortunately no longer exists—was surmounted by a bust of Apelles, the most famous painter of antiquity. The interior was decorated with allegorical representations of Painting, Architecture and Sculpture. In the sections of the ceiling one could admire the seven liberal arts—and also an additional eighth, 'Painting', executed by Leonaert Bramer 'out of love for the Guild'.[65]

Bramer was one of the officers of the guild in 1661, but in the following year he was succeeded by Vermeer, who was re-elected in 1663 (and served on the board again in 1670 and 1671). The new quarters of the guild must have been still unfinished when Vermeer took office in 1662. Consequently he must have been involved, if not in the planning of the building, at least in its completion—particularly of its decorations, which included the symbolic representation of the arts, above all, the art of painting. It is against the background of this project that we should consider Vermeer's own treatment of *The Art of Painting* (Plate 19), now in Vienna and often called *An Artist in his Studio*.

Documents tell us that the picture was in the possession of Vermeer's widow after his death in 1675, and that she did everything in her power to avoid selling it. The fact that Vermeer kept the painting during his lifetime, and the special care that he seems to have taken in its execution, suggest that it enjoyed a privileged place in his *œuvre*, and may very well have been on his easel for a period of years.

Vermeer's painting was of an established type, if we consider not the specific subject, but the general motif—a painter depicting a young woman,

34. FRANS VAN MIERIS (1635–81): *The Artist's Wife (?)*. 11 × 8 cm. London,
National Gallery

who appears again in the unfinished painting on his easel. More than a
century earlier Maerten van Heemskerck (1498–1574) had painted a *Saint
Luke painting the Madonna* (Fig. 35). With a 'love for the guild' which recalls
that of Vermeer's friend Leonaert Bramer, van Heemskerck donated his
picture to the Haarlem Guild of Saint Luke. Vermeer may well have known
of Heemskerck's work (and of its donation), for it is described in Carel van
Mander's famous treatise on Netherlandish painters which was published in
1604.[66] It is even conceivable that Vermeer's painting was also originally
intended to be a gift to his guild.

In the nineteenth century—when Vermeer had just been rediscovered—
The Art of Painting was considered a realistic glimpse into a painter's studio.
Theophile Thoré even speculated, erroneously, that it might be Vermeer's
self-portrait. Today its allegorical intention is recognized. Many of its details
are clarified by the *Iconologia* which was written by the influential Italian
inventor and explicator of symbols Cesare Ripa, and had been published in a
Dutch translation in 1644.

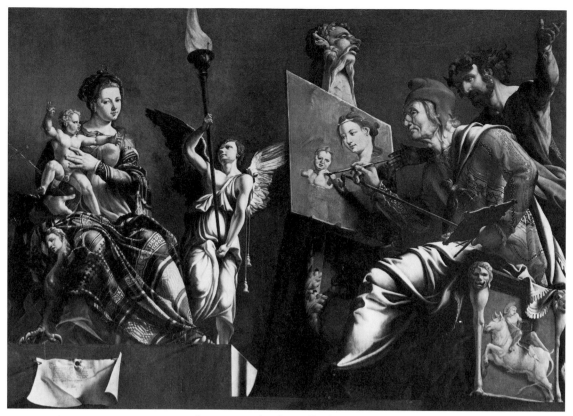

35. MAERTEN VAN HEEMSKERCK (1498–1574): *Saint Luke painting the Madonna.* 168 × 235 cm.,
monogrammed and dated 1532. Haarlem, Frans Hals Museum.

Since painting is an art of imitation, the mask on the table is an appropriate
symbol for it. Ripa wrote that 'the mask and the ape show the imitation of
human activities.' The costume of the painter is not contemporary, but is
inspired by the clothing depicted in late medieval art. Thus to a seventeenth-
century viewer the painter was dressed in 'the antique way'. The woman
who poses for him wears a laurel wreath and carries a book and trumpet.
These attributes are mentioned by Ripa as those of Clio, the Muse of History.
Thus the painter depicts History, and she in turn inspires the painter.[67]
Vermeer has thus expressed in symbolic guise the idea that history painting
was an artist's noblest calling. Clio wears a laurel wreath which never
withers, and carries a trumpet to blare out praise. It seems that Vermeer had a
high opinion of his own profession!

The map in the background, which depicts the Netherlands, evidently
alludes to the fame and importance of Netherlandish painting.[68] It is
revealing that the map does not show political boundaries as they existed in
Vermeer's lifetime, but as they were before 1581, when the entire
Netherlands were part of the Habsburg Empire. In 1648 at the Peace of
Westphalia the original Netherlands had been divided: the northern half,
present-day Netherlands, became a Protestant republic; the southern half,
now Belgium, remained a province of a Roman Catholic monarchy.

Artists and connoisseurs, however, failed to take cognizance of this
political division. In his autobiography Constantyn Huygens groups
painters according to subject-matter, such as history or landscape; regardless
of whether they lived in the north or the south, he calls them 'my fellow
Netherlandish countrymen'.[69] It made no difference to him if a painter lived

in Amsterdam or Utrecht, or in Antwerp or Brussels, and when he organized the decoration of the royal palace, the '*Huis ten Bosch*' in The Hague, he gave commissions not only to masters from Utrecht and Haarlem, but also to Jacob Jordaens from Antwerp. Even Arnold Houbraken, in his book on Netherlandish painters (which was published as late as 1718–21) indiscriminately mixes northern and southern Netherlandish artists in his discussion, without a hint of a division between them. Vermeer, also, clearly conceived the art of both the north and south Netherlands as a single entity.

In *The Art of Painting* Vermeer unified the delicate attention to detail of his three earlier paintings of women (Plates 13, 14, 15) with the complex spatial effects of the *Music Lesson* (Plate 16). No other work so flawlessly integrates naturalistic technique, brightly illuminated space, and a complexly ordered composition. Exquisitely worked out details—the chair in the foreground, the crinkled wall map, and the painter's jacket—may be enjoyed individually, and yet are perfectly integrated with the serenity of the larger sunlit space.

Once again a work of Frans van Mieris, who addressed a similar compositional and iconographical challenge, provides an illuminating parallel with Vermeer's painting (Fig. 36). The direction of influence between the artists cannot be firmly resolved because it is not clear which painting is the earlier. Van Mieris sets brightly lit forms against a dark background, thereby preventing the numerous picturesque background details from disturbing the overall effect. Vermeer selected a light background, which obliged him to keep the number of miscellaneous objects to a minimum, and to define those objects he retained with the greatest care. Van Mieris's painter and model communicate with each other through lively gestures and facial expressions. Vermeer instead depicts a moment of inaction which still retains the vitality of life—an effect which he realizes here even more ingeniously than in any of his other works. The girl who poses is quite naturally motionless. However, we might expect some movement from the painter's right hand, which is engaged in painting the laurel wreath. Vermeer cleverly satisfies us that this hand should indeed be inactive by showing the moment when the painter has turned his head to the left to study his model. For an instant he rests motionless while he considers how to place his next brushstroke.

A crisis in style

It is difficult to imagine a more successful realization of Vermeer's artistic ideals than *The Art of Painting* (Plate 19). After such perfection in the illusionistic depiction of reality there was little room for improvement, and the other alternative, repetition, could only lead to sterility and tedium. Vermeer now confronted a situation which other Dutch painters, whether consciously or unconsciously, also faced at this time.

Between 1650 and 1670 the detailed depiction of 'reality' had reached a virtually unsurpassable level of perfection in the works of Vermeer, Frans van Mieris, Jan van de Capelle, Willem Kalf, Adriaen van de Velde, Jacob van Ruisdael, and others of their generation. Most of the later Dutch painters working in a 'realistic' manner derived their inspiration from these

36. FRANS VAN MIERIS (1635–81). *The Studio*. 60 × 46 cm., signed. Lost in Dresden during the Second World War
37. WILLEM VAN MIERIS (1662–1747): *A Woman and a Fish-pedlar*. 49 × 41 cm., signed and dated 1713. London, National Gallery

masters, but seldom achieved the same level of quality. By about 1660 the goals of Dutch art, as they had been defined shortly after 1640, had been realized in such convincing form that other approaches were pre-empted, and younger artists faced no challenge but that of rivalling their teachers. This lack of room for the further development of Dutch painting after 1670 is perhaps the chief cause of its gradual decline, for which so many explanations have been advanced.

Artists reacted variously to this crisis. The sons of Frans van Mieris merely strove to elaborate the compositions of their father (Fig. 37); more talented masters, realizing that a kind of perfection had been reached, created works dominated by restlessness and tension. Adam Pynacker, for example, who painted harmonious, balanced landscapes in the 1650s (Fig. 8), created intensely agitated and dramatic ones in his later years (Fig. 39). Jacob

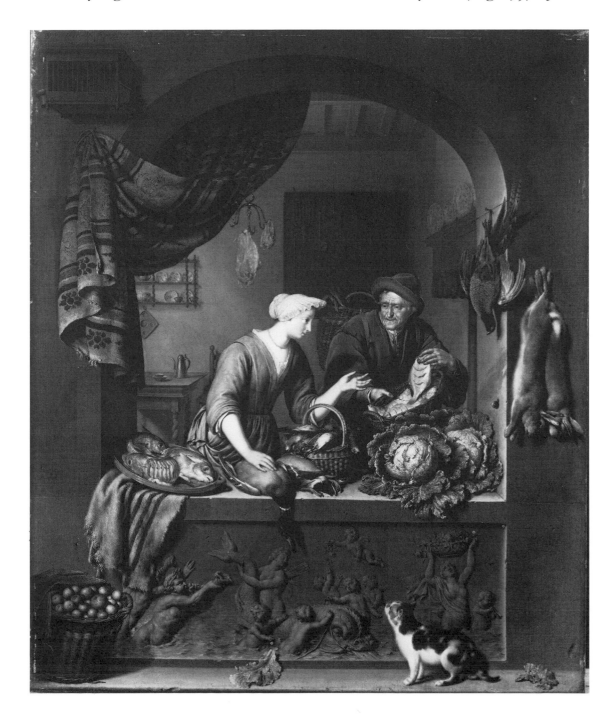

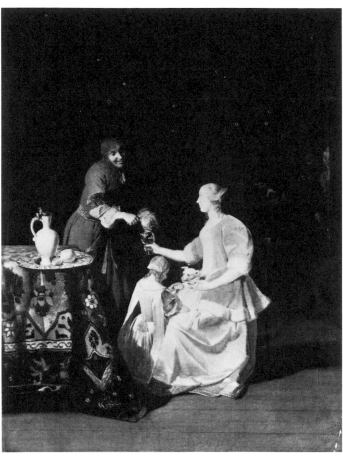

38. JACOB OCHTERVELT (1634–82): *The Gallant.*
81 × 60 cm., signed and dated 1669. Dresden,
Staatliche Kunstsammlungen

39. ADAM PYNACKER (1621–73): *Landscape.* 119 × 103 cm.,
signed. Paris, Louvre

40. PIETER DE HOOCH (1629–after 1684): *Couple with a
Parakeet.* 73 × 62 cm. Cologne, Wallraf-Richartz
Museum

41. FRANS VAN MIERIS (1635–81): *Couple.* 36 × 30 cm.,
signed and dated 1678. Amsterdam, Rijksmuseum

Ochtervelt, aware that it was impossible to improve upon ter Borch's genre paintings, invented a new formula in which compositions in the manner of ter Borch are staffed with excessively elegant and unnaturally elongated figures, whose facial expressions often look like grimaces (Fig. 38). Both Pynacker and Ochtervelt explored that tense balance between the orderly and the erratic that can be termed manneristic.[70]

Vermeer's late style

Vermeer, who appears to have been an artist of imperturbable self-assurance, did not seek to resolve this problem by means of the excursiveness of a Willem van Mieris, or the exaggeration of a Pynacker or Ochtervelt—but rather in an increased stylization. He simplified details, schematized his modelling, and made his shapes more rigorously geometric.

Once again there is a parallel between the work of Vermeer and that of Frans van Mieris, for in the later paintings of van Mieris (which are seldom very attractive) we find a glassy or metallic manner of rendering which in many respects is a stylized version of his earlier velvety technique (Fig. 41).

It is uncertain when Vermeer initiated this new style, which culminated in his *Lady standing at a Virginal* of about 1670 (Plate 25). Presumably not later than 1667. Until recently, Vermeer's painting of *The Love Letter* (Plate 22) in the Rijksmuseum, Amsterdam, which bears all the traits of the new style, seemed to provide a secure indication of this date. Pieter de Hooch clearly borrowed its unusual spatial arrangement for a painting which, when it turned up on the art market, was said to be dated 1668 (Fig. 40). Unfortunately, this date was not accurate. When de Hooch's painting, which is now in the Wallraf-Richartz Museum in Cologne, was thoroughly examined a few years ago, no date was found, and the fashion of the costumes indicated that it was probably painted in the latter half of the 1670s.[71] Accordingly, it is no longer of much value for dating the Vermeer. Fortunately, the date of *The Love Letter* need not remain in limbo. A date of about 1667 is still very plausible as the painting seems to have inspired one of the very last works of Gabriel Metsu, who died in the autumn of that year (Fig. 42).[72]

Like the later *Lady standing at a Virginal* (Plate 25), *The Love Letter* is crisply linear. This is particularly striking in the jambs of the door: the moulding on the right side of the doorway is indicated by a single sharp vertical stroke of light. Vermeer's new schematic technique of modelling, which was to culminate in his *Lady standing at a Virginal*, is boldly and skilfully employed. Nuances and gentle transitions of shading are eliminated, yet Vermeer perfectly captures the overall distribution of values. The painting's unorthodox viewpoint places us in a dark hallway, looking into a brightly lit room. To borrow photographic terminology, it is divided into an 'under-exposed' and an 'over-exposed' area. Vermeer flaunts his skill in correctly reproducing the varied brightness of all the details of the scene under the most difficult lighting conditions.

In the brightly lit background a lady interrupts her music to receive a letter from her maid. Vermeer's contemporaries would have deduced, from the seascape on the wall behind, that this was a letter of love. Other Dutch

paintings, as for example the canvas by Metsu (Fig. 42), to which we have just referred, show the same juxtaposition of a lady receiving a letter, and a seascape on the background wall. Contemporary emblem books also reveal the import of this combination. Their wide popularity shows that the seventeenth-century Dutch delighted in representations with a double meaning. Such books contain illustrations of quite ordinary subjects accompanied by captions which give them a metaphorical or moralizing interpretation, often in rhyme. Harmen Kruls's *Minnebeelden* (*Images of Love*), a well-known emblem book of 1634, interprets a print of a seascape with the lines:

> *De ongebonde Zee, vol spooreloose baren*
> *Doet tusschen hoop en vrees, mijn lievend herte varen:*
> *De liefd' is als een zee, een Minnaer als een schip,*
> *U gonst de haven lief, u af-keer is een Klip*

> In the boundless sea, full of trackless waves,
> my loving heart sails between hope and fear.
> Love is like a sea, the lover like a ship,
> your favour, my love, is the harbour; your rejection a reef.

The lute which the lady in the painting sets aside is also significant. Music making is a sign of love in many emblem books, for it symbolized the harmony between lovers. Sometimes the lover is compared with a musical instrument, whose strings or keys are touched by the beloved. Vermeer alluded to the connection between music and love not only in *The Love Letter* (Plate 22) but also even more clearly in his *Lady standing at a Virginal* (Plate 25). On the larger of the two paintings behind the lady making music, Amor, the little god of love, holds his emblem, the bow, and holds up the playing card of 'chance', which symbolizes the accidents of love. This imagery, like that of the ship at sea, is described in detail in contemporary emblem books.[73]

While *The Love Letter* is the earliest painting to incorporate all the features of Vermeer's late style, the beginnings of this style are already evident in the *Lady writing a Letter* (Plate 20), a painting pledged to the National Gallery in Washington D.C. When he composed this canvas, Vermeer must have had his three earlier paintings of solitary women (Plates 13, 14, 15) in mind, for it resembles those works in its refinement of execution. However, many details, such as the woman's sleeve and hair-ribbons, already display the stylization which emerges in his later work. If we suppose that *The Love Letter* was painted in 1667, we can assign the *Lady writing a Letter* to about 1666.

Lady with her Maidservant (Plate 21) in the Frick Collection, New York, belongs to the same period as the *Lady writing a Letter*. The motif, the division of the picture surface, the jacket worn by the seated girl, and the writing materials on the table, are very similar in both paintings. The *Lady with her Maidservant* is a more ambitious composition, for it depicts not a solitary figure, but (as in *The Love Letter*) the contact between two women. Its large format strikes an unusual note in Vermeer's *œuvre*; it is his only attempt to give a humble household theme truly monumental force. The

result must not have satisfied Vermeer. From the flat undifferentiated areas, especially in the main figure, we can deduce that he left the painting unfinished.[74]

Vermeer embarked upon a new theme in *The Astronomer* (Plate 23) in a private collection in Paris, and the closely related *Geographer* (Plate 24) in the Städelsches Museum in Frankfurt. Once again he explored a specific thematic and compositional type in more than one painting. Half-length views of scholars amidst their books, globes, compasses and other attributes were first painted by the young Rembrandt around 1630. His pupils picked up the motif and it was popularized by many later masters. Significantly, Vermeer's probable teacher, Bramer, was one of those who treated the subject.[75]

Vermeer's interpretation of the theme is somewhat reminiscent of that by the Leiden *Feinmaler* Gerard Dou, who had studied with Rembrandt around 1630. At the same time the compositional arrangement of *The Astronomer* and *The Geographer* harks back to Vermeer's own earlier works. Again he depicts a single figure, in the corner of a room lit through a window at the left, at a table with crumpled carpets.

Along with *The Procuress* (Plate 3) of 1656, these are the only Vermeers to bear a date. On *The Astronomer* we read MDCLXVIII (1668) under Vermeer's monogram, and on *The Geographer* MDCLXVIIII (1669). The irregularity of the inscriptions makes a strange impression, and their authenticity has often been doubted. Further cause for scepticism is the absence of a date on a very accurate print which was made of *The Astronomer* in 1792.[76] In general, however, it is assumed that the inscriptions, even if they are later additions rather than clumsy restorations, are none the less based on original inscriptions or annotations by Vermeer. The dates of 1668 and 1669 are plausible. The paintings are in the late style. Admittedly, despite their late date, their style is less emphatic than *The Love Letter* (Plate 22) but we have found Vermeer back-tracking on other occasions. Possibly he modified his schematic modelling in these pieces under the influence of his prototype, which was doubtless in the meticulous style of Dou.[77]

The culmination of Vermeer's late style

Vermeer's best works in the new style date from about 1670. Through the evidence of the woman's costume, the *Lady standing at a Virginal* (Plate 25) in the National Gallery in London, can be placed at about this date.[78] The composition is stripped of all the incidentals which are so noticeable in his earlier works—nails and cracks in the walls, articles of clothing and other objects scattered around the room. Light and shade are more rigorously bounded, and more distinctly separated from each other than before. For example, Vermeer sharply sets off the sides of the virginal from each other and from the background wall; and he crisply demarcates the line between light and shadow, in the chair in the foreground.

He achieves a new purity and sobriety. The folds of the model's gown, and the moulding of the window frame in the upper left remind us of the fluting of Greek columns. He now gives full play to his love of straight edges and right-angles: the frame of the landscape on the lid of the virginal, and the

sharp strips of light along the right side of the larger painting on the wall even bring to mind the art of Mondrian.

Vermeer's pursuit of a simpler and more abstract depiction of reality led him to a radical change in technique. Instead of gradual transitions in the modelling he now juxtaposes clearly defined and unmodulated tones of light and dark. We see this most clearly in the sleeve of the woman and the gilt frame of the smaller painting. Though the modelling is simpler it is no less precise than that of Vermeer's early works. Writers on Vermeer tend to disparage his later style, but to my taste the *Lady standing at a Virginal* is one of the master's finest works.

The astonishing reductiveness which characterizes the *Lady standing at a Virginal* appears in an even more striking arrangement in the *Lacemaker* (Plate 26) in the Louvre. Seldom has a human activity been recorded with such concentration. Vermeer focuses on the face and hands of the girl, and eliminates every distracting feature. Caspar Netscher's less focused and more fussy treatment of the same theme makes an interesting contrast (Fig. 43).

Vermeer was no less successful in the *Lady writing a Letter with her Maid* (Plate 27) in the Beit Collection in Blessington, Ireland. Twice already in his late period he had painted a woman writing a letter (both with and without a maidservant, see Plates 20, 21), a theme which originated with ter Borch (Fig. 44). In this example Vermeer combines elements from his own earlier paintings. In an arrangement which by now looks quite familiar to us, he depicts two figures near a table, in a room lit from the left through a window. The left foreground is closed off by a curtain (see Plates 19, 23, 24). *Lady writing a Letter* combines Vermeer's characteristic serenity with a solemnity and grandeur which are lacking in his earlier works.

This monumental quality is one result of his new tendency toward stylization. The solid, columnar folds of the green curtain are handled altogether differently from the rippling waves of patterned carpet which occupies the same place in the earlier *The Art of Painting* (Plate 19). Likewise the carpet on the table hangs with the unnatural flatness of a screen, in contrast to the similar carpet in the earlier *Music Lesson* in the Royal Collection (Plate 16), which is handled much more sensuously. As in the *Lady standing at a Virginal* (Plate 25), all incidentals and accessories are suppressed. The subdued colouring eschews bright accents. The painting on the back wall is represented as a single dark area, its principal features delineated schematically, in contrast to the richly detailed wall map in *The Art of Painting*.

Mannerism

The late style reaches its most extreme form in *The Guitar Player* (Plate 28) in Kenwood House, London. The frame of the painting on the wall is treated with the same striking schematization as that on the small painting on the wall in the *Lady standing at a Virginal* (Plate 25). In other passages the schematization is carried even further: the head of the guitar is accented by daubs of solid tones laid on in an effect which resembles gouache.

The composition of *The Guitar Player* is unique in Vermeer's *œuvre*. The

42. GABRIEL METSU (1629–67): *The Letter Reader*. About
1662–5. 32 × 20 cm. Blessington, Ireland, Sir Alfred
Beit, Bt.

43. CASPAR NETSCHER (1635/6–1684). *The Lacemaker*.
33 × 27 cm., signed and dated 1664. London, Wallace
Collection

figure is placed so far to the left that her right arm is cut off by the edge of the
picture. The main background motif, the painting on the wall, is also far to the
left, directly over the head of the woman. The right side of the picture,
however, remains dramatically empty, with the result that the composition as a
whole is strangely unbalanced.[79]

As unprecedented for Vermeer as this unbalanced composition is the
smiling face and lively pose of the model. Here Vermeer departs from his
usual formula of motionless figures who only suggest activity. However, the
woman appears unnaturally stiff, as she is delineated by hard outlines in
Vermeer's most stylized late technique. Both the uncomfortable com-
position, and the peculiar rendition of the figure, endow the painting with
some of the tension of the work of Ochtervelt, and the late Pynacker (Figs.
38, 39). In contrast to all his previous works, in *The Guitar Player* Vermeer
seems wilfully to cast aside the whole logical progression of his earlier goals
and accomplishments.

Vermeer's last years

In the crisis of 1672, which followed the French invasion of Holland,
Vermeer encountered financial difficulties which plagued him until his death
three years later (see above p. 9ff.). Some of the oddities of what appear

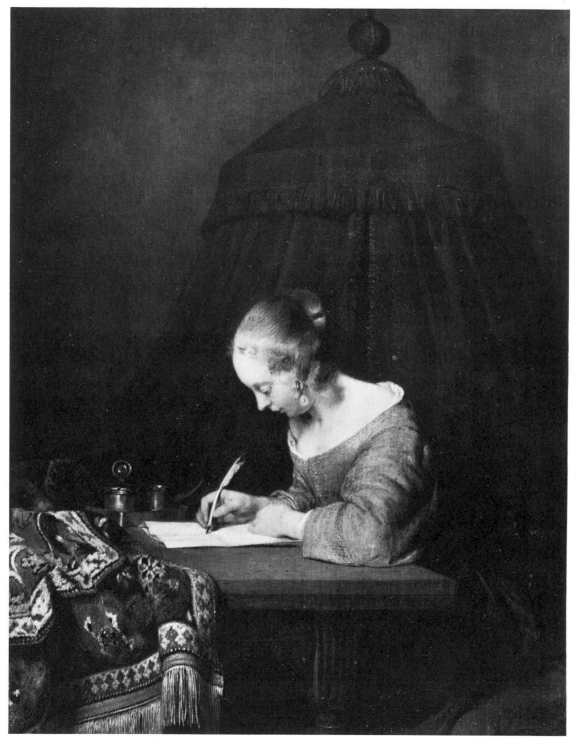

44. GERARD TER BORCH (1617–81): *The Letter Writer*. 38 × 29 cm., about 1655. The Hague, Mauritshuis

to be his last paintings may be explained by reference to his financial difficulties.

The *Allegory of Faith* (Plate 29) in the Metropolitan Museum, New York, differs in essential respects from everything else Vermeer had previously painted. He not merely inverted his old values, as he did in the Kenwood *Guitar Player* (Plate 28), but introduced some altogether alien ones. Vermeer's earlier paintings, no matter how schematic or imbued with symbolic intentions always make sense on a primary level as 'natural' representations. The *Allegory of Faith*, on the other hand, contains elements

such as the snake crushed under a stone and the impassioned woman with a globe beneath her feet, that are intelligible only at the secondary level of their symbolic meaning (see below p. 169). Even if we understand the symbolism it is unclear why the scene takes place in a fashionable Dutch living room. The peculiarities of the subject are most readily explained by the assumption that it was dictated by someone other than Vermeer himself, presumably by the patron who commissioned the piece.

The best candidates for the authorship of the iconography are the learned Jesuit fathers who lived a few doors down the street from Vermeer. The patron may well have been a wealthy Catholic of Delft, who, desiring a devotional piece, naturally turned to a fellow Catholic, Vermeer.[80] Vermeer's acceptance of a commission with such precise specifications can be explained by his financial situation. Probably the patron was impressed by the use of allegory in *The Art of Painting* (Plate 19), which Vermeer still had in his home, and asked for an allegory of faith with a similar composition. Such a course of events would explain the strong external resemblance between the two pictures (compare the tapestry hanging on the left, the ceiling, the floor, and the general disposition of the space). In technique, however, the two paintings are fundamentally different, for the *Allegory of Faith* is a work in the stylized late manner.

A similar chain of events could explain the origin of the *Head of a Girl* (Plate 30). It too is a variant of an earlier painting—the *Girl with a pearl Ear-ring* (Plate 18) in the Mauritshuis. Yet it is painted in the schematizing style of the late period (compare the different treatment of the cloth in the two paintings). The women in Vermeer's previous paintings generally had handsome faces with regular features, and were even somewhat idealized, as in the painting of the *Girl with a pearl Ear-ring* (see above p. 46). In the Wrightsman painting, however, the face, with its broad proportions and wide-set eyes, is of quite unprepossessing appearance, if disarming in its friendliness. Perhaps in these needy years Vermeer accepted a portrait commission—for the first time in his career, as far as we know—with the stipulation that he use *Girl with a pearl Ear-ring* as a point of departure.

Lady seated at a Virginal (Plate 31) in the National Gallery, London, is another product of these last, difficult years—and shows a noticeable decline in Vermeer's powers. The pose of the lady reminds us of that of the girl in Vermeer's early picture of *The Glass of Wine* (Plate 8). A few passages—the viola da gamba, and the marbelized virginal—are executed with the same strength and virtuosity which were displayed not long before in the closely related *Lady standing at a Virginal* (Plate 25). But the folds of the costume are now harsh and coarsely executed, and the blots making up the frame of the painting on the back wall lack the sureness of touch which is apparent in the frame on the small landscape in the earlier picture. The painting must have been made shortly before Vermeer's death.

Conclusion

Vermeer introduced neither a new style nor new conceptions of art. On the contrary, his style and subject-matter were derived from Dutch painters of his immediate milieu. He freely appropriated the unified compositions,

constructed around a few large figures, which had come into vogue around 1650; he borrowed from de Hooch's clear and illusionistic construction of space, and from van Mieris's refined technique. Vermeer's distinction lies in his appreciation of the possibilities inherent in modes that had already been developed. Others adopted new approaches more quickly, but more superficially. Vermeer, with single-minded dedication, followed through each new approach to its most profound consequences.

Even in his very earliest works, his history paintings, Vermeer strikes us as a purist. In a genre based upon the accomplishments of Italian art, only Vermeer, among the Dutch painters of his day, turned directly to Italian models for inspiration. In his later work he developed with remarkable logic and consistency. He seldom altered his course, and when he did so it was with a keen awareness of his objectives. He concentrated on one problem at a time, and his intensity of concentration engendered an unrivalled mastery. He visualized a perfect world in a form so natural that it seems almost effortless.

3. VERMEER AND HIS PUBLIC
Seventeenth and eighteenth centuries

Vermeer is often cited as an example of neglected genius. During his lifetime and for almost two centuries after his death—so goes the tale—he and his work went unesteemed, until, in the nineteenth century, he was finally discovered and properly appreciated. Was Vermeer really so underestimated? In fact, he was not. While he did not achieve widespread fame until the nineteenth century, his work had always been valued and admired by well-informed connoisseurs.

During his lifetime Vermeer's paintings brought very high prices (see above p. 10). On four different occasions he was elected to the ruling body of the Guild of Saint Luke in Delft. Moreover, he is mentioned by Dirck van Bleyswyck in *The Description of the City of Delft* (1667) as an artist of the city. The passage in van Bleyswyck's book is often produced to support the argument that Vermeer was underestimated, since Vermeer is only mentioned by name and date of birth, while other artists and their works are discussed in greater detail. This is of little import, however, for chroniclers of Dutch cities generally wrote eloquently only about masters who were dead, or who had left the city being described. Vermeer was still alive and working in Delft when van Bleyswyck's book appeared. He is mentioned in a short list of painters 'still alive today'—and he is by far the youngest of those mentioned.

In his book van Bleyswyck includes a poem by the printer Arnold Bon in honour of Carel Fabritius, Rembrandt's great pupil, who had died in the terrible explosion of the Delft powder magazine in 1654—an explosion which, as we remember, levelled much of the central part of the town. The last stanza of Bon's poem reads:

Soo doov' dan desen Phenix t'onser schade
In't midden, en in't beste van zyn swier
Maar weer gelukkig rees' er uyt zyn vier
Vermeer, die meesterlyck betrad zyn pade.

> Thus did this Phoenix, to our loss, expire,
> in the midst and at the height of his powers.
> But happily arose out of his fire
> Vermeer, who masterly trod his path.

The last line implies that after the death of Fabritius, Vermeer was considered the foremost painter in Delft. This could hardly have been written as early as 1654, when Vermeer's talent was only in the bud; it must have been written rather later, but surely before the publication of van Bleyswyck's book in 1667. Perhaps it was composed when the new headquarters of the Guild of Saint Luke were dedicated, probably early in 1662. Vermeer was by then at the peak of his artistic powers.

It has never previously been noted that the poem exists in two versions. Although van Bleyswyck's book exists in only one edition, the first and last line of the poem are given differently in the various copies I have examined. It can be shown that the version quoted above is the earlier of the two, while in later copies the first line is changed to 'Dus bleev' dien Phenix op zyn dertig jaren' ('Thus died this Phoenix, in his thirtieth year'), and the last line to 'Vermeer, die 't meesterlyck hem na kost klaren' ('Vermeer, who masterly emulated him') (see p. 147, document 22). The change was apparently made while the book was actually being printed, for the copies are identical in all other respects.

Arnold Bon, who wrote the poem, was the printer of the book, and may have thought of the change himself.[81] But it is quite possible that it was suggested by Vermeer, who lived near Bon on the Market Square. Legal records show that Vermeer's obsession with precision was not restricted to his paintings. Twice in documents he had his name crossed out and corrected, apparently because he found fault with the spelling (see p. 146, document 13, and p. 148, document 26). This is the more remarkable because his Dutch contemporaries often spelled their names in various ways themselves. Vermeer presumably took printed statements about himself and his art very seriously, and if he was not satisfied with the first version of the stanza he might well have persuaded Bon to change the typesetting.[82]

Who were Vermeer's patrons? His most important customer was Jacob Dissius, who, like Bon, was a printer and lived on the Market Square, not far from Vermeer. In addition, a baker of Delft is known to have owned a painting by Vermeer in 1663. Vermeer's patrons, however, were not restricted to people of his own rank in his own city. In 1664 'a face by Vermeer' was in the estate of the sculptor Jean Larson in The Hague. In 1682 another Vermeer was in the collection of Diego Duarte, an immensely wealthy banker of Antwerp. It is suggestive that Duarte maintained contact with Holland through Constantijn Huygens the Younger, who, like Larson, lived in The Hague. Duarte's father had a clavecin made for Huygens, and Duarte corresponded with Huygens about music. With his musical interests it is appropriate that Duarte's Vermeer represented 'a lady playing the clavecin, with accessories' (see document 60, p. 153).

The writers on art and artists who followed van Bleyswyck were laconic concerning Vermeer.[83] Arnold Houbraken's *Groote Schouburgh der Nederlan-*

tsche Konstschilders en Schilderessen (The Great Theatre of Male and Female Dutch Painters)—for many generations the chief source of information on Dutch painters of the seventeenth century—adopted van Bleyswyck's entry on Vermeer unchanged. (It is included in Volume I (1718) without addition or commentary.)[84] Houbraken recorded all information on artists he could find, whether in print or from verbal tradition, but none the less his neglect of Vermeer is not very significant, for he was poorly informed with regard to painters in Delft. Concerning Carel Fabritius he recounts only what he could read in van Bleyswyck's book and Samuel van Hoogstraten's *Inleyding tot de Hooge Schoole der Schilderkonst* (Introduction to the Great School of Painting) of 1678. For de Hooch he gives only a superficial indication of the kind of subjects that the master painted.

Vermeer's small *œuvre* made it easy for his name to be lost. Attribution in the eighteenth century—not yet facilitated by photographs and good reproductions—was entirely based on the stock of impressions a connoisseur could build up at auctions, and from studying private collections. Masters with a huge production, whose works could be seen most frequently, were those whose work was easiest to remember, and it was such masters—Adriaen van Ostade, Rembrandt van Rijn, Nicolaes Berchem, Philips Wouwerman—who were the great names in Dutch painting in the eighteenth century. Vermeer's *Girl reading a Letter at an open Window* (Plate 6) in Dresden was attributed on different occasions to Govaert Flinck and to Rembrandt; other works by Vermeer went under the names of Gabriel Metsu, Pieter de Hooch, and Frans van Mieris (Plates 6, 12, 16, 19).

However, the eighteenth century seems to have had a keen appreciation of the quality of Vermeer's paintings, even if unaware of the identity of their creator. The transmission of his *œuvre* through the centuries nearly intact is in itself strong evidence that his works were always objects of value. In the auction of 1696 his paintings fetched considerable prices. Later his name was forgotten, but between 1710 and 1760 four Vermeers—then attributed to other artists—were acquired by the Duke of Brunswick, the Elector of Saxony, and King George III (Plates 3, 6, 11, 16). Historical accuracy was not the strong point of eighteenth-century collectors and connoisseurs; their taste, however, was superb.

An untapped source of information on the eighteenth-century view of Vermeer is auction catalogues. These catalogues—generally from the sale of a complete collection, after the decease of the owner—were at first rather summary in their descriptions, but later became more detailed, and came to include the dimensions of the painting and its support—whether canvas or panel. Many such catalogues have been preserved in which the buyer and the price fetched have been inscribed by someone present at the auction. So far as possible we have listed the prices which Vermeer's paintings brought, along with the provenance, in the catalogue. Shortly before and after 1800 it seems that the value of Vermeers, and of paintings generally, fell sharply, doubtless due to war and economic crisis.

The most important sales in Holland were held in Amsterdam in the 'Oudezijdsherenlogement' (formerly the city's official lodging house for guests of high rank) and later in the *Trippenhuis* at the *Kloveniersburgwal*. From 1760

on Philips van der Schley and his associates were the chief auctioneers. Most of the Vermeers we know today, excluding those then in the collections of princes, are described in these early sales catalogues (see pp. 155ff., under provenance).

The mentions of Vermeer's paintings in the catalogues of these sales and of the royal collections—which we here bring together for the first time—are fascinating both for their descriptions of the paintings and in their critical judgments.

The 'Merry Company in a Room', which is mentioned in the auction catalogue of 1696, was long supposed to have been lost, but turns out to be the *Woman and two Men* in Brunswick (Plate 11). The girl in *The Procuress* (Plate 3) in Dresden is called a 'Courtesan' in 1765 and 1782, but in 1825—evidently a more prudish era—this was changed into 'a young girl'.

The *Woman in blue reading a Letter* (Plate 14) is praised in a sale catalogue of 1791 because of the 'fine composition, which is generally characteristic of the works of this famous master'. *The Milkmaid* (Plate 7) is in 1719 already called 'The *famous* Milkmaid by Vermeer' [my italics].

In 1765 *The Milkmaid* was said to be 'vigorous in light and brown, and very expressive'. In 1798 it was noted of the same picture that, 'The light, falling in through a window gives a miraculously natural effect.' In 1778 the light of *The Astronomer* (Plate 23) was commended with the words: 'The pleasing light . . . gives a beautiful and natural effect.' In 1803 the light in *The Geographer* (Plate 24) was termed 'striking'. The well-known 'light of Vermeer' over which so much ink has flowed is apparently not a modern invention![85]

Except for these mentions in catalogues, nothing was printed about Vermeer between 1718 (when Houbraken only mentioned his name) and the end of the eighteenth century.

In 1781 Sir Joshua Reynolds—distinguished both as a painter and an art critic—visited the Netherlands to look at Dutch and Flemish paintings of the seventeenth century. His journal gives a resumé of the pieces—mainly genre paintings and landscapes—that most impressed him. Among these is 'A Woman pouring milk from one vessel to another: by D. Van dermeere,'—that is to say, Vermeer's *Milkmaid* (Plate 7). Although mentioned without further commentary it was certainly a work which impressed Reynolds, for he writes: 'I have mentioned only those [paintings] which I considered worthy of attention.' Reynolds closes his account with the words: 'The account which has been given of the Dutch pictures is, I confess, more barren of entertainment than I had expected. One would wish to be able to convey to the reader some idea of that excellence, the sight of which has afforded me so much pleasure.'[86]

The earliest reproductions after Vermeer's works, three engravings, were printed in 1783 (after Plate 6, which was then still attributed to Govaert Flinck) and in 1784 and 1809 (after Plates 23, 21). The engraving of 1784, after Vermeer's *Astronomer* (Plate 23), appears again in a volume of prints published by the art dealer Jean Baptiste Lebrun in 1792. The volume reproduces paintings in his possession, accompanied by short captions. The text to his reproduction of the Vermeer reads: 'This van de Meer, never once

mentioned by historians, merits special attention. He is a very great painter, in the manner of Metsu. His pictures are very rare, and are better known and more appreciated in Holland than anywhere else. He was especially fond of rendering effects of sunlight, and sometimes succeeded to the point of complete illusion.'[87]

That Vermeer received attention in Holland at this time is corroborated by a previously unnoticed passage in a speech delivered in November 1789 by the professor of anatomy at Amsterdam, Andreas Bonn. The occasion was the opening of the drawing studio in the large new building of the 'Felix Meritis' Society ('Happy through Merit') of Amsterdam, an association of both amateurs and practitioners of the arts and sciences. In his long discourse Bonn praised a number of Dutch artists with a few words apiece. When he came to depictions of 'Merry companies' he mentions, 'the satin and velvet costumes of ter Borch and Metsu; the detailed figures and neat accessories of Dou, Slingelandt, van Mieris senior and junior, and the Delft van der Meer.'[88]

We find a more significant indication of the reputation Vermeer enjoyed on the art market, and with collectors, from an auction of 1765 in which Pieter de Hooch's famous *Woman with a Child in a Pantry*, now in the Rijksmuseum, was put up for sale. The seven line description of the painting in the auction catalogue ends with the words 'being as good as the Delft van der Meer'. This description was reprinted in a list of paintings sold at auctions which was published by Pieter Terwesten in 1770. In 1774 another de Hooch was recommended in an auction catalogue to prospective buyers with the phrase: 'in composition and colour it very much resembles the paintings of the Delft van der Meer.'[89]

A surprising number of paintings not by Vermeer were given his name in auction catalogues in the period from about 1780 onward. A 'Goldweighing Woman', which was auctioned as a Vermeer four times in the years from 1780 to 1809 is undoubtedly the well-known painting by Pieter de Hooch which is now in the museum in West Berlin.[90] A painting for which no satisfactory attribution has been found in modern times was sold as a Vermeer in sales of 1779 and 1792 (Fig. 46).[91] Many pictures by Jacob Vrel and Esaias Boursse were brought under the hammer as Vermeers, and a splendid Job Berckheyde was suddenly baptized Vermeer in 1824.[92]

One of the first to attempt a summation of Vermeer's *œuvre* was the Dutch merchant and engraver Christian Josi. Around 1800 he wrote: 'The paintings of Jan van der Meer . . . so remarkable for the simplicity of their subjects and their truth of expression, were once little known. . . . Today connoisseurs appreciate the works of this master.'[93]

One of the connoisseurs to whom Josi referred was the merchant and poet of Amsterdam, Pieter van Winter, who in 1800 purchased *The little Street* (Plate 9) for a considerable sum. When he died in 1807 his daughter Lucretia inherited it, and in 1813 she herself acquired an additional Vermeer, *The Milkmaid* (Plate 7), buying it for an even higher price than her father had paid for the other picture.

A passage from the *Geschiedenis der Vaderlandsche Schilderkunst (History of Painting of the Fatherland)* of 1816, by van der Eynden and van der Willigen,

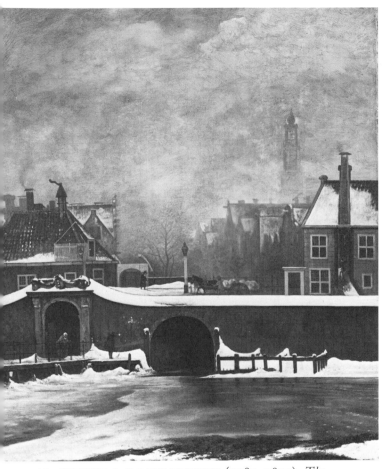

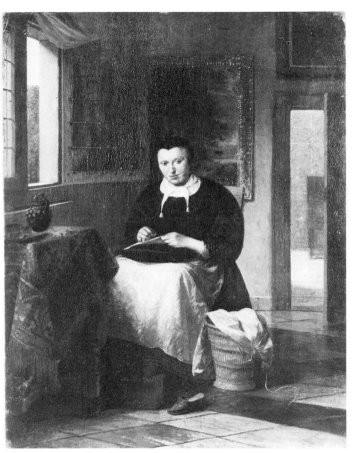

45. WOUTER J. VAN TROOSTWYK (1782–1810). *The 'Raampoortje' at Amsterdam.* 57 × 48 cm., signed and dated 1809. Amsterdam, Rijksmuseum

46. Anonymous artist: *Woman sewing.* 50 × 38.5 cm. Hanover, Niedersächsisches Landesmuseum. In 1779 and 1792 the picture was sold as a Vermeer

confirms that Vermeer, and these two paintings in particular, were indeed admired in Holland. 'It is hardly necessary', they write, 'to point out that the works of the so-called Delft van der Meer deserve a place in the most distinguished collections: all amateurs of art know that his paintings are ranked with those of the greatest masters of the Dutch school, and are sold for great sums. Nor should this cause any surprise if one takes into consideration that, just as Adriaen van Ostade is sometimes called "the Peasant Raphael" for his ingenious union of ideal character with simple imitation of nature, so also Johannes Vermeer may well be called the Titian of the modern painters of the Dutch school, for his strong colours and fluent brush technique.'

Remarkably, van Eynden and van der Willigen knew only two Vermeers at first hand. *The Milkmaid* (Plate 7) they 'saw with exceptional pleasure', noting that 'we must say that we know no other painting of this kind of subject that surpasses it in power and naturalness of expression.' *The little Street* (Plate 9) so impressed them that they wrote that they 'cannot recommend it more highly to the attention and judicious imitation of young painters who wish to devote themselves to similar subjects.'[94]

In fact, this recommendation was superfluous. *The little Street* had already been copied by Cornelis van Noorde (1731–95) and by at least two other Dutch artists. At least ten copies were made by Dutch painters born after about 1725 after five other paintings by Vermeer. The best known of these

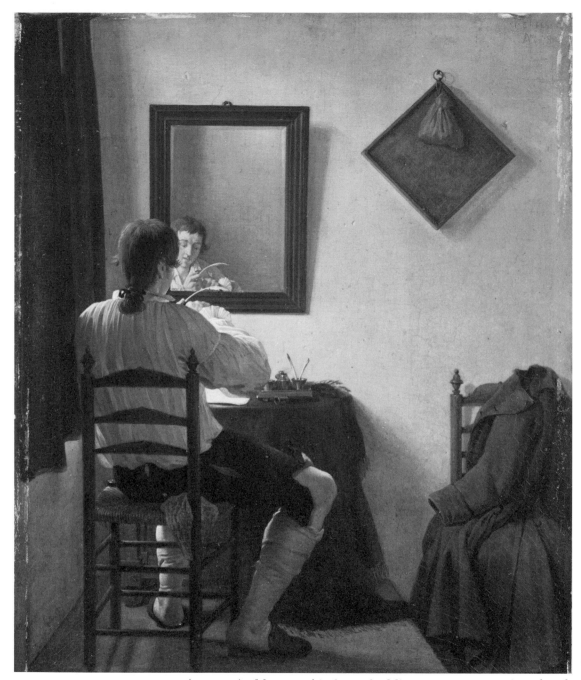

47. JAN EKELS THE YOUNGER (1759–93): *Man seated in front of a Mirror*. 27 × 23 cm., signed and
 dated 1784. Amsterdam, Rijksmuseum

masters today is Wybrand Hendriks (1744–1831), who made a copy after
Vermeer's *View of Delft* (Plate 10).[95] A number of works by young painters,
from about 1800, show an unusual grasp of seventeenth-century art, and a
striking ability to imitate it successfully. In the best of these works it is
certainly the Vermeer-like qualities of old Dutch pictures which these artists
sought to recapture (Figs. 45, 47).[96]

Van Eynden and van der Willigen concluded their entry on Vermeer with
the remark: 'There exists a picture of the city of Delft by him which is praised
highly, as an artistic wonder . . . but [we do not know] where it is now to be
found.' Six years later, in May 1822, the *View of Delft* (Plate 10) turned up at
an auction in Amsterdam, and was purchased by the newly-opened
Mauritshuis in The Hague. This was the first Vermeer acquired by a public
collection.

To finance the purchase the trustees of the Mauritshuis obtained 2,900 guilders from the state—a very substantial sum to pay at this time for the work of a master who was not widely known. Their decision to purchase the painting showed remarkable aesthetic insight. Doubtless they were also aware that since the end of the eighteenth century a small circle of connoisseurs had recognized Vermeer as an artist of the first rank.

Theophile Thoré and appreciation in the nineteenth century

In the nineteenth century two developments had a decisive influence on Vermeer's reputation. The first was the acceptance, from 1820–30 on, of the daily activities of 'ordinary' people, and of landscape in its 'natural' condition, as suitable subjects for painting. In a sudden turnabout, History and Allegory, heretofore the most prestigious subjects in art, came to seem artificial and contrived, and were replaced by depictions of reality and daily life. This change coincided with the rise of the liberal bourgeoisie in Western Europe, and was forcefully reflected in the work of artists such as Corot, Millet and Courbet. As a consequence of this shift of artistic standards the best of the Dutch painters of the seventeenth century could suddenly be ranked on the same level as such prestigious Italian masters as Raphael and Michelangelo.

The second change was the application of the scientific approach to history, which had led to such impressive results in the study of archaeology and political history, to the field of art.

In 1816 van Eynden and van der Willigen could cite only three paintings by Vermeer. In 1834 John Smith was equally summary in his mention of Vermeer, despite his extensive research for his famous series of *Catalogues Raisonnés of the works of the most eminent painters*. Under 'pupils and imitators of Gabriel Metsu' he writes of Vermeer: 'Writers appear to have been entirely ignorant of the works of this excellent artist, [whose] pictures are treated with much of the elegance of Metsu mingled with a little of the manner of De Hooge.' Under 'Pupils and Imitators of Peter de Hooge' Smith adds: 'This master is so little known, by reason of the scarcity of his works, that it is quite inexplicable how he attained the excellence many of them exhibit.'[97]

To his credit Smith had recognized Vermeer's hand in three paintings that in his day were catalogued as 'Jacques van der Meer de Utrecht', 'De Hooch', and 'Metsu' (Plates 3, 6, 15). In his own copies of the catalogues of the collections where these paintings were then located he crossed out these names and wrote above them 'Delft Van de Meer'. These three discoveries, however, were not included in his own publications.

As early as 1792 Lebrun had encouraged connoisseurs to pay 'particular attention' to Vermeer's work. But not until half a century later, when Lebrun's countryman Etienne-Josephe Theophile Thoré fell in love with the *View of Delft* (Plate 10), did anyone undertake any publication or serious research into Vermeer's œuvre.

As a radical democrat, Thoré (1807–69) viewed politics and art criticism as parts of a single whole.[98] To him 'All history is a perpetual insurrection against the powers that rule the world.' In his own time he saw 'three forms

48. *Portrait of E. J. Th. Thoré* (1806–69). After photo-engraving in the auction catalogue of Thoré-Bürger's collection, 1892

of servitude: Catholicism, Monarchism and Capitalism', and 'three forms of liberty: Republicanism, Democracy, and Socialism.' In the 1840s Thoré founded a 'Société des Artistes' in Paris, which he conceived as a kind of trade union. Strongly maintaining that art should present a true image of the daily life of the common people, he was one of the first to recognize the special qualities of Théodore Rousseau's 'natural' landscapes. In opposition to the popular phrase 'Art for Art', Thoré launched the slogan 'Art for man'.

Thoré's admiration for seventeenth-century Dutch painting stemmed naturally from his political views, for he saw it as the art of an emancipated society. Thoré observed that, 'in Holland, since its emancipation at the end of the sixteenth century, only domestic and civic painting has existed.'

Elected to the legislative assembly after the Revolution of 1848, Thoré became involved in an abortive leftist coup, launched in the name of the people of Paris. Forced to flee France, for many years he shuttled between England, Holland, Belgium and Switzerland. Exile gave him the opportunity to pursue his passion for intensive historical research, which he saw as a logical extension of his political and artistic beliefs. His studies of Dutch painting of the seventeenth century were written during his exile.

Thoré was the first to search systematically for all the documents and data concerning Vermeer. He looked everywhere, culling old auction catalogues, and visiting archives to urge Dutch researchers to be on the lookout for the

name Vermeer in seventeenth-century documents. 'I spent lots of money' (*J'ai fait des folies*), he writes, 'for a photograph of the *View of Delft*.' Everywhere he went he examined the signatures on paintings, and he was able to recover for Vermeer works which had previously gone under the name of de Hooch.

He was forced to adopt an alias during a stay in Belgium, where the secret police of Napoleon III operated unrestrained. It was under this pseudonym of 'William Bürger'—the surname is the German word for citizen—that he published the first major study of Vermeer, which appeared in the *Gazette des Beaux-Arts* in 1866.[99]

Thoré's persuasive and enthusiastic account of Vermeer's art, which included a catalogue of his works, brought Vermeer wide international repute for the first time. An immediate consequence of this new attention was an increase in prices paid for Vermeers, which increased by a factor of ten over the next few years. The advent of Impressionism during this period enhanced Thoré's efforts to revive Vermeer. For with his stress on bright colour and the effect of sunlight, Vermeer is the closest precursor of the Impressionists among the old masters. At this time was born the notion, nearly axiomatic in modern art literature, that Vermeer and the Impressionists were doing the same thing.[100]

Thoré's brilliant study quickly elevated Vermeer to the status of a Great Master. But despite Thoré's intense appreciation of the artist, and his passion for historical accuracy, the picture he painted of Vermeer left much to be desired. Unfortunately, he interpolated into Vermeer's *œuvre* the works of other painters, such as the landscapes of another Vermeer, Jan Vermeer of Haarlem, and the cityscapes of Jacob Vrel, which had been labelled as Vermeers since the end of the 1790s. The result was a most contradictory image of the painter's style. It is hardly surprising that Thoré dubbed Vermeer 'the Sphinx of Delft'.

Fortunately, later art historians trimmed these additions from the corpus of Vermeer's paintings. Henry Havard made a notable contribution in his study of 1888,[101] and in 1907 C. Hofstede de Groot compiled a *catalogue raisonné*, which until now has remained the primary source of information on the pedigree of Vermeer's paintings.[102] A convincing scholarly reconstruction of Vermeer's stylistic development was written in 1911 by the young Eduard Plietzsch.[103] He was able to include many new facts, unknown to Thoré and Havard, which had been discovered after 1880 from research in the Dutch archives, and his picture of Vermeer, while obsolete in some details, is still generally valid.

Van Meegeren's forgeries of Vermeer

In the twentieth century old master paintings have enjoyed enormous prestige. All regimes—however diverse their ideologies and politics—have in some measure espoused the modern notion that the creations of the old masters should be honoured, and that they embody eternal truths for mankind.[104] This is well illustrated by the esteem for Vermeer, who since the beginning of the twentieth century has been acknowledged as one of the greatest old masters.

After the annexation of Austria, Adolf Hitler had Vermeer's *The Art of Painting* (Plate 19) removed from a collection in Vienna and brought to Berchtesgaden, where he deemed it worthy to hang on the wall of his headquarters. Until 1956 the Soviet Union retained the works of art that had been transported out of Dresden in the post-war confusion of 1945: among them were Vermeer's *Procuress* (Plate 3) and *Girl reading a Letter at an open Window* (Plate 6). In the late nineteenth and early twentieth centuries the wealth of American bankers and industrialists acquired the few Vermeers that were available for purchase and eventually gave them to the public collections of Boston, New York and Washington which bear their names.[105]

It is against the background of almost universal, but hardly very critical appreciation of Vermeer that we should consider the extraordinary deceptions of Han van Meegeren. It is gratifying that Vermeer's paintings have been valued. But the belief that they have universal meaning has caused needless mystification and serious misunderstandings. For all values are based on context. Experience teaches that in the last resort nothing but the basics of existence are considered valuable by all, everything else only keeping its value for groups or individuals. To ignore the context is to ignore the basis for a painting's meaning. The re-evaluation of Vermeer and the identification of his *œuvre* was a truly remarkable achievement. But when scholars failed to consider Vermeer's work in its context they committed one of the greatest blunders of twentieth-century scholarship.

In 1937 Abraham Bredius, a pioneer of Dutch art history, who, as early as 1885, had discovered new documents on Vermeer, published *Christ at Emmaus* (Fig. 49) as a newly discovered masterpiece by Vermeer.[106] In the same year it was sold for 550,000 guilders to the Boymans Museum in Rotterdam. After the acquisition the most eminent art historians and art critics unanimously praised it as one of Vermeer's greatest masterpieces.

Not a dissenting voice was heard until 1945, when, shortly after the liberation of Holland from the Germans, the Dutch artist Han van Meegeren—in prison on charges of collaboration with the Germans—claimed that he himself had painted *Christ at Emmaus*, as well as additional pictures credited to Vermeer and other Dutch painters of the seventeenth century. His statements stirred up scandal and controversy, but were not at first accepted. Only extensive examination and scientific tests of the paintings in question established that he was telling the truth. A major motivation for his forgeries, apparently, was his desire to retaliate against the art critics who had failed to acknowledge the worth of the paintings he exhibited under his own name (Fig. 50).[107]

One cannot help admiring van Meegeren's virtuosity in recreating the appearance of a seventeenth-century painting, and in unmistakably evoking the atmosphere of Vermeer's work. Yet it is certainly astounding that a canvas such as *Christ at Emmaus* could have been hailed as a masterpiece by Vermeer—the angular and wooden drawing of the hands and draperies would hardly have been acceptable in the seventeenth century! The love of textures so conspicuous in the works of the best old Dutch masters is completely lacking in *Christ at Emmaus*; the modelling and the texture of

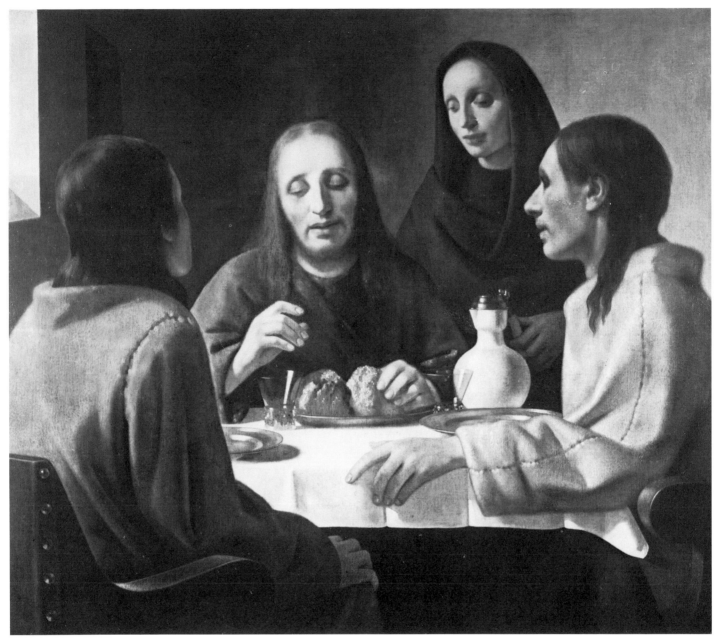

49. HAN VAN MEEGEREN (1880–1947). *Christ at Emmaus*. 129 × 117 cm., signed as Vermeer.
Rotterdam, Museum Boymans-van Beuningen

figures and objects are indicated in a manner which seems superficial and schematic when compared with authentic works of the period.

Without question a belief in the universal significance of the great old masters contributed to the inability of connoisseurs to recognize the *Christ at Emmaus* as a forgery. For a belief in universals suggests a treacherous short-cut to the understanding of art; it suggests that the most ideal confrontation with a work of art is the most direct one, one unencumbered by ideas and information that come between the work and the viewer. Those scholars who stress what a work of art 'does to us' often forget that because of changes in cultural context our responses may be quite unrelated to what the artist originally wished to communicate.

A totally unhistorical doctrine is expounded by some of the best modern art historians. In practice, such reasoning with its consequent errors is primarily applied to the 'greatest' old masters but seldom to the lesser ones.

50. HAN VAN MEEGEREN (1889–1947). *The Pianist Theo van der Pas with the 'Ghosts' of Mozart, Beethoven, Bach, Brahms, Schumann, Chopin and Schubert in the Background.* Auction H. van Meegeren, 1950

Outstanding connoisseurs such as Bredius and Hofstede de Groot spent their lives sorting out the corpus of Dutch painting, often re-attributing to followers the works formerly given to well-known masters. Judgements based on some barely perceptible stylistic idiosyncrasy would often be corroborated later by positive proof, such as the discovery of a signature in subsequent cleaning.

Yet these great scholars were capable of breathtaking errors when confronted with Hals, Rembrandt and Vermeer. Clearly they were overwhelmed by the aura of greatness surrounding these artists, and in their desire for a direct emotional confrontation with their work they set aside their reservoirs of historical knowledge. As a consequence, rather than liberating themselves from history, they became most affected by those aspects of old paintings that appealed to contemporary taste and its sensibility.[108]

Amidst the anxious and seemingly hopeless events of the late 1930s, the quiet and peace of Vermeer exercised magic on men's minds. Writers often called Vermeer's works 'elevated'—elevated above the reality everyone found so unpleasant, we seem to hear them saying. In his *Christ at Emmaus* van Meegeren, with great precision, emphasized the aspect of Vermeer which most appealed to his time.

To van Meegeren the painting was successful as a personal vengeance on the art criticism of his day. For the elevated pathos of *Christ at Emmaus* was

also to be found in the works van Meegeren exhibited under his own name (Fig. 50). The same critics who had rejected that pathos as hollow and exaggerated when it was presented to them as the brainchild of the unknown Han van Meegeren, were completely seduced by it when they thought it came from Johannes Vermeer. The affair dramatizes the danger of succumbing to superficial emotional reactions when they are disconnected from detailed study of the matter in hand.

Two questionable Vermeers

Problems remain in regard to the authenticity of certain well-accepted Vermeers. Two small paintings in the National Gallery in Washington, *Girl with a red Hat* and *Girl with a Flute* (Plates B3, 4) have been regarded as original works by Vermeer since the turn of the century. *Girl with a red Hat* is particularly attractive, and is a great favourite with the general public; in the upper left it is marked with Vermeer's monogram. I find it impossible to believe that these two paintings are by Vermeer, and I was gratified to discover that the eminent connoisseur of Dutch genre painting, the late S. J. Gudlaugsson, also felt serious doubts about them.[109]

The lively and momentary quality of *Girl with a red Hat* (Plate B3) is difficult to reconcile with Vermeer's way of working. He never attempted a 'snapshot' effect, but composed carefully considered arrangements. The treatment of the girl's sleeve and the lions' heads on the chair remind us of Vermeer's method of modelling light and dark in about 1665. But in contrast with authentic paintings by Vermeer from that period, the dramatic virtuosity with which highlights are placed in the two paintings is not matched by a corresponding skill in the transition from light to dark. These transitions are left vague and indeterminate, and lack the particular sensitivity with which such passages are handled in paintings that are certainly by Vermeer.

The way the girl in *Girl with a red Hat* is positioned is extremely odd. She seems to be sitting on a chair with her arm over the back; the back of the chair is apparently turned towards the spectator. Paradoxically, however, the lions' heads on the chair are also turned towards the viewer; in seventeenth-century chairs they always face the seat (compare Fig. 19; Plates 4, 6, 8, 12, 14, 20). We must conclude either that the chair is inaccurately rendered, or that the woman is seated or standing in an unclearly indicated position behind the chair.[110] Either explanation makes one doubt the authenticity of the painting, for the work of Vermeer, or of any other seventeenth-century painter, shows a concern for consistency in the representation of action and in the relationships of objects in space.

The support of *Girl with a red Hat* and *Girl with a Flute* is also uncharacteristic of Vermeer: both are on panel, while all the paintings undoubtedly by Vermeer are on canvas.

If Vermeer did not paint these pictures, who did? I am inclined to believe the artist was French, probably of the eighteenth or nineteenth century. Seldom have Dutch genre paintings been so skilfully imitated as in France, particularly at the time of Napoleon III. The decorative and momentary qualities of the paintings seem characteristic of French taste; the tapestry in

the background of the *Girl with a red Hat* even brings to mind the forms of Gauguin.

Two arguments have been put forth in defence of the paintings. First, the provenance of *Girl with a red Hat* shows that as early as 1822 it was considered a work of Vermeer. However, as we have already seen, attributions to Vermeer in the eighteenth and nineteenth century are by no means reliable (see pp. 62, 64). Second, if we can indeed trust a study put out in defence of the two paintings by the National Gallery, the pigments employed in them are characteristic of paintings of the seventeenth and eighteenth century, but not of a later date.[111] Even if this study was correct in its individual chemical analysis, it may be questioned whether its conclusions about dating are indubitably valid.

The paintings still present a problem. To my mind the arguments based on provenance and chemistry do not overrule the stylistic inconsistency of these paintings with all Vermeer's genuine works. I believe that they are not by Vermeer, and probably were not even painted in the seventeenth century. Hopefully, time will reveal the truth.

1. G. J. Hoogewerff, *De Geschiedenis van de St.-Lucasgilden in Nederland*, Amsterdam, 1947, p. 172, with additional data on the painters' Guild of Delft.

2. See A. J. J. M. van Peer, 'Was Jan Vermeer van Delft katholiek?', in *Katholiek Cultureel Tijdschrift* 2, 1946, p. 468–70. The *Allegory of Faith* (cat. no. 29) symbolizes the Catholic faith in particular; and his youngest child had the typically Catholic name of Ignatius (see document 36).

3. In the documents concerning Vermeer the number of his children varies. In 1667, 1669 and in 1673 children of his were buried. When Vermeer himself died in 1675, the clerk noted that eight children under age were still alive (see document 36). In 1676, however, his widow, declared she was 'burdened . . . with eleven living children' (document 42), while in 1677 she says she had ten 'minor children' (document 53). The names of seven children are known (document 36).

4. Bredius was the first to identify this baker with van Buyten (*Bredius 1885*).

5. This was demonstrated by Elisabeth Neurdenburg (see documents 59 and 62).

6. For Vermeer van Utrecht: *Thieme-Becker* 34, p. 275. Van der Helst and Uylenburgh: A. Bredius, *Künstlerinventare* 5, The Hague, 1918, p. 398. Van Neck: J. E. Elias, *De vroedschap van Amsterdam* I, Haarlem, 1903, p. 478.

7. Recently this opinion was expressed by *Van Peer 1957* and *Van Gelder 1958*.

8. The lists printed in *Van Peer 1957*. See also document 40.

9. On Bramer: *Wichmann*.

10. Carel Fabritius is also often said to have been Vermeer's teacher, I think without justification. While Vermeer did indeed exhibit an interest in the work of Fabritius, this occurred only several years after Fabritius's death (see p. 28). Goldscheider published a copy after Plate 8, in which Vermeer's figures are replaced by a clumsily drawn guitar-playing lady. Suggesting that this copy was a joint work by Vermeer and Hendrick van den Burch (active 1649–64), Goldscheider interpreted this as proof of van den Burch having been Vermeer's teacher (L. Goldscheider, 'Vermeers Lehrer', in *Pantheon* 22, 1964, p. 35–8; *Goldscheider*, p. 14, 127, fig. 4).

11. While a general consensus has been reached concerning the general chronology of Vermeer's development, historians are not yet in agreement about the details. Compare the chronology given here with the sequence proposed by *Trautscholdt*, *Gowing*, *Rosenberg-Slive*, *Gerson* and *Gudlaugsson-Kindler*. The more precise dates given by *De Vries*, *Bloch* and *Goldscheider* are listed in the catalogue (p. 155ff). Often the costumes depicted in seventeenth-century paintings, because they reflect changes in fashion, provide helpful indications of a work's date (see pp. 41, 55). In his short essay on Vermeer, the most able specialist in this field, Dr S. J. Gudlaugsson, did not indicate how far the chronology he proposes for the paintings is based on the study of costumes (*Gudlaugsson-Kindler*). In some cases the conclusions based on costume are misleading. For example, a specialist in seventeenth-century fashion believed that the clothing of the painter in *The Art of Painting* (Plate 19) dated from shortly after 1660 (*Van Thienen*, p. 46). Van Gelder, however, has subsequently pointed out that the painter wears an archaic costume of a period much earlier than the date of the work (*Van Gelder 1958*).

12. Only Valentiner attempted to date a number of household scenes before *The Procuress*, but his arguments did not convince later authors (*Valentiner 1932*).

13. M. Kitson has proposed adding a third painting, a *Holy Praxedis* in the art trade in New York, to these two early Vermeers. (M. Kitson, 'Florentine Baroque Art in New York', in: *Burlington Magazine* 111, 1969, p. 409–10). The attribution, however, cannot be sustained. Vermeer's 'signature' on this work is irregular and the 'M' does not fit with the following letters. The indications that the painting is no more than a copy after the Florentine painter Felice Ficherelli are corroborated by the crude execution. More seductive, but in my view not convincing, is van Regteren Altena's ascription of some other pieces, including a drawing, to the young Vermeer (J. Q. van Regteren Altena, 'Een jeugdwerk van Johannes Vermeer', in: *Oud Holland* 75, 1960, p. 175–94). Sometimes the most illogical theories get a maximum of attention in the mass media. A striking example is a slim volume written by D. Hannema. He tried to enrich Vermeer's *œuvre* with no less than six paintings, which caused a sensation in the form of front page news in serious newspapers and extensive television coverage (D. Hannema, *Over Johannes Vermeer van Delft, twee onbekende jeugdwerken*, Stichting Hannema-de Stuers Fundatie, 1972). While some of these paintings are no doubt seventeenth-century Dutch works, none of them has anything to do with the known work of Vermeer.

14. This borrowing was noted by M. D. Henkel, 'Jan Steen und der Delfter Vermeer', in: *Kunstwanderer* 14, 1931–2, pp. 265–6.

15. The signature on the *Diana* is illustrated in the catalogues of the Mauritshuis of 1895 and 1935. The text of the latter added, however, that by 1935 the signature had become indiscernible under the darkened varnish. After a new cleaning of the painting in 1952, the letters again became vaguely visible. See: A. B. de Vries, 'Vermeer's Diana', in: *Bulletin van het Rijksmuseum* 2, 1954, pp. 40–2, with a drawing of the signature which is slightly different from the one in the above mentioned catalogues of the Mauritshuis.

16. Observation of J. G. van Gelder (*Van Gelder 1956*). Van Gelder also suggested that the hunter Actaeon might have been depicted to the right (on a portion which was cut off). However, this seems less plausible. Actaeon encountered Diana and her companions *bathing*, i.e. when they were nude. And Actaeon is not represented on a number of other paintings of Diana and her companions, which are comparable to Vermeer's (see Fig. 6).

17. The most important of these painters are Pieter de Grebber, Jan and Salomon de Bray and Caesar van Everdingen. Even the most recent textbook on Dutch seventeenth-century art, which includes chapters on Genre, Landscape, Portraiture etc. does not allocate a chapter to History Painting. The Haarlem academists are treated in a few lines in the chapter on 'Italianate painters' (*Rosenberg-Slive*, p. 172).

18. *Manke* cat. nos. 3 and 4, with illustrations.

19. These masters have never been studied as *a group*.

20. This was noticed by W. von Bode, *Rembrandt und seine Zeitgenossen*, Leipzig, 1906, p. 50. Recent publications repeatedly state that van Loo's painting was burned during the Second World War. However it is preserved in the Bode-Museum in East Berlin.

21. In the *Diana and her Companions* such van Loo-like folds are conspicuous only in the sleeve of the woman who washes the feet of the goddess. The surface of this painting is so worn, however, that the original modelling may have looked quite different and may have once been much more similar to the modelling of the picture in Edinburgh.

22. On these commissions: H. van de Waal, *Drie eeuwen vaderlandsche geschieduitbeelding*, 1500–1800, 2 vols, The Hague, 1952. A. Blankert, *Kunst als regeringszaak in Amsterdam in de 17e eeuw*, Lochem, 1975.

23. H. Schneider, 'Erasmus Quellinus in Amsterdam', in: *Oud Holland* 42, 1925, pp. 54–7.

24. The connection between Vermeer's picture and the one by Quellinus was discovered by Trautscholdt, who also showed that Quellinus's piece must have been painted before 1652 (*Trautscholdt*, p. 267). Additional information on Quellinus's painting in exhibition catalogue *De eeuw van Rubens*, Koninklijk Museum voor Schone Kunsten, Brussels, 1965, no. 175. Previously the resemblances between the Christ on Vermeer's piece and similar Christ figures on works by Vaccaro and Allori were thought to be significant. Gowing, however, demonstrated those resemblances to be of a too general character to prove a direct relation between the work of Vermeer and the Italians (*Gowing*, p. 81).

25. See F. Lugt, 'Italiaansche Kunstwerken in Nederlandsche verzamelingen van vroeger tijden', in: *Oud Holland* 53, 1936, pp. 97–135.

26. That is 246 of the 351 paintings in the *catalogue raisonné* of Bramer's work compiled by Wichmann (*Wichmann*, pp. 91–165).

27. Bramer's painting is mentioned in 1765 (*Wichmann*, p. 119, no. 108). For the subject see Luke, 7, 36–50.

28. On the Italianate Landscape Painters: (A. Blankert, exhibition catalogue *Nederlandse 17e eeuwse Italianiserende landschapschilders*, Centraal Museum, Utrecht, 1965 (reprinted 1978).

29. Compare on Dutch Still-life: I. Bergström, *Dutch Still-Life Painting in the Seventeenth Century*, New York, 1956. It should be added that after a trip to Italy, van Aelst worked primarily in Amsterdam, although van Bleyswyck included him with the painters of Delft (*Bleyswyck*, p. 855). In Delft his uncle Evert van Aelst must have worked in the same style. From 1657 to 1661, the excellent still-life painter Abraham van Beyeren also lived in Delft.

30. On Fabritius: K. E. Schuurman, *Carel Fabritius*, Amsterdam, 1947.

31. Recent literature on the painting is listed in *Mauritshuis . . . Illustrated general catalogue*, The Hague, 1977, pp. 86–7, no. 605.

32. On trompe-l'oeil painting: A. P. de Mirimonde, 'Les peintres flamands de trompe l'oeil et de natures mortes au XVIIe siècle et les sujets de musique', in: *Jaarboek Koninklijk Museum voor Schone Kunsten*, Antwerp, 1971, p. 223–72, with literature. The importance of Hoogstraten's picture has not previously been mentioned. An early forerunner of van Hoogstraten was the Venetian Jacopo de Barbari, who had explored the principle of 'trompe-l'oeil' in his *Still-life* dated 1504 in the Alte Pinakothek, Munich (cat. 1936, no. 5066–1443). It is notable that van Hoogstraten mentions as painters of trompe-l'oeil effects, in addition to himself and Carel Fabritius, another early sixteenth-century Venetian, Giorgione (*Inleyding tot de Hooge Schoole de Schilderkunst*, Rotterdam, 1678, p. 275).

33. See *Koslow*. J. Wheelock objected to this idea ('Carel Fabritius: Perspective and Optics in Delft', in *Nederlands Kunsthistorisch Jaarboek*, 24, 1973, pp. 63–83). He ingeniously argued that the distortions on the painting can only be explained if we assume that Fabritius depicted the buildings while looking through a concave lens. This creates an effect similar to that of a wide-angle lens in photography. Wheelock continues that Fabritius, with this wide-angle effect, 'felt free to utilize its expressive characteristics without concern for the distortions it created' (*idem*, p. 73). To me this last observation seems to stem from a twentieth-century point of view. I wonder if perhaps Fabritius intended the painting to be viewed from a fixed point, through a convex lens or a glass sphere—which would thus compensate for the distortions. The hypothesis that Fabritius's painting originally was part of a perspective box was recently revived by W. A. Liedtke, "The View in Delft" by Carel Fabritius', in *Burlington Magazine* 118, 1976, pp. 61–73.

34. S. van Hoogstraten, *Inleyding . . .* (see note 32), p. 274. Also Dirck van Bleyswyck, in his description of the city of Delft, calls Fabritius 'incomparable in matters of perspective' (*Bleyswyck*, p. 825).

35. On these perspective boxes see *Koslow*. See also the articles by Wheelock and Liedtke (see note 33) and: F. Leeman, *Anamorphosen, Ein Spiel mit der Wahrnehmung . . .*, Cologne, 1975, pp. 82–4, ills 67–96; Exhibition catalogue *Anamorfosen . . .*, Rijksmuseum, Amsterdam / Musée des Arts Décoratifs, Paris, 1975–6.

36. From May 1651 up to the end of 1654 van Hoogstraten travelled to Vienna, Rome and then again to Vienna. In the latter city he made 'illusionistic' paintings like Fig. 14 from 1654. When he returned to Holland at the end of the same year, Fabritius had just died. Thus the contacts between the two artists must have taken place before Hoogstraten's departure in 1651. We may conclude then that this concern for illusionistic representation on the part of both artists had already taken definitive shape in or before 1651.

37. H. E. van Gelder, 'Perspectieven bij Vermeer', in: *Kunsthistorische Mededeelingen van het Rijksbureau voor Kunsthistorische Documentatie* 3, 1948, pp. 34–6.

38. K. Boström, 'Peep-show or case?' in: *Kunsthistorische Mededeelingen van het Rijksbureau voor Kunsthistorische Documentatie* 4, 1944, pp. 21–4, I. Q. van Regteren Altena, 'Hoge Kunst of Spielerei?' in: *idem* 4, 1949, p. 24. Sometimes, pictures were also painted on the doors of such cases.

39. See illustrations and early references in *Koslow*.

40. On Saenredam: (H. J. de Smedt), exhibition catalogue *Pieter Jansz. Saenredam*, Centraal Museum, Utrecht, 1961.

41. It was mentioned above (p. 19) that a similar change occurred in the repertory of motifs used by still-life painters. After 1650 the commonplace objects which had been depicted by masters like van Steenwyck (Fig. 12) were replaced by glassware, silver and exotic fruits in the work of van Aelst and van Beyeren (see Fig. 9).

42. On van den Eeckhout: R. Roy, *Studien zu Gerbrand van den Eeckhout*, typewritten dissertation, Vienna, 1972. On van Loo: a monograph by W. L. van de Watering is in preparation. On Metsu: *Gudlaugsson 1968* and F. W. Robinson, *Gabriel Metsu (1629–67) . . .*, New York, 1974.

43. See *Gudlaugsson 1959*, I, pp. 72–101.

44. See C. Wilnau, 'Ein Selbstporträt Vermeers?' in: *Zeitschrift für Kunst* 4, 1950, pp. 207–12; *Goldscheider*, p. 17, 32 note 28.

45. For instance the *Merry Company* by Jan Gerritsz van Bronchorst in Sibiu (illustrated in *Gowing*, p. 84).

46. *Slive* (p. 457): 'If Vermeer's picture was meant as an admonition to use alcoholic beverages moderately, it was probably a failure. The chance of looking as beautiful as Vermeer's Sleeping young woman is enough to drive a woman to drink!' For another, more recent interpretation of the painting see my p. 156.

47. For the dates on de Hooch's paintings, see *MacLaren*, p. 184.

48. See especially: *Welu*. Also the text of cat. nos 5, 12, 14, 17, 19, 23, 24, 29, 31, B1. The yellow satin jacket hemmed with white fur which is worn by Vermeer's models in Plates 13, 20, 21, 22 and 28 must be the one mentioned in the inventory after his death (see document 40).

49. This point of view has been most strongly stressed by *Swillens*.

50. See Daniel A. Fink, 'Vermeer's use of the Camera Obscura, a comparative study', in: *The Art Bulletin* 53, 1971, pp. 493–505.

51. The scarce information on Pick was assembled in *Thieme-Becker* XXVI, p. 588, before any work by his hand was known. A few years ago the Museum het Prinsenhof in Delft acquired a *Still-life in an interior* signed A. Pick, resembling the work of Rotterdam painters. On the album of which the drawing is a part, see: A. Blankert, 'Over Pieter van Laer als dier- en landschapschilder', in: *Oud Holland* 84, 1969, p. 119.

52. Mentioned by *Hofstede de Groot* I, p. 573, no. 56, auctioned in 1729.

53. The motif of the curtain pushed aside occurs exactly as on Plate 6 in several views in Delft churches by Emanuel de Witte and Gerard Houckgeest, dating from the years 1650–5 (*Manke* figs. 11, 13, 14). For the curtain-motif in Dutch seventeenth-century art, see P. Reuterswärd, in *Konsthistorisk Tidskrift* 25, 1965, pp. 97–113.

54. Another aspect of this stage in Vermeer's development is represented in the *Interruption of the Music* in the Frick Collection, New York (Plate B2). While the painting is very charming and unmistakably Vermeer-like, its modelling, especially of the costumes, is superficial and gives no evidence of Vermeer's superior technique.

55. Compare W. Stechow, *Dutch Landscape Painting of the Seventeenth Century*, London, 1966, pp. 124ff. and my review of this book in *Simiolus* 2, 1967/8, p. 106.

56. This ingenious discovery of Swillens was doubted by van Peer, whose arguments, however, have not convinced me (*Swillens*, p. 93ff.; *Van Peer 1959*, pp. 243–4). Van Peer does publish one surprising document which indicates that as late as September 1661 no preparations had yet been made for building the new Saint Luke's Guild hall. Nevertheless, van Bleyswyck's account of 1667 indicates the building started in that year, (*Bleyswyck*, p. 646).

57. *Swillens*, p. 90ff.

58. *Obreen* III, p. 197ff.

59. *Gowing* (expressing the opinion of Dr S. J. Gudlaugsson), p. 118: 'the dress in the Berlin picture was worn before 1660. The fashion which is seen in the work at Brunswick does not appear until 1663 or later.' *Van Thienen*, p. 29, notes that the costume on the painting in Brunswick is 'not later than shortly after 1660'.

60. An early positive re-appraisal of van Mieris is to be found in W. Martin, *De Hollandsche Schilderkunst in de zeventiende eeuw*, II, Amsterdam, 1936, p. 220ff. More recently: E. Plietzsch, *Holländische und Flämische Maler des XVII. Jahrh.*, Leipzig, 1960, pp. 49–55.

61. To be connected with these three paintings is the *Woman playing the Lute near the Window* in the Metropolitan Museum in New York (Plate B1). The surface of this painting is in such poor condition that only the high quality of the rendering of the map on the wall makes it clear that the painting is a 'lost' authentic Vermeer.

62. *Wichmann*, œuvre catalogue nos. 267–71 ('A person weighing gold at a table upon which are many valuables').

63. See: H. Rudolph, '"Vanitas": Die Bedeutung mittelalterlicher und humanistischer Bildinhalte in der Niederländischen Malerei des 17. Jahrhunderts', in: *Festschrift Wilhelm Pinder*, Leipzig, 1938, p. 408 ff. See also *Slive*, p. 454.

64. The same inscription with the word *dolorum* (not *doloris*) is written in full on two instruments, dating from 1624 and 1640, made by the Antwerp manufacturer of keyboard instruments Andries Ruckers (B. Nicolson, *Vermeer, Lady at the virginals*, Gallery Books, no. 12, London, 1946). It also appears on a book in a still-life painting signed by E. Collier, which depicts in addition a globe, a violin and a musical score. From the book hangs a piece of paper with another text: 'Haec mea voluptas' (Van der Heyden Gallery, Rotterdam, Antique Fair, Delft, 1975). Nicolson reproduces a musical instrument by Ruckers in the Musée Instrumental du Conservatoire, Brussels, which is almost identical to that depicted in Plate 16. He labels it a virginal, as this is the correct term from a musicological point of view. A virginal by Ruckers in the Gementemuseum, The Hague (inv. no. EC 34-x-1976, on loan from the Rijksmuseum, Amsterdam) has around the keyboard exactly the same decoration as Plate 16. See a complete list of the virginals by Ruckers that still exist: D. H. Boalch, *Makers of harpsichord and clavichord 1440–1840*, Oxford, 1974, p. 129ff. Also Plates 25 and 31, in which similar instruments are depicted, are called, in recent publications of the London National Gallery, *A young woman standing at a virginal* and *A young woman seated at a virginal* (see *MacLaren*, nos. 1383 and 2568). Dutch seventeenth-century inventories, however, always called these instruments 'clavesingels' (spelled in various ways). Moreover, in 1682 Plate 16, 25 or 31 is mentioned as a 'piece with a lady playing the *clavesingel*', and in 1696 as a '*klavecimbael*'-player' (see p. 167, cat. no. 25). Thus, I usually use the word 'clavecin' to denote this instrument.

65. *Bleyswyck* p. 646ff. See above p. 39.

66. C. A. van Mander, *Het Schilder-Boeck warein on t'leven der vermaerde doorluchtighe schilders . . .*, Haarlem / Alkmaar 1604, fol. 245.

67. For this interpretation see *Van Gelder 1958*.

68. Other interpretations of the map are mentioned in *Van Gelder 1958*, pp. 10, 23, and in H. Miedema (op. cit. on p. 163, cat. no. 19), p. 74. Compare *Welu*, p. 540.

69. *De Jeugd van Constantijn Huygens door hemzelf beschreven . . . vertaald . . . door. . . .* A. H. Kan, Rotterdam / Antwerp, 1946, p. 66ff.

70. Compare W. Friedländer's lucid exposition on the transition from 'high renaissance' to 'mannerism' in Italian painting of the sixteenth century (*Mannerism and anti-mannerism in Italian Painting, two essays*, New York, 1957, originally published in 1925).

71. H. Vey and A. Kesting, *Katalog der Niederländischen Gemälde . . . im Wallraf-Richartz-Museum . . .*, Cologne, 1967, p. 57, no. Dep. 239. Peter Sutton, who is preparing a monograph on de Hooch, informs me that he also dates the painting to the late 1670s.

72. This was convincingly argued by *Gudlaugsson (1968, p. 37)*.

73. All this information from *De Jongh*, pp. 49–52. See the same author on the *Love letter* in exhibition catalogue *Rembrandt en zijn tijd*, Paleis voor Schone kunsten, Brussels, 1971, pp. 176–7 and *De Jongh 1976*, p. 269. On music and love in Vermeer's paintings also: A. P. de Mirimonde, 'Les sujets musicaux chez Vermeer de Delft', in: *Gazette des Beaux-Arts* 6, 57, 1961, pp. 29–52. Also my p. 170 cat. no. 31.

74. On the unfinished state of the painting see *The Frick Collection, an Illustrated Catalogue I, Paintings . . .*, New York, 1968, p. 296.

75. On the origin and dissemination of the theme see: H. van de Waal, 'Rembrandt's Faust Etching, a Socinian document, and the iconography of the inspired scholar', in: *Oud Holland* 79, 1964, p. 37ff. That Bramer also treated the subject is apparent from the description of a painting by him in an auction of 1776: 'A philosopher stands in a room at a table, upon which a globe and some books' (*Wichmann*, cat. no. 251, see also e.g. no. 258). Ample

discussion of the subject with Vermeer and other artists: *De Jongh 1976*, p. 83.

76. This was pointed out by P. Bianconi (P. Ungaretti and P. Bianconi, *L'Opera Completa di Vermeer*, Milan, 1967, p. 96).

77. Gudlaugsson noted the relation with Dou's work (*Gudlaugsson-Kindler*).

78. *MacLaren*, p. 437.

79. It is unlikely that the painting was cut at a later date: A fine old copy of exactly the same size exists in the John G. Johnson Collection, Philadelphia (*Swillens*, Plate 31B, see my p. 169). Only the coiffure is different. The hairstyle on the copy seems to follow the fashion prevalent shortly after 1700. On this basis it is unlikely that it was painted later, for at a later date the coiffure on Vermeer's original would not have seemed so disturbing that the copyist would have felt the need to modernize it.

80. See *Van Peer 1968* p. 222.

81. Mr C. de Wolf, The Hague, proposes the following reason for the change. Before citing the poem van Bleyswyck notes that Fabritius died at 'only thirty years of age'. When Bon proof read the first sheets from the press, he decided that he should actually have mentioned this fact in his poem. It was not unusual in elegies and funeral poems to mention the age of death of the deceased, especially when there was something remarkable about it—in the case of Fabritius, his youthful age and the tragic cause of his death.

82. Vermeer is named in the poem as *the* successor of the great Fabritius. That an artist should imitate his great forerunners was a prevailing idea at the time, but it was considered even more important to emulate and, if possible, surpass them. These concepts were termed '*imitatio*' and '*aemulatio*' (see: E. de Jongh, 'The Spur of Wit: Rembrandt's Response to an Italian challenge', in *Delta* 12, 1969, no. 2, pp. 49–67). Perhaps Vermeer felt that the phrase 'who masterly trod his (Fabritius's) path' (reminding of 'downtrodden paths') stressed too much his '*imitatio*' of Fabritius, at the expense of the more important '*aemulatio*'.

83. It has surprised modern scholars that in his *Inleyding tot de Hooge Schoole der Schilderkonst* of 1678 van Hoogstraten makes no mention of Vermeer at all (see: *Van Gelder, 1958*, p. 6). This is remarkable indeed, as his contacts with Fabritius make it highly probable that he was well acquainted with the Delft *milieu*. And in fact he does include remarks on the Leiden painters Dou and van Mieris. In one passage he adds over-emphatically: 'But let me stop. In order not to excite envy, I want to leave out the painters who are still alive' (*Inleyding . . .* p. 257). Van Mieris was still alive at the time, Vermeer had died three years before.

84. A. Houbraken, *De Groote Schouburgh der Nederlantsche Konstschilders en schilderessen*, I, Amsterdam, 1718, p. 236. He also left out the last stanza of Arnold Bon's poem (see p. 60 and *Wheelock*, op. cit. (on p. 76, note 33) p. 77 note 4.

85. The concept and title of the exhibition 'In the light of Vermeer' (*In het licht van Vermeer*, Mauritshuis, The Hague / Louvre, Paris (1966) led to a lengthy and heated discussion by art historians and critics in the Dutch press.

86. *The literary works of Sir Joshua Reynolds*, II, London, 1819, pp. 367, 369, 374.

87. J. P. Lebrun, *Galerie des peintres flamands, hollandais et allemands*, II, Paris, 1792–6, p. 49.

88. *Redevoeringen ter inwijding der volbouwde tekenzaal . . . en voor de Gehoorzaal . . . in het Gebouw der Maatschappije Felix Meritis te Amsterdam gehouden den IIIen en XXen November 1789 door A. Bonn*, Amsterdam, 1790, p. 52.

89. Both cases were kindly brought to my attention by Peter Sutton. The painting sold in 1765: P. Terwesten, *Catalogus of naamlijst . . .* (additional volume to *Hoet*), The Hague, 1770, p. 504, no. 15. The one sold in 1774: Sale Frans van de Velde,

Amsterdam, 7 September 1774, no. 43; it now is in the City Museum of Art, Birmingham.

90. See *Hofstede de Groot*, I, no. 9a. He mentions the auctions of 1780 and 1809, but failed to connect the painting with de Hooch. W. L. van de Watering has found the painting also attributed to Vermeer in auction catalogues: G. H. Trochel, Amsterdam, 11 May 1801, no. 48, for F.60 to Van der Schley and Amsterdam, 16 June 1802, no. 99, for F.140 to Gruyter. The descriptions (size etc) given in the auction catalogues make it almost certain that the painting was the *Goldweigher* by de Hooch now in Berlin (cat. KFM 1931 and cat. Gemäldegalerie Dahlem 1966, no. 1401B).

91. *Hofstede de Groot*, no. 12. From the descriptions in the auction catalogues it appears that the painting is identical with the painting Fig. 45 (as already stated in cat. Provinzialmuseum, Hannover, 1930, no. 57).

92. For the paintings by Berckheyde, Vrel, Boursse, etc. see: *Hofstede de Groot* I, pp. 612–13.

93. See S. Sulzberger, 'Ajouté à la biographie de Vermeer de Delft', in: *Kunsthistorische Mededeelingen van het Rijksbureau voor Kunsthistorische Documentatie* 3, 1948, p. 37. Josi adds that in 1798 he himself had bought a Vermeer at the Nyman auction: 'l'homme tenant un compas à la main pour 7 louis'. In fact he bought the painting in 1797 (see cat. no. 24 under provenance).

94. E. van Eynden and A. van der Willigen, *Geschiedenis der vaderlandsche schilderkunst sedert de helft der XVIII eeuw*, I, Haarlem, 1816, pp. 164–8.

95. See the copies mentioned under cat. nos. 7, 9, 10, 13, 24, 26 by: A. Brondgeest, W. Hendriks, G. Lamberts, C. van Noorde, H. Numan, P. E. H. Praetorius, J. Stolker, R. Vinkeles, V. van de Vinne and J. G. Waldorp.

96. A *View on a Canal* by Dirk Jan van der Laan (1759–1829), which Thoré-Bürger published in 1866 as a Vermeer (*De Vries*, Plate XXVIII), dates from the same period.

97. J. Smith, *A catalogue-raisonné of the works of the most eminent Dutch, Flemish and French painters*, IV, London, 1834, pp. 110, 242.

98. This data on Thoré is primarily derived from Stanley Meltzoff's excellent article: 'The rediscovery of Vermeer', in *Marsyas* 2, 1942, pp. 145–66; unless stated otherwise this article is the source of the following quotations from Thoré. See also: A. Heppner, 'Thoré-Bürger en Holland, de ontdekker van Vermeer en zijn liefde voor Neerlands Kunst', in: *Oud Holland* 55, 1938, pp. 17–34, 67–82, 129–44. For an extensive exploration of Thoré's ideas see P. Grate, *Deux critiques d'Art de l'Epoque romantique: Gustave Planche et Théophile Thoré*, Stockholm, 1959, and the recent publications of F. Suzmann Jowell, 'Thoré-Bürger and the Revival of Frans Hals', in: *The Art Bulletin* 56, 1974, pp. 101–17; *Thoré-Bürger and the art of the past*, New York, 1977.

99. *Bürger*. As early as 1860 Thoré published a short article on Vermeer with a catalogue of works (W. Bürger, *Musées de la Hollande, II, Musée van der Hoop à Amsterdam et Musée de Rotterdam*, Brussels / Ostende, 1860, pp. 67–88).

100. Appreciation of the 'Impressionistic' qualities of Vermeer's *œuvre* lingers, playing a larger role than is justified. The paintings B1 and B2 are so strongly abraded that their 'Impressionistic' aspects are accentuated. Hardly anything is visible of the meticulous modelling, which is so characteristic of Vermeer. Nevertheless the two paintings are illustrated again and again, without much comment, as Vermeers.

101. H. Havard, *Van der Meer de Delft*, Paris, 1888.

102. *Hofstede de Groot*, German edition, Esslingen/Paris, 1907.

103. E. Plietzsch, *Vermeer van Delft*, Leipzig, 1911; 2nd edition, Munich, 1939.

104. Disquieting reports from China made it clear that during the cultural revolution, the destruction of art treasures was

encouraged from above. It is less clear how far this destruction is balanced by the restorations and excavations conducted with seemingly equal enthusiasm in that country.

105. See the provenances included under cat. nos. 5, 15, 20, 21.

106. A. Bredius, 'A new Vermeer' in: *Burlington Magazine* 71, 1937, p. 211.

107. On this case: H. M. van Dantzig, *Johannes Vermeer, de Emmausgangers en de critici*, Leiden/Amsterdam, 1947; P. B. Coremans, *Van Meegeren's Faked Vermeers and De Hooghs*, Amsterdam, 1949.

108. On the 'period' quality of forgeries compare: H. van de Waal 'Forgery as a Stylistic Problem, in: Aspects of Art Forgery', *Strafrechterlijke en criminologische Onderzoekingen*, No. 6, The Hague, 1962, pp. 1–14. Van de Waal's ideas on the all-pervading nature of the *'Zeitgeist'*, however, are outdated by E. H. Gombrich's *In Search of Cultural History* (Oxford, 1969).

109. The doubts of the late Dr S. J. Gudlaugsson are cited by Vitale Bloch (*Bloch*, list of Vermeer's paintings nos. 24, 25). Also, the two paintings are not mentioned in *Gudlaugsson-Kindler*.

Before him, H. M. van Dantzig questioned the authenticity of the *Girl with a red Hat* and Swillens catalogued both paintings in his section on 'incorrect attributions' to Vermeer (H. M. van Dantzig, op. cit. (above in note 107) p. 89, note 50; *Swillens*, pp. 64–5, nos. E. and G).

110. Verbal communication of Dr S. J. Gudlaugsson to Gary Schwartz.

111. M. Kühn, 'A Study of the Pigments and the Grounds used by Jan Vermeer', in *National Gallery of Art Report and Studies in the History of Art* II, Washington, 1968, pp. 155–202. Small particles of pigment of thirty paintings generally accepted as Vermeers were studied in this article. It does not mention two other paintings in the National Gallery of Art in Washington which at that time were exhibited as authentic Vermeers (Illustrations and data on these paintings: *De Vries* pp. XXI, XXII, Plates 35, 38; *Goldscheider*, p. 146, Plates VI, VIII). In 1973 they were removed to the storerooms as twentieth-century forgeries. In my view old pigments in the *Girl with a red Hat* could also be from the older portrait (revealed by X-ray) upon which it is painted (see p. 172).

List of plates

Reproductions of complete paintings are in numerical sequence, with details reproduced near the plates to which they refer. Catalogue entries (pp. 155–72) are in the same sequence.

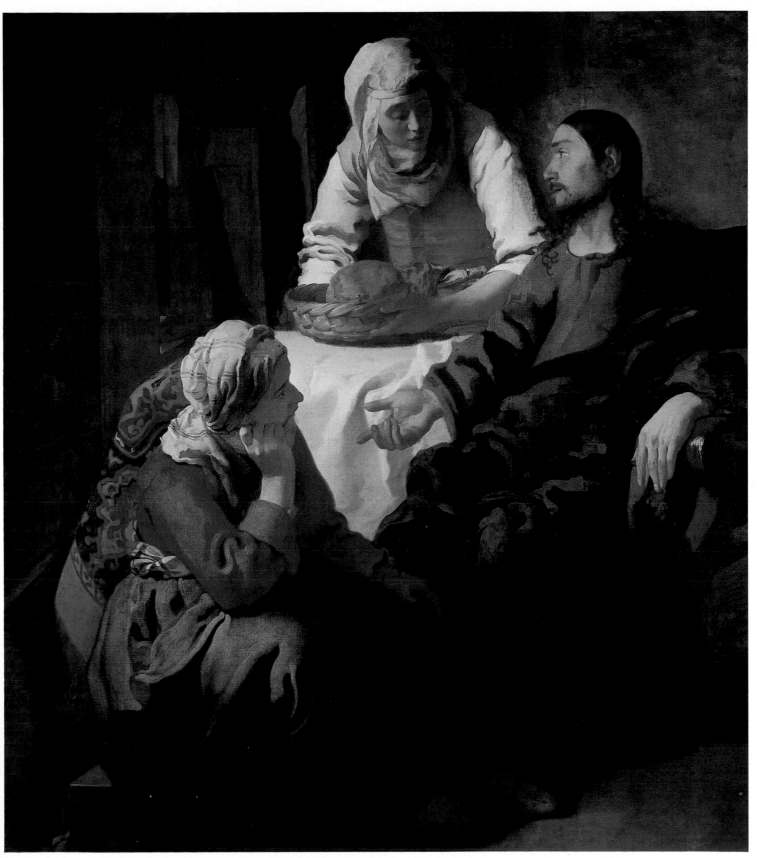

1. *Christ in the House of Mary and Martha.* 1654–6. 160 × 142 cm. Edinburgh, National Gallery
of Scotland

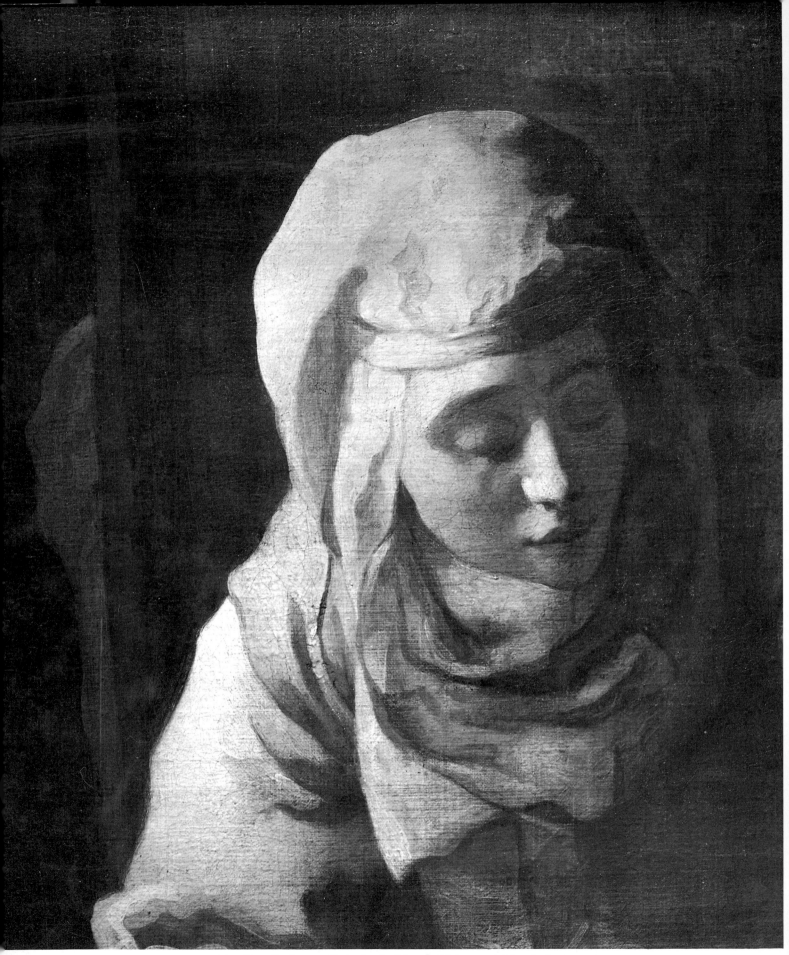

1a and b. Details from *Christ in the House of Mary and Martha* (PLATE 1)

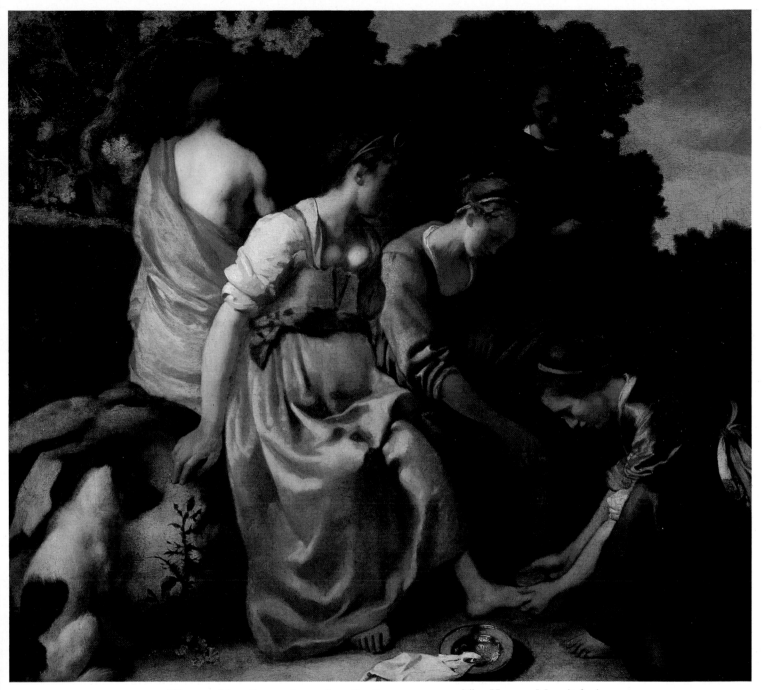

2. *Diana and her Companions*. 1654–6. 98.5 × 105 cm. The Hague, Mauritshuis

1c (*left*). Detail from *Christ in the House of Mary and Martha* (PLATE 1)

2a and b. Details from *Diana and her Companions* (PLATE 2)

3 and 3a. *The Procuress*. 1656. 143 × 130 cm. Dresden, Staatliche Gemäldegalerie

3b. Detail from *The Procuress*: Self-portrait of the Artist? (PLATE 3)

4a. Detail from *Girl asleep at a Table* (PLATE 4)

4b. Detail from *Girl asleep at a Table* (PLATE 4)

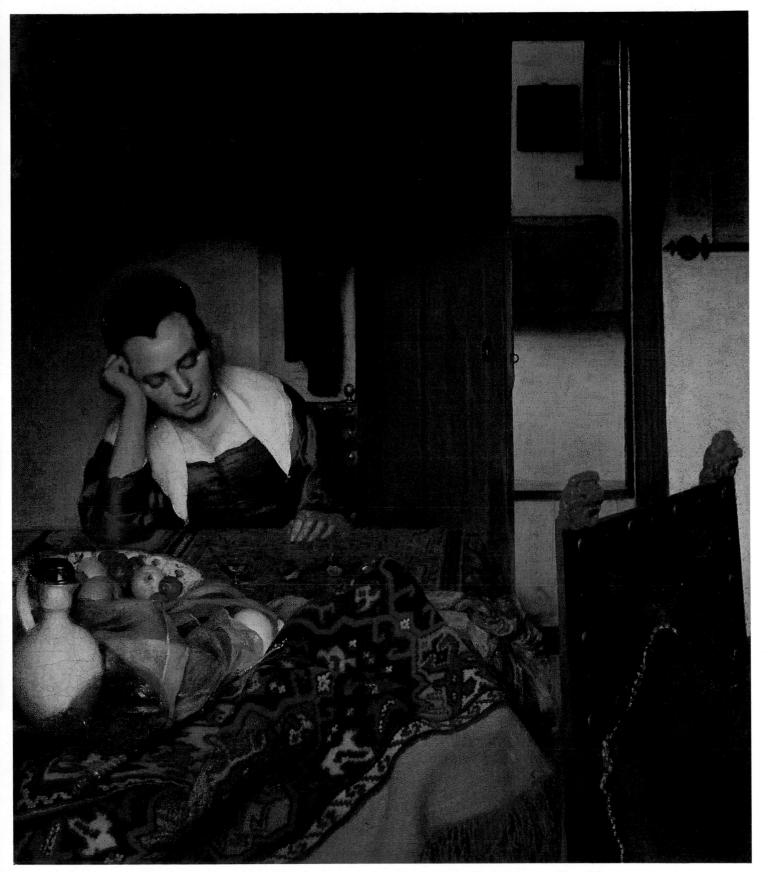

4. *Girl asleep at a Table.* About 1657. 86.5 × 76 cm. New York, Metropolitan Museum

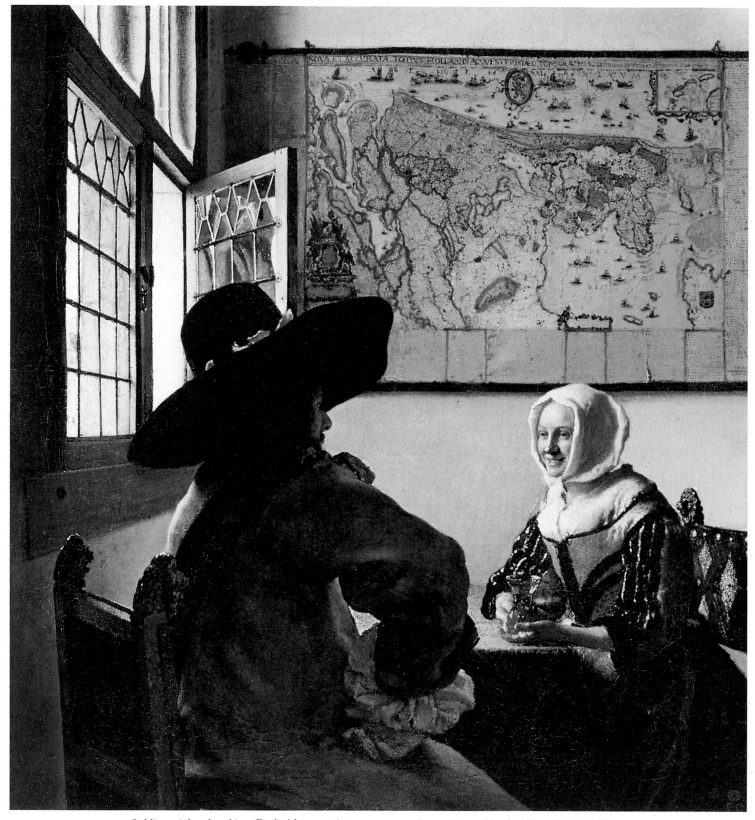

5. *Soldier with a laughing Girl*. About 1658. 50.5 × 46 cm. New York, The Frick Collection

6. *Girl reading a Letter at an open Window*. About 1659. 83 × 64.5 cm. Dresden, Staatliche Gemäldegalerie

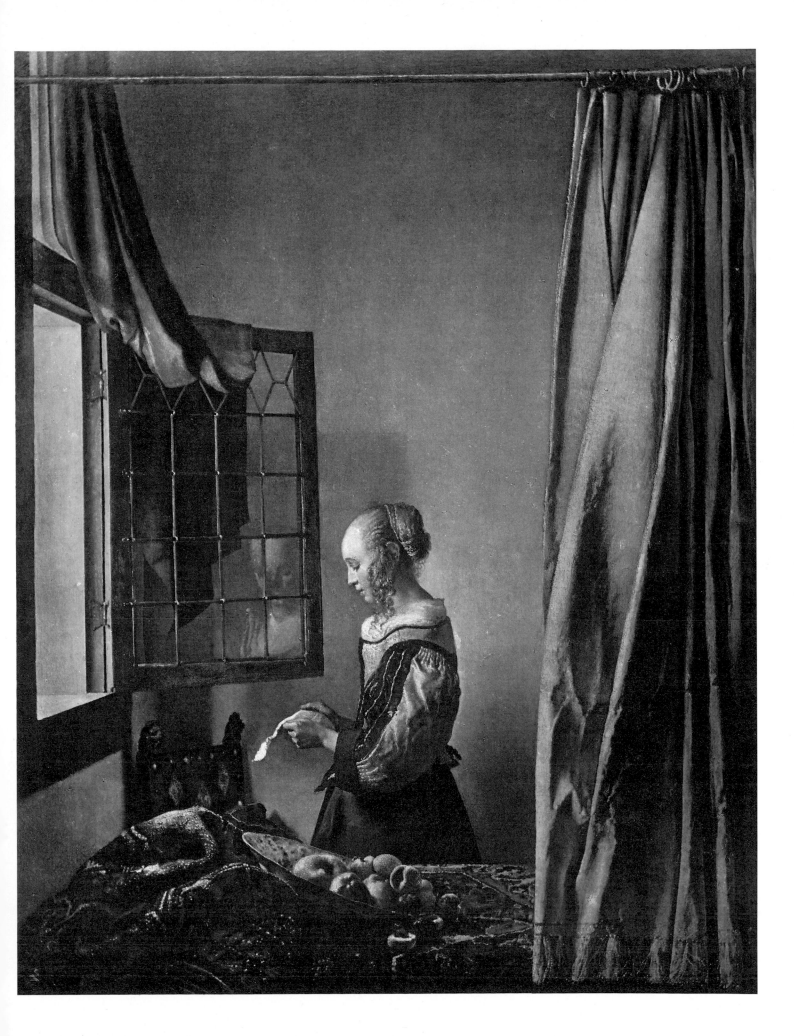

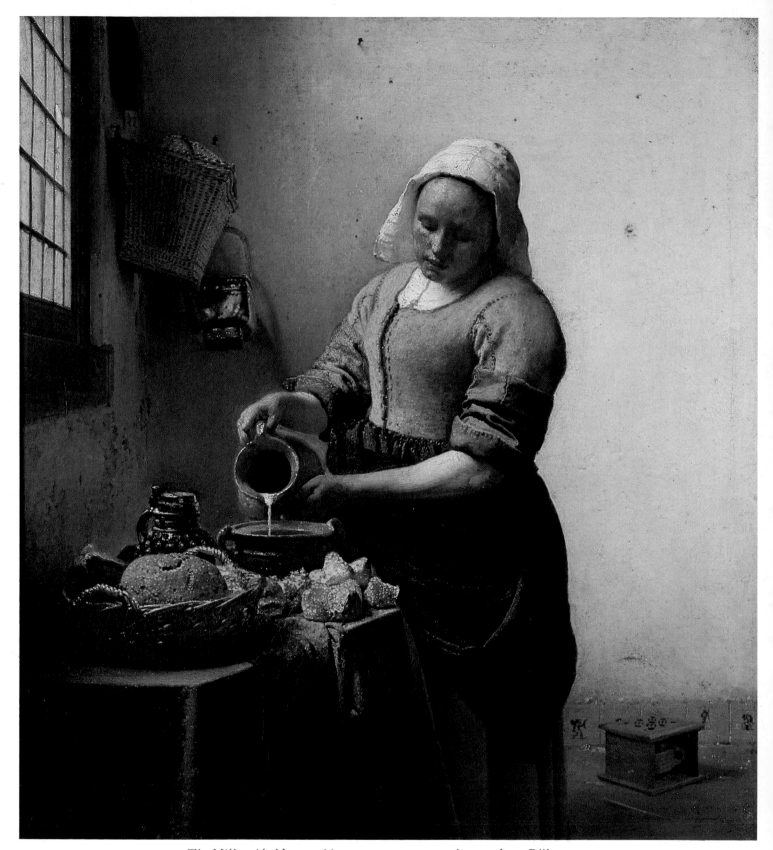

7. *The Milkmaid*. About 1660–1. 45.5 × 41 cm. Amsterdam, Rijksmuseum

8a (*right*). Detail from *The Glass of Wine* (PLATE 8)

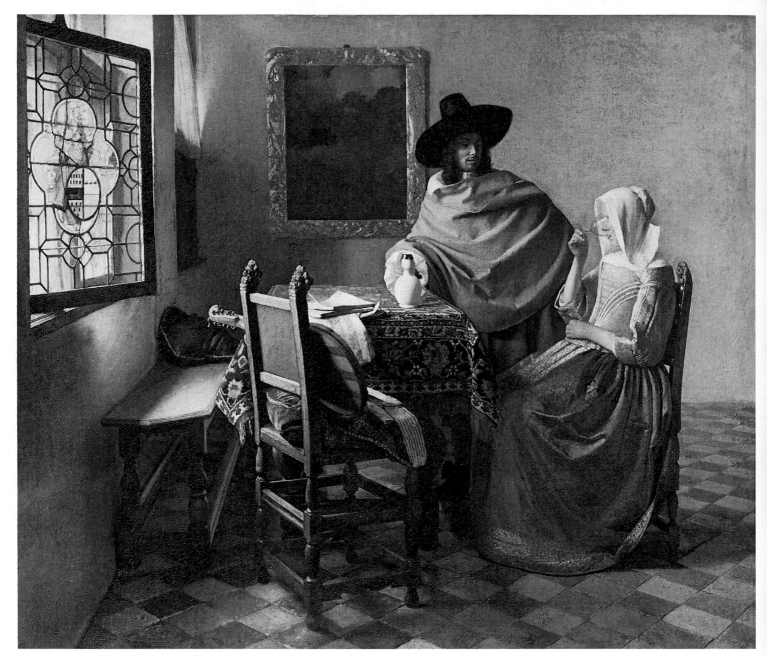

8 and 8b. *The Glass of Wine*. About 1660–1. 65 × 77 cm. Berlin-Dahlem, Gemäldegalerie

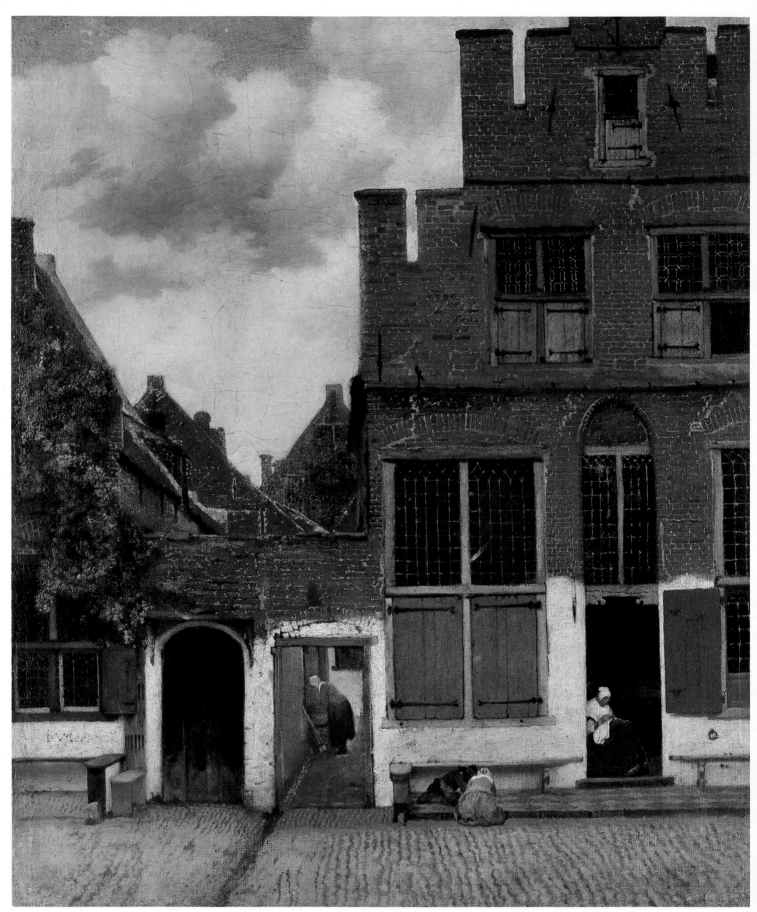

9 and 9a. *The little Street* (‘*Het Straatje*’). 1661. 54.3 × 44 cm. Amsterdam, Rijksmuseum

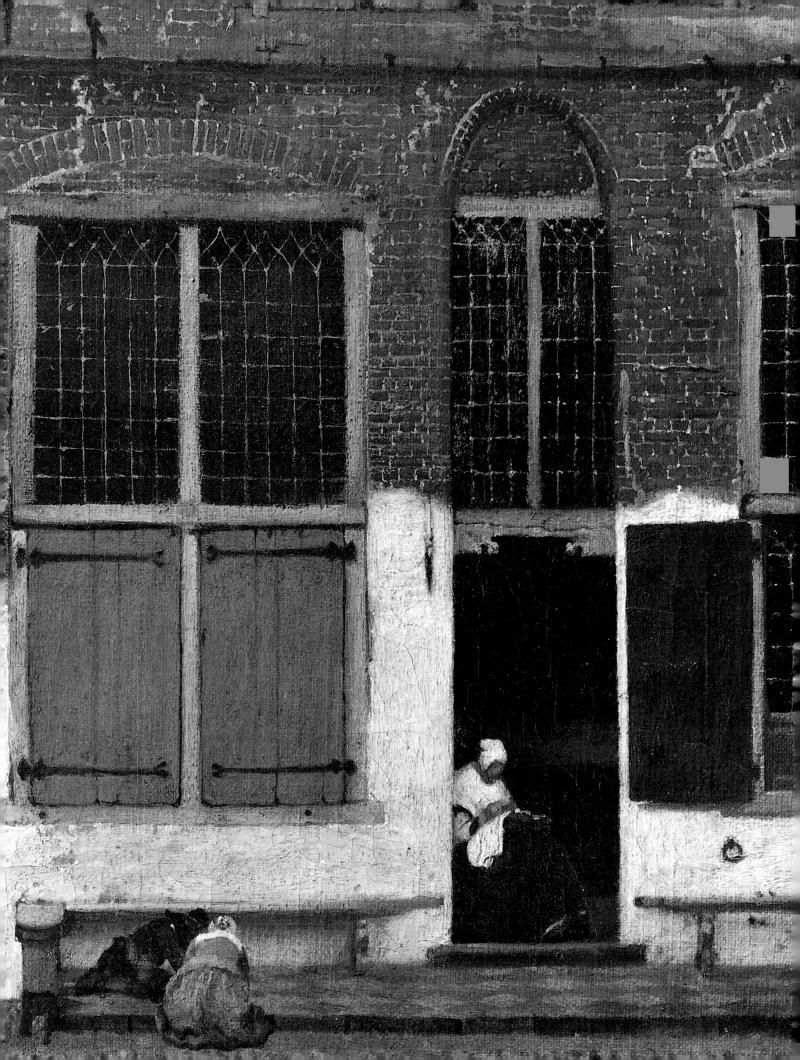

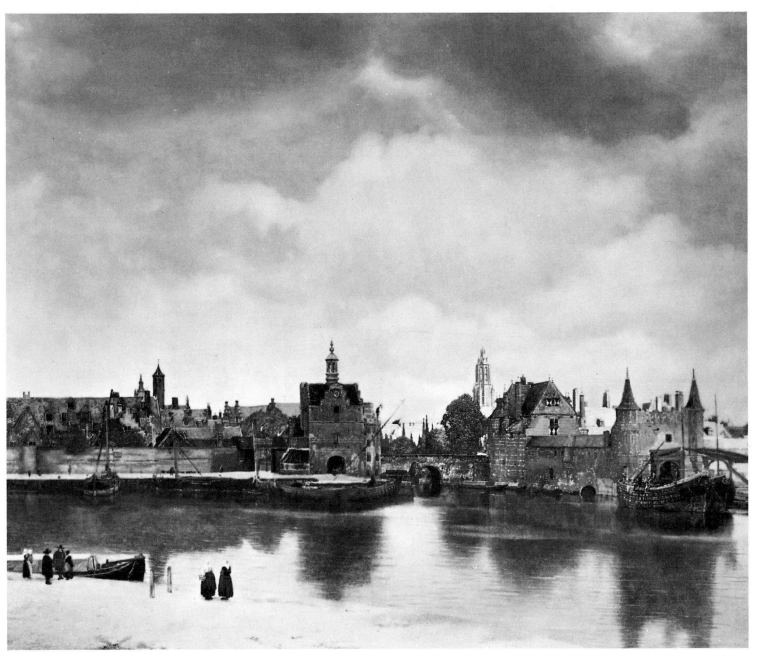

10 and 10a (*above and overleaf*). *View of Delft*. About 1661. 98 × 117.5 cm. The Hague,
Mauritshuis

9b (*left*). Detail from *The little Street* (PLATE 9)

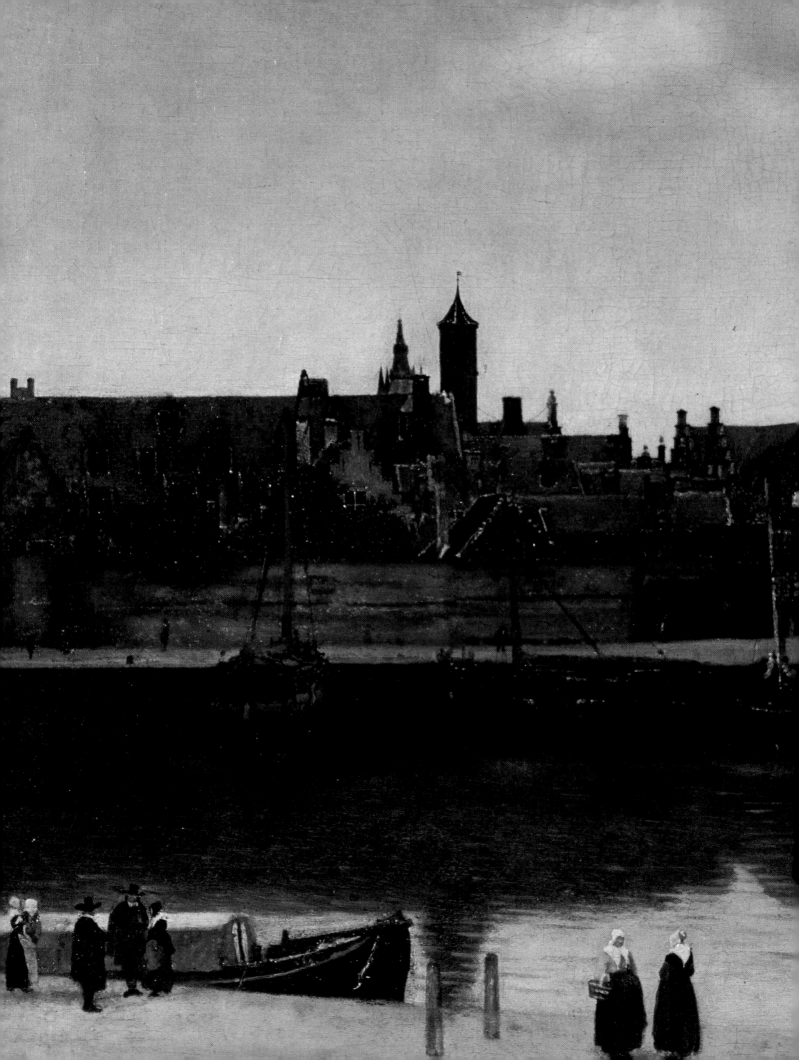

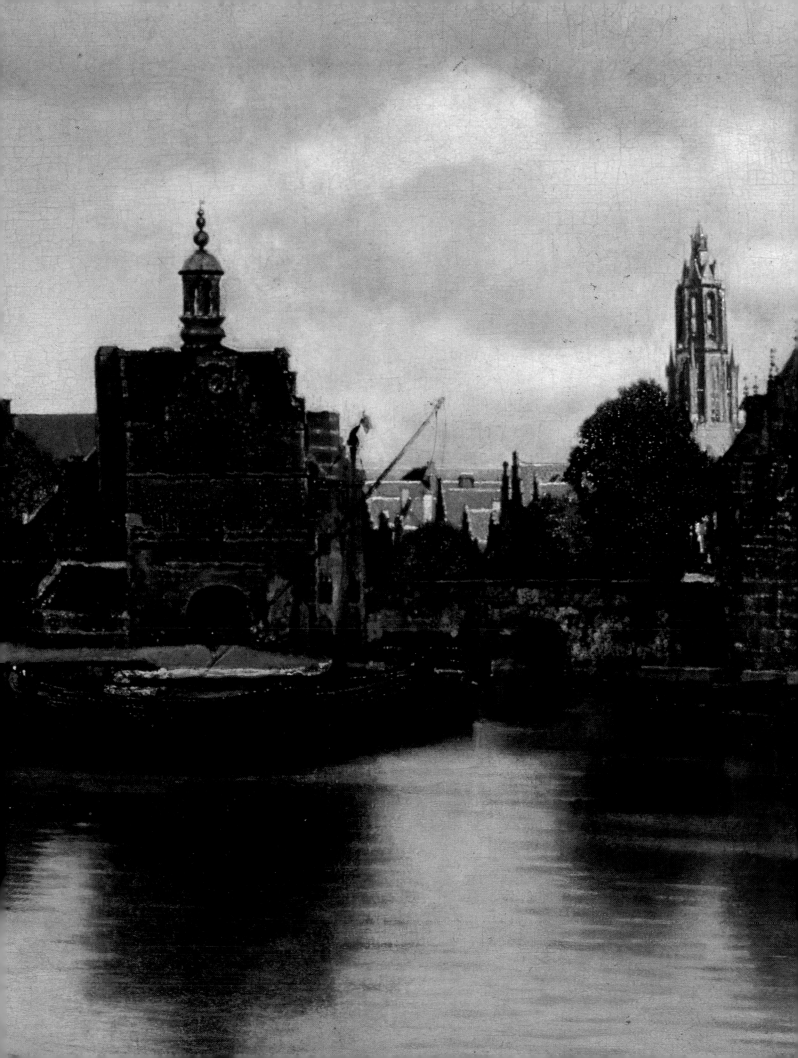

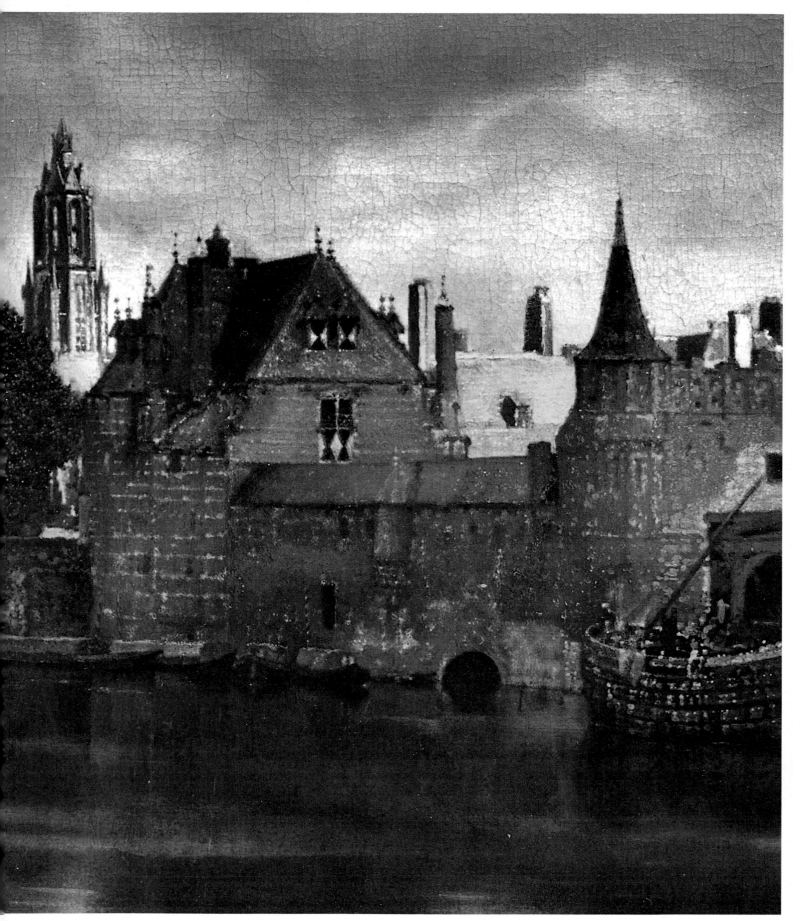

10b (*above*). Detail from *View of Delft* (PLATE 10)

11a (*right*). Detail from *Woman and two Men* (PLATE 11)

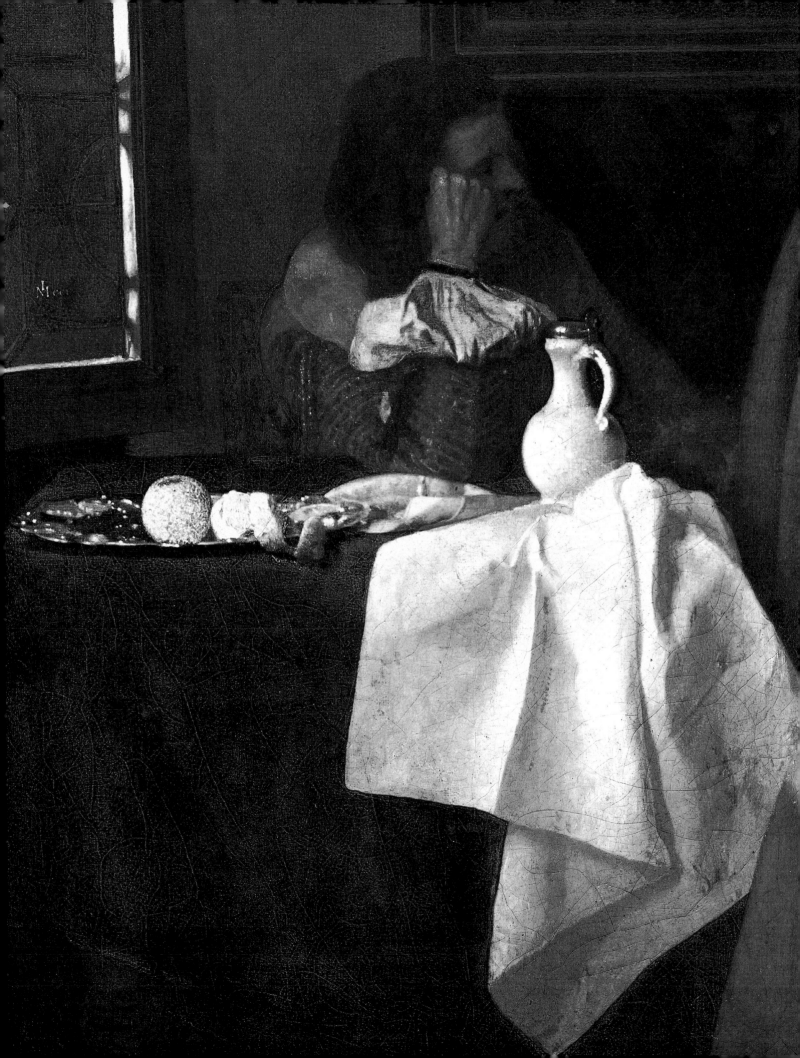

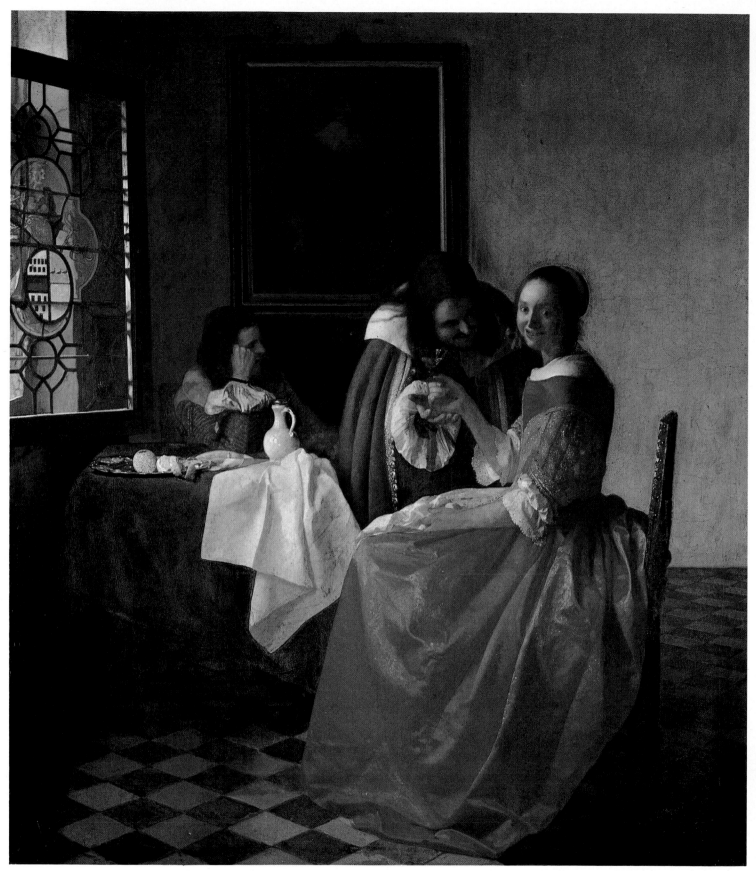

11. *Woman and two Men.* About 1662. 78 × 67 cm. Brunswick, Herzog Anton Ulrich-Museum

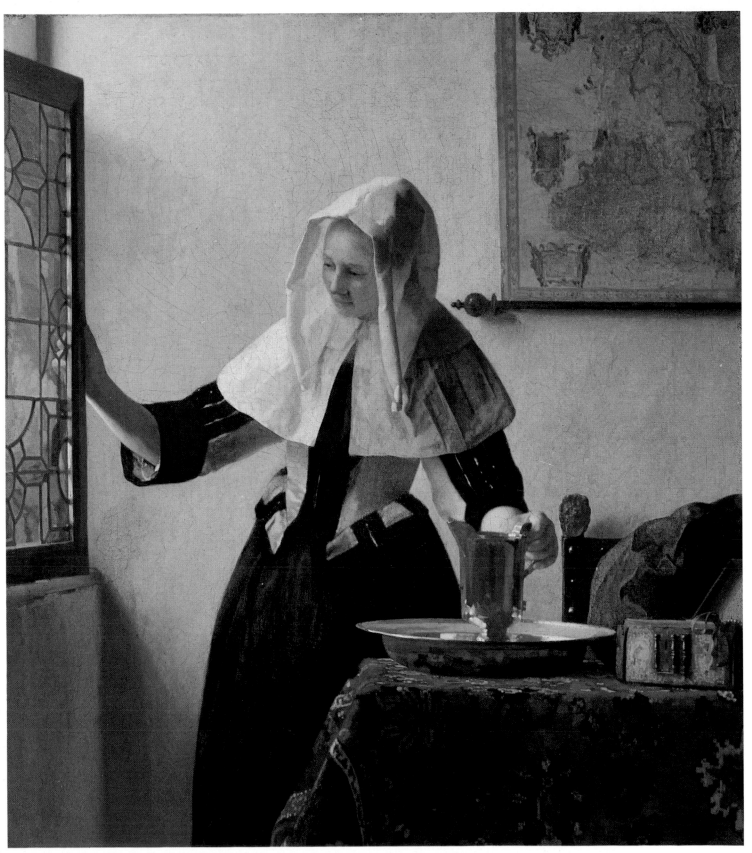

12. *Woman with a Water Jug*. About 1662. 45.7 × 42 cm. New York, Metropolitan Museum

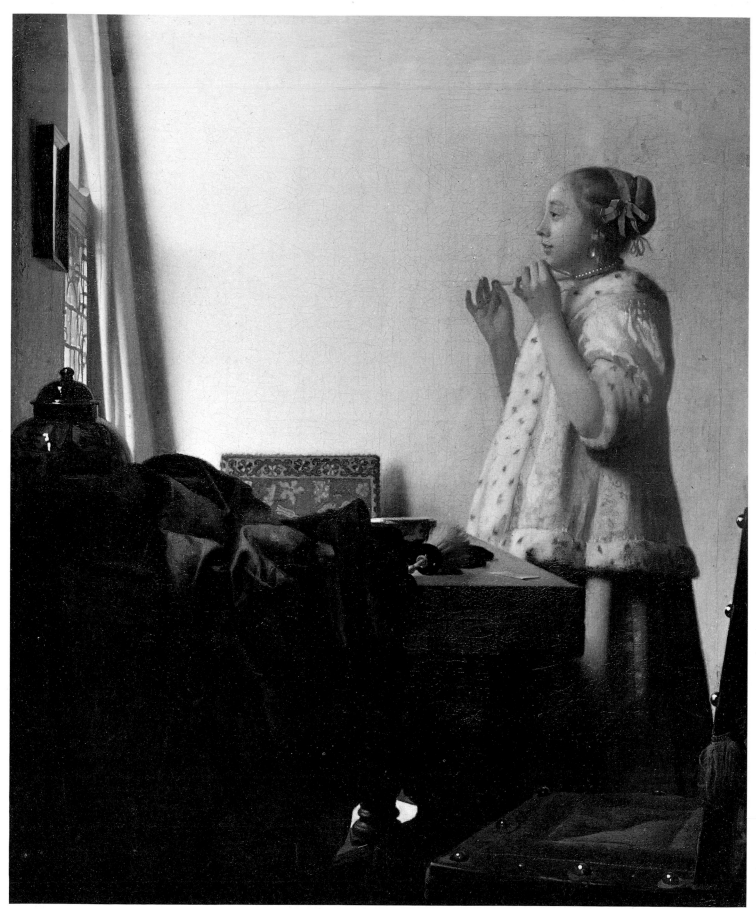

13. *Woman with a pearl Necklace.* 1662–5. 55 × 45 cm. Berlin-Dahlem, Gemäldegalerie

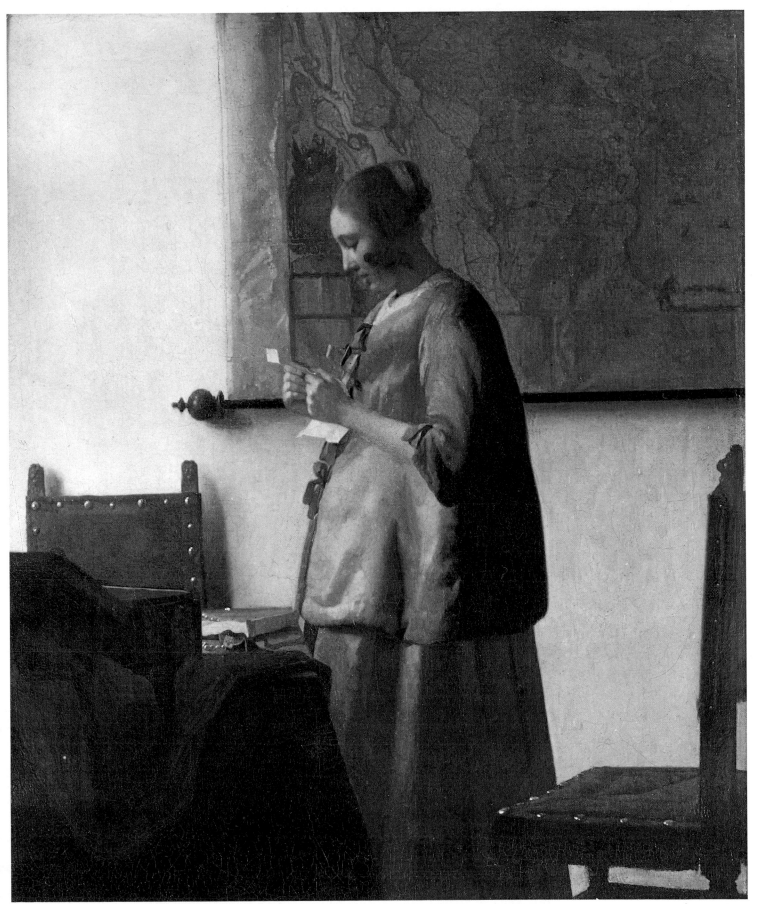

14. *Woman in blue reading a Letter.* 1662–5. 46.5 × 39 cm. Amsterdam, Rijksmuseum

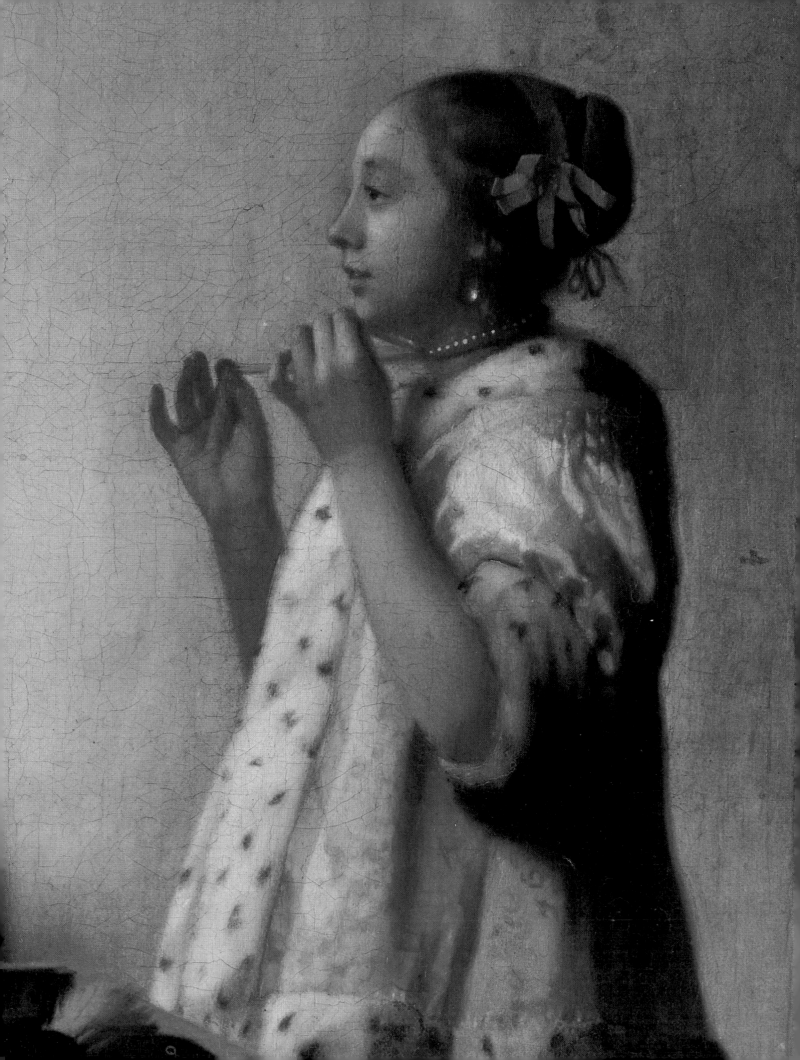

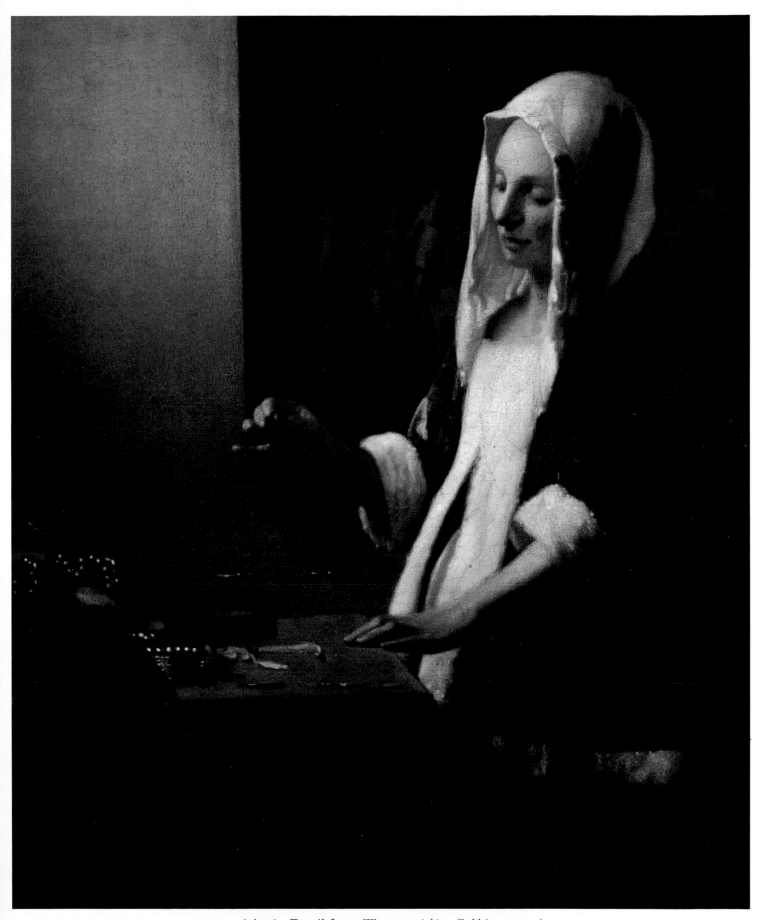

15a (*above*). Detail from *Woman weighing Gold* (PLATE 15)

13a (*left*). Detail from *Woman with a pearl Necklace* (PLATE 13)

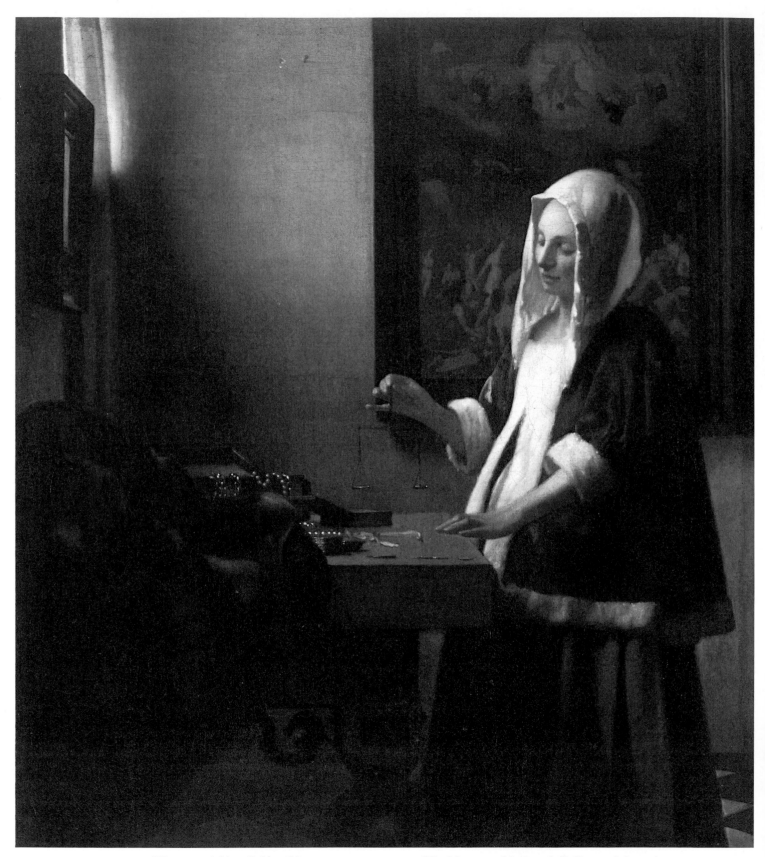

15. *Woman weighing Gold*. 1662–5. 42 × 35.5 cm. Washington, National Gallery of Art

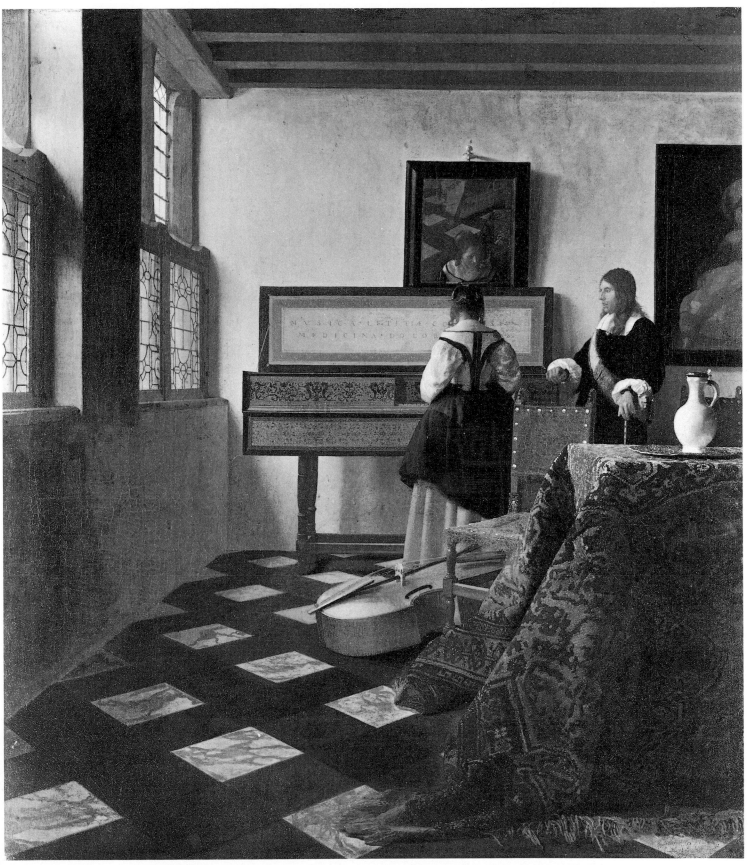

16. *The Music Lesson*. About 1664. 73.6 × 64.1 cm. London, Buckingham Palace.
Reproduced by Gracious Permission of Her Majesty the Queen

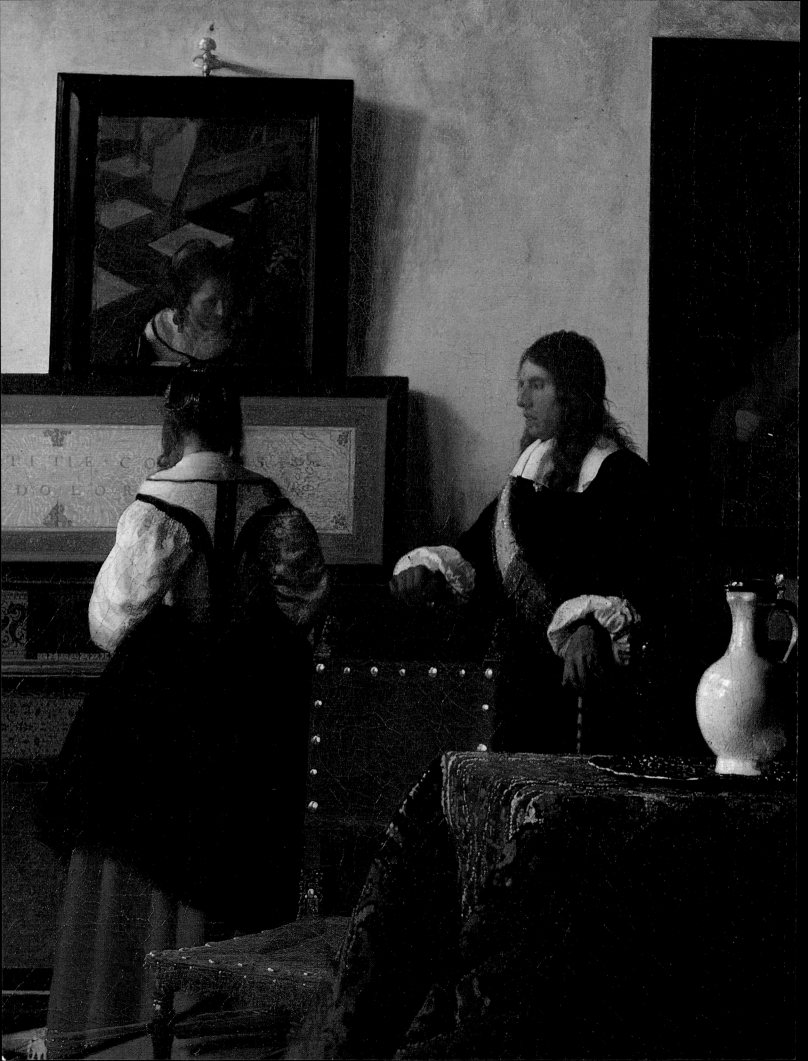

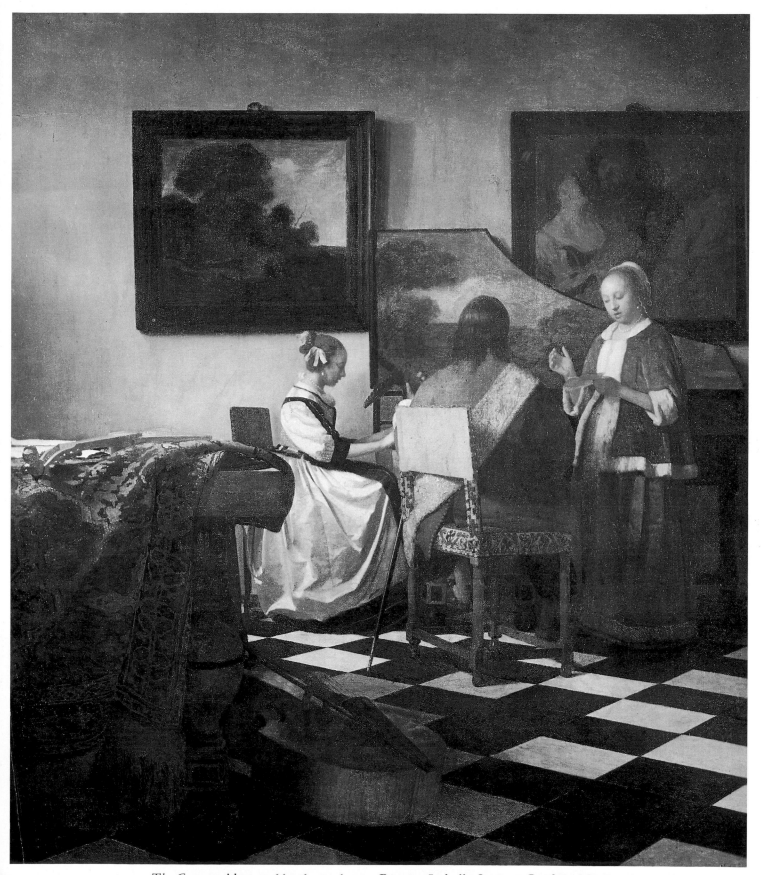

17. *The Concert*. About 1664. 69 × 63 cm. Boston, Isabella Stewart Gardner Museum

16a (*left*). Detail from *The Music Lesson* (PLATE 16)

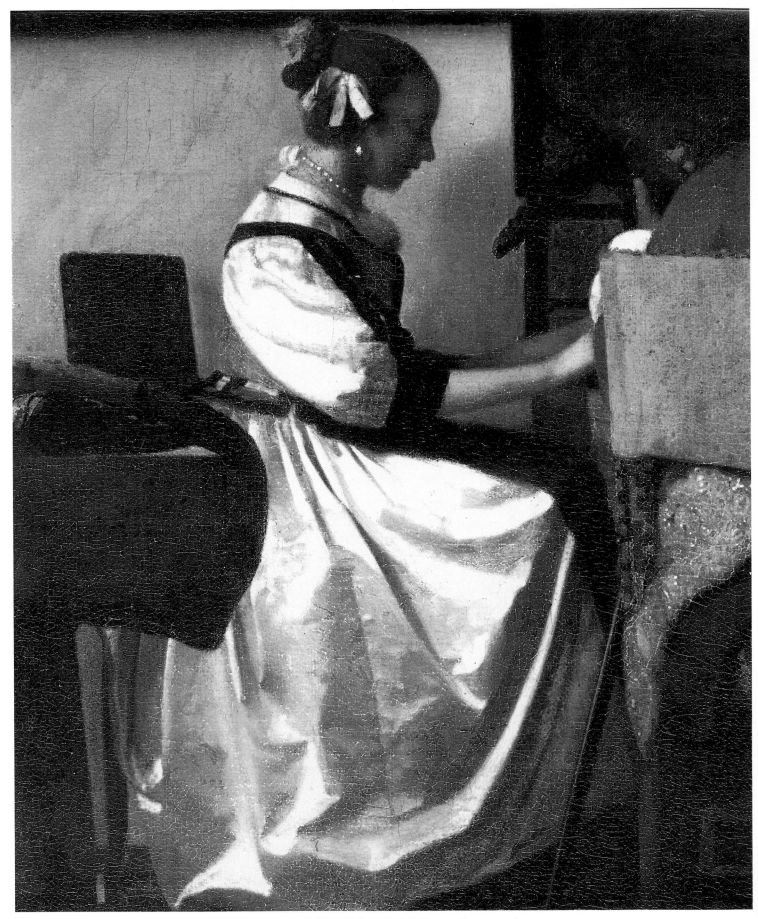

17a (*above*). Detail from *The Concert* (PLATE 17)

18a (*right*). Detail from *Girl with a pearl Ear-ring* (PLATE 18)

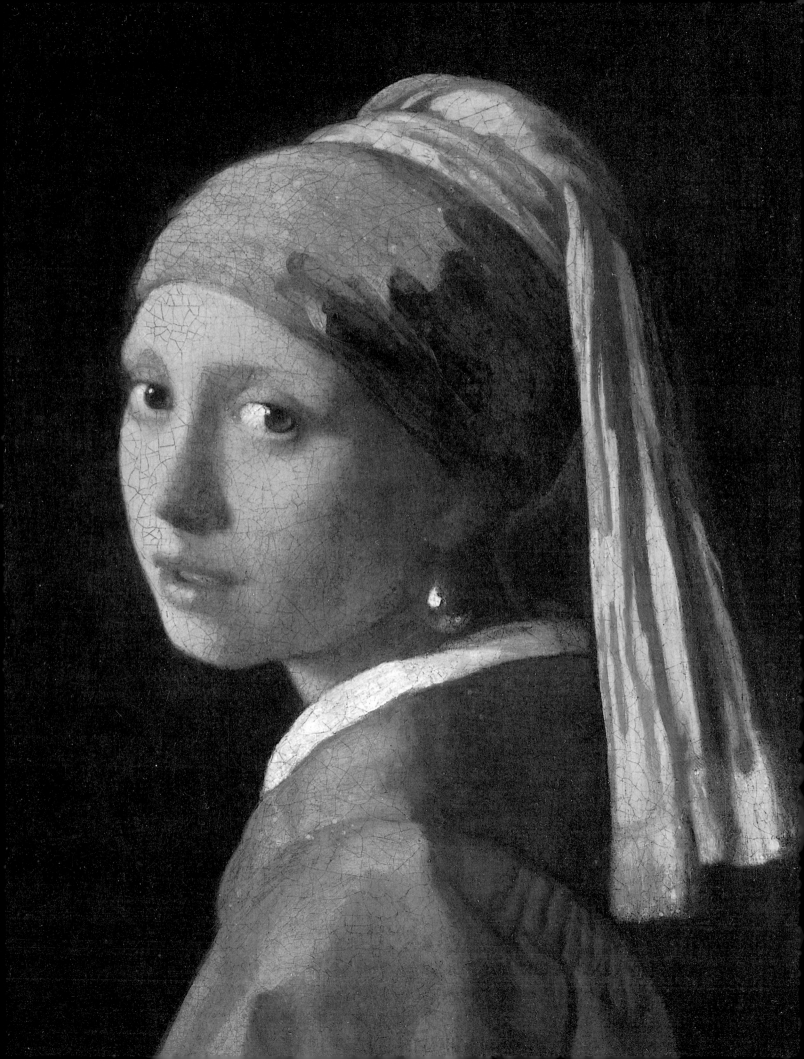

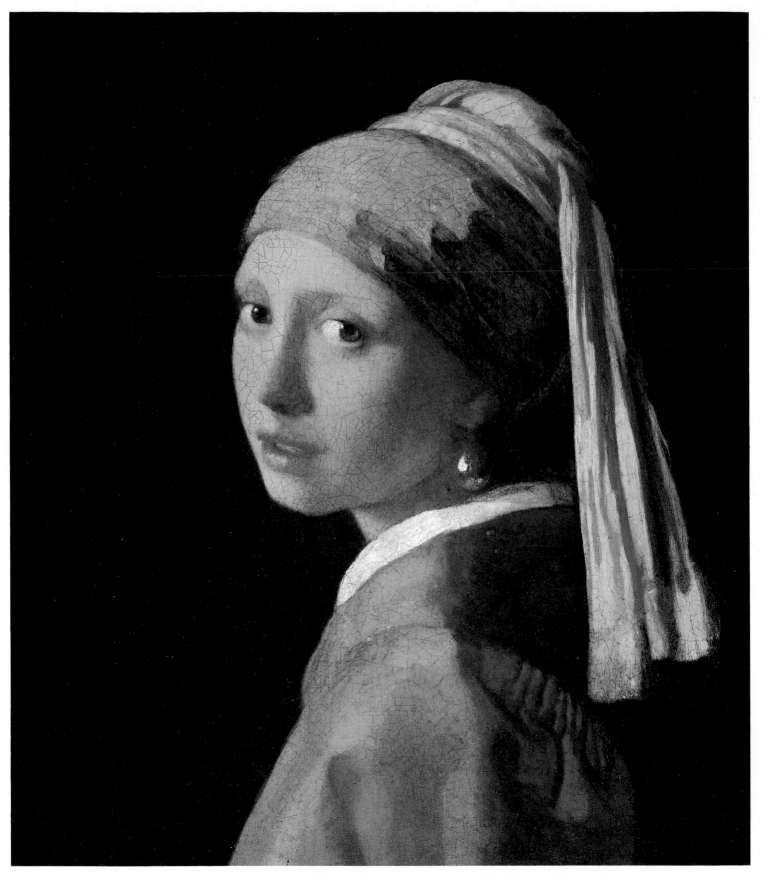

18. *Girl with a pearl Ear-ring.* About 1665. 46.5 × 40 cm. The Hague, Mauritshuis

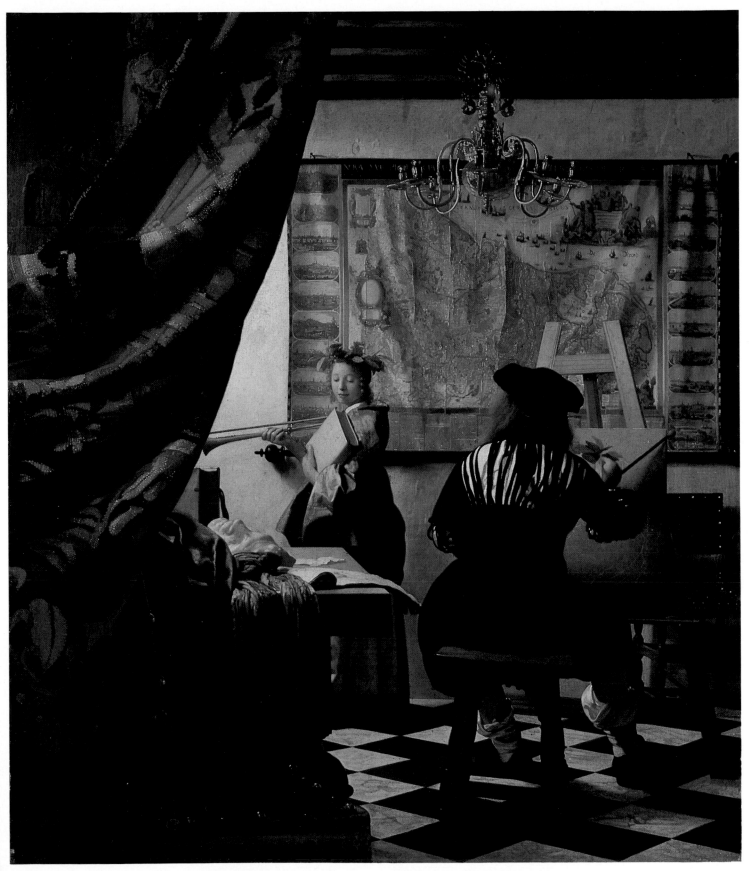

19. *The Art of Painting*. 1662–5. 130 × 110 cm. Vienna, Kunsthistorisches Museum

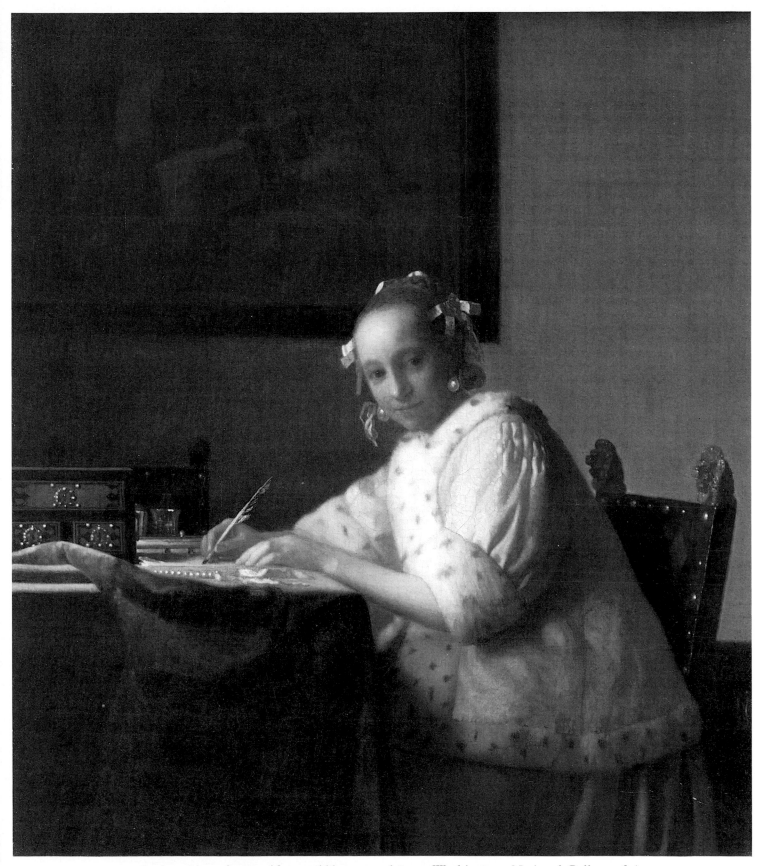

20. *Lady writing a Letter*. About 1666. 47 × 36.8 cm. Washington, National Gallery of Art

19a (*left*). Detail from *The Art of Painting* (PLATE 19)

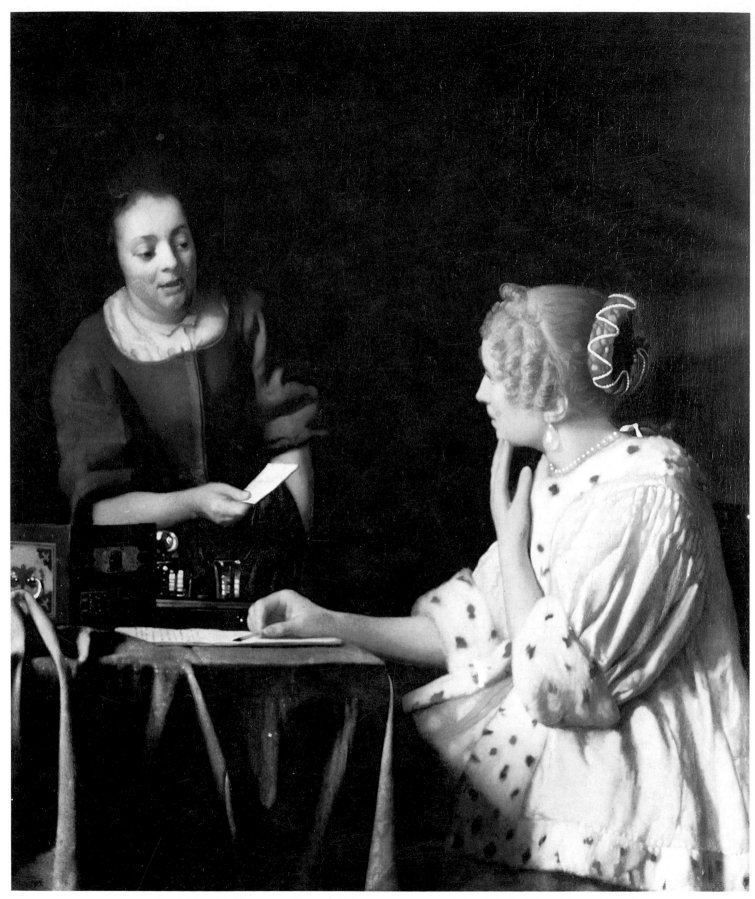

21. *Lady with her Maidservant*. About 1666. 92 × 78.7 cm. New York, The Frick Collection

20a (*right*). Detail from *Lady writing a Letter* (PLATE 20)

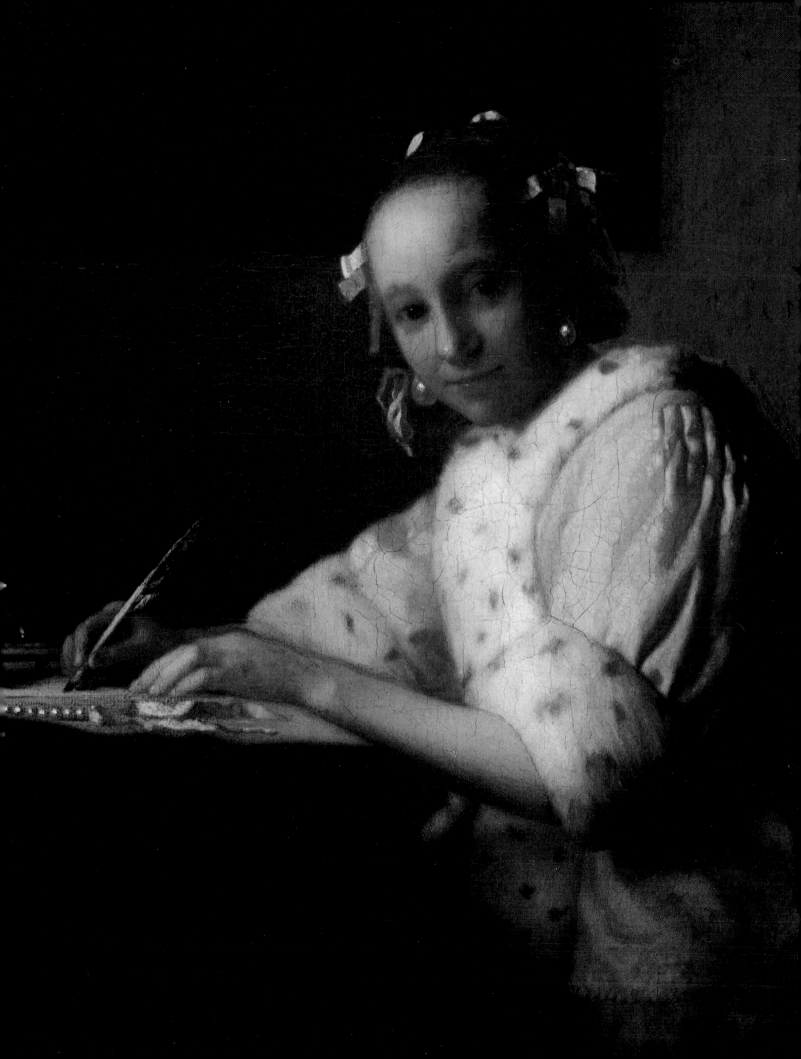

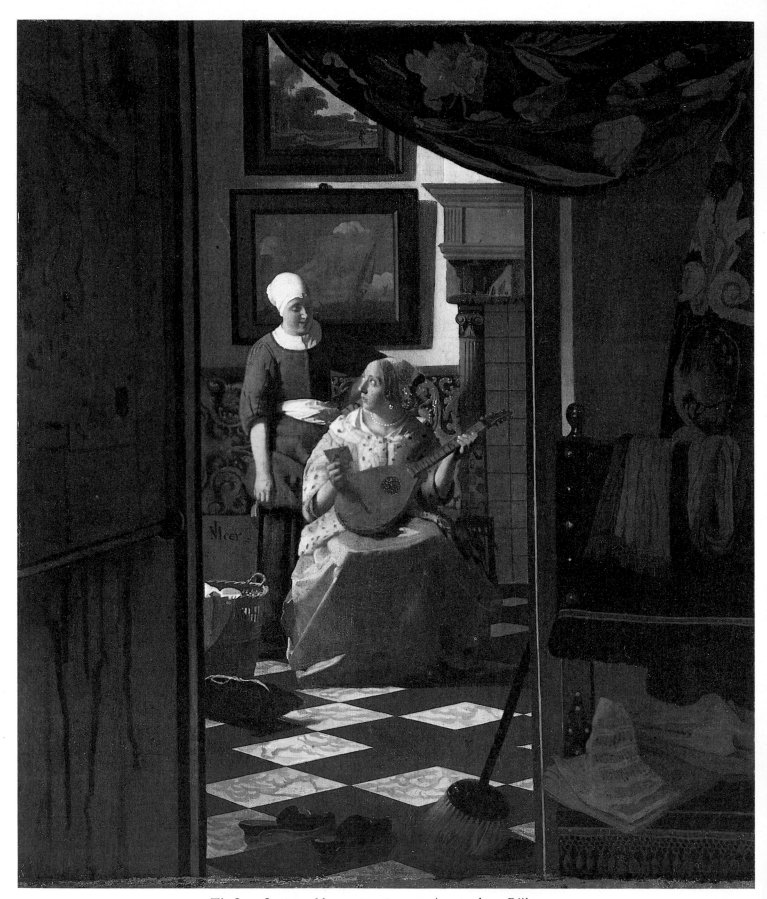

22. *The Love Letter.* 1667. 44 × 38.5 cm. Amsterdam, Rijksmuseum

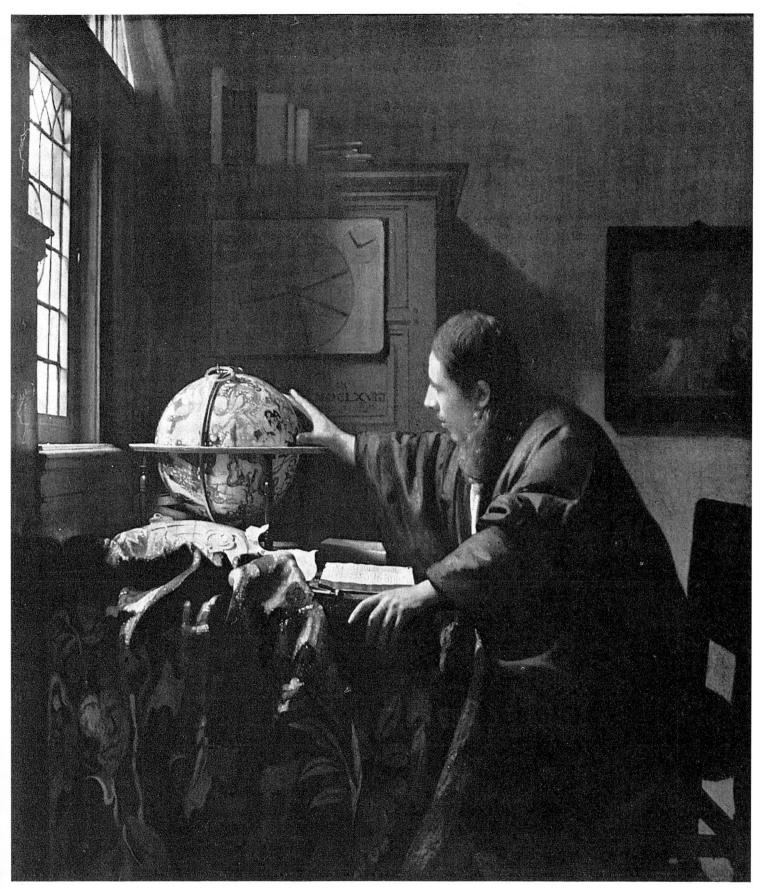

23. *The Astronomer*. 1668. 50 × 45 cm. Paris, Private Collection

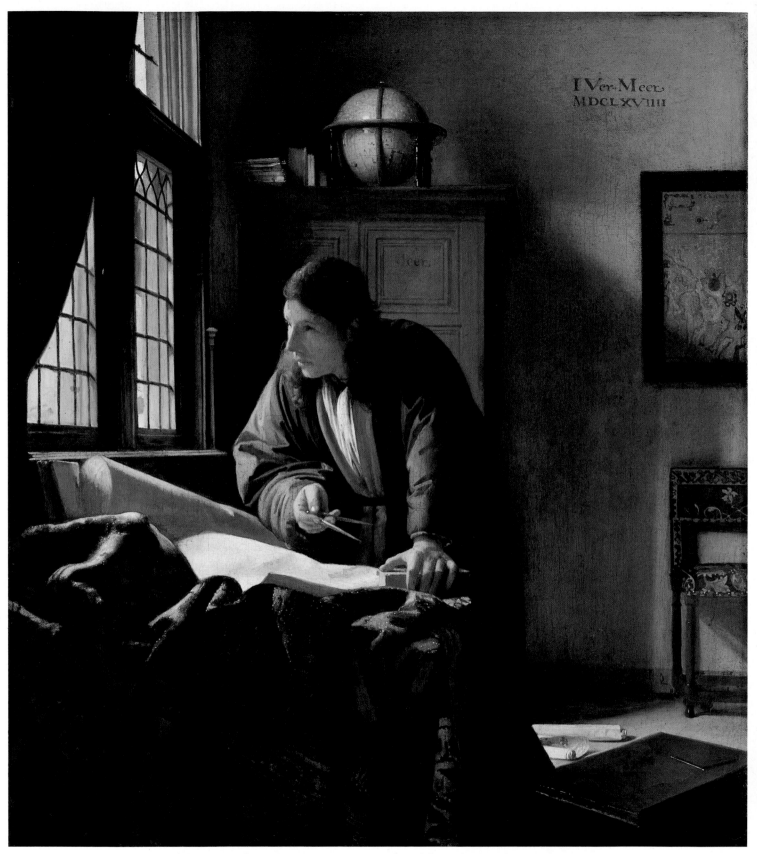

24. *The Geographer*. 1669. 53 × 46.6 cm. Frankfurt, Städelsches Kunstinstitut

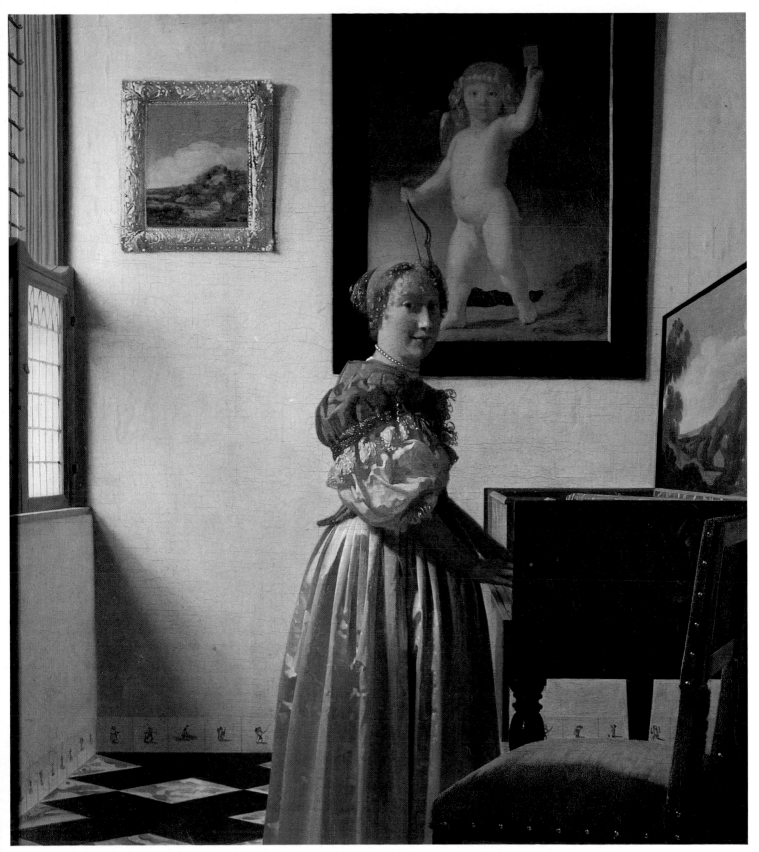

25. *Lady standing at a Virginal*. About 1670. 51.7 × 45.2 cm. London, National Gallery

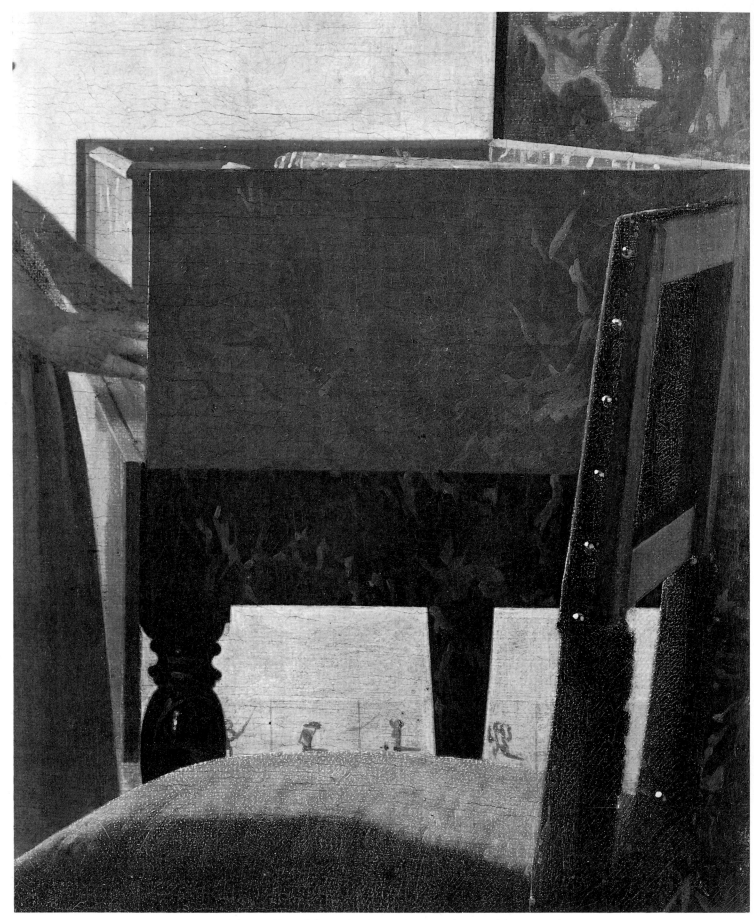

25a (*above*). Detail from *Lady standing at a Virginal* (PLATE 25)

24a (*right*). Detail from *The Geographer* (PLATE 24)

26. *The Lacemaker.* 1670–1. 24.5 × 21 cm. Paris, Louvre

27a (*right*). Detail from *Lady writing a Letter with her Maid* (PLATE 27)

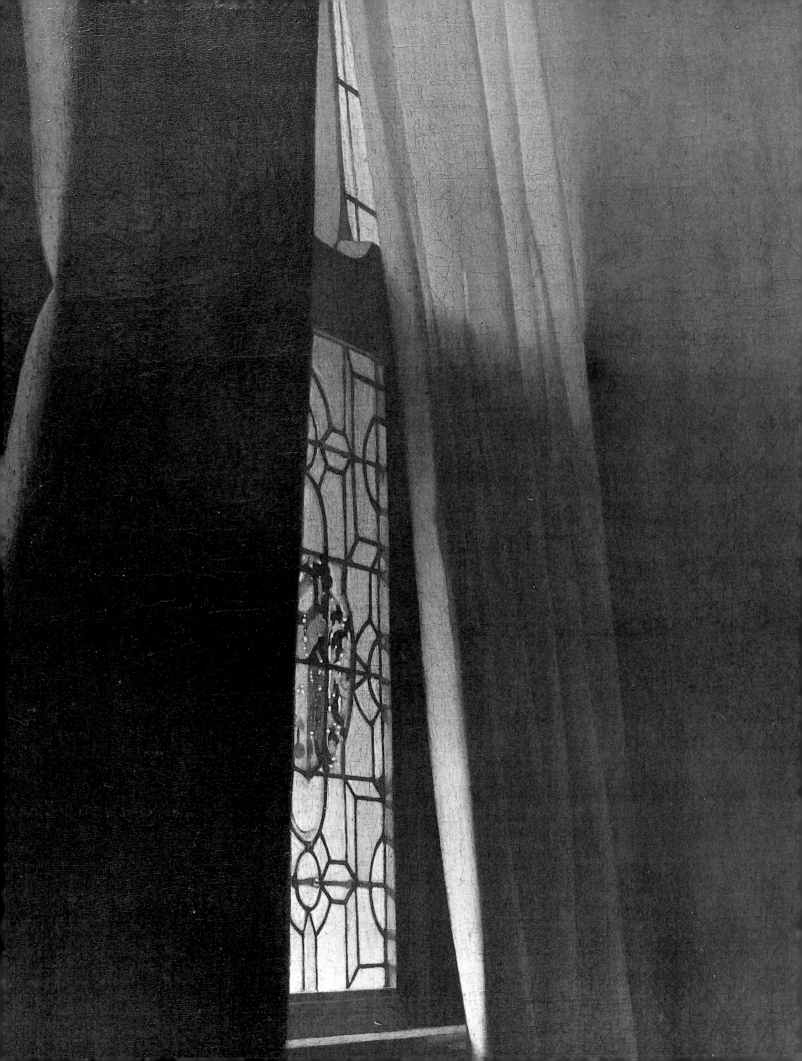

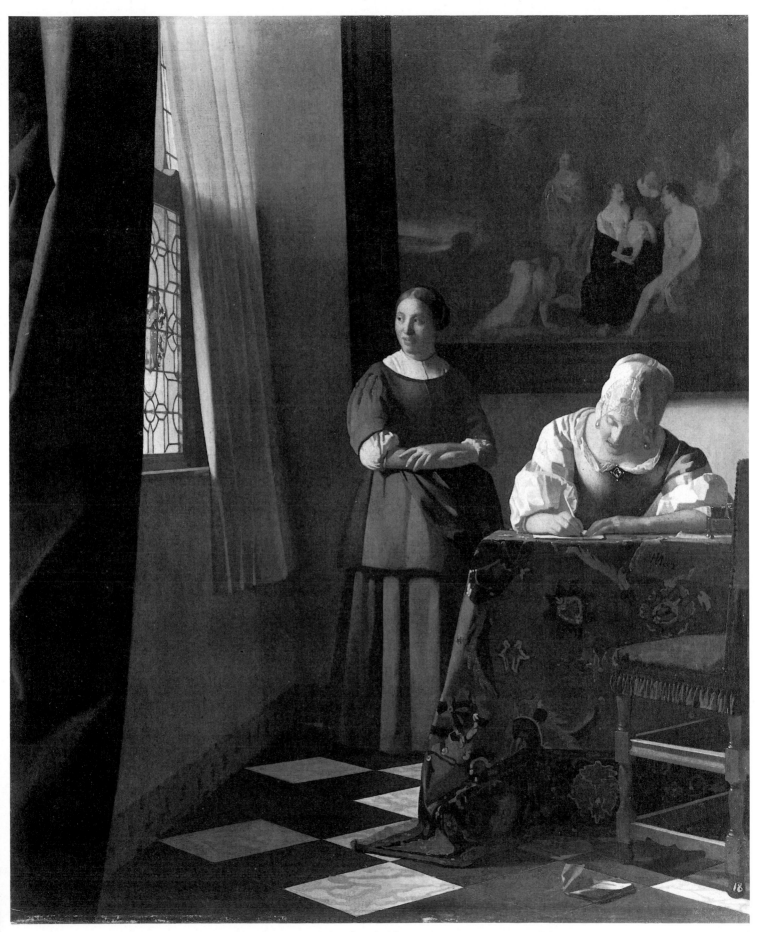

27 and 27b. *Lady writing a Letter with her Maid.* About 1671. 71 × 59 cm. Blessington, Ireland,
Sir Alfred Beit, Bt.

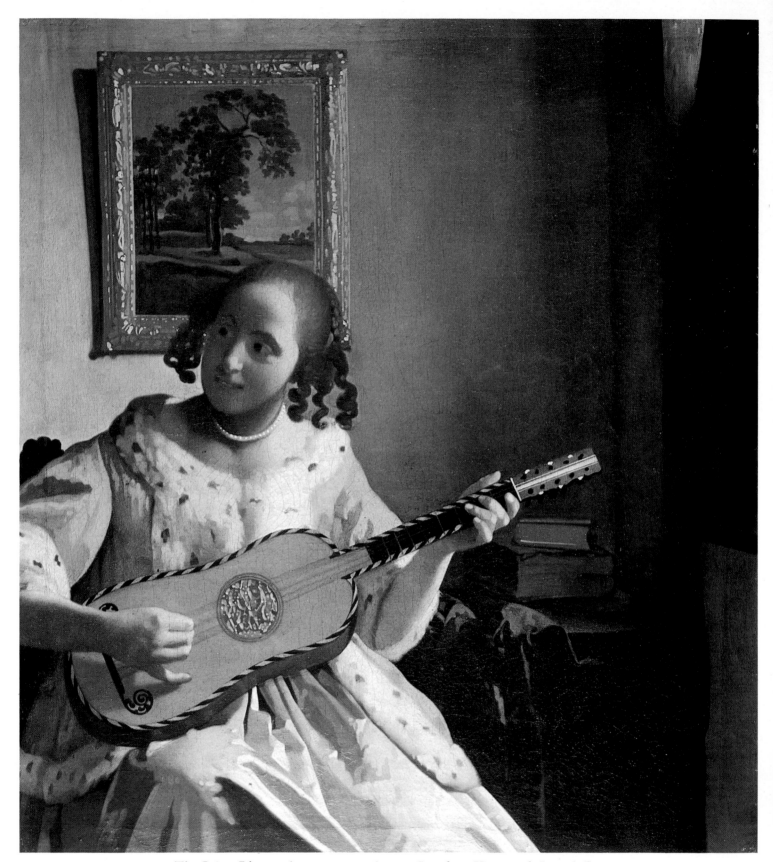

28. *The Guitar Player*. 1671–2. 53 × 46.3 cm. London, Kenwood, Iveagh Bequest

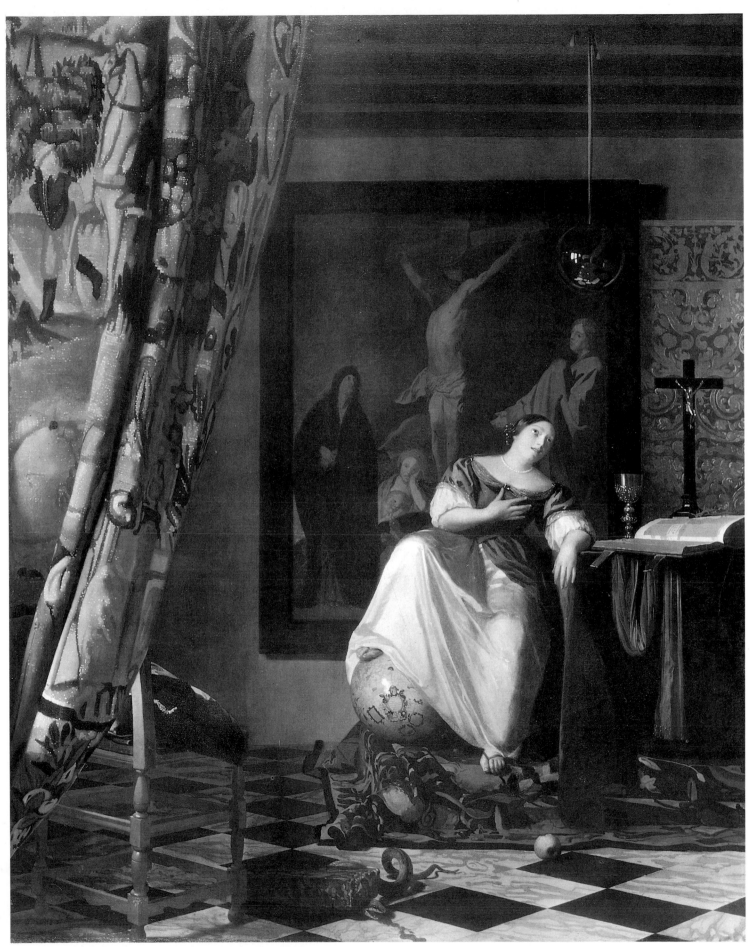

29. *Allegory of Faith*. 1672–4. 113 × 88 cm. New York, Metropolitan Museum

29a and b. Details from *Allegory of Faith* (PLATE 29)

30. *Head of a Girl.* 1672–4. 45 × 40 cm. New York, Private Collection

31. *Lady seated at a Virginal.* 1674–5. 51.5 × 45.5 cm. London, National Gallery

31a and b. Details from *Lady seated at a Virginal* (PLATE 31)

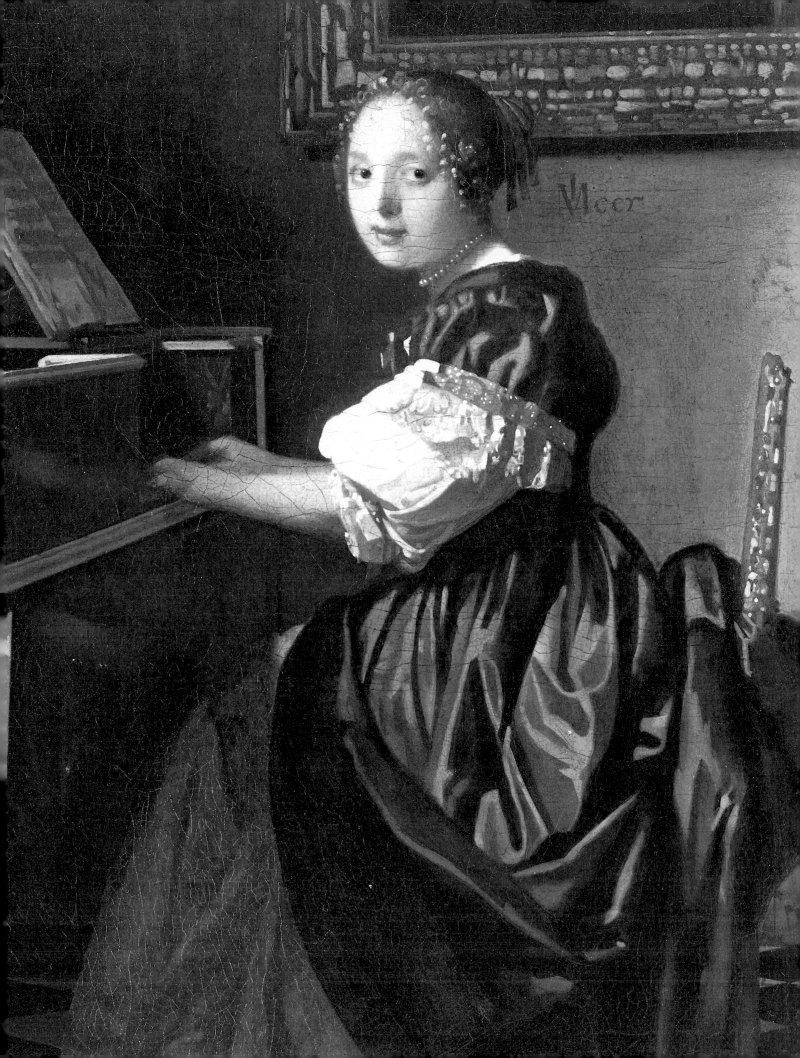

B1. *Woman playing a Lute near a Window.* 1662–5. 52 × 46 cm.
New York, Metropolitan Museum

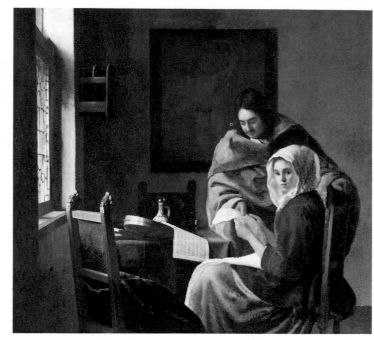

B2. *Girl interrupted at her Music.* 38.7 × 43.9 cm.
New York, The Frick Collection

B3. *Girl with a red Hat.* 23 × 18 cm.
Washington, National Gallery of Art

B4. *Girl with a Flute.* 20.2 × 18 cm.
Washington, National Gallery of Art

Included in chronological order are all the handwritten or printed texts, dating from before 1700, in which Vermeer himself, his work or his direct relations occur (this in so far as they have been published). A similar series of documents was published by Swillens in 1950; however, this was only a selection (*Swillens*, p. 181 ff.). Since then, van Peer has published a number of new archival finds in several periodicals. The documents discovered by Prof. J. M. Montias (see p. 8) have not yet been included in our list. New transcriptions of all archive documents are in preparation.

1. **1591**: From document 2 it appears that Reynier Jansz., who was to be the painter's father, was born in or around 1591 (*Van Peer 1959*, p. 240).

2. **27 June 1615**: Publication of the bans (betrothal) between Reynier Jansz., '*caffawercker*', twenty-four years of age, and Digna Baltasars from Antwerp, twenty years of age (Gemeentearchief Amsterdam, Register van Huwelijken; *Van Peer 1959*, p. 240). Johannes Vermeer was a child of this marriage.

3. **9 January 1622**: Reynier Cornelisz. Bolnes and Maria Thin, both from Gouda, marry before the Aldermen in Gouda (*Swillens*, p. 193). Catharina Bolnes, who was to be the wife of the painter, was a child of this marriage.

4. **26 July 1625 and 4 August 1625**: It appears from notarial acts of these dates (published by A. C. Boogaard-Bosch in the *Nieuwe Rotterdamse Courant*, 25 January 1939, evening edition, reprint in *Swillens*, pp. 181, 182) that Reinier Jansz. Vos (the father of the painter), together with two other men, wounded the soldier Willem van Bylandt in a brawl in the inn 'Mechelen'. While Reinier Vos was still a fugitive, '*Dingenom Baltasardr., huysvrouwe van Reynier Janszn. Vos*' ['Dingenom Baltasardr., housewife of Reynier Janszn. Vos'] and the mother of one of the two other perpetrators settled this matter by the payment of blood-money to van Bylandt.

5. **13 October 1631**: '*Den 13 October 1631 heeft Reijnier Vos off Reijnier van der Minne hem doen aenteijckenen als Mr Constvercoper, sijnde burger, sal betalen het recht 6 gulden*'. ['The 13th October 1631 Reijnier Vos or Reijnier van der Minne has himself registered as Master Art Dealer and being a burgher will pay the fee of 6 gulden.'] (From '*Register van alle de niewe meesters die sindt den jare 1613 int Childe syn gecomen*' ['Register of all new masters who entered the Guild since the year 1613']; *Obreen I*, p. 27). Reynier van der Minne must be identical with Reynier van der Meer (*Bouricius*, p. 272; *Van Peer 1959*, p. 241).

6. **31 October 1632**: '*Dito* [31 October 1632] '*t kint Joannis, vader Reynier Janssoon, moeder Dingnum Balthasars, getuijgen Pr. Brammer, Jan Heijndricxz., Maertge Jans.*' ['Ditto [31 October 1632] the child Joannis, father Reynier Janssoon, mother Dingnum Balthasars, witnesses Pr. Brammer, Jan Heijndricxz., Maertge Jans.'] (New Church, Baptismal Register no. 12, Delft, *Obreen IV*, p. 29.)

6a. **20 April 1641**: Jan Tin, brother of Maria Tin (the future mother-in-law of the painter) buys a house on the Oude Langedijk in Delft. For this he pays 2400 car. gulden (Delft, prot. not. C. P. Bleysweijck, no. 1914, fol. 120; *Van Peer 1968*, p. 223).

7. **27 November 1641**: About 1640 the marriage between Reinier Bolnes and Maria Tin came to an end. The divorce was not without problems, since furniture and paintings belonging to the Tin family as their family property were part of the estate. Johan, Maria's brother, and Cornelia, her sister, demanded these goods via a judgment of the court of aldermen. By order of the latter the goods were divided into three parts and then drawn by lot:

'*Lotingh van de onderschrevene Goederen toecomende Johan Thins voor tweederde part, Cornelia Thins en Reynier Bolnes voor een derde part nomine uxoris, gestelt in drie coten; welcke goederen onder Reynier Bolnes berustende zijn geweest.*' ['Apportionment of the goods mentioned below, two thirds earmarked for Johan Thins, and one third for Cornelia Thins and Reynier Bolnes in his wife's name, made up in three lots; which goods have been lodged with Reynier Bolnes.]

Het Lot A.
Een schilderij van een man die gevilt wort.
Een Homo Bulla.
Een trony van Dirck Cornsz. Hensbeek.
Een cipresse kist.
Dit lot is te beure gevallen Johan Thins.
Het Lot B.
Een schilderije van een die op een trompet speelt.
Een dito die op een fleuit speelt.
Een landscap van daer men in de hant kijckt.
Een kasgen.
Een sermoenboeck Hendr. Adriani.
Dit lot is te beure gevallen Reynier Bolnes.
Het Lot C.
Een schilderije van een die de borst suyght.
Een dito die de werelt beschreyt.
2 wapenkussens.
Dit lot is te beure gevallen Johan Thins.
Noch sijn bij denselven Reynier Bolnes overgeleverd deze navolchende goederen Johan Thins Willemszn. alleen toecomende.
Een schilderije van de winter daer men op schaetsen rijdt.
Een schilderije daer een coppelerste die in de hant wijst.
Actum ter Goude in presentie van Hendryck Cornsz. Camp ende Corns. Franszn. Rotteval, als arbiters bij de Heeren Schepenen tot dese lotinghe geëlegeerd, ter oirconde desen bij hen ondertekent, den 27 november 1641'

[Lot A.
A painting of a man being skinned.
A Homo Bulla.
A 'trony' of Dirck Cornsz. Hensbeek.
A cypress chest.
This lot fell to the share of Johan Thins.
Lot B.
A painting of someone playing on a trumpet.
A ditto of someone playing on a flute.
A landscape wherein someone looks in the hand.
A box.
A sermon-book of Hendr. Adrianus.
This lot fell to the share of Reynier Bolnes.
Lot C.
A painting of one who suckles the breast.
A ditto of one bewailing the world.
Two cushions with coats of arms.
This lot fell to the share of Johan Thins.
Furthermore the goods mentioned next, due solely to Johan Thins Willemszn., were delivered by the same Reynier Bolnes.
A scene of winter with people skating.
A painting of a procuress pointing in the hand.
Act made in Gouda in the presence of Hendryck Cornszn. Camp and Corns. Franszn. Rotteval, arbiters named for this drawing of lots by the Lords Aldermen, signed by them in witness to the above, 27 November 1641.'] (Municipal Archives, Gouda, Prot. not. Straffintveldt; *Van Peer 1968*, p. 221.). According to van Peer (1968) all these goods later were inherited by Maria Tin. The '*schilderije daer een coppelerste die in de hant wijst*'

['painting of a procuress pointing in the hand'] is undoubtedly the painting of that subject by D. van Baburen, 1622, which can be seen in the background of two paintings by Vermeer (Plate 22, see p. 27 and Plate 17). Likewise the '*schilderije van een die de borst suyght*' ['painting of one who suckles the breast'] must be the *Cimon and Pero*, hanging on the wall on another painting by Vermeer (see p. 162 and Plate 16). For the events in connection with the divorce see also *Swillens*, p. 193ff.

8. **12 August 1651**: '*Op huyden den 12 Augustus 1651 compareerde voor mij Andries Bogaert, openbaar notaris bij den Hove van Hollant geadmitteert, binnen de stad Delft residerende, ter presentie van de getuyghen onder genoemt, Reynier van der Meer, Anders genoemt Vos, herbergier wonende aan de noortsijde vant marcktvelt binnen de voorsz. stede, mij Notaris bekent, . . . enz.*' ['Today on the 12th of August 1651 appeared before me, Andries Bogaert, notary public admitted to the Court of Holland and residing in the town of Delft, in the presence of the witnesses mentioned below, Reynier van der Meer, alias Vos, innkeeper living on the northern side of the market place in said town, known to me, Notary . . . etc.'] (Prot. not. A. Bogaert, Delft; *Van Peer 1959*, p. 240). It appears from this fragment that Reynier Jansz. Vos (with which name the act is signed) is indeed identical with Reynier Vermeer, the father of Johannes Vermeer, as Bouricius observed earlier (*Bouricius*, p. 272).

9. **12 October 1652**: '*Reinier Jansz. Vermeer op 't Marctvelt*' is buried 12 October 1652 in the New Church in Delft (Burial book New Church, Municipal Archives Delft; *Van Peer 1959*, p. 240).

10. **5 April 1653**: At first Maria Tin refused to give her consent to the marriage of her daughter Catharina (Trijntgen) to Johannes Vermeer. Thereupon two friends of the couple accompanied by a notary paid a visit to Maria Tin in the evening of 4 April 1653; of this visit notary Ranck drew up an act in which he stated the next morning that: '*Op buijden den 5den april 1653 compareerde voor mij Johannes Ranck, openbaer notaris, bij den Hove van Hollant geadmitteert, binnen der stad Delft residerende, in presentie van de ondergeschreven getuijgen, Capiteyn Melling, out ontrent 59 jaeren, ende Leonart Bramer, schilder, out ontrent 58 jaeren, beyde burgers alhier, die verclaerden ende attesteerden ten versoucke van Jan Reijniersz ende Trijntgen Reijniers waerachtich te weesen, dat sij getuijgen neffens mijn, notaris, gisteren avont, sijnde den 4den deser, sijn geweest ten huijse aen ende bij de persoon van Joffrouwe Maria Tints, woonende alhier, als wanneer bij den voornoemden notaris Ranck in onser presentie is versocht off de voorseyde joffrouwe Tints (geadsisteert met Cornelia Tints, haer suster) gelieffde te teijcknen de acte van consent van het aenteyckenen van de huijwelijcks gebooden van haer joffrouwe Maria Tints dochter, genaemt Trijntgen Reijniers, met Jan Reyniersz, mede woonende alhier, beyden voornoemt, om deselve gebooden te doen vercondigen naer gebruijck deser stad; die wij alsdoen tot antwoort hebben hooren geven, niet van meninge was te teijckenen ende haer hant bekent te maken, maar wel mochte lijden dat de gebooden gingen ende hetselve soude aensien, ende tot verscheyde maelen seyde, dat sÿ die niet soude beletten off verhinderen. Wijders niet getuijgende, presenteerende tgeene voorseyt staet des noot ende versocht sijnde tselve met eede te confirmeeren, consenteren hiervan acte gemaeckt ende gelevert te werden omme te strecken ende dienen naer behooren. Aldus verleden ende gepasseert binnen der stad Delft in presentie van Gerrit Jansz van Oosten ende Willem de Lange, mede notaris alhier, als getuygen ten desen versocht ten dage voorseyt.*' ['Today 5th of April 1653 appeared before me Johannes Ranck, public notary, admitted to the Court of Holland, residing in the town of Delft, in the presence of the undersigned witnesses, Captain Melling, about 59 years of age, and Leonart Bramer, painter, about 58 years of age, both burghers in this town, who declared and attested at the request of Jan Reijniersz and Trijntgen Reijniers to the fact that they, witnesses, and I notary, were present yesterday night on the 4th of this month at the house and in the presence of Joffr. Maria Tints, living in this town, when the question was raised by the aforementioned notary Ranck in our presence whether the aforesaid joffr. Tints (assisted by Cornelia Tints, her sister) was prepared to sign the act of consent for the registration of the marriage vows between Joffr. Maria Tints's daughter, named Trijntge Reijniers, and Jan Reyniersz., also living here, both of them aforementioned, in order to make public these vows according to the custom of this town; whom we then heard give for an answer that she did not intend to sign and to put her signature to it, but would suffer the vows to be published and would tolerate it, and said several times that she would not prevent nor hinder those. Not testifying further, offering to confirm the foregoing by oath, if need be and if asked to do so, they consent to have a deed thereof drawn up and delivered in order to serve

as many befit. Thus passed and executed in the town of Delft in the presence of Gerrit Jansz van Oosten and Willem de Lange, also notary in this town, requested as witnesses in this instance on the aforesaid day. (signed) *B. Mellijng.* (signed) *W. de Langue.* (signed) *Leonart Bramer.* (signed) *Gerrijt IJansz van Oosten.* (signed) *Johannes Ranck, notaris. Anno 1653.*'] The betrothal indeed took place. In the '*Legger van de persoonen, die haer begaven in den H. echten staat binnen de Stadt Delff, begonnen metten jare 1650 ende eyndigende den lesten December 1656*' ['Register of the persons who entered the marital state in the Town of Delft, starting in the year 1650 and ending the last of December 1656'] this betrothal is mentioned as follows: '*Den 5en Apprill 1653: Johannes Reÿniersz. Vermeer, jongeman op 't Marctvelt. Catharina Bolenes jongedochter mede aldaer. [in margine:] Attestatie gegeven op Schipluij den 20en April 1653.*' ['The 5th April 1653: Johannes Reÿniersz. Vermeer, bachelor, living on the Marctvelt. Catharina Bolenes, spinster, also there.' [In the margin:] 'Attestation given in Schipluij 20 April 1653'.] (*Obreen IV*, p. 292; C. D. Goudappel, 'Ondertrouw en huwelijk van Jan Vermeer', in: *Delftse historische sprokkelingen*, Delft 1977, pp. 20–6.)

11. **29 December 1653**: '*Register van alle de nieuwe meesters en winckelhouders (behoorende onder Ste Lucas gilde) Tsedert den Jare 1650*': '*Schilder. Den 29 December 1653 Johannis Vermeer he(e)ft hem doen aanteijkenen als meester Schilder, sijnde burger en heeft op sijn meester geldt betaelt 1 gul. 10 stuyv. rest 4 gul. 10 st. Den 24 July 1656 is alles betaelt.*' ['Register of all the new masters and shopkeepers (belonging to the Guild of Saint Luke) since the Year 1650': 'Painter. On 29 December 1653 Johannis Vermeer had himself registered as Master Painter, being a burgher and paid one gulden 10 stuivers toward his master's-fee. 4 gulden 10 stuivers remain to be paid. On 24 July 1656 the total amount is paid'.] '*Meesters-bouck behoorende onder Ste Lucas gilde 1650–1714: 78. Johannes Vermeer.*' ['Johannes Vermeer is listed as no. 78, in the Masterbook of the Guild of Saint Luke.'] [*Obreen I*, p. 56, 45].

13. **14 December 1655**: '*Sr. Johannes Reyniersen Vosch Mr. Schilder ende Juffr. Catharina Bollenes, wonende binnen deze stadt, sijne huysvrouwe*' appear as witnesses. The name 'Vosch' was crossed out and 'Vermeer' inserted instead. (Prot. Not. G. Rota, Delft; *Van Peer 1959*, p. 241). According to Bredius it emerges from this act, which has never been published completely, that Reynier Jansz. Vermeer, father of the painter, had borrowed 250 gulden, which were never repaid. Johannes Vermeer and his wife appeared before the notary to declare themselves secondary guarantors for the repayment of the loan (*Bredius 1885*, p. 218).

14. **24 July 1656**: See document 11.

15. **30 November 1657**: '*Johannis Reyniersz Vermeer, schilder, ende Catharina Reyniers Bolnes, sijne huysvrou*', living in Delft, borrow 200 gulden from Pieter Claesz van Ruyven, at an interest of $4\frac{1}{2}$%. (Prot. not. J. van Ophoven, Delft; *Bredius 1885*, p. 218 and *Bredius 1910*, p. 61). Swillens erroneously states that this loan took place on 30 November 1655 and was recorded in the records of the Orphan Chamber in Delft (*Swillens*, p. 24).

16. **28 December 1658**: A house figuring in the estate of the widow Schilperoort is mentioned as: '*Staende aende Noortzijde van 't Marctvelt, belent ten Oosten de weduwe van Reynier Vos, alias van der Meer*' and as '*Belent Dingenum Balten, Wed. van Reynier Vos, genaemt "Mechelen"*' ['Situated on the Northern side of the Marctvelt, with the eastern side next to the widow of Reynier Vos, alias van der Meer' and as 'Contiguous with the house of Dingenum Balten, Widow of Reynier Vos, called "Mechelen".'] (Archives of the Orphan Chamber, Delft; *Swillens*, p. 25).

17. **28 January 1661** and **11 April 1661**: From the testament of Cornelia Tin, sister of Vermeer's mother-in-law Maria Tin: '*In den Name Godes Amen. In den jare ons Hr. dusent ses hondert een ende sestich de 14de Indictie op den 28 dach der maent January de clock ontrent zes uyren nae de middag compareerde etc. de eerbare Juffr. Cornelia Thins bejaerde dogter poortersse de stat Goude my Notario bekent, sieckelyck van lichaem op een stoel by de vier sittende nochtans haer verstant, rede ende memorie wel hebbende ende gebruyckende ende zoo uyterlyck blycken mochte, dewelck ten opsigte van de sekerheyt des doots ende onseckere uyre vandien zeide van meninge te zijn op de successie van heure tydelycke goederen testamentairlyck te disponeren. . . . Item, legateerde nog aan Maria Jans Vermeer mede dochtertje van dezelfde Catharina Bolnes een woning met omtrent tien en een halve morgen land, liggend in Bonrepas omtrent Schoonhoven, zijnde leen en te leen*

gehouden van de Grafelijkheid van Holland en West-Friesland.' ['In the Name of God Amen. In the year of our Lord 1661 the 14th Indiction on the 28th of the month of January at about 6 o'clock in the afternoon appeared etc. the honourable Juffr. Cornelia Thins, of age, burgher of the town of Gouda and known to me, Notary, sick in body and sitting on a chair near the fire, nevertheless in the possession of, and using her reason, mind and memory, as much as may be clearly discernible, who, in view of the certainty of death and the uncertainty of its time, stated to be intent on disposing by testament of the succession of her worldly goods. . . . Similarly [she], bequeathed to Maria Jans Vermeer, also daughter of the same Catharina Bolnes, a house with approximately 10½ 'morgen' of land, situated in Bonrepas in the neighbourhood of Schoonhoven, being a fief and kept as a fief from the Earldom of Holland and West-Frisia.'] (Prot. not. Straffintvelt, Gouda).

Maria Jans Vermeer was the eldest daughter of the painter. For obscure reasons however, Bon Repas is transferred some days later (**1 February 1661**) to Catharina Bolnes, wife of Vermeer, *'zonder dat Maria Jans Vermeer daeraen eenig prerogatieve ofte voordeel sal genieten'*. ['without Maria Jans Vermeer enjoying any prerogative or advantage therefrom'] The Repertorium op de Lenen (State Archives, The Hague, no. 227) mentions that the property came *'aan Catharina Bolnes, oud 30 jaar, bij dood ende makinge van Cornelia Thin'* ['to Catharina Bolnes, aged 30 years at the death and by the testament of Cornelia Thin'] on 11 April 1661. Furthermore the Register op de Lenen mentions: *'Ende voor de voorn. Catharina Bolnes heeft hierin ons hulde, eed ende manscap gedaen de voorn. Joh. Vermeer haer man ende voogt in handen van onse lieve ende getrouwe Raadspensionaris Johan de Witt als stadhouder ende registermeester van onze lenen.'* ['And in place of the aforementioned Catharina Bolnes the aforementioned Johannes Vermeer, her husband and guardian, has done us homage, oath and fidelity, in the hands of our dear and faithful Grand Pensionary Johan de Witt as Stadholder and master of the register of our loans'.] (After *Van Peer 1951*, pp. 618, 619).

18. 10 December 1661 and 4 January 1662: *'Compareerde Johannes Vermeer Mr. Schilder alhier ende constitueerde hem selve cautionaris voor Clement van Sorgen ter somme van acht en tseventich gul. die Phil[i]ps van der Bilt tot laste van hem Van Sorgen is pretendeerende ende waevooren denselven Van der Bilt twee japponse rocken hem Van Sorgen toebehoorende onder sich is behoudende geweest ende die ter ordonnantie van de Heeren Schepenen op het Stadhuys alhier gebracht heeft omme onder beneficie van dese cautie deselve rocken by hem Van Sorgen gelicht ende naar hem genomen te werden, beloovende deselve somme met de rechtelijke costen daer omme te doen onder renunciatie van de beneficie ordinis sive excussionis, van den effecte van dien wesende onderricht, te sullen betalen ende voldoen in cas sulcx in tyt en wijlen souden mogen werden te verstaan te behooren, onder verbant als naar rechten. Gedaan den 10 December 1661.*
(In margine:) Compareerde ter Secretarie der Stadt Delft Philips van der Bilt ende verclaerde Joannes Vermeer van de nevenstaende gedeponeerde borgtochte te ontslaen. Gedaan den 4 Januarij 1662.' ['Appeared Johannes Vermeer Master Painter in this town and constituted himself guarantor for Clemens van Sorgen for the sum of 78 gulden, claimed by Phil[i]ps van der Bilt from the said Van Sorgen and for which the same Van der Bilt has been keeping two Japanese robes belonging to him, Van Sorgen, which robes Van der Bilt has brought to the Town Hall in this town, on the order of the Lords Aldermen, so that they might be picked up and taken by him Van Sorgen, under benefit of this guaranty, [he Vermeer] promising to pay and settle the said sum together with the pertinent legal costs, renouncing the beneficium ordinis sive excussionis (guarantor's right to compel the creditor who has sued him before the principal, to sue the principal first; see Adolf Berger, *Encyclopedic Dictionary of Roman Law*, Philadelphia 1953, p. 373), acquainted with the consequences thereof to be done in case this would be necessary, in accordance with common law. Done the 10th of December 1661.
(In the margin): Appeared before the Secretary of the Town of Delft Philips van der Bilt and pronounced Joannes Vermeer discharged of the adjoining deposited guaranty. Done 4 January 1662.'] (Reg. der Acten van Cautien voor Schepenen van Delft f. 74; *Obreen IV*, p. 293, 294).

19. 1662: *'Regerende Hooftmans deses Jaers waren Cornelis de Man Arent van Sanen, Aelbrecht Keijser, Johannes Vermeer, Jan Dirckse van der Laen, Ghijsbrecht Kruijck'*. *(Register van alle de nieuwe meesters en winckelhouders behoorende onder Ste Lucas Gilde)* ['Acting Headmen for this Year were Cornelis de Man, etc.' (Register of all the new masters and shopkeepers belonging to the Guild of St Luke)] *Obreen I*, p. 68.

20. 1663: *'De regerende Hooftluijden deses jaers waren Joannes Vermeer, Arent van Saenen, Gijsbrecht Cruick, Anthonij Pallemedes, Frans Janse van der Fijn, Jan Gerritse van de Houven'. (Register van alle de nieuwe meesters en winckelhouders behoorende onder Ste Lucas Gilde)* ['Acting Headmen for this year were Joannes Vermeer, etc.'] *Obreen I*, p. 69.

21. August 1663: *'A Delphes ie vis le Peintre Vermer qui n'avoit point de ses ouvrages: mais nous en vismes un chez un Boulanger qu'on avoit payé six cens livres, quoyqu'il n'y eust qu'une figure, que i'aurois creu trop payer de six pistoles.'* ['In Delft I saw the Painter Vermeer who did not have any of his works: but we did see one at a baker's, for which six hundred livres had been paid, although it contained but a single figure, for which six pistoles would have been too high a price in my opinion'] (*Journal de voyages de Monsieur De Monconys*, II, Lyon, 1666, p. 149). For De Monconys's visit to Delft see also *Neurdenberg 1951*.

21a. 4 August 1664: *'Een tronie van Vermeer'*, estimated at 10 gulden, figures in the inventory of the estate of Jean Larson, sculptor in The Hague (see p. 171 cat. no. 32).

21b. 13 January 1665: From an act of 25 November 1676, published by Obreen (document 46), it emerges that on 13 January 1665 Maria Tin was appointed guardian of the estate of her son Willem Bolnes (*Obreen IV*, p. 296).

22. 1667: *'Ende gelijck tot hier toe d'afgestorvenen naer ordre en vervolgens den tijdt haeres overlyden, zijn gerangeert, soo sullen wy eenige resterende konstenaren, die, als ick dit schreef, noch in leven waeren, na haer ouderdom van Jaeren hares geboorte noemen, als daer zijn, Leonard Bramer, geboren op Kermis-avond 1596. Pieter van Asch, geboren Anno 1603. Adriano van Linschoten, geboren in den Jaere 1607, of acht. Hans Jordaens, in Maert 1616. Cornelio de Man, den 1 July 1621. Johannes Vermeer, 1632. en anderen meer, behalven noch die geene die hier boven by haer Vrinden zijn genoemt, en te dier occasie alberyts oock eeniger mate beschreven. En van deze, sich in de konst dagelijcx noch oeffenende, practiserende en in haer studie meer en meer geluckig toenemende, soude men met Jesus Siracch mogen seggen: Hun wercken sullen in der Konstenaren hand | Altyd gepresen zyn van 't eene in 't ander Land.'* ['And in the same way as we just listed the deceased in order of the time of their death, we will now list a few other artists, who were still alive when I wrote this, according to their age, viz.: Leonard Bramer, born on Kermis-night 1596. Pieter van Asch, born Anno 1603. Adriano van Linschoten, born in the Year 1607 or eight. Hans Jordaens, in March 1616. Cornelio de Man, the first of July 1621. Johannes Vermeer, 1632, and others, apart from those mentioned above along with their Friends, already described in some measure on that occasion and of those who are still training and practising their art daily and advance more and more happily in their studies, one could say with Jesus Sirach: "Their works in the Artist's hand | will Always be praised from land to Land." '] (D. van Bleyswyck, *Beschryvinge der Stadt Delft*, printed by Arnold Bon, Boeckverkooper, op 't Marct-velt, Delft 1667, p. 859, with reference to 'I. Sirach.9.21' in the margin).

In Bleyswyck's book there is also a poem in eight stanzas by Arnold Bon, who also printed the book, *'Op de droevige, en ongelukkigste Doot van den aldervermaarsten, en konstryckstem schilder. CAREL FABRICIUS.'* ['On the sad and most miserable Death of the most famous and most artful painter, CAREL FABRICIUS'.] Seven stanzas are printed on p. 853, the eighth stanza is printed on p. 854. The Royal Library (KB) in The Hague owns three copies of Bleyswyck's *Beschryvinge . . .*; in these three copies the title-page, the page with 'errata', and the first seven stanzas of the poem are all identical. When applying the 'ruler method' all three copies appear to be of one setting matter (for this method see R. B. McKerrow, *An Introduction to Bibliography*, Oxford 1927, p. 183). There are two versions, however, of the eighth stanza of the poem on p. 854: the first and last line differ.
KB no. 3113 D 24 and no. 553. J 41:

'Soo doov' dan desen Phenix t'onser schade
In 't midden, en in 't beste van zyn swier,
Maar weer gelukkig rees' er uyt zyn vier
VERMEER, *die meesterlyck betrad zyn pade'*

[Thus expired this Phoenix to our loss
In the midst and in the best of his powers,
But happily there rose from his fire
VERMEER, who, masterlike, trod his path.]

KB no. 2000 Fl. 2:

'Dus bleev' dien Phenix op zyn dertig jaren
In 't midden, en in 't beste van zyn swier,
Maar weer gelukkig rees' er uyt zyn vier
VERMEER, *die 't meesterlyck hem na kost klaren'*

[Thus died this Phoenix when he was thirty years of age,
In the midst and in the best of his powers,
But happily there rose from his fire
VERMEER, who, masterlike, was able to emulate him.]

Mr C. de Wolf, of the department of early printed works of the Dutch Royal Library, told me that the first version must be the earlier one and the second the corrected one. In the seventeenth century the first word of the next page was printed at the bottom of the preceding one (the 'catchword'). In all three copies the catchword on p. 853 is the word '*Soo*', that is to say the first word of the first-mentioned version of the stanza, beginning on p. 854. Some more differences between the three copies are: At the back of KB 3113 D24 a theatrical work '*Delftsche Broertgens-Kermis*' is included; there are more portrait prints; and the entire work is bound in one volume, whereas the two other copies are bound in two volumes. The version in which '*jaren*' rhymes with '*klaren*' appears also in a copy bound in two volumes, in the Widener Library of Harvard University, Cambridge, Mass. (A.Bl.).

22a. **3 March 1667**: Vermeer acts as witness at the appointment of Jan van der Wielen, as executor of the will of Jannetje van Buyten, the sister of the baker Hendrick van Buyten (cf. document 37). (Delft, prot. not. C. P. van Bleyswyck; *Van Peer 1957*, p. 95).

23. **10 July 1667 and 16 July 1669**: Burial dates of two children of Vermeer. See document 36.

23a. **27 September 1667**: On this date Maria Tins, Vermeer's mother-in-law, makes a testament in which she leaves five sixths of her goods to her daughter, Catharina Bolnes, the wife of the painter, and one sixth to her son Willem Bolnes. She justifies this division by referring to the misbehaviour of her son Willem (Delft, prot. not. Frans Boogert, no. 2006; cf. *Van Peer 1957*, p. 98).

24. **1670**: '*De Hooftmans waren Louijs Elsevier, Michiel van den Houck, Gijsbrecht Kruijck, Joannes Vermeer, Jasper Serrot, Jacob Kerton op den 28 October An.º 1670*' (*Register van alle de nieuwe meesters en winckelhouders behoorende onder Ste Lucas Gilde; Obreen I*, p. 76).

25. **13 February 1670**: '*Begraven in de Nieuwe Kerk 13 Februarij 1670 Dyna Baltens, weduwe van Reynier Vermeer in de Vlamingstraet*'. ['Buried in the New Church 13 February 1670 Dyna Baltens, widow of Reynier Vermeer, in the Vlamingstraet'].(*Register der doden te Delft*, Part VIII; *Obreen IV*, p. 291). Dyna Baltens was Johannes Vermeer's mother.

26. **13 July 1670**: After the death of Johannes Vermeer's parents (see documents 9 and 25) notary Frans Boogert drew up the act of division of the parental estate on 13 July 1670. In his draft, which was later to serve as minutes, he first cited 'Johannes van der Meer' as first attestant. He then crossed out 'Van der Meer' and wrote above it 'Vermeer.' (In this connection compare document 13). According to this division of the estate, the parental home 'Mechelen' was allotted to Johannes Vermeer, with the approval of his brother-in-law Anthonie van der Wiel (After *Bouricius*, p. 271).

27. **1671**: '*De regerende Hooftmans waren: Joannes Vermeer, Jasper Serrot, Jacob Corton, Cornelis de Man, Cijbrant van der Laen, Claes Jansz. Metschert*'. (*Register van alle de nieuwe maesters en winckelhouders behoorende onder Ste Lucas Gilde; Obreen I*, p. 78).

28. **18 July 1671**: According to an act of 18 July 1671 (prot. not. G. van Assendelft, Delft), published by Bredius in part only, Johannes Vermeer, painter in Delft, acknowledges having received his part of the estate of Geertruijt Vermeer, his late sister, with the exception of 648 gulden, which sum is still due to him as the remaining portion of the estate, from his brother-in-law Anthony van der Wiell. He also settled with the latter all matters pertaining to the estate of Dina Baltens, their late mother and mother-in-law. Johannes Vermeer assumed all debts and charges of the said estate. He will have the right to collect the debts, due to the estate, to his own profit (*Bredius 1885*, p. 218).

29. **14 January 1672**: According to a deed of 14 January 1672 (prot. not. F. Boogert, Delft), published by Bredius in part only, Johannes Vermeer rented his house 'Mechelen', situated on the north side of the Marktveld on the south-western corner of the Oudemanhuissteegje, to Johannes van der Meer, for the duration of six years, starting 1 May forthcoming for 180 gulden per annum (*Bredius 1910*, p. 62).

30. **23 May 1672**: '*Op huyden den 23 Mey 1672 compareerden voor mij Pieter van Swieten, Openb. Notaris ... d'Heeren Johannes Jordaen ende Johannes Vermeer uytmuntende Kunstschilders tot Delft en verclaerden sy deposanten te saemen ter instantie van Sr. Hendrick de Formanteau voor de oprechte waerheyt getuycht, verclaert en gedeposeert waer te syn dat sy deposanten op haere Confrery Camer alhier op dato gesien en gevisiteert hebben 12 stucks Schilderiën d'welcke op de lijste ofte cathalogus die de requirant hen deposanten heeft geëxhibeert, gestelt ende genaemt staen voor uytmuntende Italiaense schilderiën, mitsgaders getaxeert soodanigh als achter yeder stuck uytgetrocken Staet, namentlyck:*

	Ryxdaelders
een Venus en Cupido, beelden grooter als het leven van Michiel Angelo Bonarotti, Hollants gelt	350 : 320
een Conterfeytsel van Giorgion del Castelfrancko van Titiaen, naer het leven geschildert	250 : 240
een harder ende harderinnetje van Titiaen	160 : 150
Weergadingh van deselve groote van Titiaen	120 : 110
een dans van naeckte Kindertjens levensgroote van Iacomo Palma	250 : 240
een Venetiaense Dame van Paris Pordinon	160 : 150
een Conterfeytsel van een Prelaet van Hans Holbeen	120 : 110
een Ceres met overvloet, met veele naeckte Kindertjes van Giorgion del Castel Franco	120 : 110
een out mans confeytsel van Raphael Urbin	150 : 140
een St. Paulus, halfbeelt, levensgroote, van de Oude Jacomo Palma	80 : 70
een Schoone Venetiaense vrouw van Titiaen	200 : 185
een lantschap van Titiaen met een Satier die de nimphe Caresseert	240 : 230

sijnde de voorsz. Schilderien gecachetteert met het signet van syne Ceurvorstelycke Doorluchticheyt Van Brandenburch, welcke Schilderiën niet alleen niet en syn uytmuntende Italiaense Schilderiën, maer ter contrarie eenige groote vodden ende slechte schilderiën, die op verre nae de tiende part van de voorsz. uytgetrocke prysen niet weerdich en sijn, ende sy deposanten die niet en connen estimeren, dewijle deselve niet geacht en konnen werden.

Eyndigende enz., Johannes Jordaen, Joannes Vermeer.'

['Today 23 May 1672 appeared before me Pieter van Swieten, Public Notary ... Messrs Johannes Jordaen and Johannes Vermeer, excellent Painters in Delft and they, attestants, declared together, at the request of Sr. Hendrick de Fromanteau, and in all truth testified, stated and averred to be true, that they, deponents, saw and examined here, at this date in the Guildhall, 12 items of Painting, which were described and named as outstanding Italian paintings in the list or catalogue shown to them, deponents, by the petitioner, as well as appraised as stated after each painting, viz.:

a Venus and Cupid, figures larger than life-size, by Michiel Angelo Bonarotti, Dutch currency

a Portrait of Giorgion del Castel-Francko by Titiaen, from life

a shepherd and shepherdess by Titiaen

Pendant of the same size by Titiaen

a dance of naked Children life-size by Iacomo Palma

a Venetian Lady by Paris Pordinon

a Portrait of a Prelate by Hans Holbeen

a Ceres with abundance, with many naked Children by Giorgion del Castel Franco

a portrait of an old man by Raphael Urbin

a St Paul, half-length, life-size, by the Old Jacomo Palma

a Beautiful Venetian woman by Titiaen

a landscape by Titiaen with a Satyr Caressing the nymph

being the aforementioned Paintings sealed with the signet of his Serene Highness the Elector of Brandenburch, which Paintings are not only no outstanding Italian Paintings, but, on the contrary, great pieces of rubbish and bad paintings, not worth the tenth part of the aforementioned proposed prices by far, which they, the deponents, cannot estimate, since the items have no value to speak of.

Ending etc. Johannes Jordaen, Joannes Vermeer'.]

(*Bredius 1916*, pp. 89–91). For other documents concerning this matter see: A. Bredius, 'Italiaansche schilderijen in 1672, door Amsterdamsche en Haagsche schilders beoordeeld', in *Oud-Holland* 4, 1886, pp. 41–6; 278–80.

31. **27 June 1673:** One of Vermeer's children was buried. See document 36.

32. **21 July 1673 and 25 January 1674:** '*25 januari 1674. Sr. Hendrick de Schepper wonende binnen Amsterdam, transport hebbende van Johannes Vermeer, Schilder tot Delft, (zijnde dit transport gepass[d] te Amsterdam voor Not. Outgers 21 juli 1673) verklaart te hebben verkocht aan . . . [not filled out]: 2 Obligatiën ten laste van 't gemeene lant van Hollandt en Westvriesland, een van f. 300 en een van f. 500 samen f. 800, die hij bekent ontvangen te hebben.*' ['Sr. Hendrick de Schepper living in Amsterdam, having an act of transfer of Johannes Vermeer, Painter in Delft (this transfer having been passed in Amsterdam before Notary Outgers 21 July 1673) declares having sold to . . .: 2 debentures chargeable to the common land of Holland and West-Frisia, one to the amount of 300 gulden and one of 500 gulden, together 800 gulden, which he declares having received.'] (Prot. not. A. Lock, Amsterdam; *Bredius 1910*, p. 62).

33. **18 January 1674:** '*Joannes Vermeer . . . Konstrijck schilder*' ['Joannes Vermeer . . . Artful painter'] acts as witness (Archives Delft, Not. no. 1913, fol. 130 sqq.; not. C. P. Bleyswyck). Kind communication of K. Wilkie.

34. **5 March 1675:** '*Op huijden den 5en Maart 1675 compareerden voor myn Cornelis Pietersz Bleiswyck, Not[s] publ. by den Ed. Hove van Hollandt binnen Delff, de eerbare Jouff Maria Tins, Wed[e] van za. Sr Reynier Bollenes, moeder ende voochdesse van haren zoon Willem Bollenes, en heeft . . . machtich gemaeckt den E. Johannes Vermeer, haren Swager, Constryck Schilder, special. omme uyt haren naem hem te vervangen: eerst in den boedel van za. Henrick Hensbeeck, overleden binnen de stadt Gouda, (om tot scheiding enz. te procederen en de Willem Bolnes toekomende penningen te innen) en tevens omme te ontfangen en uytgeeff te doen vant jaerlicx incommen weegen haren zoon Willem Bollenes, omme daerinne te handelen doen, dezelve administreren, als een goet administrateur gehouden is te doen, dat sy comparante haren Swager ten vollen is toevertrouwende. Enz.*' ['Today the 5th of March 1675 appeared before me Cornelis Pietersz Bleiswyck, Notary public to the Hon. Court of Holland in Delft, the honourable Jouffr. Maria Tins, Widow of the late Sr. Reynier Bollenes, mother and guardian of her son Willem Bollenes, and has authorized the honourable Johannes Vermeer, her son-in-law, Artful Painter, especially for the purpose of replacing her: first in the affair of the estate of the late Henrick Hensbeeck, deceased in the town of Gouda (to proceed to the division of the estate etc. and to collect the money due to Willem Bolnes) and also to receive the yearly income of her son Willem Bollenes, and make payments with it, to do business with it, to administer it, as a good administrator should do, that she attestant fully entrusts to her son-in-law. Etc. (signed) Marya Thins. (Pieter Roemer, master glass-painter, is witness).'] (Prot. not. J. van Bleyswyck, Delft; *Bredius 1885*, p. 218). Willem Bolnes lived with his mother, Maria Tin, in Delft, together with his sister Catharina Bolnes and his brother-in-law Johannes Vermeer, until he was put in one of the reformatories of the town. (*Van Peer 1957*, p. 98).

35. **July 1675:** According to an act drawn up by notary J. Hillerus in Amsterdam, published by Bredius in part only, Johannes Vermeer borrowed 1000 gulden in July 1675. On 2 April 1678 Maria Tin, Vermeer's mother-in-law, promises to pay this debt ('*uit haar gereedste penningen*', 'from her ready money') to the housewife of Jacob Rombouts, Johanna Kieft, in so far as this debt should not yet have been paid entirely at her, Maria Tin's, death; she would, however, not pay the accumulated interest. (*Bredius 1910*, p. 64).

36. **15 December 1675:** From the register of the '*Personen die binnen deser Stad Delff overleden ende in de Oude Kerck als oock daer buijten begraven sijn tsedert den 19 Julij 1671*' ['Persons who have died in this Town of Delft and who are buried in the Old Church as well as outside of it, since 19 July 1671.']:

15 December 1675 '*Jan Vermeer kunstschilder aen de Oude Langedijk in de kerk. [In the margin:] 8 Me: J. kind*' ['Jan Vermeer painter on the Oude Langendijk, in the church. 8 children under age.'] (*Obreen IV*, p. 294.) The body of Johannes Vermeer was laid in the grave that his mother-in-law Maria Tin had bought on 10 December 1661.

'*10 julij 1667 is in dit graf geleijt een baerkint van Johan Vermeer, uijtgesondert dat baerkint is het graff ledigh.*
Den 16 julij 1669 een kint van Johan Vermeer.

Den 27 junij 1673 een kint van Johan Vermeer.
Den 16 dec. 1675 is in dit graf geleijt Johan Vermeer ende het bovenstaende baerkint op de kist de voorn. Vermeer geset.
Den 23 maart 1676 is hier in geleijt Wm. Bolnes j.m.
Den 27 december 1680 Maria Thins wed. van Reijnier Bolnes. ende is nu vol.' ['10 July 1667 an infant of Johan Vermeer was laid in this grave; apart from this infant the grave is empty.
The 16th July 1669 a child of Johan Vermeer
The 27th June 1673 a child of Johan Vermeer
The 16th December 1675 Johan Vermeer was laid in this grave and the above mentioned infant was set on the coffin of the aforementioned Vermeer.
The 23rd March 1676 Wm. Bolnes bachelor was laid herein.
The 27th December 1680 Maria Thins widow of Reijnier Bolnes. and the grave is now full.'] (*Van Peer 1968*, p. 223).
Vermeer's oldest son was called Jan (for data about him see also documents 44 and 49), his oldest daughter was called Maria. Other daughters were named Aleydis, Geertruy, Catharina, Lysbeth and Beatrix. The youngest child, a son, was called Ignatius (see *Van Peer 1951*).

37. **27 January 1676:** '*Op den 27 January 1676 compareerde voor mij Gerard van Assendelft, Nots. tot Delff . . . Catharina Bolnes, Wed. van za: Johannes Vermeer, in sijn leven kunstschilder binnen Delff, ende bekende aen Hendrick van Buyten, Mr. backer alhier vercoft ende getransporteert te hebben twee schilderijen bij den voorn: Vermeer geschildert, d'eene vertonende twee personagien waeroff d'een een brieff sit te schrijven, ende d'ander mede een personagie spelende op een cyter. En bekende daervoor voldaen te zijn met de somme van ses hondert seventien gulden en ses stuyvers die sij comparante aen gelevert broot aen den voorn. van Buyten schuldig was en welcke reeckening, door desen gehouden wert voor geannulleert ende vernieticht. Voorts . . . sijn sij metten anderen verdragen en geaccordeert, dat in gevalle de voorn: wed. aen van Buyten op den 1 Mey 1677 comt te betalen de somme van vijftich gulden en soo voorts telcken Meydaege gelijcke vijftich gulden, geduyrende totte volle restitutie van de voorsz. 617 gulden 6 stuyvers toe, en dat hem ondertusschen volcomentl: betaelt is de éénhondert negen gulden vijff stuyvers, mede spruytende uyt voorgaende leverantie van broot, hij van Buyten als dan wederom in vollen eigendom aen de voorn. Wed. off haere erffgenaemen overlaeten sal de twee aen hem vercofte stucken schilderije, maer soo het mochte comen te gebeuren dat des voorn. Weds. moeder quam te sterven, eer de voors. somme mochte wesen gerestitueert, soo sal de lossing vant geen hierop zoude mogen resteeren, moeten gedaen werden met 200 gulden jaerlycks, ende in dat gevalle vant restant van dese oock moeten betalen interest tegens 4 ten hondert in 't jaer vant overlijden van deselve haere moeder aff, totte voldoeningh toe, gelijck oock gelijcke interest betaelt sal moeten werden in gevalle de gestipuleerde lossinge van 50 gl. jaerlijcks niet precijse quame te volgen. Maer de restitutie der penn: in voege voorz. gedaen sijnde, (daerbij gevoecht ende voldaen sijnde 't gunt in tijt en wijle weder op nieus soude werden gelevert) sal hij van Buyten alsdan de twee stucken schilderije hierboven gedesigneert, gehouden wesen te restitueren.*' ['On the 27th January 1676 appeared before me Gerard van Assendelft, Notary in Delft . . . Catharina Bolnes, Widow of the late Johannes Vermeer, during his life painter in Delft, and stated to have sold and transferred to Hendrick van Buyten, master baker in this town, two paintings done by the aforementioned Vermeer, one representing two persons one of whom is writing a letter and the other with a person playing the lute, and stated to have been paid the sum of 617 guilder and 6 stuivers for these paintings, which sum she, attestant, owed to van Buyten for bread delivered, and which bill he now considers null and void. Furthermore . . . they agreed and were accorded that in case the aforementioned widow should pay on 1 May 1677 to him, van Buyten, the sum of 50 gulden and so on, each first of May such 50 gulden, until full restitution of the aforementioned 617 gulden 6 stuivers and if meanwhile he is paid the entire 109 gulden 5 stuivers, also due for preceding delivery of bread, he, van Buyten will then again relinquish in full property to the aforementioned widow or her heirs the two paintings sold to him, but should it come to pass that the mother of the aforementioned widow should die before the aforesaid sum had been restituted, then the redemption of any sum that might still remain outstanding must be effected with 200 gulden a year, and in that case [she] must also pay interest on this remnant at four per cent per annum from the decease of her mother onwards, until settlement, just as the same interest shall be paid in case the stipulated repayment of 50 gulden a year had not precisely been paid. But the restitution of the money having been made in the above mentioned fashion (having been added and paid that,

which from time to time will be delivered again) he, van Buyten, will then be held to restitute the two paintings designated above.'] (Solicitors of the Widow are Floris van der Werff and Philippus de Bries.) In a second version of the same contract the following changes appear: van Buyten states, that he made this restitution settlement *'bewogen door 't serieus versoeck ende instantelijck aenhouden van de voorsz. transportante'*. ['moved by the serious plea and urgent persistence of the aforementioned transferor!] Should the widow fail to meet her obligations, van Buyten is then allowed to sell the paintings, whereupon she *'sal suppleren, opleggen en vergoeden 't geent hij comp[t] alsdan de twee schilderijen vercoopende, daervan minder als de 617 gl. 6 st. sal comen te consequeren'* ['shall supply, pay for and make good whatever may still fall short of 617 gulden 6 stuivers when the two paintings are sold'] (Prot. not. G. van Assendelft, Delft; *Bredius 1885*, pp. 219, 220).

38. **10 February 1676**: *'30 November 1676 compareerde Sr. Jan Colombier Coopman binnen dese stadt . . . en heeft ten versoeke van d'eerbare Jannetie Stevens, bejaerde dochter, wonende tot Delft verklaart . . . dat hij deposant op den 10en February deses jaers 1676 tot Amsterdam ten huyse van seker apothecaris aldaer in "De drie Limoenen' van de Wed. van salr Johannes van der Meer, in sijn leven Mr. Schilder tot Delft, voor rekeninge en in de name van de voorsz. requirante heeft gekocht 26 stucks, soo groot als cleyne Schilderyen te samen om en voor de somme van 500 guldens welke somme soude strekken tot betalinge op tgene de voorsz. Wed. van Johannes van der Meer aen de voorn. requirante wegens winkelwaren schuldich was, dat voorsz. koopmanschap in voegen alsvoren getroffen sijnde, de voorn. 26 stuks schilderyen by de voorn. Wed. van Johannes van der Meer aenstonts aen hem deposant voor rekeningh ende in de name van de gemelte requirante sijn gelevert en bij hem deposant ook medegenomen, hebbende hij deposant de 26 stuks schilderijen naer dese Stadt Haerlem laten vervoeren en tsijnen huyse brengen, alwaer deselve schilderijen gebleven sijn, omdat hij deposant tot laste van de requirante eenige praetensie had en t'resterende aen haer reqte off met gelt off met waren soude voldoen. Eyndigende etc.* ['30 November 1676 appeared Sr. Jan Colombier Merchant in this town . . . and declared at the request of the honourable Jannetie Stevens, spinster of age, living in Delft . . . that he deponent on 10 February of this year 1676 in Amsterdam at the house of a certain apothecary in that town in "De Drie Limoenen" has bought from the Widow of the late Johannes van der Meer, during his life Master Painter in Delft, on account and in behalf of the aforementioned petitioner, 26 large as well as small Paintings, together amounting to 500 gulden which sum has been set aside to pay that which the aforementioned Widow of Johannes van der Meer owed to the aforesaid petitioner for shop-wares; that after the aforesaid transaction had been effected as described above, the aforementioned 26 Paintings were immediately delivered by the aforementioned widow of Johannes van der Meer to him deponent on account and in behalf of the mentioned petitioner and [they] have also been taken along by him deponent, he deponent having caused the 26 Paintings to be transported to this town of Haarlem and to be brought to his house, where these same paintings now remain, since he deponent had some claims on the petitioner and would settle the differences to her, petitioner, either with money or with goods. Ending etc.'] *(signed)* Jan Colombier' (Prot. not. P. Baes, Haarlem; *Bredius, schilderijen*, p. 161) 'Jan Colombier' is the painter Jan Coelenbier. (*Obreen IV*, p. 298). Compare documents 50 and 52.

39. **24 February 1676**: *'Op huyden den 24 Febr: 1676 compareerde . . . Juffr[e] Catharina Bollenes, wed[e] wijlen Sr Johan Vermeer, woonende tot Delff, en verclaerde in minderinge van 't geene sy schuldich is, soo voor haer selven als in qualité als wed[e] en boedelhouster, en oock als voochdesse van haere kinderen, geprocreëert bij den voorn. Vermeer, haeren man za: aen Juff[r] Maria Tins, Wed[e] wijlen Reynier Bollenes, haer moeder in vollen en vrijen eygendom over te geven een stuck schilderie, geschildert by den voorn. haeren man za: waerin wert uytgebeelt "de Schilderconst", alsmede haer recht, actie en pretentie op de revenues van de helft van 5 mergen lants gelegen in Out-Beyerlant . . . enz. enz.'* ['Today the 24th of Febr. 1676 appeared . . . Juffr. Catharina Bollenes, widow of the late Sr. Johan Vermeer, living in Delft and stated that she hereby ceded in full and free property, as part payment on her debt, both for herself and in her capacity as widow and trustee, and also as guardian of her children, procreated by the aforementioned Vermeer, her late husband, to her mother Juffr. Maria Tins, Widow of the late Reynier Bollenes, a painting done by her aforementioned late husband, in which is depicted 'the Art of Painting', as well as her rights, action and claim to the revenues of half of 5 "morgen" of land situated in Out-Beyerlant . . . etc. etc.'] *(signed)*

Catharina Bolnes. (Prot. not. J. Vos, The Hague; *Bredius 1885*, p. 220). Compare documents 48 and 51.

40. **29 February 1676**: Within three months after the death of the painter an inventory of the estate was made up; in separate lists was stated which goods belonged to his widow Catharina Bolnes, and which were the common property of Catharina Bolnes and her mother Maria Tin. Bredius published an excerpt of these lists, which follows below: *'Specificatie van alsulcke goederen . . . als Catharina Bolnes, wed[e] wijlen Sr. Johannes Vermeer, wonende aen den Ouden Langendijck op den houck van den Molepoort in eygendom sijn toecomende, en in opgemelte huysinghe berustende.*

In 't voorhuys: Een freuytschilderytge, een zeetje, een lantschapie. Een stuckie schildery door Fabritius.

In de groote zaal: Een schildery sijnde een boere schuyr — Nog een schildery. — Twee schildery-tronijen van Fabritius. — De conterfeytsels van Sr. Vermeers zalrs. vader en moeder. — Een geteekent wapen van den voorn. Sr. Vermeer, met een ebbe lijst. — Meubels, harnas, stormhoed en kleinigheden. — Onder linnen en wolle: Een turxe Mantel van den voorn. Sr. Vermeer zalr. — Voorts kleederen en huisraad.

In de binnenkeuken: Een groote schildery, sijnde Christus aen 't Cruys. — Twee Trony schilderyen gedaen by Hoochstraten. — Een schildery daerin allerley vrouwentuijch. — Een van Veronica. — 2 Tronyen geschildeert op sijn Turcx. — Een Zeetje. — Een waerin een bas met een dootshooft. — 7 ellen goutleer aen de muyr.

Op de kelderkamer: Een Christus aent Cruys, een vrou met een ketting aen' (etc., all without the names of the painters)

'Op de voorkamer: En rotting met een ivoren knop daerop. — 2 schilderseesels, drye paletten, 6 paneelen, 10 schilderdoucken, drie bondels allerhande slach van printen, een lessenaer en rommelingh.

Aldus gedaen te Delft enz. 29 February 1676.' ['Specification of all such goods . . . as are due to accrue in ownership to Catharine Bolnes, widow of the late Sr. Johannes Vermeer, living on the Ouden Langendijck on the corner of the Molepoort, and present in the abovementioned house.

In the front part of the house: a painting with fruit, a small seascape, a small landscape. A small piece of painting by Fabritius.

In the big hall: a painting being a peasant's barn — Another painting. — Two painted 'tronies' by Fabritius. — The portraits of the late Sr. Vermeer's father and mother. — A drawing of the coat of arms of the aforesaid Sr. Vermeer, with an ebony frame. — Furniture, armour, morion and paraphernalia. Among linen and wool: a turkish Coat of the aforementioned late Sr. Vermeer. — Furthermore clothing and household effects.

In the kitchen: A large painting, being Christ on the Cross. — Two 'Tronie' paintings done by Hoochstraten. A painting on which all kinds of women's paraphernalia. One [painting] of Veronica. — 2 'Tronies' painted in Turkish fashion. — A small Seascape. — One wherein a bassviol and a skull. — 7 Ells of goldleather on the wall.

In the basement room: A Christ on the Cross, a woman wearing a necklace.

In the front room: a cane with an ivory handle on it. — 2 painter's easels, three palettes, 6 panels, 10 canvases, three volumes with prints of different kinds, a lectern and miscellaneous paraphernalia. Thus done in Delft etc. 29 February 1676.'] *(Signed)* Catharina Bolnes.

'Specificatie der goederen, voor de helft toecomende Juffr. Maria Tins Wed.[e] wijlen Sr. Reijnier Bolnes en voor de helft haere dochter Juffr. Catharina Bolnes. Wed.[e] wijlen Sr. Joannes Vermeer, berustende ten woonhuyse van de voorn. Wed. op den Ouden Langendyck tot Delft.

Schilderijen: Een Mars en Apollo; nog 8 schilderijen; familieportretten, een drye Coningen, een moeder Christi. Nog 11 schilderijen. Een steene Tafel om verruwe op te vryven, met de steen daerby. Aldus gedaen enz. 29 Februari 1676.' ['Specification of the goods, due in half to Juffr. Maria Tins Widow of the late Sr. Reijnier Bolnes and for the other half to her daughter Juffr. Catharina Bolnes . . . Widow of the late Sr. Joannes Vermeer, deposited in the residence of the aforementioned Widow, at the Ouden Langedijck in Delft.

Paintings: A Mars and Apollo; 8 more paintings; family portraits, a Three Magi, a mother of Christ. 11 more paintings. A stone Table to rub paints on, along with the stone. Thus done etc. 29 February 1676.'] (Prot. not. J. van Veen, Delft; *Bredius 1885*, p. 219). A complete transcription of this document was published by van Peer, with the specification of the goods as belonging to Maria and to Catharina. It appears from his lists that, apart from furniture and household effects, there were also a painting representing Cupid, another with '3 pumpkins and other fruit

on it', a yellow satin jacket hemmed with white fur, an ebony crucifix, furthermore some 35 books (*Van Peer 1957*, pp. 98–103).

41. 23 March 1676: Burial of Vermeer's brother-in-law Willem Bolnes. See document 36.

41a 28 April 1676: From an act of 25 November, published by Obreen (document 46), it appears that Vermeer's mother-in-law Maria Tins authorized on 28 April 1676 the lawyer Pieter de Bie to represent her in matters concerning her claims to the estate of her daughter Catharina Bolnes, widow of the painter (The Hague, prot. not. Ter Beecq van Coetsveld; cf. *Obreen IV*, p. 296).

42. 30 April 1676: Petition of '*Catharina Bolnes, Wed⁶ van Johannes Vermeer, in sijn leven Schilder, wonende binnen der Stadt Delft*' ['Catharina Bolnes, Widow of Johannes Vermeer, in his lifetime Painter, living in the Town of Delft',] to the Supreme Court, in which she says: "*hoe dat sy Suppliante belast synde met elff levende kinderen vermits de voorn. haere man geduerende desen oirlogh met den Coninck van Vranckrijck nu eenige jaren herwaarts seer weinich ofte bynae nietwes hebbende konnen winnen, oock die Kunst, die hy hadde ingekocht ende waermede hy was handelende, met seer groote schaede heeft moeten uijt sijn handen smijten tot alimentatie der voorsz sijne kinderen daerdoor dan soo verre is geraeckt in verloop van schulden, dat sij Supplte. niet machtich is alle haere crediteuren (die geen regard willen nemen op het voorsz haer groot verlies en quade fortuijn door den voorsz oorloogh gecauseert*") *te voldoen . . .*' ['how she, Supplicant, charged with the care of eleven living children, since her aforementioned husband during this war with the King of France some years ago now, having been able to earn very little or hardly anything at all [and]—for the support of his children—having also had to dispose—with great loss—of the works of Art which he had bought and with which he was trading, because of this he has then run into such debts, that she Supplicant is not able to pay all her creditors (who do not want to make allowance for her abovementioned large losses and misfortune caused by the aforesaid war) . . .'] and requests letters of cession, which are granted to her 30 April 1676. (*Bredius 1910*, p. 62). Mentioned as creditors in this act are: Maria Tin—N. Hogenhouck, brewer—N. Rombouts—N. Dirckse—N. van Leeuwen—Hendrick Dircks—Tanneken—Hendrick van Buytenen—Emmerentia. (*Van Peer 1957*, p. 96).

43. 25 September 1676: In a testament of this date, which has never been published in its entirety, Maria Tin, Vermeer's mother-in-law, revokes all her preceding wills and names his (Vermeer's) children as her sole heirs. (The Hague, prot. not. Terbeeck van Coetsfelt; *Van Peer 1951*, p. 626; *Van Peer 1968*, p. 223). Compare also *Bredius 1910*, p. 63.

44. 26 September 1676: In a petition to the States of Holland and West-Frisia Maria Tin, Vermeer's mother-in-law, declares: '*als wettige ende eenige patronesse van seeckre vicarie gefundeert inde kercke der stede Schoonhoven op St. Laurens ende Barbara altaer, nu sijnde comende te vaceren door doode van haer comparantes soonᵉ Willem Bolnes, deselve vicary te hebben geconfereert, gelijck sij confereert bij desen op haeren neeff Johannes Vermeer soon van haere dochter Catharina Bolnes ende haeren swager Johannes Vermeer Zr in sijn leven constrijck schilder gewoont hebbende binnen de stadt Delft.*' ['as legal and sole patroness of certain vicary founded in the church of the town of Schoonhoven on the altar of St. Lawrence and Barbara, now becoming vacant by the death of her appearer's son, the late Willem Bolnes, to have assigned same vicary, as she assigns herewith, to her grandson Johannes Vermeer, son of her daughter Catharina Bolnes and of her late son-in-law Johannes Vermeer during his lifetime artful painter having lived in the town of Delft.'] (Prot. not. Terbeeck van Coetsfelt, The Hague; *Van Peer 1951*, p. 621). For Jan Vermeer II see also document 49.

45. 30 September 1676: '*De Heeren Schepenen der Stad Delft, stellen bij desen Anthonij (van) Leeuwenhouck tot Curateur over den boedel ende goederen van Catharina Bolnes weduwe van wylen Johannes Vermeer in sijn leven mr. Schilder. Impetrante van mandement van cessie, des hij gehouden blijft . . . etc. Gedaen den 30ᵉ September 1676.*' ['The Lords Aldermen of the Town of Delft, hereby appoint Anthony (van) Leeuwenhouck as Curator of the estate and goods of Catharina Bolnes widow of the late Johannes Vermeer during his lifetime mr. Painter. Cession obtained on request, so that he is bound to . . . etc. Done the 30th September 1676.'] (*Kamerboek der Stad Delft*, 1671–1684; *Obreen IV*, p. 295). See documents 42, 50, 51, 52 and 54.

46. 25 November 1676: In an extensive act of this date Maria Tin and her daughter Catharina Bolnes (Vermeer's widow) settle the inheritance of Willem Bolnes, respectively the son and brother of the above mentioned. Maria Tin takes upon her all debts and charges of her deceased son. The act was published in its entirety in *Obreen IV*, pp. 295–8.

47. 30 November 1676: At the request of Jannetie Stevens, the merchant Jan Coelenbier declares having received on 10 February 1676, 26 paintings from Vermeer's widow. Cf. documents 38 and 50.

48. 11 December 1676: In a document of this date published by Bredius, Maria Tin declares that she '*geen goederen van haar dochter of swager Johannes Vermeer in fraudem creditorium onder haar heeft geslagen*' ['has not taken in her keeping any goods belonging to her daughter or son-in-law Johannes Vermeer, in order to defraud the creditors.'] (*Bredius 1910*, p. 63). Cf. documents 39 and 51.

49. 6 January 1677: In a testament of this date which was never completely published, Maria Tin states: '*doch of binnen de voorsz. tijdt Johannes Vermeer sijne studie op het incoomen van de Vicarye goederen gefundeert op St. Barbara ende Laurens Autaer inde Kercke tot Schoonhoven hem bij de voorsz. Testatrice geconfereert niet en soude connen vervolgen*' ['but if within the aforesaid time Johannes Vermeer should not be able to continue his studies on the income from the estate of the vicariate founded on the altar of St. Barbara and Lawrence in the church of Schoonhoven, bestowed on him by the aforesaid testatrix,'] that his guardian mr. van der Eem can assist him with money from other sources. She also demands on this occasion that her goods remain undivided and not be parcelled out until the youngest child of her daughter Catharina Bolnes will have reached the age of 14 years and she recommends that her grandchildren '*eenige coopmanschappe ofte eerlycke hantwerck coomen te leeren, oordelende, dat het getal van haer dochters kinderen al te groot is omme alle leedich te gaen en niets by de hand te nemen*' ['learn some kind of merchant's trade or honest handicraft, judging that the number of her daughter's children is too large for them to be idle and not to take up any occupation.'] (Not. Terbeeck van Coetsfeld, The Hague; *Bredius 1910*, p. 63; *Van Peer 1951*, pp. 621, 626). For data concerning Johannes Vermeer II and the estate of the vicariate see also document 44.

50. 2 February and 5 February 1677: '*Ingevolge van den appoinctemente van de Heeren Schepenen der Stad Delft gedateerd den . . . January Jongst voorleden syn op huyden den 2 February 1677 voor ons Adriaen van der Hoef ende Mr. Nicolaes van Assendelft Schepenen derselver Stad als Commissarissen hebbende tot adjunct den Secretaris Mr. Hendrik Vockestaert gecompareert ende verschenen Anthony Leeuwenhoek als Curateur van den Boedel van wylen Johannes Vermeer in syn Leven Mr. Schilder was, Eijsscher geassisteert met Floris van der Werf synen Procureur ter eenre ende Jannetge Stevens b:d: ged.ᵉˢˢᵉ geadsisteert met Steven van der Werf Mr. Metselaer alhier haren Neef ende Philips de Bries haren procureur ter andere syde; ende syn deselve partyen door intercessie van ons Commissarissen en adjunct, nopende haere differenten op approbatie van het Collegie van haer Agtb: verdragen ende geaccordeert in manieren hierna volgende namentlyk dat by den eyscher in qualite voorsz., aen de ged.ᵉˢˢᵉ sal werden betaelt de somme van drie hondert twee en veertig gl. eens ende dat in volle betaling van sodanige vier hondert twee en veertig gl. als sy ged.ᵉˢˢᵉ van den Boedel van den voorn. Vermeer te pretenderen heeft welk hare pretensie ende de deugdelykheyt van dien sy ged.ᵉˢˢᵉ dan ook gehouden wesen sal t'allen tyde des nader versogt werdende met eede solemnelyken te verclaren, waertegens de ged.ᵉˢˢᵉ aengenomen ende belooft heeft, sooals by haer insgelyks aengenomen ende belooft wert by desen omme aan den eysscher in qualite voorsz. ter naester gelegentheyt te overhandigen sodanige 26 stucken Schilderie den voorsz. boedel aenbehorende als jegenwoordig berustende syn onder Johannes Columbier, woonagtig tot Haerlem onder speciale overgifte ende belofte van deselve ged.ᵉˢˢᵉ dewelke hy mede doet by desen dat de voorsz. stucken Schilderie by publique vercopinge metten anderen t'allen tyde ten behoeve van den voorsz. boedel suyver sullen comen te renderen de somme van vyf hondert gl. waer voren sig insgelyks den voorn. Steven van der Werven tot borge als principael onder speciale renunciatie van de beneficien ordinis sive excussionis van den effecte van dien hem ten genoegen houdende onderregt, geconstitueert heeft, soo als hy synenthalven mede doende is by desen, alles met verbant van hare respective personen ende goederen ende sullen daermede parthyen voorsz. differenten af, doot ende te niette wesen met compensatie van costen.*

Actum ten dage en Jare als boven.

Op huyden den 5 febr: 1677 ter Camere van Haer Agtb. de Heeren Schepenen

der Stad Delft van den inhoude van het bovenstaende verbael berigt ende communicatie gedaen wesende, is het selvige in het regard van Haer Agtb. geapprobeert sooals hetselvige geapprobeert wert bij desen.

Actum ten dage en Jare als boven.' ['In pursuance of the appointment of the Lords Aldermen of the Town of Delft dated the ... January last, there appeared today, the 2 February 1677, before us Adriaen van der Hoef and Mr. Nicolaes an Assendelft Aldermen of this Town as Commissioners, having as adjunct the secretary Mr. Hendrik Vockestaart: Anthony van Leeuwenhoek as Curator of the Estate of the late Johannes Vermeer during his life Master Painter, Plaintiff, assisted by Floris van der Werf his solicitor on one side, and Jannetge Stevens, daughter of age, defendant, assisted by her nephew Steven van der Werf, master mason from this town and Philips de Bries her solicitor on the other side; and through intercession of us Commissioners and adjunct, concerning their differences, the same parties have agreed and arranged, with the approval of the College of their Hons. Mssrs. the Aldermen, as follows: to wit, that the plantiff in his aforesaid capacity shall pay to the defendant the sum of 342 gulden in one sum and as full payment of those 442 gulden as she defendant claims from the Estate of the aforementioned Vermeer, which claim and the validity thereof the defendant then will be obliged to affirm with solemn oath at any time, whenever asked for, in consideration of which the defendant has undertaken to do and promised, so as by her similarly is undertaken to do and promised herewith, to hand over to the plantiff in his aforesaid capacity, at the first opportunity those 26 paintings belonging to the aforesaid estate as at present are deposited with Johannes Columbier, living in Haarlem, under special pledge and promise of same defendant, which he [Columbier] also does herewith, that the aforesaid paintings through public auction altogether will accrue to the sole benefit of the aforesaid estate up to the sum of five hundred gulden, for which the aforementioned Steven van de Werven has declared himself principal guarantor, under special renunciation of the *beneficia ordinis sive excusionis* (*see document 18*), considering himself to be sufficiently instructed of the effect of this condition, so he does herewith on his own account, for all of which they pledge their respective persons and goods and state that the aforesaid disagreement between the parties shall be over, dead and nullified, with compensation of the costs.

Done on the day and the Year as above.

Today 5 February 1677 in the Chamber of their Honours Mssrs the Aldermen of the Town of Delft, having been informed of the contents of the record above and having consulted together, the same has been approved by their Honours, as the same is approved hereby.

Done on the day and the Year as above.'] (Kamerboek der stad Delft, 1671–1684; *Obreen IV,* p. 298–300). Compare in this connection documents 38 and 47.

51. **12 March 1677:** On this date Maria Tins states: '*Alsoo op den 24 Februari 1676, volgens Acte van transport voor den Nots. J. Vosch, bij mijne dochter Catharina Bolnes in mindering vant geene sij aen my schuldich is, soo voor haer selven ende in qualité als Weduwe ende boedelhouster ende oock als voochdesse van haere kinderen geprocreëert by Johannes Vermeer zal.er in vollen en vrijen eygendom heeft overgegeven, opgedragen ende getransporteert seeker stuck schilderije, geschildert bij den voorn. Vermeer, waerinne wert uitgebeelt de Schilderkonst, van welcke voorsz. acte van overgifte ende opdracht Mons.r Anthony Leeuwenhoek, als Curateur over den boedel van voorn. Vermeer ende Catharina Bolnes, visie en copie is gegeven. Ende dat des niettegenstaende de voorn. S.r Leeuwenhoeck in de voorsz. qualiteyt by affixie van gedruckte billietten, (waervan mij een is toegezonden) by publicque opveylinge aen den meest biedende op den 15 Meert toecomende 1677 op S.t Lucas Gildecamer binnen deser stadt Delft presenteert te vercoopen de voorsz. schilderije, aen mij opgedragen als voorschreven is. Soo sal den eersten not.r, hiertoe versocht, zich hebben te vervoegen aen den persoon, van den voorn. S.r Leeuwenhoeck ende denselven uyt mijnen naem te insinueren ende aen te seggen, dat ick niet en verstae, dat de voorschreven schilderije bij hem sal werden vercocht, als moetende coomen in minderingh van mijn achterwesen, off wel dat hij, die vercoopende, sal stipuleeren, dat bij mij de penningen daervoor comende niet zullen werden uytgekeert, maer strecken in minderingh van mijn achterwezen. Enz.*

Actum Hage, den 12 Martii, 1677.'

['Whereas on the 24 February 1676, according to Deed of transfer before Notary J. Vosch, by my daughter Catharina Bolnes, in deduction of the amount which she owes me, both for herself and in her capacity as Widow and trustee and also as guardian of her children procreated by the late Johannes Vermeer, has handed over, assigned and transferred in full and free property a certain painting done by the aforementioned Vermeer, on which is represented the Art of Painting, of which aforesaid deed of delivery and cession has been given vision and copy to Monsr. Anthony Leeuwenhoek, as Curator of the estate of the aforementioned Vermeer and Catharina Bolnes; and whereas nevertheless the aforementioned Sr. Leeuwenhoeck in the aforesaid capacity intends to sell, by posting of printed notices (one of which has been sent to me) by public auction to the highest bidder on the coming 15th of March 1677 in the St Lucas Guild chamber in this town of Delft the aforementioned painting transferred to me as heretofore mentioned; so the first notary requested to do so will have to present himself before the person of the aforementioned Sr Leeuwenhoeck and to inform him in my name and to tell him that I do not understand that the painting described before will be sold by him, as serving to reduce the debt owed to me, or that he, selling it, should stipulate that the money coming from this sale shall not be paid out to me, but serve to reduce the debt owed to me. Etc.

Done at The Hague, 12 March 1677.'] (Prot. not. J. Vos, The Hague; *Bredius 1885,* p. 221). Compare documents 39 and 48.

52. **13 March 1677:** '*Ingevolge van de bovenstaande insinuatie soo hebbe ick ondergeteekende, Notaris, my vervoegt aen de persoon van Antony Leeuwenhoeck en hem deselve insinuatie voorgelesen, die mij tot antwoord gaff, dat hij de schilderije daerin vermelt, niet hadde connen machtigh werden als met proces en door transport van Annetge Stevens en dat hij daervoor hadde moeten betalen de somme van dryehondert tweeenveertig gulden, behalve de oncosten vant proces, dat hij van sin was (niet jegenstaande dese insinuatie) met de vercoopinge van dien voort te gaen, en dat, soo de insinuante metieende eenigh regt te hebben, sulcx soude op de preferentie moeten eijschen, Aldus op den 13 Martii 1677 gedaen ter presentie enz.'* ['In pursuance of the abovementioned insinuation, I undersigned, notary, have presented myself before the person of Anthony Leeuwenhoeck and have read to him the same insinuation, who replied that he had been unable to take possession of the paintings mentioned therein except by lawsuit and by transfer from Annetge Stevens and that for this he had had to pay the sum of three hundred forty two gulden, the costs of the lawsuit excluded, that he planned (the insinuation notwithstanding) to proceed with the sale of it and that, should the insinuator pretend to have any rights thereto, she would have to claim preferred debts. Thus done on 13 March 1677, in the presence of etc.'] (Prot. not. Corn. van Oudendijck, Delft). Published by Bredius (*Bredius 1885,* p. 221), who makes it appear as if this deed concerns the sale by Van Leeuwenhoek of the painting *The Art of Painting* (see document 51). From the text, however, it is evident that it concerns the sale of the 26 paintings transferred to Jan Coelenbier by Vermeer's widow (see documents 38 and 50).

53. **27 July 1677:** From a document of this date, published by Bredius in part only, it appears that Mr Hendrick van der Eem, lawyer of the Court of Holland, appointed tutor to the ten under age infants of Vermeer, in his lifetime Artful Painter, authorized Juffr. Aleidis Magdalena van Rosendael to look after the affairs of Vermeer's widow and to collect at the Orphan Chamber in Gouda a sum of 2900 gulden, a debenture of 400 gulden, a bonded debt of 400 gulden, etc. (*Bredius 1910,* pp. 63, 64).

For Aleidis Magdalena van Rosendael see: *Van Peer 1951,* pp. 623, 624. It is noteworthy that Vermeer, according to the burial register, left eight infants under age (see document 36, also p. 75 n. 3), whereas *ten* infants are mentioned here. Could it be that the fact that the issue at stake was now the collection of money at the Orphan Chamber of Gouda played a part? Compare how in 1690 Catharina Bolnes's son-in-law Joannes Cramer attempted on dubious grounds, to get money from the Orphan Chamber in Gouda (*Van Peer 1951,* pp. 621–2).

54. **1 February 1678:** '*1 Febr. 1678 compareert Anthonij Leeuwenhoeck, te Delft, als bij de E. Heeren Schepenen der stad Delft gestelde Curateur over den insolventen en gerepudieerden boedel en goederen van Catharina Bolnes, Wed.e en boedelhoutster geweest van wijlen Johannes Vermeer, in sijn leven schilder binnen desert stadt en verclaerde machtich te maecken ... Nicolaes Straffintvelt, Notaris binnen Gouda, omme in den naeme van hem aen de coopers te doen wettige opdracht van een gerecht derde part van een huys en erve met een bleeckvelt daerachter staende in de Peperstraet binnen Gouda, alsmede voor een derde part van drie morgen lants gelegen in Wilnis buyten Gouda, de voorn. Catharina Bolnes op en aenbesturven uyt den boedel van wijlen Jan Bolnes, haeren Oom sa: ... de gereedde cooppenn: te ontfangen, en dienaengaende te rekenen en te liquideren. Enz.'* ['1 Febr. 1678 appears Anthonij Leeuwenhoeck of Delft as Curator

appointed by the Hon. Lords Aldermen of the Town of Delft over the insolvent and abandoned estate and goods of Catharina Bolnes, Widow and former trustee of the estate of the late Johannes Vermeer, in his lifetime painter in this town, and declared to authorize ... Nicolaes Straffintvelt, Notary in Gouda, to transfer in his name to the purchasers a precise third part of a house and yard with a bleaching field at the back situated in the Peperstraat, as well as a third part of three morgen of land situated in Wilnis outside Gouda, inherited by the aforementioned Catharina Bolnes from the estate of the late Jan Bolnes, her late Uncle ... to receive the ready money, and accordingly to settle and to liquidate. Etc.'] (Prot. not. Floris van der Werff, Delft; *Bredius 1885*, p. 221, 222).

55. **2 April 1678:** Maria Tin declares herself guarantor for a debt contracted in 1675 by her son-in-law Jan Vermeer. See document 35.

56. **26 November 1678:** According to a document published by Bredius in part only, on this date Maria Tin authorizes the solicitor Bogaert in Delft to look after her business as preferential creditor with respect to the other creditors of the late Johannes Vermeer, her son-in-law (*Bredius 1910*, p. 63).

57. **24 January 1680:** Maria Tin, mother-in-law of the painter, possessed about 27 morgen of land near Oud-Beijerland, the yield of which amounted to 486 gulden yearly. In a document published by Bredius in part only, dated 24 January 1680 (Prot. not. Boogert, Delft), she stipulates that this piece of ground may never be sold nor be mortgaged. The executors of her will are entrusted with the care, at their discretion, of her daughter Catharina Bolnes, '*daer sy misschien geene genoegsame levensmiddelen soude konnen suppediteren*' ['since she might not have enough means to live on.'] They will distribute the money according to her needs, be it once a month or four times a year. (*Bredius 1910*, p. 63).

58. **27 December 1680:** Maria Tin, widow of Reijnier Bolnes, was buried in Delft. See document 36.

58a. **16 July 1681:** From an act of this date, mentioned by Bredius, it appears that Catharina Bolnes, the widow of the painter, borrowed 400 gulden from Pieter van Bleeck, at an interest of 5% (*Bredius 1910*, p. 63).

58b. **28 July 1681:** From an act of this date, mentioned by Bredius, it appears that Catharina Bolnes borrowed 400 gulden from Francois Smagge, at an interest of $4\frac{1}{2}$% (*Bredius 1910*, p. 63).

59. **20 June 1682:** The wife of the bookprinter Jacob Abrahamsz. Dissius was buried in the Old Church in Delft (Burial register 44; *Neurdenburg 1942*, p. 73). In the same year an inventory of their estate was drawn up, in which Bredius found: '*Acht schilderijen van Vermeer.-Drie dito van denselven, in kastjes.—Een zee, door Percellus.—Op de achterkamer: Nogh vier schilderijen van Vermeer.—Op de kelderkamer: Twee schilderijen van Vermeer.—En later: Nogh twee schilderijen van Vermeer.*' ['Eight paintings by Vermeer.—Three ditto by the same, in boxes.—A sea by Percellus.—In the backroom: Four more paintings by Vermeer.—In the basement room: Two paintings by Vermeer.—And later: Two more paintings by Vermeer.'] (Prot. not. P. de Bries, Delft; *Bredius 1885*, p. 222).
N.B. 1683 is mentioned by Neurdenberg as being the year in which this inventory was made up (*Neurdenberg 1951*, pp. 37, 38).

60. **12 July 1682:** '*Register vande schilderyen alhier in onsen huyse my Diego Duarte aengaende tot heden july 1682 ...*

182. Een stukxken met een jouffrou op de clavesingel spelende met bywerck van Vermeer, kost ... guld. 150'. ['Register of the paintings here in our house belonging to me Diego Duarte up to this day july 1682 ...

182. A piece with a lady playing the clavecin with accessories by Vermeer, cost ... 150 gulden.'] (H. G. Dogaer, 'De inventaris der schilderijen van Diego Duarte' in *Jaarboek van het Koninklijk Museum voor Schone Kunsten*, Antwerp, 1971).
Duarte was a very rich jeweller and banker who lived in Antwerp in a large house on the Meir. The list of 192 paintings from his property was published earlier by F. Muller (in *De Oude Tijd* 1870, p. 597 sqq.) with the deceptive title 'Catalogus der schilderijen van Diego Duarte, te Amsterdam'. The list, however, was not drawn up in Amsterdam, but in Antwerp (Dogaer, *op. cit.* p. 198). Presumably basing himself only on Muller's title, J. Zwarts brought out the story that Duarte moved to Amsterdam in 1682. (*Nieuw Nederlandsch Biografisch Woordenboek* ... VI, Leiden, 1927, col. 390 sqq). In 1687, however, he is still mentioned as

resident of Antwerp and Nic. Tessin pays him a visit in that town (J. Denucé, *De Antwerpsche 'Konstkamers'* ... Antwerp, 1932, p. 345; Dogaer, p. 196). In 1676 Constantyn Huygens jr had admired his collection in this same town (Dogaer, p. 196). Huygens also corresponded with Duarte about music, the latter being a famous organist and composer. Duarte's father had had a clavecin built for Huygens (Zwarts, loc. cit.) (A.Bl.).

60a. **1684 and 1687:** Catharina Bolnes, widow of the painter, living in Breda, receives financial support from the Weeskamer of Gouda (Municipal Archives Gouda, Requestboek 1683–95; *Van Peer 1951*, p. 620).

61. **30 December 1687 and 2 January 1688:** The registers of the Jesuit Station of the Cross (Roman Catholic Presbytery, Burgwal in Delft) record the fact that Domicella Catharina Bolnes was given the last sacraments on 30 Dec. 1687. (*Van Peer 1946*, p. 469; *Van Peer 1951*, p. 620). The burial book of the New Church in Delft mentions: '*2 Januari 1688 Catharina Bolnits Wed. van Johan Vermeer aen de Verwersdijck in de blauwe hant, in de kerck*'. ['2 January 1688 Catharina Bolnits Widow of Johan Vermeer from the Verwersdijk in [the house] the blue hand, in the church.'] In the margin: '*12 Dragers, 5 m: j.k.*' ['12 Bearers, 5 children under age.'] (*Obreen IV*, p. 300).

61a. **25 October 1688:** Baptism of Jan Vermeer III, grandson of the painter (Municipal Archives Rotterdam, baptismals of the Roman Catholic Community; *Van Peer 1951*, p. 620).

61b. **1690:** Joannes Cramer, Vermeer's son-in-law, tries in vain to get (on dubious grounds) money from the Orphan Chamber of Gouda (Municipal archives Gouda, Requestboek 1683–95; *Van Peer 1951*, p. 620).

62. **16 May 1696:** *Catalogus van schilderyen, Verkogt den 16. May 1696. in Amsterdam.*
1. Een Juffrouw die goud weegt, in een kasje van J. vander Meer van Delft, extraordinaer konstig en kragtig geschildert. 155-0
2. Een Meyd die Melk uytgiet, uytnemende goet van dito. 175-0
3. 't Portrait van Vermeer in een Kamer met verscheyde bywerk ongemeen fraai van hem geschildert. 45-0
4. Een speelende Juffrouw op een Guiteer, heel goet van den zelve. 70-0
5. Daer een Seigneur zyn handen wast, in een doorsiende Kamer, met beelden, konstig en raer van dito. 95-0
6. Een speelende Juffrouw op de Clavecimbael in een Kamer, met een toeluisterend Monsieur door den zelven. 80-0
7. Een Juffrouw die door een Meyd een brief gebragt word, van dito. 70-0
8. Een dronke slapende Meyd aen een Tafel, van den zelven. 62-0
9. Een vrolyk geselschap in een Kamer, kragtig en goet van dito. 73-0
10. Een Musiceerende Monsr. en Juffr. in een Kamer, van den zelven. 81-0
11. Een Soldaet met een laggent Meysje, zeer fraei van dito. 44-10
12. Een Juffertje dat speldewerkt, van den zelven. 28-0
(Nos. 13 to 30 are paintings by other masters).
31. De Stad Delft in perspectief, te sien van de Zuyd-zy, door J. vander Meer van Delft. 200-0
32. Een Gesicht van een Huys staende in Delft, door denzelven. 72-10
33. Een Gesicht van eenige Huysen van dito. 48-0
35. Een Schryvende Juffrouw heel goet van denzelven. 63-0
36. Een Paleerende dito, seer fraey van dito. 30-0
37. Een Speelende Juffrouw op de Clavecimbael van dito. 42-10
38. Een Tronie in Antique Klederen, ongemeen konstig. 36-0
39. Nog een dito Vermeer. 17-0
40. Een weerga van denzelven. 17-0
[Catalogue of paintings, Sold on 16 May 1696. In Amsterdam.
1. A Young Lady weighing gold, in a box by J. vander Meer of Delft, extraordinarily artful and vigorously painted. 155-0
2. A Maid pouring out Milk, extremely well done, by ditto. 175-0
3. The Portrait of Vermeer in a Room with various accessories uncommonly beautifully painted by him. 45-0
4. A Young lady playing the Guitar, very good of the same. 70-0
5. In which a gentleman is washing his hands, in a see-through Room, with sculptures, artful and rare by ditto. 95-0
6. A Young Lady playing the Clavecin in a Room, with a listening gentleman by the same. 80-0
7. A Young Lady who is being brought a letter by a maid, by ditto. 70-0

8. A drunken, sleeping Maid at a Table, by the same, 62-0
9. A gay company in a Room, vigorous and good by ditto. 73-0
10. A gentleman and a Young Lady making Music in a Room, by the same. 81-0
11. A Soldier with a laughing Girl, very beautiful by ditto. 44-10
12. A Young Lady doing needlework, by the same. 28-0
31. The Town of Delft in perspective, to be seen from the South, by J. vander Meer of Delft. 200-0
32. A View of a House standing in Delft, by the same. 72-10
33. A View of some Houses by ditto. 48-0
35. A Writing Young Lady very good by the same. 63-0
36. A Young Lady adorning herself, very beautiful by ditto. 30-0
37. A Lady playing the Clavecin by ditto. 42-10
38. A Tronie in Antique Dress, uncommonly artful. 36-0
39. Another ditto Vermeer. 17-0
40. A pendant of the same. 17-0]
(G. Hoet, *Catalogus of Naamlyst van Schilderyen, met derzelver pryzen*, I, The Hague, 1752, pp. 34–6.)

Neurdenburg showed that these paintings most probably came from the collection of Jacob Abramsz. Dissius (cf. document 59; *Neurdenburg 1942*, pp. 72, 73; *Neurdenburg 1951*, p. 38). Dissius had died seven months before the auction took place: '*Op 14 October 1695 Jacob Abrahamsz Dissius weduwnaar op 't Marctvelt int Vergulde A.B.C. vervoert met een koets naar 't Wout (met 18 dragers)*.' ['On 14 October 1695 Jacob Abrahamsz Dissius widower on the Marctvelt in the Golden A.B.C., transported in a carriage to 't Wout (with 18 bearers).'] (Burial Register 45, New Church, Delft; *Neurdenburg 1942*, p. 73). In April 1696 an advertisement for the auction appeared in which mention was made of: '*uytstekende konstige Schilderyen, daer onder zyn 21 stuks uitnemend krachtig en heerlyk geschildert, door wylen J. Vermeer van Delft, verbeeldende verscheide Ordonnantien, zynde de beste die hy ooit gemaekt heeft, vevens nog eenige andere van dese voorname Meesters . . .*' ['excellent artful Paintings, among them 21 pieces extraordinarily vigorously and delightfully painted by the late J. Vermeer van Delft, representing several compositions, being the best he ever made, besides some others of these eminent Masters . . .'] (then follow fourteen more names of painters; see S. A. C. Dudok van Heel, in: *Jaarboek van het Genootschap Amstelodamum* 37, 1975, p. 159).

63. **22 April 1699**: '*Catalogus van Schilderyen, van Herman van Swoll verkogt den 22 April 1699 in Amsterdam*.
25. Een zittende Vrouw met meer beteekenisse, verbeeldende het Nieuwe Testament, door Vermeer van Delft, kragtig en gloejent geschildert 400-0.'
['Catalogue of Paintings, sold on 22 April 1699 in Amsterdam by Herman van Swoll.
25. A seated Woman with several [symbolical and allegorical] meanings, representing the New Testament by Vermeer of Delft, vigorously and glowingly painted 400-0.'] (G. Hoet, *Catalogus of Naamlyst van Schilderyen, met derzelver pryzen*, I, The Hague, 1752, p. 487, our cat. no. 29).

There is now almost general agreement as to which paintings are genuine Vermeers and which pieces came to be wrongly ascribed to him in the course of time. In my opinion the most careful and reliable lists of 'genuine Vermeers' are those of *De Vries* and *Bloch*. I include in my list all those paintings considered by them to be from his own hand. The attributions of more recent date are discussed in the notes (p. 75 notes 10, 13).

When stating the measurements the height precedes the width. Principal page references are here given in roman, subsidiary ones in italic.

Facsimiles of all signatures can be found in *De Vries* (page xxix) and *Swillens*.

After the names of the authors of earlier *œuvre*-catalogues of Vermeer follows the number under which the painting occurs in their list (in *Bloch* there is no continuous numbering of Vermeer paintings). Then the date, if the author suggests one.

PROVENANCE of the paintings is by W. L. van de Watering, final editing by A. Blankert. The descriptions from early catalogues are cited literally. Mentions marked * do not, as far as we know, occur in the literature on these paintings, at least not complete. Between brackets after a location: the publication in which this location is (first) mentioned.

ABBREVIATIONS: d.='duim', *c.* 1750–*c.* 1816 equals a modern English inch, afterwards a centimetre; *HdG*=Dr C. Hofstede de Groot (see also abbreviations for literature on page 173); h.=height, *hauteur*; l.=width, *largeur*; P.=on panel (N.B. in the eighteenth century canvases pasted on panel were often mentioned as just: 'panel'); p.=pouce='duim'; R.K.D.=Rijksbureau voor Kunsthistorische Documentatie, Den Haag (Netherlands Institute for Art History, The Hague); v=voet=12 d(uim).

Information about sales is given in abbreviated form as shown in the following example:
Sale N. D. Goldsmid (The Hague), Paris (Drouot), 4 May 1876, no. 68=Sale of the N. D. Goldsmid collection (living in The Hague) held in Paris (by the auctioneer Drouot), on 4 May 1876, printed catalogue number 68. Prices and buyers are quoted from annotated copies of the sale catalogues. To check where (annotated) copies are kept one should consult F. Lugt, *Répertoire des catalogues de ventes publiques intéressant pour l'art ou la curiosité*, 3 volumes, The Hague, 1938–64. Information about the sales printed between square brackets has been taken from Lugt.

1. *Christ in the House of Mary and Martha*
Edinburgh, National Gallery of Scotland
Signed lower left on little bench.
Canvas, 160 × 142 cm. (63 × 56 ins.)
HdG 1. De Vries 2: 1654–5. Bloch: before 1656. Goldscheider 1: 1654.
1654–6. See pp. 13–17, 34, 76 n. 24.
Swillens was the only recent author not to believe the painting to be by Vermeer (Swillens, p. 64, no. B). 'Repentirs' prove that the master has somewhat changed the position of Christ's right hand and the index finger of his left.
The painting was published as Vermeer in 1901 (see publications mentioned in *De Vries*).

PROVENANCE: Bought by a furniture dealer from a Bristol family for £8.—(Cat. National Gallery, Edinburgh, 1929) or '81 st.' (*De Vries*).
—Coll. Arthur Leslie Collie, London (*De Vries*).
—Art gall. Forbes & Paterson, London, exh. April 1901, cat. no. 1; in this catalogue W. A. Coats is mentioned as the owner.
—Coll. W. A. Coats, Skalmorlie Castle, Scotland, cat. 1904 no. 37, with the note: 'engraved'.
—Given to the museum in 1927 by his two sons in memory of their father (Cat. National Gallery, Edinburgh, 1929, p. 277ff.).

2. *Diana and her Companions*
The Hague, Mauritshuis
Indistinctly signed lower left on rock.
Canvas, 98.5 × 105 cm. (38 × 41 ins.)
HdG 3. De Vries 1: 1654. Bloch: before 1656. Goldscheider 2: 1655.
1654–6. See pp. 13–17, 75 n. 15, 76 n. 21.

PROVENANCE: Sold by Dirksen art gallery, The Hague to N. D. Goldsmid for F 175.—(cat. Mauritshuis 1935, no. 406).
—Sale Neville D. Goldsmid (The Hague), Paris (Drouot), 4 May 1876, no. 68, as by Nicolaes Maes with reference to C. Vosmaer, *Rembrandt Harmens van Rijn* . . . (The Hague, 1868, p. 232: 'la *Diane* de la Collection Goldsmid', mentioned there amongst Maes's *'chefs d'oeuvre'*), for fr. 10000 to the state of the Netherlands, destined for the Mauritshuis. In Mauritshuis cat., 1876, no. 71a, as Nicolaes Maes; in the catalogues after 1877 with the addition: '*marqué N.M. 1650*' and, from 1883 onwards: '*wellicht van Johannes ver Meer*' ['maybe by Johannes ver Meer']. In cat. 1888 no. 71 c as: '*Johannes ver Meer . . . 1650*' In cat. 1891, no. 194, again as Maes and: '*valsch gem. N.M. 1650 . . . niet zeker van Maes. Dat het van den Delftschen Vermeer zou zijn . . . valt zeer te betwijfelen*' ['falsely signed. N.M. 1650 . . . not an ascertained Maes. It must very much be doubted that it could be by Vermeer of Delft']. In cat. 1895, no. 406 as: Johannes Vermeer van Utrecht, with facsimile of the signature and the note: '*attribué aussi à Joh. Vermeer de Delft*' ['also attributed to Joh. Vermeer of Delft']. In cat. 1898, no. 406, as Vermeer of Utrecht, with the remark: '*niet zeker . . .; vroeger . . . aan . . . Maes en door Sommigen aan den Delftschen Vermeer toegeschreven*' ['not certain . . .; formerly . . . ascribed . . . to Maes and by some to the Delft Vermeer'].

3. *The Procuress*
Dresden, Staatliche Gemäldegalerie
Signed and dated lower right 1656.
Canvas, 143 × 130 cm. (56¼ × 51¼ ins.)
Bürger 1. HdG 41. De Vries 3: 1656. Bloch: 1656 Goldscheider 4: 1656.
1656. See pp. 13, 27–8, 63, 67, 70, 75 n. 12, also 62.
The young man on the left is wearing a costume and a beret which strongly resemble the dress of the painter in *The Art of Painting* (Plate 19)

PROVENANCE: Acquired in 1741 for the coll. of the Elector of Saxony from the Wallenstein coll., Dux (Cat. Dresden, 1896, no. 1335).

—Mentioned in the Dresden catalogues as follows: cat. 1765, no. 299: '*Jean van der Meer . . . Une jeune Courtisane entre les bras d'un Homme, qui lui donne de l'argent en présence de deux autres Hommes. Sur toile, de 5 pieds 1 pouce de haut, sur 4 pieds 7 pouces de large*' ['Jean van der Meer . . . A young Courtesan in the arms of a Man who gives her money in the presence of two other Men. On canvas, height 5 feet 1 inch, width 4 feet 7 inches']; cat. 1782, no. 299, as appears from context by J. Vermeer van Haarlem; cat. 1826, no. 371 as: '*Jacques van der Meer, de Utrecht . . . Une jeune fille en société de trois hommes, dont l'un lui donne une pièce d'argent en l'embrassant; elle tient un verre à vin dans la main gauche. La partie inférieure du tableau est couverte d'un tapis. Figures de grandeur naturelle. Sur t. 5' 1" de h. 4' 7" de l.*' ['Jacques van der Meer, of Utrecht . . . A young girl in the company of three men, one of whom gives her a coin and embraces her; she holds a glass of wine in her left hand. The lower part of the painting is covered by a carpet. Lifesize figures. On C. height 5' 1" width 4' 7".'] N.B. in the copy of the catalogue belonging to J. Smith now in the R.K.D. '*Jacques*' is struck out and '*Delft*' written above.

—Once again recognized as Vermeer of Delft by Thoré (see W. Bürger, *Musées de la Hollande*, II, Brussels, etc. 1860, p. 77).

—In the Soviet Union from 1945 to 1955, see cat. *Ausstellung der von der Regierung der UDSSR an die Deutsche Demokratische Republik übergebenen Meisterwerke*, Dresden / 1956, pp. 7–14, cat. no. 1335).

4. *Girl asleep at a Table*
New York, Metropolitan Museum
Signed on the left above the girl's head
Canvas, 86·5 × 76 cm. (34 × 30 ins.)
HdG 16. De Vries 4: 1656. Bloch: 1655–60. Goldscheider 3: 1656. 1657. See pp. *13, 28, 29, 73.*
The painting of which a part is depicted in the top left corner is the *Cupid* ascribed to C. van Everdingen. This painting can be seen complete in Plates 25 and B2. Here, however, the Cupid has a mask lying at his feet. Contrary to the opinion of de Jongh and Mrs Kahr, Slive supposes that no symbolic significance can be attached to this mask (*Slive; De Jongh* p. 95, note 69; M. Millner Kahr, 'Vermeer's Girl Asleep, a Moral Emblem', in *Metropolitan Museum Journal* 6, 1972, pp. 115–32, with the assembled data on cat. no. 4). In my opinion it is quite hazardous to draw interpretations from the *Cupid* in Plate 4 as Mrs Kahr does in her otherwise most careful study. No more than just part of one of his legs is visible, and only those who know the complete painting from Plates 25 and B2 can or could recognize Cupid here. Mrs Kahr's theory that Vermeer was representing 'Sloth' in Plate 4 is more plausible. In some sixteenth and seventeenth-century prints this vice is represented by a sleeping woman leaning on her arm in the same way (Kahr, op. cit.; her interpretation elaborated in *De Jongh 1976*, p. 146). From recent X-rays it can be seen that Vermeer probably first painted a dog in the door-opening and a portrait of a man instead of a mirror in the back room and that the fallen rummer (bottom left) was painted or re-painted by a later hand (*Walsh and Sonnenberg*, pl. 95; Kahr, op. cit., pls. 3, 10).

PROVENANCE: Coll. Dissius, Delft, 1682; sale Amsterdam, 16 May 1696, no. 8: '*Een dronke slapende Meyd aen een Tafel . . . F 62*' ['A drunken sleeping Girl at a Table . . . F. 62']. (See document 62).

—*Sale Amsterdam (Posthumus), 19 December 1737, no. 47: '*Een slapent vrouwtje, van de Delfse van der Meer*' ['A sleeping woman, by the Delft van der Meer'] to Carpi for f. 8.5st.

—Sale John W. Wilson (Paris), Paris (Ch. Pillet), 14 March 1881, no. 116, with ill. (etching by Courtry) and elaborate description, for 8500 to Sedelmeyer. N.B. does not (yet) occur in Cat. *Collection de John W. Wilson exposé dans la Galerie du cercle artistique et littéraire de Bruxelles*, Paris, 1873.

—Art gall. Sedelmeyer, Paris, *Illustrated catalogue of 300 paintings . . . Paris*, 1898, no. 88, with ill. N.B. we know from notes made by Sedelmeyer in a copy of this cat. now at the R.K.D., that this painting was sold to Rodolphe Kann, Paris, in 1881 for fr. 12 000.

—Coll. Rodolphe Kann, Paris, cat. 1907, I, no. 89, with ill.

—Coll. Benjamin Altmann, New York (Cat. exh. *Hudson-Fulton Celebration*, New York, 1909, cat. I, addenda no. 137A).

—Bequeathed by him to the museum, 1913 (Cat. *Metropolitan Museum*, 1931, no. V 59-2).

5. *Soldier with a laughing Girl*
New York, The Frick Collection
Canvas, 50.5 × 46 cm. (19¾ × 18⅛ ins.)
Bürger 7. HdG 39. De Vries 6: 1657. Bloch: 1655–60. Goldscheider 5: 1657.
1658. See pp. *32, 33, 35, 40, also 73, 77 n. 48.*
The map on the wall, also depicted in nos. 14 and 22, represents Holland and West Frisia as indicated by the Latin inscription: NOVA ET ACCVRATA TOTIVS HOLLANDIAE WESIFRISIAEQ. TOPOGRAPHIA. Other legible words: HOLLAND, MARE GERMANICVM and DE ZUYDER ZEE. It was a wall-map made in 1620 by Balthasar Florisz van Berckenrode. In the years 1621–9 editions of this map were also published by Willem Jansz. Blaeu (*Welu*, p. 529ff.)

PROVENANCE: Coll. Dissius, Delft, 1682; sale Amsterdam, 16 May 1696, no. 11: '*Een Soldaet met een laggent Meysje, zeer fraei . . . F. 44.10*' ['A Soldier with a laughing Girl, very fine . . . F 44.10'] (see document 62).

—*Sale Charles Scarisbrick, London (Christie's), 10 May 1861, no. 89: 'De Hooghe . . . Interior of an apartment with a cavalier in a red dress and large hat, in conversation with a lady in a yellow and black dress; they are seated at a table, near an open window, through which the light falls on the lady's face with admirable effect; a map of Holland is suspended against the wall', for £87.3 to Lee Mainwaring (identification by Peter Sutton).

—Coll. Leopold Double (lender to *Exposition rétrospective, tableaux anciens, . . .*, Palais des Champs-Elysées, Paris, 1866, cat. no. 107); acquired by Double in a sale in London as by Pieter de Hooch for 235 gns according to Bürger. (*Bürger*, p. 548, with etching by J. Jacquemart).

—Sale Double (Paris), Paris (Pillet) 30 May 1881, no. 16, with detailed description, for fr. 88 000 to Gauchey for Prince Demidoff (see P. Eudel, *L'Hôtel Drouot 1881*, Paris, 1882, p. 233).

—Coll. Samuel S. Joseph (lender to exh. *Royal Academy*, London, 1891, cat. no. 52).

—Coll. Mrs Joseph (lender to exh. *Royal Academy* 1900, cat. no. 18 and 1909/10, cat. no. 50).

—Art gall. Knoedler; acquired by H. C. Frick, 1911 (cat. *Frick* 1968).

6. *Girl reading a Letter at an open Window*
Dresden, Staatliche Gemäldegalerie
Traces of signature in background.
Canvas, 83 × 64.5 cm. (32¾ × 25¼ ins.)
Bürger 31. HdG 34. De Vries 5: 1657. Bloch: 1655–60. Goldscheider 6: 1658.
1659. See pp. *32, 33–5, 40, 44, 62, 67, 70, 77 n. 53.*

PROVENANCE: ? Sale Pieter van der Lip, 1712 (see cat. no. 14).

—Data taken from cat. Dresden 1896, no. 1336: Acquired in 1742 by de Brais in Paris for August III, Elector of Saxony, Dresden; in 1753 in that coll. as '*Maniera di Rembrandt*'; in 1754 and 1782 as by Rembrandt; in 1783 engraved by Joh. Ant. Riedel as by 'Flinck'; in 1856 in the coll. as by P. de Hooch, from 1862 onwards as by 'Jan van der Meer van Delft'.

—In addition to this: *Cat. des tableaux de la Galerie Electorale à Dresde*, 1765, p. 68, no. 346: '*De l'école de Rembrandt . . . Une jeune Fille debout devant une Fenêtre ouverte, lisant une lettre, figure jusqu'aux genoux. Sur toile, 2 pieds 9 pouces de haut, sur 2 pieds 3 pouces de large*' ['School of Rembrandt . . . A young Girl standing before an open Window, reading a letter, three-quarter length figure. On canvas, height 2 feet 9 inches, width 2 feet 3 inches']. The same description occurs in: *Abrégé de la vie des peintres dont les tableaux composent La Galerie . . . Dresde*, 1782, p. 317, no. 346.

—*Verzeichnis der Gemälde . . . zu Dresden*, 1801, p. 49, no. 346, as: *Aus der Schule Rembrants, von Gobert*' ['From the school of Rembrandt, by Gobert'] i.e., Govert Flinck).

—*Cat. des tableaux de la Galerie Royale de Dresde*, 1826, p. 74, no. 486, as by: 'Pierre de Hooghe', with a note in J. Smith's handwriting in his copy at the R.K.D.: '*Delfts van der Meer*'.

—Recognized anew as Vermeer of Delft by G. F. Waagen, *Einige Bemerkungen über die . . . Koeniglichen Gemäldegallerie zu Dresden*, Berlin, 1858, pp. 35, 36 (see W. Bürger, *Musées de la Hollande* II, Brussels etc., 1860, p. 75).

—*Verzeichnis der Dresdner Gemäldegalerie*, 1862, no. 1433 as: 'Jan van der Meer (van Delft)'.

—From 1945 to 1955 in the Soviet Union (see cat. *Ausstellung der von der Regierung der UDSSR an die Deutsche Demokratische Republik übergebenen Meisterwerke*, Dresden [1956], pp. 7–14, cat. no. 1336).

7. *The Milkmaid*
Amsterdam, Rijksmuseum
Canvas, 45.5 × 41 cm. (17⅞ × 16⅛ ins.)
Bürger 25. HdG 17. De Vries 9: 1658. Bloch: 1655–60. Goldscheider 9: 1660.
1660–61. See pp. *32, 35, 40, 63–5.*
In my opinion *The Milkmaid* may be a modernized, greatly simplified version of a 'kitchen-piece'. This genre originates with the sixteenth-century masters Pieter Aertsen and Joachim Beuckelaer and had become archaic and uncommon in the seventeenth century. Exceptionally in Delft, however, it was continued in the seventeenth century by numerous masters: Cornelis Delff and Pieter van Rijck. Moreover, the Delft topographer, van Bleyswyck, praises in 1667 the '*keuckens*' (kitchens) by Christiaen van Bieselingen and Michiel van Miereveld (*Bleyswyck*, pp. 842–50).

PROVENANCE: Coll. A. Dissius, Delft; sale Amsterdam, 16 May 1696, no. 2: '*Een Meyd die Melk uytgiet, uytnemende goet . . . F 175.—*' ['A Girl pouring Milk, extremely well painted . . . F 175.—'] (see document 62).

—Sale Amsterdam, 20 April 1701, no. 7: '*Een Melkuytgietstertje, van dito* [= Vermeer van Delft], *krachtig gegeschildert*' ['A Milk-pouring Girl, by ditto [Vermeer of Delft], vigorously painted'] for F 320 (*Hoet*, I, p. 62). *This was a sale of paintings owned by Isaac Rooleeuw; in his inventory the painting is mentioned as: '*Een melkuytgieterstie van dezelve*' ['a milkpouring girl by the same'] (S. A. C. Dudok van Heel: see cat. no. 15).

—Sale Jacob van Hoek, Amsterdam, 12 April 1719, no. 20: '*Het vermaerde Melkmeysje, door Vermeer van Delft, konstig*' ['The famous Milkmaid, by Vermeer of Delft, artful'], for F 126.— (*Hoet*, I. p. 221).

—Sale [Pieter Leender de] N[eufville], Amsterdam (J. M. Cok), 19 June 1765, no. 65: '*Delfse vander Meer . . . Een keuken-Vrouwtje, met Bywerk; zynde krachtig van licht en bruin, en sterk werkende. P. 17½ duim hoog, 15½ duim breed*' ['Delft vander Meer . . . A kitchen-Maid, with Accessories; vigorous in light and brown, and very expressive. P. Height 17½ inches, Width 15½ inches'], for F 560 to Yver '*voor een Engels lord*' ['for an English lord'] (note *HdG*).

—Sale of '*een voornaam Liefhebber*' ['A distinguished Amateur'] [Dulong], Amsterdam (H. de Winter and J. Yver), 18 April 1768, no. 10: '*De Delfsche vander Meer . . . Een Binnen-vertrek, op Doek geschilderd, hoog 17, breed 15½ duim. In dit Stuk ziet men een Vrouwtje aan een Tafel staan, gietende Melk uit een Kan in een Pan, die op de Tafel staat; waarby een Mantje met brood en eenig ander bywerk gezien wordt: zynde krachtig van licht en bruin, en van een natuurlyke werking*' ['The Delft vander Meer . . . An Inner room, painted on Canvas, height 17, width 15½ inches. In this Painting one sees a Woman standing at a Table, pouring Milk from a Jug into a Bowl, which stands on the Table; also a little Basket with bread and some more accessories: being vigorous in light and brown, and giving a natural effect'], for F 925 to Van Diemen.

—Seen in 1781 by J. Reynolds at J. J. de Bruyn's (see p. 63).

—Sale Jan Jacob de Bruyn, Amsterdam, (Ph. van der Schley), 12 September 1798, no. 32: '*De Delfsche vander Meer . . . Dit uitmuntend en fraai Tafreel, verbeeld in een Binnenvertrek, een Vrouwtje in oude Hollandsche Kleeding staande voor een tafel, met een groen kleed bedekt, waar op een korfje met brood, eenig ander gebak, een aarde bierkan en pot geplaatst is, in welke zy uit een aardekom melk, schynt te gieten; verder aan de muur hangt een mandje en koperen emmer, en op den grond staat een stoof; het Licht, het geen door een Vengster ter zyde invalt geeft eene verwonderlyk natuurwerking, is kragtig van coloriet en uitmuntende van penceel behandeling, en een der schoonste van deezen onnavolgbaaren Meester. hoog 18, breed 16 duim. Doek*' ['The Delft vander Meer. . . . This excellent and beautiful Scene, represented in an Inner-room, a Woman dressed in old Dutch Costume standing before a table covered with a green cloth, on which are placed a little basket with bread, some other pastry, an earthenware tankard and a pot into which she seems to pour milk from an earthenware jug; on the wall hangs a small basket and a copper bucket, and on the floor is a foot-warmer; the Light, falling in through a Window at the side, gives a miraculously natural effect, the painting is of vigorous colour, and excellent for its handling of the brush and one of the most beautiful of this inimitable Master. Height 18, width 16 inches. Canvas'] for F 1550 to J. Spaan.

—Sale Hendrik Muilman, Amsterdam (Ph. van der Schley), 12 April 1813, no. 96: '*De Delftsche vander Meer . . . In een Keukenvertrek ziet men eene Dienstmaagd in oud Hollandsche Kleeding, staande voor eene Tafel met een groen Kleed bedekt, waarop een Korf met Huisbakken Brood; op de Tafel zijn nog andere dergelijke stukken brood, als mede aan aarden Bierkan en Pot, in welken zij uit een aarden Kan melk schijnt te gieten; een den Muur, waarop zeer kunstig en natuurlijk de ingeslagen spijkers zigtbaar zijn, hangt een Mandje en Koperen Emmer; op den voorgrond staat een Stoof, onder tegens den Muur gebakken Steentjes; het licht ter zijde door een venster invallende, doet eene voortreffelijke werking, overeenkomstig de natuur. Het is krachtig van kleur, stout van behandeling, en het best van dezen Meester. Hoog 18, breed 16 duimen, Doek*' ['The Delft vander Meer. . . . In a Kitchen-room one sees a Servant girl in old-fashioned Dutch Costume, standing before a Table covered with a green Cloth on which a Basket with Homemade Bread; on the Table are other pieces of this kind of bread, as well as an earthenware Tankard and a Pot, into which she seems to pour milk from an earthenware Jug; on the Wall, where the hammered-in nails are visible in a very artful and natural way, hangs a little Basket and a Copper Bucket; in the foreground stands a Foot-warmer, below against the Wall baked Tiles; the light, falling in through a window at the side, makes an excellent impression, in accordance with nature. It is of vigorous colour, audacious of treatment, and the best of this Master. Height 18, width 16 inches. Canvas'], for F 2125 to 'De Vries W.' N.B. this should be understood as: 'to Art Dealer Jer. de Vries by order of Van Winter', that is to say Lucretia Johanna van Winter

(1785–1845). In 1822, she married Jhr. Mr Hendrik Six van Hillegom (1790–1847). At the same Muilman auction other paintings were also sold to 'De Vries W.' which, like our cat. no. 7, became part of the collection of the direct descendants of Mr Hendrik Six (Muilman 131: J. Ruisdael and no. 138: R. Ruysch are cat. exh. coll. Six 1900, nos. 120 and 181).

—Coll. Six, Amsterdam, cat. exh. 1900 no. 70.
—Purchased by the museum, 1907/8 (see also: F. Lugt, '*Is de aankoop door het Rijk van een deel der Six-collectie aan te bevelen?*' ['Is the purchase by the State of part of the Six Collection to be recommended?'], brochure, 1907, 2 printings).

A **copy** by Reinier Vinkeles, (1741–1816), with additions done by him, was sold at the Jan van Dyk sale, Amsterdam (Ph. van der Schley), 14 March 1791, Portfolio G, no. 11 (for F 50 to Van Loon) and at the Amsterdam sale (Roos), 14 February 1855, cover C, no. 94 (to Gruyter, for F 30). A coloured drawing after the painting was made by Jan Gerard Waldorp (1740–1808; sale W. T. Groen, Amsterdam, 2 November 1813, Portfolio C. no. 39).

8. *The Glass of Wine*
Berlin-Dahlem, Gemäldegalerie
Canvas, 65 × 77 cm. (25 × 29⅞ ins.)
Bürger 20. HdG 37. De Vries 11: 1658–60. Bloch: 1655–60. Goldscheider 11: 1660.
1660–61. See pp. 35, 40, 75 n. 10, 77 n. 59, also 73.
The coat of arms in the window (depicted in the same way in Plate 11) is believed to have been the coat of arms of the family of Janettje Jacobsdr. Vogel, the first wife of Moses Jans van Nederveen, who died in 1624 in Delft; possibly this couple lived in the house where Vermeer later resided. According to *Neurdenburg* 1942 p. 69, the artist may have found this coat of arms in a window and painted it. The picture on the rear wall is in the style of the landscape painter Allaert van Everdingen.

PROVENANCE: Sale Jan van Loon, Delft, 18 July 1736, no. 16: '*Een zittend drinkend Vrouwtje, met een staande Mans-Persoon, door van der Meer h 2 v. 2 d. br. 2 v. 6 d. f. 52*' ['A seated Woman, drinking with a Man standing, by van der Meer h. 2 f. 2 inches w. 2 f. 6 inches, f. 52'] (*Hoet*, II, p. 390).
—*Coll. J. Hope, Amsterdam, 1785, handwritten '*Catalogus van het Cabinet Schilderyen*' of this collection at the R.K.D.: '*Meer (van der) bijgenaamd de Delftse. Een Heer staande by een dame die in een groot vertreck aan een tafel zit en een glas uitdrinkt . . . 26¼ × 30¼ D.*' ['Meer (van der) alias the Delft one. A gentleman standing with a lady who in a large room sits at a table and empties a glass. 26¼ × 30¼ in.']
John Hope (1737–84) was a prominent merchant and banker in Amsterdam. His sons Thomas (died 1830) and Henry Philip Hope (died 1839) fled to England when the French invaded Holland in 1794. In England they both had an important collection of paintings. The *Glass of Wine* does not figure in Waagen's full description of Thomas Hope's collection in London, visited by him in 1830 (G. F. Waagen, *Treasures of Art in Great Britain* II, London, 1854, p. 112ff.). The collections of both brothers were inherited by Sir Henry Thomas Hope of Deepdene, Surrey (died 1862), then by his daughter Henrietta Adela (died 1884), who married Henry Pelham, 6th Duke of Newcastle-under-Lyme (1834–79). Henry Francis Hope Clinton-Hope, who owned the Vermeer in 1891, was their son and heir (these data derive from sale cat. *Hope Collection of Pictures of the Dutch and Flemish School*, 1898, introduction; *Burke's Peerage*, 1953, p. 1555; J. E. Elias, *De vroedschap van Amsterdam*, II, Haarlem, 1905, pp. 933 and 934).
—Coll. Lord Henry Francis Hope Pelham-Clinton-Hope cat. 1891, no. 54.

—Sold in 1898, as part of the complete H. F. Clinton Hope coll., for £121 550 *in toto*, to art dealers P. & D. Colnaghi and A. Wertheimer (sale cat. *Hope . . .* op. cit., introduction and no. LIV, with ill.).
—Purchased by the museum in 1901 (cat. Berlin 1931, no. 912 C).

9. *The little Street ('Het Straatje')*
Amsterdam, Rijksmuseum
Signed left below the window.
Canvas, 54.3 × 44 cm. (21¼ × 17 ins.)
Bürger 49. HdG 47. De Vries 7: 1658. Bloch: 1655–60. Goldscheider 7: 1659.
1661. See pp. 7, 36–40, 43, 64, 65, 77 n. 56.

PROVENANCE: Coll. Dissius, Delft, 1682; sale Amsterdam, 16 May 1696, no. 32: '*Een Gesicht van een Huys staende in Delft f 72–10*' ['A View of a House standing in Delft f 72–10'] (see document 62).
—On 22 November 1799 in the estate of Mrs Croon, widow of G. W. van Oosten de Bruyn: '*Een gezigt op 2 huysjes in de stad Delft door de Delftsche Vermeer*' ['A view on 2 little houses in the town of Delft by the Delft Vermeer'] (A. Bredius, in *Oud-Holland* 39, 1921, pp. 59–62).
—Sale [van Oosten de Bruyn], Haarlem (Van der Vinne), 8 April 1800, no. 7: '*Een Gezigt op twee Burger Huizen in de Stad Delft, tusschen byde ziet men een Gang, alwaar agter in, een Vrouw aan een Tobbe staat te waschen, in 't Huis ter regterzyde zit in 't Voorhuis voor aan de deur een Vrouw te naaijen, en op de Stoep leggen twee Kinderen te speelen, dit stuk is wonder natuurlyk en fraai geschildert, door de Delftsche vander Meer, h. 1 v. 10, b. 1 v. ¾ d.*' ['A View on two Burgher Houses in the Town of Delft, between them one sees an Alley, at the far end of which a Woman stands washing at a Tub, in the house on the right a Woman sits sewing at the front door and two Children lie playing on the step, this painting is wonderfully natural and beautifully painted, by the Delft vander Meer, h. 1 f. 10, w. 1 f. ¾ inches'], for F 1040 (first figure is indistinct) to H. van Winter. N.B. This refers to the Amsterdam merchant and poet Pieter van Winter (1745–1807), father of Lucretia van Winter, who inherited his collection.
—Inherited by the Six family (for this inheritance see cat. no. 7).
—Cat. exh. coll. Six, Stedelijk Museum, Amsterdam, 1900, no. 71.
—Bought by H. W. A. Deterding and given to the Rijksmuseum, 1921 (cat. Rijksmuseum 1934, no. 2528b).

A painted **copy** after the painting was in the sale of E. B. Rubbens *et al.* Amsterdam, 11 August 1857, no. 67. From the beginning of the nineteenth century numerous drawn and watercolour copies by the following artists are also mentioned: *C. van Noorde* (1731–95): sale A. Watering, Amsterdam, 7 Nov. 1866, no. 158, *R. Vinkeles* (1741–1816): Mr. D. Baron van Leyden, Amsterdam, 13 May 1811, cover K, no. 20; sale W. Baartz, Rotterdam, 6 June 1860, Portfolio B., no. 43; sale Blussé v. Zuidland & Velgersdijk, Amsterdam, 15 March 1870, no. 324, *G. Lamberts* (1776–1850): sales 1825 and 1827 (see *HdG*) and sale Jer. de Vries, Amsterdam, 15 November 1853, no. 243; sale D. van Lankeren, Amsterdam, 22 January 1856, Portfolio G, no. 166; sale A. Watering, Amsterdam, 7 November 1866, no. 171. *A. Brondgeest* (1786–1849): sale J. Schepens et al., Amsterdam, 21 January 1811, Portfolio L, no. 13.
Some copies mentioned here may not have been after our cat. no. 9, but perhaps after cat. no. 10 or 36 or after one of the paintings by Vrel (see p. 64) at that time attributed to Vermeer.

10. *View of Delft*
The Hague, Mauritshuis
Signed with monogram below left, on the boat.
Canvas, 98 × 117.5 cm. (38 × 46¼ ins.)
Bürger 48. De Vries 8: 1658. Bloch: 1660. Goldscheider 10: 1660.
1661, See pp. 40, 43, 66–7, 69.

To the right of the two women in the foreground a man was painted and then overpainted by Vermeer himself; now he is vaguely visible again (see *Swillens*, pls. 69A and B).

PROVENANCE: Coll. Dissius, Delft, 1682; sale Amsterdam, 16 May 1696, no. 31: '*De Stad Delft in perspectief, te sien van de Zuyd-zy . . . 200–0*' ['The Town of Delft in perspective to be seen from the South-side . . . 200–0'] (see document 62).

—Sale S. J. Stinstra (Harlingen), Amsterdam (Jer. de Vries), 22 May 1822, no. 112: '*Dit kapitaalste en meestberoemdste Schilderij van dezen Meester, wiens stukken zeldzaam voorkomen, vertoont de stad Delft, aan de Schie; men ziet de geheele stad met hare poorten, torens, bruggen als anderzins; op den voorgrond heeft men twee vrouwen, met elkander in gesprek, terwijl ter linkerzijde eenige lieden zich als gereed maken in eene jaagschuit te treden; verder liggen voor en aan de stad verscheiden schepen en vaartuigen. De schildering is van de stoutste, kragtigste en meesterlijkse, die men zich kan voorstellen; alles is door de zon aangenaam verlicht; de toon van licht en water, de aard van het metselwerk en de beelden maken een voortreffelijk geheel, en is dit Schilderij volstrekt eenig in zijn soort. hoog 9 p. 8 d., breed 1 el 1 p. 6 d. Doek*'. ['This most capital and most famous Painting of this master, whose works seldom occur, shows the town of Delft, on the Schie river; one sees the whole town with its gates, towers, bridges etc.; in the foreground there are two women in conversation, while on the left some people seem to be preparing to step on board a canal-barge; furthermore in front of and against the town lie diverse ships and vessels. The way of painting is of the most audacious, powerful and masterly that one can imagine; everything is illuminated agreeably by the sun; the tone of light and water, the nature of the brickwork and the people make an excellent ensemble, and this Painting is absolutely unique of its kind. Height 9 dm., 8 cm., width 1 m., 1 dm., 6 cm. Canvas'], for F 2900 to de Vries.

—Purchased by the State of the Netherlands, as stated in a letter of the Ministry of the Interior dated 5 June 1822 to the director of the museum (HdG; cat. Mauritshuis 1935, no. 92)

Een '*Stadsgezigt, zijnde een* **kopie** *naar een beroemd Schilderij van den Delftschen van der Meer*' [View of a Town, being a **copy** after a famous painting by the Delft van der Meer] by P. E. H. Praetorius (1791–1876) was at the exh. *Levende Meesters*, Amsterdam, 1814, cat. no. 116. Another copy, on panel, after the '*Gezigt op de Stad Delft*' was at an Amsterdam sale, 8 Nov. 1824, no. 46 (for F 126 to de Vries). Drawn and watercolour copies were made by: C. van Noorde (1731–95; sale 1834); R. Vinkeles (1741–1816; sale 1833); W. Hendriks (1744–1831; sale 1819), and H. Numan (1744–1820; sale 1793, 1800 and 1820). For dates of sales etc. see: HdG. The last mentioned copy was also in the sale of Mr Dr D. Baron van Leyden, Amsterdam, 13 May 1811, cover N, no. 15. An anonymous copy done '*in sapverwen*' [watercolours] was in the sale of I. Nauta *et al.*, 12 April 1842, cover O, no. 10. Undoubtedly identical with one of these copies is a drawing in the Staedelsches Institut at Frankfurt, sometimes wrongly considered to be a preliminary study by Vermeer. This drawing is thought to originate from the sale de Vos, Amsterdam, 1833, sold for F 92. In the municipal archives in Delft is a drawn view of the same site by P. van Liender, dated 1752 (information from cat. Mauritshuis 1935). For other copies possibly after cat. no. 10, see cat. no. 9.

11. *Woman and two Men*
Brunswick, Herzog Anton Ulrich-Museum
Signed left on the window.
Canvas, 78 × 67 cm. (*30⅝ × 26 ins.*)
Bürger 6. HdG 38. De Vries 12: 1658–60. Bloch: 1660. Goldscheider 15: 1663.
1662. See pp. 41, 62, 63, 77 n. 59.
For the coat of arms in the window see no. 8. The portrait in the

background may be after one of the family portraits mentioned in the inventory of Vermeer's widow (cf. *Van Peer 1957*, p. 97). Lately it has been plausibly suggested that Vermeer has characterized the man sitting at the table as the mournful, jilted lover (J. B. Bedaux, in: *Antiek* 10, 1975, p. 35). Judging from the descriptions of the painting made in 1744 and 1776 (cited below) this man was at that time overpainted.

It is often said that the painting is now in bad condition. As early as 1900 Jan Veth remarked that the Berlin restorer Hauser had handled it too roughly ('*te zeer heeft aangepakt*', in: *De Kroniek* 6, 1900, p. 68). Beneath the spoilt varnish, however, the details appear to have been generally well preserved.

PROVENANCE: Coll. Dissius, Delft; sale Amsterdam 16 May 1696, no. 9: '*Een vrolijk gezelschap in een kamer, kragtig en goet . . . F 73*' ['A merry company in a room, vigorously and well painted . . . F 73'] (see document 62). N.B. this text has never before been connected with our cat. no. 11. Since, however, this painting is, in 1711, 15 years later (again) called '*Eine lustige Gesellschaft*' ['A merry Company'] (see below) it is quite possible that the two paintings are identical.

—First mentioned as being in Brunswick around 1711, in: T. Querfurt, *Kurtze Beschreibung des fürstlichen Lust-Schlosses Saltzdahlum . . . Braunschweig, Catalogus derer vornehmsten Schildereyen so in dem Fürstl. Saltzdahlischen Lust Schlosse befindlich . . .*:' '*Eine Lustige Gesellschaft*'; in manuscript dated 1744 as: '*Einen jungen Herrn mit seiner Geliebten*' ['A young Gentleman with his Beloved'] (see H. Riegel, *Beiträge zur Niederl. Kunstgeschichte* II, Berlin 1882, p. 331ff). Described in C. N. Eberlein, *Verzeichniss der . . . Bilder-Galerie zu Salzthalen*, 1776, p. 127, p. 128, no. 30: '*Johann von der Meer . . . Ein Frauenzimmer in einem rothen Kleide von Atlas, sitzet mit einem Glase Wein in der Hand, an einem Tische, und lächelt. Hinter ihr steht eine Mannsperson, welcher ihr Glas mit anfasst, und sie zärtlich ansieht. Das Zimmer hat ein bemahltes Fenster, und an der Wand hängt ein Portrait. Auf Leinwand, 2 Fuss 4 Zoll breit, 2 Fuss 8 Zoll hoch*' ['Johann von der Meer . . . A Woman in a red satin Dress, sits with a Glass of Wine in her Hand at a Table, and smiles. Behind her stands a Man, who holds her Glass with her and looks at her tenderly. The Room has a painted Window, and on the Wall hangs a Portrait. On Canvas, 2 feet 4 inches wide, 2 feet 8 inches high.]

—In cat. by L. Pape, 1849, no. 142, called: 'Jacob van der Meer'.

—Recognized by Thoré as Vermeer van Delft (W. Bürger, *Musées de la Hollande*, II, Brussels etc. 1860, p. 72ff.).

12. *Woman with a Water Jug*
New York, Metropolitan Museum
Canvas, 45.7 × 42 cm. (*17⅞ × 16¼ ins.*)
HdG 19. De Vries 10: 1658–60. Bloch: 1660. Goldscheider 16: 1663.
1662. See pp. 41, 62, 73, 77 n. 48.
In the background part of a map of the Seventeen Provinces published by Huyck Allart is visible, one copy of which has been preserved (*Welu*, p. 534). For the technique of the painting see text, illustrated with an X-ray photograph etc., by H. von Sonnenburg (*Walsh and Sonnenburg*).

PROVENANCE: * Coll. Robert Vernon, 1838 (*exh. Pictures by Italian . . . Masters*, British Institution, London, 1838, cat. no. 29: 'A Female at a window, Metzu').

—*Sale Robert Vernon (Hatley Park, Cambridgeshire), London (Christie), 21 April 1877, no. 97: 'Metzu Interior, with a lady at a table covered with a carpet, on which is an ewer and dish, opening a window', for £404.5sh., to Art dealer M. Colnaghi, London.

N.B. The above has never been connected with our painting, but was published by Hofstede de Groot as referring to a lost work by Metsu (*HdG*, I, Metsu, no. 62).

—Sold by Colnaghi to Lord Powerscourt for 600 gns (author's copy HdG), i.e. Mervyn Wingfield, 7th Viscount Powerscourt, 1836–1904 (see: *Burke's Peerage . . .* ed. 1953); in his coll. as early as 1878, according to cat. exh. *Old Masters, Winter Exhibition*, Royal Academy, London, 1878, no. 267: 'Jan van der Meer, of Delft . . . Lady at a casement. Threequarter figure of a lady, in a blue and yellow jacket and blue skirt, and white hood and cape, standing near a table, on which is a basin and ewer, and a casket; she has her l. hand on the ewer, and is in the act of closing the casement with her r. Canvas, 17½ by 15½ in'.

—Art Dealer Thos. Agnew, London (author's copy HdG).

—Art gall. Ch. Pillet, Paris, sold to Henry G. Marquand, New York, 1887, for $800 as by Pieter de Hooch (author's copy HdG). N.B. according to W. R. Valentiner, in *Monatshefte für Kunstwissenschaft* III, 1910, p. 11 acquired by Marquand for 800 dollars at an American sale, as by Pieter de Hooch.

—Given to the museum in 1888 by Marquand (cat. Metropolitan Museum . . . 1931, no. V 59–1).

13. *Woman with a Pearl Necklace*
Berlin-Dahlem, Gemäldegalerie
Signed on the table.
Canvas, 55 × 45 cm. (21⅛ × 17¾ ins.)
Bürger 33. HdG 20. De Vries 18: 1662–3. Bloch: 1665. Goldscheider 18:1665.
1662–5. See pp. *25, 42, 43, 49, 54, 77 n. 48.*

PROVENANCE: Coll. Dissius, 1682; sale Amsterdam, 16 May 1696, no. 36: '*Een Paleerende dito [=juffrouw], seer fraey . . .*' ['Another ditto (=a young lady) adorning herself . . . very beautiful'] for F 30 (see document 62)

—Sale Johannes Caudri, Amsterdam (Ph. van der Schley), 6 September 1809, no. 42: '*De Delfsche van der Meer . . . In een gemeubileerde Kamer staat eene bevallige jonge Dame voor een Tafel, waar boven een spiegel geplaatst is, zij is gekleed in een geel satijn Jakje met Bont gevoerd, en schijnt zig te Paleeren; het invallende zonlicht verspridt zig tégen een witte Muur en doet alle de Voorwerpen met luister voorwaards koomen; dit bevallig tafreel is een der natuurlykste en alleruitvoerigste gepenceelden van deze beroemde Meester, hoog 20, breed 17 duim. Doek*' ['The Delft van der Meer . . . In a furnished Room stands a graceful young Lady at a Table, above which a mirror is placed, she is dressed in a yellow satin Jacket lined with Fur, and seems to be Adorning herself; the incoming sunlight spreads against a white Wall and makes all Objects stand out with splendour; this elegant scene is one of the most natural and most elaborately painted of this famous Master, height 20, width 17 inches. Canvas.'] for F 55 to Ths. Spaan.

—Sale [D. Teengs], Amsterdam (Ph. van der Schley), 18 April 1811, no. 73: '*De Delftsche van der Meer . . . In een gemeubileerde Kamer, ziet men eene jonge bevallige Dame voor eene Tafel, zij is gekleed in een geel Satijn Jakje met Bont, het invallende zonlicht verspreidt zich tegen een witte Muur en doet een schoone werking. Het is zeer fraai en uitvoerig gepenceeld. Hoog 18, breed 16 duimen. Doek*' ['The Delft van der Meer . . . In a furnished Room, one sees a young graceful Lady at a Table, she is dressed in a yellow Satin jacket with Fur, the entering sunlight spreads against a white Wall and makes a beautiful effect. It is very beautifully and elaborately painted. Height 18, width 16 inches. Canvas'], for F 36 to Gruyter.

—* Sale Amsterdam (Roos), 26 March 1856, no. 93: '*De Delftsche van der Meer . . . Een binnenvertrek; voor eene tafel staat een rijk gekleede Dame, bezig zijnde een snoer paarlen om te doen, zeer natuurlijk en fraai behandeld. h. 52, br. 46 d. Doek*' ['The Delft van der Meer . . . An inner-room; at a table stands a richly dressed Lady, occupied in putting on a string of pearls; very naturally and beautifully done. h. 52, w. 46 inches. Canvas'], for F 111 to Philip.

—Coll. H. Grevedon (*Bürger*, p. 559) (not as Vermeer in sale Grevedon, Paris, 15 January 1853.)

—Coll. Thoré Bürger, 1866 (*Bürger*, p. 559, engraving on p. 325).

—Sale Comte C[ornet de Ways Ruart of Cremer, George H. Phillips and W. Bürger], Brussels (Etienne le Roy), 22 April 1868, no. 49, with description cited after *Bürger*, pp. 558–9, for 3500 to Sedelmeyer. (N.B. It is therefore improbable that Bürger possessed the painting in 1869, as is always stated.)

—Coll. Suermondt, 1874 (Cat. Kaiser-Friedrich-Museum, 1911 and 1931, no. 912 B).

A drawn **copy** after the painting done by Jan Gerard Waldorp (1740–1808) was in the sale of P. Yver, Amsterdam, 31 March 1788, no. 27 (for F 10.10 to Pruyssenaar).

14. *Woman in blue reading a Letter*
Amsterdam, Rijksmuseum
Canvas, 46.5 × 39 cm. (18⅛ × 15¼ ins)
Bürger 32. HdG 31. De Vries C: 1662–63. Bloch: 1660–65. Goldscheider 17: 1664.
1662–5. See pp. *42, 43, 49, 54, 63, 77 n. 48.*
The map is the same as that depicted in nos. 22 and 5 (see there and *Welu*, pp. 532ff.).

PROVENANCE: The following reference from 1712 may relate to either catalogue no. 14 or cat. no. 6: Sale Pieter van der Lip, Amsterdam, 14 June 1712, no. 22: '*Een leezent Vrouwtje, in een kamer, door vander Meer van Delft 110.0*' ['A Woman Reading, in a room, by vander Meer of Delft 110.0'] (*Hoet*, I, no. 22).

—* Sale Amsterdam, 30 November 1772, no. 23: '*Van der Neer, de Delftsche . . . Dit Kabinet-stukje, verbeeld een Binnevertrek; waar in een bevallig Dametje, staande een Brief te leezen voor haar Toilet; ziende men agter dezelve, aan de Muur, een Land-Kaart. Zeer fraai, uitvoerig en natuurlijk behandeld; op Doek, hoog 18 en een half, breed 16 duim*' ['Van der Neer, the Delft one . . . This Cabinet-Piece, depicts an Inner-room; in it a graceful Lady, standing and reading a Letter at her Toilet; behind her, on the Wall, a Map is visible. Very beautifully, elaborately and naturally done; on Canvas, height 18 and a half, width 16 inches'].

—Sale Mr P. Lyonet, Amsterdam, 11 April 1791, no. 181: '*De Delfsche van der Meer . . . In een Binnenvertrek ziet men een jonge Dame gekleed in een Blaauw Zatyn Jakje, staande voor een Tafel waar op een Koffertje, Paarlen en Papieren leggen; schynende beezig met veel aandagt een Brief te leezen; aan de witte Muur hangt een groote Landkaart, gestoffeerd met verder Bywerk; dit Stuk is fraay en natuurlyk behandeld op Doek, door de Delfsche van der Meer, het bevallig ligt en donker geeft een schoone welstand, gemeenlyk eigen aan de werken van deeze beroemde Meester, h. 18, br. 15 duim*' ['The Delft van der Meer . . . In an Inner-room one sees a young Lady dressed in a Blue Satin Jacket, standing at a Table on which lie a small Box, Pearls and Papers; seemingly reading a Letter with much attention; on the white Wall hangs a large Map, filled in with other Accessories; this Painting is beautifully and naturally done on Canvas, by the Delft van der Meer, the pleasing light and shadow give it a fine appearance commonly characteristic of the works of this famous Master, h. 18, w. 15 inches'] for F 43 to Fouquet.

—* Sale Amsterdam, 14 August 1793, no. 739 '*Delfsche van der Meer . . . In een Binnekamer staat een Vrouwtje, in 't blauw Satyn gekleed voor een tafel, bezig zynde een brief te leezen die zy met beide handen vasthoud, op de Tafel ziet men een Koffertje en een snoer Paarlen, en aan de muur hangt een groote landkaart; dit schildery dat van een byzonder natuurlyke werking is, is ongemeen fraai uitvoerig en meesterlyk gepenceeld. Doek, hoog 19, breed 15½ duim*' ['Delft van der Meer . . . In an Inner-room stands a Lady, dressed in blue Satin at a table, reading a letter which she holds with both hands, on the Table one sees a little Box and a string of Pearls,

and on the wall hangs a large map; this painting, which has an extremely natural effect, is painted in an unusually beautiful elaborate and masterly way. Canvas, height 19, width 15½ inches'], for F 70.

—Sale Herman ten Kate, Amsterdam (Ph. van der Schley), 10 January 1801, no. 118: '*Delftsche van der Meer . . . Een Dame in 't blauw Fluweel gekleed, staat voor een Tafel een brief te leezen, tegen de muur hangt een Landkaart, het licht in dit stukje geeft een goede uitwerking en is kloek gepenceeld. Hoog 19, breed 16 duim. Doek*' ['Delft van der Meer . . . A Lady dressed in blue Velvet, stands at a Table, reading a letter, on the wall hangs a Map, the light in this piece gives a good effect and is of vigorous touch. Height 19, width 16 inches. Canvas'], for F 110 to Taijs.

—Sale Paillet, Paris, 1809, with description and notice: '*H. 17 pouces; L. 14 pouces*', for fr. 200 (mentioned by *Bürger*, p. 558, always repeated by later authors, but not traced by them, nor by us).

—Sale L[apeyrière], Paris (Henry), 19 April 1825, no. 127: '*Van der Meer . . . La Toilette. Une femme vue à mi-corps, debout, nue tête, vêtue d'une camisole de soie bleu de ciel, est placée vis-à-vis d'une toilette sur laquelle on remarque un collier de perles et un coffre ouvert. Elle tient dans ses mains une lettre qu'elle paraît lire avec beaucoup d'attention. Cette figure se détache en demi-teinte sur une muraille blanche, ornée d'une grande carte géographique suspendue à des rouleaux. Outre que ce tableau est très-piquant d'effet, rien n'est plus naturel que la pose de la femme, ni mieux exprimé que l'intérêt que lui inspire la lettre qu'elle lit. Toile, hauteur 17 pouces, largeur 14 pouces*' ['Van der Meer . . . The Toilet. A woman seen at half-length, standing, bareheaded, dressed in a chemise of sky blue silk, is placed before a toilet-table, on which a string of pearls and an open box can be seen. In her hands she holds a letter which she appears to be reading with much attention. This figure detaches itself in half-tones from a white wall, adorned with a large map suspended by rollers. This painting is of a very piquant effect and moreover nothing is more natural than the pose of the woman, nor better expressed than the interest inspired by the letter she reads. Canvas, height 17 inches, width 14 inches'], for fr. 2060 (according to *Bürger*, p. 558: possibly for fr. 1122 to Bellandel).

—N.B. ever since the cat. *Rijksmuseum . . . schilderijen*, 1885, p. 103, no. 164, it has been stated that the painting was in the Sommarive sale, 18 February 1839, sold for F 882, but it does not figure in the catalogue.

—Bought from J. Smith, London, 1839 by A. van der Hoop, Amsterdam (cat. Rijksmuseum 1934).

—Coll. Van der Hoop, bequeathed to the city of Amsterdam, 1854; on loan to the Rijksmuseum, 1885.

15. *Woman weighing Gold*
Washington, National Gallery of Art
Canvas, 42 × 35.5 cm. (16½ × 13¾ ins.)
Bürger 26/27. HdG 10. De Vries 17: 1662–63. Bloch: 1660–65.
Goldscheider 21: 1665.
1662–5. See pp. 22, 42–4, 49, 54, 67.
The painting on the wall appears to be an otherwise unknown work by a sixteenth-century Netherlandish master. According to Goldscheider it 'looks like a later version of a famous composition by Jean Bellegambe' (*Goldscheider*, p. 130).

PROVENANCE: Coll. Dissius, 1682; sale Amsterdam, 16 May 1696, no. 1: '*Een Juffrouw, die goud weegt, in een kasje . . . extraordinaer konstig en kragtig geschildert . . . F 155*' ['A Young Lady, weighing gold, in a box . . . painted in an extraordinarily skilful and vigorous way . . . F 155'] (see document 62).

—Sale Amsterdam, 20 April 1701, no. 6: '*Een Goudweegsterstje, van Vermeer van Delft*' ['A Woman weighing Gold, by Vermeer van Delft'], for F 113 (*Hoet* I, p. 62). This was a sale of paintings belonging to the Amsterdam merchant Isaac Rooleeuw (c. 1650–1710), who had gone bankrupt. In his inventory, which also included our cat. no. 7, the painting is called: '*Een goutt weegstertie van Van der Meer van Delft*' (S.A.C. Dudok van Heel, in *Jaarboek van het Genootschap Amstelodamum* 37, 1975, p. 162).

—* On 15 August 1703 in the inventory of Paulo van Uchelen (c. 1641–1702), Amsterdam: '*Een goudt weegstertien van Van der Meer*' ['A woman weighing gold by Van der Meer'], valued at F 150, allotted to Paulo van Uchelen jr. (Dudok van Heel, loc. cit.).

—* Sale Amsterdam, 18 March 1767, no. 6: '*Een Binnevertrek in het zelfe een Goudweegster, zynde een staand Vrouwtje voor een Tafel, hebbende een Jakje aan met een witte Bontte rand, en is van vooren en op de zyde te zien, in haare Regterhand heeft zy een Goud schaaltje, en verder is de Tafel half overdekt met een Kleed, op dezelven leggen Paarlen en andere Kleinodie, kragtig uytvoerig en Zonagtig op Doek geschildert, hoog 16 duim, breed 14 duim*' ['An Inner-room in which a Woman weighing Gold, being a Woman standing at a Table, wearing a Jacket with a border of white Fur, and is seen from the front and from the side, in her Right hand she holds a pair of Gold scales, and furthermore the Table is half covered with a Cloth, on which lie Pearls and other Trinkets, painted in a vigorous, elaborate and Radiant way on Canvas, height 16 inches, width 14 inches']

—Sale Nicolaas Nieuhoff, Amsterdam (Ph. van der Schley), 14 April 1777, no. 116: '*De Delftsche van der Meer . . . Een binnenkamer; alwaar een vrouwtje bezig is, goud te wegen, haar hoofd is gedekt met een wit kapje, hebbende een donker blaauwen fluweelen mantel, met wit bont gevoerd, om; zy staat voor een tafel, waarop een blaauw kleed legt, beneffens een kasje met paarlen, en andere kleinodien: ten einde van 't vertrek aan de muur een schildery, verbeeldende 't laatste oordeel, dit is zeer malsch en vet in de verf geschilderd, en wel in den besten tyd, van dezen meester. Hoog 16¼, en breed 14 duim. Pnl.*' ['The Delft van der Meer . . . An inner-room; where a woman is weighing gold, her head is covered with a white cap, wearing a dark blue velvet coat, lined with white fur; she stands at a table, on which lies a blue cloth, next to a little box with pearls, and other trinkets; at the end of the room a painting on the wall, representing the Last Judgment; this is painted very softly and thickly being from the best period of this master. Height 16¼, and width 14 inches. Panel'], for F 235 to Van den Bogaard.

—Sale [Roi de Bavière], Munich, 5 December 1826, no. 101: '*Gabriël Metzu, et selon d'autres van der Meer . . . L'interieur d'une chambre où une femme debout devant une table tient une balance de la main droite, sur la table on voit des perles éparses et un écrin auprès d'un tapis bleu foncé. La muraille qui est derrière la femme est ornée d'un grand tableau. Sur toile. H. 1' 3" 6''', L. 1' 4" (pieds, pouces et lignes de France). Ce tableau est marqué du monogramme: GM'.* ['Gabriel Metsu, and according to others van der Meer . . . The interior of a room where a woman standing at a table holds a pair of scales with her right hand, on the table one sees scattered pearls and a jewel case next to a dark blue cloth. The wall behind the woman is decorated with a large painting. On canvas. H. 1' 3" 6''', W. 1' 4" (French measurements). This painting is marked with the monogram: GM.'] N.B. In J. Smith's copy of this sale cat. in his handwriting: 'Delft Van der Meer' (copy at the R.K.D.).

—Sale Duc de C[araman], Paris (Lacoste), 10 May 1830, no. 68: '*Vander Meer de Delft . . . La Peseuse de perles. Une jeune dame, la balance à la main, est debout dans une chambre à coucher, près d'une table en partie couverte d'un tapis; des perles sont sur la table à côté d'un écrin, et c'est par désoeuvrement, sans doute qu'elle s'amuse à les peser. M. le duc de C . . . a fait acheter ce délicieux tableau à la vente du Cabinet particulier du feu roi de Bavière, aux yeux de qui on l'avait fait*

passer pour un ouvrage de Gabriel Metzu. Il n'est point de peinture dont l'exécution soit d'une douceur plus exquise. La figure vêtue d'un japon et d'un manteau de lit garni d'hermine (costume simple que le goût ne réprouvra jamais) se détache sur un fond de muraille grisâtre, ce qui produit un effet aussi naturel qu'il est heureusement rendu. Un tableau marque une partie du mur. Les productions de Vander Meer de Delft sont si rares que nous ne pouvons nous dispenser de signaler celle-ci d'une manière toute particulière aux amateurs. T., h. 15p. 6 l., l. 16 p.' ['Van der Meer of Delft . . . The Woman weighing pearls. A young lady, a pair of scales in her hand, stands in her bedroom, at a table partly covered with a cloth; on the table are pearls next to a box of jewels, and it is certainly from idleness that she amuses herself weighing them. The Count of C . . . has had this delicious painting bought at the sale of the private Collection of the late king of Bavaria, to whom they had passed off the painting as a work by Gabriel Metsu. There exists no painting of which the execution is of more exquisite softness. The figure wearing a gown and a bed-jacket trimmed with ermine (a simple costume which taste can never find fault with) detaches herself from a background of a greyish wall, which produces an effect as natural as it is felicitously represented. A painting fills part of the wall. The works of Vander Meer of Delft are so rare that we cannot avoid calling the art lover's attention to this one in a very special way. C., h. 15 p. 6 l., w. 16 p.'] for fr. 2410.

—* Sale Casimir Périer, London (Christie), 5 May 1848, no. 7: 'Van der Meer . . . An Interior, known as "La Peseuse de perles"; a woman dressed in velvet corset lined with fur, is weighing some jewels at a table near a window. 1 ft. 3 in. by 1 ft. 5 in.—upright. From the Delapeyriere collection', bought in by the son of Périer for £141.15 sh.

—Coll. Comtesse de Ségur-Périer; Art gall. F. Lippmann, London; Art gall. P. & D. Colnaghi, London (author's copy HdG).

—Coll. P. A. B. Widener, Lynnewood Hall, Elkins Park, Penn., cat. 1913, vol. I, no. 47, with ill.

—Coll. Joseph Widener, Lynnewood Hall . . ., cat. 1931, p. 50.

—P. A. B. and J. E. Widener collection in the museum (Cat. National Gallery, Washington, 1965, no. 693. N.B. The painting is not yet included in the *Preliminary Catalogue of paintings . . .*, Washington, 1941).

16. *The Music Lesson*
London, Buckingham Palace
Signed right on lower edge of picture frame.
Canvas, 73.6 × 64.1 cm. (28⅞ × 25 ins.)
Bürger 10. HdG 28. De Vries A: 1659–60. Bloch: 1660. Goldscheider 13: 1662.
1664. See pp. 41, 44, 45, 49, 56, 62, 77 n. 64.
Just enough can be seen of the painting in the background for it to be recognized as a *Caritas Romana* painted in the manner of the Utrecht Caravaggists, viz. a picture of Pero suckling her father Cimon, who has been condemned to death by starvation. Such a *'schilderije van een die de borst suygt'* [painting of a figure who sucks the breast] was owned by Vermeer's mother-in-law in Delft (see document 7). In the mirror the painter's easel is discernible (Nicolson, op. cit. on p. 77, note 64).

PROVENANCE: Maybe in coll. Diego Duarte, Antwerp, 1682 (see below cat. no. 25).

—Sale Amsterdam, 16 May 1696, no. 6: *'Een speelende Juffrouw op de Clavecimbael in een Kamer, met een toeluisterend Monsieur . . . F 80'* ['A young Lady playing the Clavecin in a Room, with a Gentleman listening . . . F 80'] (see document 62).

—Probably sale Amsterdam, 11 July 1714, no. 12: *'Een Klavecimbael-speelster in een Kamer, van Vermeer van Delft, konstig geschildert . . . F 55–0'* [A woman playing a Clavecin in a Room,

by Vermeer van Delft, skilfully painted . . . F 55–0'] (*Hoet*, I, p. 176). N.B. Until now it has always been assumed that this reference could just as well concern cat. no. 25 or cat. no. 31. However, Joseph Smith (1675–1770), English consul in Venice, bought Dutch paintings there in about 1741 from the widow of the painter Giovanni Antonio Pellegrini (1675–1741); later on Smith sold the greater part of his collection to King George III (F. Haskell, *Patrons and painters*, London, 1963, p. 307; F. Herrmann, *The English as collectors*, London, 1972, p. 26). One of the paintings acquired by George III from Smith was our cat. no. 16: 'nr. 91. Frans van Mieris. A woman playing on a Spinet in presence of a Man seems to be her father, 2 feet, 5 inches, 2 feet 1½ inches' (list of 1762; see A. Blunt and E. Croft-Murray, *Venetian drawings of the XVII & XVIII centuries in the collections of Her Majesty the Queen at Windsor Castle*, London, 1957, p. 21; F. Vivian, *Il console Smith, mercante e collezionista*, Vicenza, 1971, p. 206, cat. no. 91.) Pellegrini stayed in The Hague in 1718 (*Obreen*, V, p. 141) and we may assume that he bought his Dutch paintings on that occasion. The painting that was on the market in 1714 was, as far as we know, the only *'clavecimbaelspeelster'* by Vermeer for sale in the Netherlands at that time. The most probable provenance of cat. no. 16, therefore, is chronologically: * Sale 1714; coll. Pellegrini, coll. Jos. Smith; coll. George III; English Royal Collection.

Joseph Smith probably had a **copy** made after the painting, listed thus in his inventory of 1770: *'Altro quadrato con specchio sopra, soaza detta (dorata d'intaglio) rappresenta una Giovane che tocca il Clavicembalo con il Maestro al di lei fianco'* (Vivian, loc. cit.)

17. *The Concert*
Boston, Isabella Stewart Gardner Museum
Canvas, 69 × 63 cm. (27¼ × 24¾ ins.)
Bürger 23. HdG 29. De Vries 14: 1658–60. Bloch: 1660. Goldscheider 14: 1662.
1664. See pp. 27, 45, 77 n. 48.

The painting on the right in the background is the 'Procuress' by van Baburen (my Fig. 22; noticed by H. Voss, in: *Monatshefte für Kunstwissenschaft* 5, 1912, pp. 79 sqq.). It was in the possession of Vermeer's mother-in-law (see document 7). It is also depicted in Plate 31.

PROVENANCE: * Sale Johannes Lodewijk Strantwijk (Amsterdam), Amsterdam (Ph. van der Schley), 10 May 1780, no. 150: *'Jan vander Meer, de Delfze . . . In een binnenkamer zit eene Dame die op 't Klavier speelt, werdende geaccompagneert door een Heer die op een Gitar speelt, en een Vrouwtje die zingt, beneffens eenig bywerk, ongemeen fraay en meersterlyk behandelt, hoog 28, breed 24, op Doek* ['Jan vander Meer, the Delft one . . . In an inner-room sits a Lady who plays the Clavecin, being accompanied by a Gentleman who plays a Guitar, and a Woman who sings, and some accessories, painted in an extraordinary beautiful and masterly way, height 28, width 24, on Canvas'], for F 315 to A. Delfos for the 'Heer' van Vlaardingen N.B. This undoubtedly refers to Diederik van Leyden, 'Heer' van Vlaardingen (1744–1810).

—Sale M[onsieur] van Leyden (Amsterdam), Paris (Paillet), printed catalogues dated 5 July 1804, 10 September 1804 and of the definitive sale, 5 November 1804 no. 62: *'Jean van der Meer de Delft . . . L'Intérieur d'un Salon, avec grands Carreaux de marbre noir et blanc. On y voit dans le milieu un Homme assis, et vu par le dos, faisant de la Musique avec deux jeunes Personnes. L'une touche du Clavecin, tandis que l'autre chante en battant la mesure. A droite est une Table négligemment couverte d'un Tapis de Turquie, où sont posés des Livres de Musique et une Guitare. On distingue encore dans la demi-teinte une Basse jetée à terre. Van der Meer, de Delft, est un des Peintres qui a le plus approché de la manière large et moelleuse de*

Gabriel Metzu, et ses Ouvrages sont tellement rares, particulièrement en Sujets composés, que les Amateurs sont réduits aujourd'hui à se contenter de quelques Portraits d'Artistes, de la main de cet Auteur, dont les productions ont toujours été regardées comme classiques, et dignes de l'ornement des plus beaux Cabinets. Peint sur toile, haut. 25½. larg. 23 p.' ['Jean van der Meer of Delft . . . The Interior of a Drawing-room, with large Tiles of black and white marble. One sees in the middle a sitting Man, seen from the back, Music-making with two young Persons. One woman plays the Clavecin, while the other one sings and beats time. At the right is a Table carelessly covered with a Turkish carpet, on which Music Books and a Guitar have been put. Also, in the semi-shade, can be distinguished a Bass lying on the floor. Van der Meer, of Delft, is one of the painters who has come nearest to the spacious and mellow manner of Gabriel Metzu, and his Works are so rare, particularly extensive compositions, that the Amateurs have to content themselves nowadays with a few Portraits of Artists, by the hand of that Author, whose products have always been considered classic and worthy to adorn the most beautiful collections. Painted on canvas, height 25½, width 23 inches'], for fr. 350 to Paillet.

—* Sale London (Foster), 26 February 1835, no. 127: 'Vandermeer of Delft. Interior of an Apartment, with a Lady at a piano, Gentleman singing &c. A capital specimen of this rare master.' Printed in capitals, with five other paintings on the title-page of the catalogue: 'those most entitled to notice . . . An interior with three figures, Vandermeer de Delft' (identification by Peter Sutton).

—Sale Admiral Lysaght et al (part: 'A different Property'), London (Christie), 2 April 1860, no. 49: 'Van der Meer, of Delft . . . A musical party', for £21 to Toothe.

—Sale D[emidoff], Paris (Pillet), 1 April 1869, no. 14: '*Jan van der Meer ou Vermeer de Delft . . . Concert avec trois personnages. Intérieur d'un salon hollandais. Une jeune fille, vue de profil, touche du clavecin. Un gentilhomme, vu de dos, pince de la mandoline. A droite, une jeune femme chante en battant la mesure. Divers accessoires. Vente de la baronne Van Leyden, Paris 1804. Toile, Haut., 67 cent.; large., 60 cent.*' ['Jan van der Meer or Vermeer of Delft . . . Concert with three persons. Interior of a Dutch drawing-room. A young girl, seen in profile, touches the clavecin. A gentleman, seen from the back, plucks the mandoline. On the right, a young woman sings, beating time. Various accessories. Sale of the baronne Van Leyden, Paris 1804. Canvas, Height 67 centimetres; width 60 centimetres'], for fr. 5100, in our opinion most likely to Thoré-Bürger.

—Sale (heirs) Thoré-Bürger, Paris (Drouot), 5 December 1892, no. 31, with description taken from sale cat. 1804, for 29 000 to Robert.

—Acquired at this sale by Mrs Isabella Stewart Gardner 'who ordered the bidding of her agent Robert with a handkerchief' (cat. Stewart Gardner Museum by Ph. Hendy, Boston, 1931, p. 407).

18. *The Girl with a pearl Ear-ring*
The Hague, Mauritshuis
Signed top left.
Canvas, 46.5 × 40 cm. (18⅛ × 15 ins.)
HdG 44. De Vries B: 1660. Bloch: 1660–65. Goldscheider 23: 1665. 1665. See pp. 46, 59.

PROVENANCE: * Possibly identical with '*een tronie van Vermeer*', valued at F 10-0-0 in the inventory of Jean Larson, The Hague, 1664 (our cat. no. 32).

—Possibly identical with sale Amsterdam, 16 May 1696, no. 38, 39 or 40; probably not identical with sale Luchtmans, 20 April 1816, no. 92 (see our cat. no. 30).

—Coll. A. A. des Tombe, The Hague, purchased at sale Braam, The Hague, beginning of 1882, for F 2.30 (cat. Mauritshuis 1935, no. 670) At exh. *Schilderijen van oude meesters*, Pulchri Studio, The Hague, 1890, cat. no. 117: '*Johannes Vermeer. Meisjeskop. Borstbeeld naar links, met een blauw en witte doek om het hoofd gewonden, en een geel jak. In het linker oor een groote parel. Gemerkt links bovenaan: I. V. Meer. Hoog 0.45, breed 0.38½. Op doek*' ['Johannes Vermeer. Head of a Girl. Bust to the left, with a blue and white cloth wound around the head, and a yellow jacket. In the left ear a large pearl. Signed top left: I. V. Meer. Height 0.45, width 0.38½. On canvas'].

Bequeathed by des Tombe in 1903 to the museum (cat. Mauritshuis 1935, no. 670).

19. *The Art of Painting*
Vienna, Kunsthistorisches Museum
Signed on map, to the right of the girl.
Canvas, 130 × 110 cm. (51⅛ × 43¾ ins.)
Bürger 5. HdG 8. De Vries 23: 1665. Bloch: 1665–70. Goldscheider 24: 1666.
1662–5. See pp. 10, 11, 41, 43, 46–9, 56, 59, 62, 70, 75 n. 11, 77 n. 48. On the map, which shows the Northern and Southern Netherlands, can be read, partly covered by the chandelier: NOVA XVII. PROV[IN]CIARUM [GERMANIAE INF] ERI[O]RIS DESCRIPTIO/ ET ACCURATA EARUNDEM . . . DE NO[VO] EM[EN]D[ATA] . . . REC[TISS]IME EDIT[A P]ER NICOLAUM PISCATOREM. 'Nicolaus Piscator' is the Latin name of the Amsterdam cartographers Nicolaes Visscher sr and jr. The map also appears on paintings by Maes and Ochtervelt. Only one copy of it has been preserved, an edition of 1692, on which the town views, depicted on the left and the right of the map used by Vermeer, are missing (see: *Welu*, p. 536).

The most recent article on the painting and its meaning: H. Miedema, 'Johannes Vermeers schilderkunst', in *Proef, Kunsthistorisch Instituut van de Universiteit van Amsterdam*, Sept. 1972, pp. 67–76.

The painter's costume strongly resembles that of the young man on the left in the *Procuress* (Plate 3).

PROVENANCE: on 24 February 1676 Vermeer's widow conveyed to her mother: '*een stuck schilderie, geschildert . . . bij haeren man za: waerin wert uytgebeelt de Schilderconst*' ['a piece of painting, painted . . . by her late husband; in which is depicted the Art of Painting']; on 12 March 1677 the mother declares to have received indeed: '*seeker stuck Schilderije geschildert bij . . . Vermeer, waerinne wert uytgebeelt de Schilderkonst*' ['a certain piece of Painting painted by . . . Vermeer, in which is represented the Art of Painting'] and that it is not fair that her daughter's trustee wants to have it auctioned, as is shown by '*gedruckte billietten*' ['printed notices'] documents 39, 51).

—? Sale Amsterdam, 16 May, 1696, no. 3: '*'t Portrait van Vermeer in een Kamer met verscheyde bywerck ongemeen fraai van hem geschildert*' ['The Portrait of Vermeer in a Room with various accessories uncommonly beautifully painted by him'] at F 45 (see our cat. no. 33 and document 62). N.B. It is uncertain whether this was our cat. no. 19, as is generally assumed, since this is not a 'Portrait' and the price of F 45 is improbably low for this large and richly filled major work in Vermeer's *œuvre*: other major works, the *Woman weighing Gold, The Milkmaid* and the *View of Delft* (our cat. nos. 15, 7 and 10) fetched at that same auction F 155, F 175 and F 200 respectively.

—Acquired by Johann Rudolf Count Czernin, according to his own notes, in 1813 from the estate of Gottfried van Swieten, via a saddlemaker for 50 fl. as a Pieter de Hooch. Until 1860 in the Czernin Collection as by de Hooch (Cat. coll. Czernin, Vienna, 1936, no. 117). N.B. Gottfried Freiherr van Swieten

(died 1803) was first a diplomat. His father, Gerard baron van Swieten, occupied numerous functions at the court of Maria Theresia of Austria. When he died in 1722 his son succeeded him as prefect of the Imperial Court library. The young van Swieten may have inherited the painting from his father, since the latter was greatly interested in the arts (see: W. Müller, *Gerhard van Swieten . . .*, Vienna, 1883, *inter alia* pp. 2, 39, 110–112).

—Brought by A. H(itler) to his residence at Berchtesgaden (*De Vries*).

—Acquired by the museum in 1946 (cat. Kunsthistorisches Museum, Gemäldegalerie, II, Vienna, 1963, no. 395).

20. *Lady writing a Letter*
Washington, National Gallery of Art
Signed on the frame of the painting in the background.
Canvas, 47 × 36.8 cm. (18 × 14⅜ ins.)
Bürger 40. HdG 36. De Vries 19: 1663–4. Bloch: 1665. Goldscheider 20: 1665.
1666. See pp. 10, 25, 54, 56, 73, 77 n. 48.
The painting in the background is probably the one showing '*een bas met dootshoofd*' [a bass with skull], which appeared in the inventory of Vermeer's widow (see document 40). K. Boström plausibly suggested that it was by the still-life painter Corn. van der Meulen (K. Boström, 'Jan Vermeer van Delft en Corn. van der Meulen', in *Oud-Holland* 66, 1951, pp. 117–22).

PROVENANCE: Coll. Dissius, Delft; sale Amsterdam, 16 May 1696 no. 35: '*Een schrijvende Juffrouw heel goet . . . 63.0*' ['A young Lady writing very good . . . 63.0'] (see document 62).

—* Sale J. van Buren, The Hague (Scheurleer), 7 November 1808, p. 264, no. 22: '*Een bevallig vrouwtje in 't geel satyn met bond gekleed, zittende te schryven aan een tafel waar op een snoer paerlen in een kistje geplaatst zyn, uitmuntend fraai, uitvoerig en meesterlyk gepenseeld door de Delfsche van der Meer D. zeer raar*' ['A graceful woman dressed in yellow satin with fur, sitting and writing at a table on which a string of pearls is placed in a box, extremely beautifully and masterfully painted in great detail by the Delft van der Meer. C. very rare'.]

—Sale d'un amateur à Rotterdam' [Dr. Luchtmans], Rotterdam (Muys), 20 April 1816, no. 90: '*J. van der Meer, de Delft . . . Une jeune personne en négligé dans un mantelet jaune, bordé de pelleterie; occupée à écrire sur une table, sur laquelle sont placés une cassette, écritoire etc. Haut 16 pouces, large 14½ pouces; Toile*' ['J. van der Meer, of Delft . . . A young woman in a morning-dress with a yellow jacket, trimmed with fur; busy writing at a table, on which are placed a box, ink-stand etc. Height 16 inches, width 14½ inches; Canvas'], (according to de Vries for F 70).

—Sale J. [should be F.] Kamermans, Rotterdam (Lamme), 3 October 1825, no. 70: '*De Delfsche van der Meer . . . Eene bevallige Jonge Dame, die op een tafel met een blauw kleed er over, zit te Schrijven, zeer fraai van dezen Meester, h. 42 d. b. 37 d. D.*' ['The Delft van der Meer . . . A graceful Young Lady, who sits Writing at a table with a blue cloth on top. Very beautiful by this Master, h. 42 inches w. 37 inches. C.']

—Sale Hendrik Reydon, *et al.*, Amsterdam (Jer. de Vries), 5 April 1827, no. 26: '*De Delftsche van der Meer . . . Eene deftig gekleede Dame, zittende aan eene tafel te schrijven, waarop eenig bijwerk ligt. Uitnemend fraai van toon en behandeling. hoog 4 p. 7 d., breed 3 p. 6 d. Doek*' ['The Delft van der Meer . . . An elegantly dressed Lady, sitting and writing at a table, on which lie some accessories. Extremely beautiful of tone and treatment. height 4 p. 7 d., width 3 p. 6 d. Canvas'], withdrawn.

—Sale Comte F. de Robiano (Brussels) Brussels (Barbé), 1 May 1837, no. 436: '*J. van der Meer . . . Devant une table couverte d'un tapis, est assise une jeune et jolie fille occupée à écrire; elle est vêtue d'une*

casaque jaune claire, garnie en hermine blanche, et tient la Tête levée vers le spectateur. L. 38, H. 45. T.' ['J. van der Meer . . . At a table covered with a carpet sits a young and lovely girl who is busy writing; she is dressed in a bright yellow jacket, trimmed with white ermine, and she holds her Head raised towards the spectator. W. 38, H. 45. C'], for fr. 400 to Heris, Brussels.

—Art gall. Paris, 1907 (according to cat. exh. *Vermeer*, Boymans Museum, Rotterdam, 1935, no. 86a).

—Coll. Pierpont Morgan, New York, exhibited in the Metropolitan Museum (newspaper report 6 October 1908).

—Art gall. Knoedler, New York; Coll. Lady Oakes, Nassau, Bahamas (*De Vries*).

—Art gall. Knoedler & Co, New York, 1958; coll. Horace Havemeyer, New York (*Goldscheider*).

—Presented to the museum 1971, by a private collector, who will transfer it in due course.

21. *Lady with her Maidservant*
New York, The Frick Collection
Canvas, 92 × 78.7 cm. (36¼ × 30¾ ins.)
Bürger 8. HdG 33. De Vries 25: 1666–7. Bloch: 1665–70. Goldscheider 29: 1670.
1666–7. See pp. 25, 54–5, 56, 63, 77 n. 48.

PROVENANCE: In our opinion, the following applies more exactly to this painting than to our cat. no. 22: Coll. Dissius, Delft; Sale Amsterdam, 16 May 1696, no. 7: '*Een Juffrouw die door een Meyd een brief gebragt wordt . . . 70-0-*' ['A Lady who is brought a letter by a Maid'] (see document 62).

—N.B. Because of dimensions and description this is not the painting in the sale Jos. van Belle, 1730 (see cat. no. 27). Sale Amsterdam (Haring), 15 October 1738, no. 12: '*Een schryvent Juffertje in haar Binnekamer die een Brief ontfangt, door de delfse van der Meer*' ['A girl writing in her Inner-room who receives a Letter, by the Delft van der Meer'], for F 160 to Oortman.

—N.B. Since the painting was auctioned in 1738 it cannot be the '*juffer die een brief schrijft en een meid bij haar*' ['lady who writes a letter with her maid-servant'] in the coll. Franco van Bleiswyck, since that painting remained in one family from (before) 1734 until (after) 1761 (see cat. no. 26).

—N.B. Bürger and all later authors stated that the painting is the one sold in the Blondel de Gagny sale, Paris, 10 December 1776, no. 72, as Ter Borch ('*une femme qui écrit, sa servante la regarde*', to Poullain) and in the Poullain sale, Paris, 15 March 1780, no. 40 bis. From the description in the latter sale cat., in which it is remarked that: '*on voit encore un lit et un fauteuil rouge*' ['a bed and a red chair are also visible'], it appears that this painting cannot have been our cat. no. 21, nor the pastiche in the Steenokerzeel sale (Brussels, 13 October 1953, no. 374, with ill.) with which S. J. Gudlaugsson identified Poullain sale no. 40 bis (*Gerard ter Borch*, II, The Hague, p. 128, no. 114n).

—N.B. No reference has previously been made to the following sale, in which our cat. no. 21 seems to figure, though the dimensions given in the sale cat. are smaller and a mirror is mentioned. It is also remarkable that the painting fetched a very high price: *Sale van Helsleuter et al.* (anonymous part), Paris (Paillet), 25 January 1802, no. 106: '*Van der Meer de Delft. L'intérieur d'une chambre hollandaise. A gauche et sur le devant on voit de profil une jeune et jolie femme de carnation blonde, ajustée d'un manteau de lit d'une étoffe d'un jaune vif et brillant, bordé d'hermine. Elle est assise auprès d'une table couverte d'un tapis vert, sur laquelle sont un miroir, un coffret et autres accessoires; elle vient de remettre à sa servante, qui est de l'autre côté de la table, et troisième plan, un billet sur lequel il n'y a point d'adresse; et semble éprouver, ainsi que son geste l'indique, beaucoup d'embarras pour expliquer à sa servante, qui la*

regarde en souriant, l'objet du message. Voici la première fois que nous avons occasion de citer dans nos catalogues cet habile peintre, et d'offrir aux amateurs un de ses ouvrages marquans. Le Brun, dans son Oeuvre sur la vie des peintres, pag. 49, tom. 2, en fait le plus grand éloge; et son mérite étonnant, ainsi qu'on peut le juger par ce beau Tableau, a droit de fixer l'attention des curieux. Peint sur toile, haut de 30, large de 24 p.' ['Van der Meer of Delft. The interior of a Dutch room. In the left foreground one sees in profile a young and lovely woman of blond flesh-tints, dressed in a bedjacket of clear and brilliant yellow material, trimmed with ermine. She sits at a table covered with a green cloth, on which are a mirror, a little box and other accessories; she has just handed over to her maid-servant, who is on the other side of the table, in the background, a note on which there is no address and she seems to feel, as her gesture indicates, much embarrassment at explaining to her servant, who looks at her smilingly, the recipient of the message. It may be noted that this is the first time that we are able to cite this able painter in our catalogues, and to offer one of his striking works to art-lovers. Le Brun gives him the highest praise in his Work on the life of the painters, p. 49, vol 2; and his astonishing merit justifies the attention of the curious, as one can judge from this beautiful Painting. Painted on canvas, height 30, width 24 p.'], for fr. 2000.

—Art gall. Ch. Lebrun, Paris, as appears from the outline in print in Lebrun, *Recueil de gravures au trait ... d'après un choix de tableaux, de toutes les écoles, recueillies dans un voyage fait en Espagne, au midi de la France et en Italie dans les années 1807 et 1808*, II, 1809, no. 166, with note: '*hauteur 33 pouces, largeur 29 pouces, toile*'.

—Sale Lebrun, Paris (Lebrun), 20 March 1810, no. 143: '*Vander Meer, de Delft. No. 166, gravé, t. 2: Une jeune Femme comptant avec sa domestique; figures vues à mi-corps, sur toile*' ['Vander Meer of Delft. No. 166, engraved, vol. 2: A Young Woman counting with her housemaid; figures seen at half-length, on canvas'], for fr. 601 to Chevallier.

—* Sale D[rouillet] & De B[ertival], Paris (Ch. Paillet), 24 March 1818, no. 48: '*Vandermeer de Delft ... Une jeune dame vêtue d'une pelisse jaune et doublée d'hermine, vient de remettre une lettre à sa servante. Sur sa table couverte d'un tapis bleu, sont posés une écritoire et un coffret. Tableau d'une grande finesse de tons et d'une suavité de pinceau. h. 36, l. 22. t.*' ['Vandermeer of Delft ... A young lady dressed in a yellow pelisse and lined with ermine, has just handed over a letter to her servant. On the table covered with a blue cloth, are an inkstand and a little box. A painting of great delicacy of tones and softness of brush. h. 36, w. 22. c.'] for fr. 460.

—* Coll. Duchesse de Berry, sale exh., London, 1834, cat. no. 11: 'An interior, with a Lady despatching a letter by a female Attendant, on canvas, 35 × 31 in.', asking price £80.

—Sale Ancienne Galerie du Palais de l'Elysée [Duchesse de Berry], Paris (Bataillard), 4 April 1837, no. 76: '*Vandermeer de Delfdt. Une jeune personne de carnation blonde, coiffée en cheveux et la tête ornée de perles en bandeau; elle est accompagnée de sa servante, debout et tenant une lettre dont elle cherche à lire l'adresse. Ces deux figures se détachent sur un fond d'appartement mystérieusement éclairé, et rappellent, par leur exécution large et bien prononcée, les bons ouvrages de Terburg. Toile; hauteur, 32 pouces, largeur 28.*' ['Vandermeer of Delfdt. A young person of blond flesh-tones, her hair done and adorned with a bandeau of pearls; she is in the company of her servant, standing and holding a letter of which she tries to read the address. These two figures stand out against a background of a mysteriously lighted room, and recall, by their broad and positive execution, the beautiful works of Terburg. Canvas; height, 32 pouces; width, 28'], for fr. 415 to Paillet. N.B. The price is low compared with, e.g. nos. 36 (Metsu), 77 and 89 (both W. van Mieris) and 93

(Schalcken), which fetched resp. fr. 1000, 4200, 4100 and 4000.

—Coll. Dufour, Marseilles from 1859 or earlier (L. Lagrange, in: *Gazette des Beaux-Arts*, I, 1859, pp. 60, 61).

—Sale E. Secrétan, Paris (Boussod), 1 July 1889, no. 139, with description, for fr. 75 000 (cat. Frick 1968, p. 298: to Sedelmeyer).

—Coll. A. Paulovstof, St Petersburg (*HdG*).

—Art gall. Lawrie & Co, London (cat. Frick 1968, p. 298).

—Art gall. Sulley, London (*HdG*).

—Exh. *Werke alter Kunst Kaiser-Friedrich-Museums-Verein*, Palais Redern, Berlin, 1906. N.B. Not mentioned in cat., but, according to notes at R.K.D., sold there to James Simon, Berlin, for 325,000 R.M.; in 1914 still in his possession, according to Cat. exh. Berlin, 1914, no. 183.

—Art gall. Duveen, London/New York (*De Vries*).

—Coll. H. C. Frick 1919 (cat. Frick 1968, p. 298).

22. *The Love Letter*
Amsterdam, Rijksmuseum.
Signed on wall, on the left of the servant.
Canvas, 44 × 38.5 cm. (17¾ × 15⅛ ins.)
HdG 32. De Vries 24:1666. Bloch: 1665–1670. Goldscheider 31: 1670.
1667. See pp. 53–6, 77 n. 48.
On the left the map of Holland and West-Friesland also depicted in nos. 22 and 5 (q.v.) is partly visible (*Welu*, p. 533). The marine on the back wall may be the '*zeetje*' [small seascape] that figures in the inventory of his wife after Vermeer's death (see document 40). In 1971, at the exhibition *Rembrandt en zijn tijd* in the Paleis voor Schone Kunsten in Brussels, the painting was stolen by a man who had himself locked in the museum at night. He demanded a steep ransom destined for war casualties in Pakistan. His deed was alarmingly well received by the public. The only result was that the painting, which had been greatly damaged, was afterwards handed over with some ceremony to the Dutch Government. Fortunately only the most evenly coloured parts of the paint surface in the shadow areas were largely lost and these were ably restored by Mr L. Kuiper, restorer of the Rijksmuseum (see A. F. van Schendel, P. J. J. van Thiel and L. Kuiper, in: *Bulletin van het Rijksmuseum*, 20, 1972, pp. 127–67).

PROVENANCE: Sometimes, in our opinion mistakenly, identified with sale Amsterdam, 1696, no. 7 (see cat. no. 21).

—Coll. Pieter van Lennep (1780–1850) and his wife Margaretha Cornelia Kops (1788–1825); afterwards to their daughter Margaretha Catharina van Lennep (1815–91), who married Mr Jan Messchert van Vollenhoven (1812–81) in 1850 (from the introduction in sale cat. 1892).

—Sale Messchert van Vollenhoven, Amsterdam (Roos), 29 March 1892, no. 14, with elaborate description, for F 41 000 + 10% to the Vereeniging Rembrandt.

—Since 1893 in the museum (cat. Rijksmuseum 1934).

23. *The Astronomer*
Paris, Private Collection
Signed and dated 1668 on the cupboard (later addition?)
Canvas, 50 × 45 cm. (19⅝ × 17⅞ ins.)
Bürger 36. HdG 6. De Vries 27: 1668. Bloch: 1668. Goldscheider 27: 1668.
1668. See pp. 13, 55, 63, 77 n. 48.
The celestial globe can be identified with a globe of which three copies are preserved, produced by the Hondius family of cartographers. It was sold, as a pair, together with the terrestrial globe depicted in cat. no. 24 (*Welu*, p. 544ff. with data on the other astronomical instruments). Maybe this indicates that cat. nos. 23 and 24, which between 1713 and 1778 were sold four times together as companion pieces, were indeed originally intended as

such. This idea was given up in the modern literature because in both paintings the figure turns to the left. The painting that is partly visible in the right background of cat. no. 23 is depicted on another scale in Plate 27. It represents the Finding of Moses in the bulrushes (maybe included in no. 23 because Moses warned against the cult of the celestial bodies, according to *De Jongh 1976*, p. 83). Jacob van Loo and Christiaen van Couwenbergh of Delft have been mentioned as possible authors of this painting; to me W. L. van de Watering's attribution to the early Peter Lely seems more plausible.

PROVENANCE: For the provenance before 1778 see cat. no. 24.

—* Sale Jacob Crammer Simonsz. (Amsterdam), Amsterdam (Ph. van der Schley), 25 November 1778, no. 18: '*J. van der Meer bijgenaamt de Delfsche . . . Dit Stukje verbeeld een kamer, waar in een Philosooph zittende in zyn Japon voor een Tafel met een Tapytje overdekt, waar op een Hemel Globe, Boeken, en Astronomische Instrumenten, hy schynt met aandagt de Globe te beschouwen, het bevallige Ligt, het geen door een Vengster ter linkerzyde nederdaalt, doed een fraaije en natuurlyke Werking. Verder is het voorzien met eenige Meubelen, alles meesterlyk en fiks gepenceelt. Op Doek, hoog 20 breed 18 duim*' ['J. van der Meer called the Delft one . . . This Piece depicts a room, in which a Philosopher sitting in his Gown before a Table covered with a small Rug on which a Celestial Globe, Books, and Astronomical Instruments, he seems to be studying the Globe attentively, the pleasing Light, which descends from a Window on the left side, gives a beautiful and natural Effect. Furthermore it is equipped with some pieces of Furniture, everything painted masterfully and vigorously. On Canvas, height 20 width 18 inches'] (together with our cat. no. 24, see there).

—Art gall. Le Brun, Paris, according to the engraving after the painting signed 'Garreau Scul. en 1784', printed in: J. B. P. Lebrun, *Galerie des peintres flamands, hollandais et allemands*, II, Paris, 1792–6, p. 49.

—Sale Danser Nyman, Amsterdam (Ph. van der Schley), 16 August 1797, no. 167: '*Den Delfsche van der Meer. Een Philosooph, zittende in een Binnenvertrek voor een Tafel, die met een Tapyt gedekt is, met eenige Boeken voor hem, hy heeft zyn regter hand aan een Hemel Globe, die op den Tafel staat; konstig en natuurlyk verbeeld, en fraai van penceelbehandeling. Hoog 20, breed 16 duim. Doek*' ['The Delft van der Meer. A Philosopher, sitting in an Inner-room before a Table, which is covered with a Rug, with some Books in front of him, he has his right hand on a Celestial Globe, which stands on the Table; artfully and naturally represented, and beautiful of brushwork. Height 20, width 17 inches. Canvas'], for F 270 to Gildemeester (together with our cat. no. 24).

—Sale Jan Gildemeester Jansz., Amsterdam (Ph. van der Schley), 11 June 1800, no. 139: '*Een Philosooph in zyn binnenvertrek. Hy is verbeeld, zittende voor een tafel met een tapyt kleed bedekt, en eenige boeken voor hem, waar by geplaatst is een hemelglobe, op welke hy zyn hand houd; zeer natuurlyk en kunstig van behandeling. hoog 20, breed 18 duim. Doek*' ['A Philosopher in his inner-room. He is depicted sitting in front of a table covered with a rug, and some books in front of him, next to which a celestial globe is placed, on which he holds his hand; very natural and artful of treatment. Height 20, width 18 inches. Canvas'] for F 340 to La Bouchère.

—Sale London (Christie), 1863, no. 73, with description (this, according to note in *Bürger*, p. 324 and p. 560, no. 36: and repeated by later authors, but we could not find it).

—Sale Léopold Double (Paris), Paris (Pillet *et al.*), 30 May 1881, no. 17, with elaborate description; for fr. 44,500 to Gauchey.

—Coll. Alphonse Baron de Rothschild, Paris (*HdG*).

—Coll. Edouard Baron de Rothschild, Paris (*De Vries*).

24. *The Geographer*

Frankfurt, Städelsches Kunstinstitut

Signed on cupboard and signed and dated 1669 top right. Both (?) later additions.

Canvas, 53 × 46.6 cm. (20 × 18¼ ins.)

Bürger 34. HdG 5. De Vries 28: 1669. Bloch: 1668 [sic!]. Goldscheider 28: 1669.

1669. See pp. 13, 55, 63, 77 n. 48, 78 n. 93.

On the cupboard the same globe as on cat. 29 (see also no. 23). Next to it a framed map of Europe with sea routes (see *Welu*, p. 543ff., and for the various geographical instruments). E. de Jongh drew the attention to a very similar geographer illustrated in *Leerzame Zinnebeelden* by Adriaan Spinneker (Haarlem, 1714); The poem below counsels man to 'travel' with the aid of the two 'maps': the gospel and the life of Jesus (*De Jongh*, pp. 67, 68, figs. 51, 52).

PROVENANCE: This painting was sold several times together with cat. no. 23; both paintings being described in much the same way until 1778:

—Sale Rotterdam, 27 April 1713, no. 10: '*Een stuk verbeeldende een Mathematis Konstenaar, door vander Meer; no. 11. Een dito door denzelven*' ['A painting representing a Mathematical Artist, by vander Meer; no. 11. A ditto by the same'], together for F 300 (*Hoet*, II, p. 365; possibly the sale of part of the coll. Adriaen Paets; see: J. G. van Gelder, in: *Rotterdams Jaarboekje*, 1974, p. 169).

—Sale Hendrik Sorgh, Amsterdam, 28 March 1720, no. 3: '*Een Astrologist: door Vermeer van Delft, extra puyk. no. 4. Een weerga, van dito, niet minder*' ['An Astrologer: by Vermeer of Delft, extra beautiful. no. 4. A pendant of ditto, not inferior'], together for F 160. (*Hoet*, I, p. 242).

—Sale Govert Looten, Amsterdam, 31 March 1729, no. 6: '*twee Astrologisten van de Delfze van der Meer, heerlyk en konstig geschildert*' ['two Astrologers by the Delft van der Meer, wonderfully and artfully painted'] for F 104 (*Hoet*, I, p. 333).

—Sale Jac. Crammer Simonsz (Amsterdam), Amsterdam (Ph. van der Schley), 25 November 1778, no. 19 (not no. 20, as HdG erroneously states): '*J. van der Meer bijgenaamt de Delfsche. Een Philosooph in zyn studeer Vertrek, staande voor een Tafel met een Tapytje overdekt, waar op legt een op Parkament geteekende Landkaart, houdende in de Regterhand een Passer, en rustende met de andere op de Tafel, verder ziet men een Kast, waar op een Globe, Boeken en ander bywerk, het bevallige ligt, is in alles niet minder konstig waargenoomen, als in de voorgaande, zynde een weerga van dezelve. Doek, hoog en breed als de voorige*' ['J. van der Meer nicknamed the Delft one. A Philosopher in his Study, standing in front of a Table covered with a little Rug, on which lies a Map drawn on Parchment, holding in his Right hand a pair of dividers, and resting the other on the Table, furthermore one sees a Cupboard, on which a Globe, Books and other accessories, the pleasing light, is observed no less artfully in all this, than in the preceding piece, being a pendant of the same. Canvas, height and width as the preceding one'] [i.e. 20 × 18 inches; see our cat. no. 23], for F 172 (*De Vries*).

—Sale Jan Danser Nyman, Amsterdam (Ph. van der Schley), 16 August 1797, no. 168: '*den Delfschen van der Meer. In een Binnevertrek, bij een Glaase Raam, staat een Persoon voor een Tafel, met een Tapytkleed bedekt, waar op een Landkaart legd, houdende in de regter hand een Passer, en met de linker hand op de Tafel rustende, verder een Kast met Boeken, waar op een Globe staat; konstig en meesterlyk gepenceeld. Hoog 20 breed 18 duim. Doek*' ['the Delft van der Meer. In an Inner-room, near a Glass Window, stands a Person in front of a Table, covered with a Rug, on which lies a Map, holding in his right hand a Pair of Dividers, and with the left hand resting on the Table, further a Cupboard with Books,

on which stands a Globe, painted in an artful and masterly manner. Height 20 width 18 inches. Canvas'], for F 133 to Joszi (cf. p. 78 n. 93).

—* Sale Arnoud de Lange, Amsterdam (Ph. van der Schley), 12 December 1803, no. 55: '*In een Gemeubileerd Binnenvertrek staat een Geleerde aan een Tafel, met een Tapyten Kleed gedekt, houdende een Passer in zyn Hand, waar mede hy een voor hem liggende Landkaart schynt af te meeten; het zonlicht, dat door het Vengster invalt, is frappant, en de schildering meesterlyk, op Doek, door de Delfsche van der Meer*' ['In a Furnished Inner-room stands a Scholar at a Table, covered with a Rug, holding a Pair of Dividers in his Hand, with which he seems to be measuring a Map lying in front of him; the sunlight, falling in through the Window, is striking, and the painting masterly, on Canvas, by the Delft van der Meer'], for F 36 to Coclers (according to note in the sale cat. at the R.K.D. the painting came from the Heirs of Greve). It was one of the few paintings in the sale which had belonged to de Lange himself; see S. A. C. Dudok van Heel, in *Maandblad. . . . Amstelodamum* 64, 1977, p. 53 ff.)

—Sale Jhr. Johan Geoll van Franckenstein (Amsterdam), Amsterdam (Jer. de Vries), 1 July 1833, no. 47: '*de Delftsche van der Meer. In een binnenvertrek staat voor een vensterraam een geleerde met eene passer in de hand, bezig zijnde eene kaart te beschouwen, nevens hem liggen op den grond eenige boeken en teekeningen, tegen de muur staat eene kast met eene globe op dezelve, en naast de kast een stoel en verder bijwerk; fraai van schildering en uitdrukking. hoog 5 p. 2 d. breed 4 p. 6 d. Doek*' ['the Delft van der Meer. In an inner-room a scholar stands before a window with a pair of dividers in his hand, busy studying a map, beside him on the floor lie some books and drawings, against the wall stands a cupboard with a globe upon it, and next to it a chair and some more accessories; beautiful of painting and expression. height 5 f. 2 inches width 4 f. 6 inches. Canvas'], for F 195 to Nieuwenhuys.

—Coll. Alexandre Dumont, Cambrai (see: P. Mantz, 'Collections d'amateurs, I, Le Cabinet de M. A. Dumont, à Cambrai', in *Gazette des Beaux-Arts*, II, VIII, 1860, pp. 304–5; also Ch. Blanc, *Histoire des Peintres . . . Ecole Hollandaise*, II, Paris, 1863, engraving on p. 3.).

—Sale M. M. Pereire, Paris (Pillet/Petit), 6 March 1872, no. 13, with engraving by Deblois and detailed description; for fr. 17 200 (HdG and De Vries erroneously say fr. 7200).

—Coll. Max Kann, Paris, (cat. Sedelmeyer 1898).

—Sale [Demidoff], Palais de San Donato, Florence (Pillet et al.), 15 March 1880, no. 1124, with engraving by Deblois and the note: '*Signé deux fois*' ['signed twice']; for 22 000 lire.

—Sale Ad. Jos. Bösch (Döbling), Vienna (G. Plach), 28 April 1885, no. 32, for 9000 to Kohlbacher for the museum. N.B. in our opinion, the painting was at some time, between about 1872 and 1880, at Art gall. Ch. Sedelmeyer, Paris, as appears from his *Cat. of 300 Paintings . . .* 1898, no. 87, with ill.

Probably a **copy** after our cat. no. 23 or 24 was: '*Een Doctor in zijne studeerkamer, uitmuntend met kleuren naar de Delftsche van der Meer door v(incen)t v.d. Vinne*' [1736–1811] ['A Doctor in his study, excellent with colours after the Delft van der Meer by V(incen)t v.d. Vinne'] (sale of drawings Haarlem, 20 July 1835, Portfolio G, no. 2). A painted copy after the painting was in the sale Math. Neven (Cologne), Cologne (Heberle), 17 March 1879, no. 131; later at sale J. B. Foucart (Valenciennes), Valenciennes (J. de Brauwere), 12 October 1898, no. 115, with ill., for fr. 2500 (note of A. Bredius in sale cat.: '*toch wel uitstekende oude copie*' ['nevertheless an excellent old copie']; at both sales as by Vermeer.

25. *Lady standing at a Virginal*
London, National Gallery
Signed on the instrument.

Canvas, 51.7 × 45.2 cm. (20¼ × 17¾ ins.)
Bürger 29. HdG 23. De Vries 30 : 1670. Bloch: late. Goldscheider 35: 1671.
1670. See pp. 10, 53–6, 59, 77 n. 64.
The larger painting on the wall (it is also depicted in nos. 4 and B1) has plausibly been attributed to Caesar van Everdingen. Less convincing is the attribution to Jan van Bronchorst (for literature see *MacLaren*, p. 437). It may well be identical with the *Cupid* in the house of Vermeer's widow (see document 40). The landscape on the left is completely in the manner of Jan Wynants.

PROVENANCE: This painting or cat. no. 16 or cat. no. 31 is probably identical with the painting owned by Diego Duarte in 1682 in Antwerp: '*Een stuckxken met een jouffrou op de clavesingel spelende met bywerck van Vermeer, kost guld. 150*' ['a small piece with a lady playing the clavecin with accessories by Vermeer, cost florins 150'] (see document 60).

The following notes may refer either to cat. no. 25 or to no. 31:
1. Coll. Dissius; Sale Amsterdam, 16 May 1696, no. 37: '*Een Speelende Juffrouw op de Clavecimbaal F 42,10*' ['A Lady playing the Clavicembalo F 42,10'] (see document 62);
2. Sale Amsterdam, 11 July 1714, no. 12: '*Een Klavecimbael-speelster in een kamer, van Vermeer van Delft, konstig geschildert, F 55.—*' ['A Lady playing the Clavicembalo in a room, by Vermeer of Delft, artfully painted, F 55.—'] (Hoet I, p. 176); for this latter painting, however, see also prov. our cat. no. 16.

—Sale Jan Danser Nyman, Amsterdam (Ph. van der Schley), 16 August 1797, no. 169: '*Den Delfsche van der Meer . . . Een Juffrouw, staande voor een Clevecimbaal te speelen; aan de W and hangen Schilderyen; zeer fraai van penceelbehandeling. Hoog 20 breed 17 duim. Doek*' ['The Delft van der Meer . . . A Lady, standing and playing a Clavicembalo; on the Wall hang Paintings; very beautiful of brushwork. Height 20 width 17 inches. Canvas'], for F 19 to Bergh.

—Coll. E. Solly, London, see below (not as has been claimed since Bürger in the Solly sale, 1847; see *MacLaren*, pp. 437–8 note 10).

—Sale Edward W. Lake, London (Christie), 11 July 1845, no. 5: '*Van der Meer, of Delft . . . The Interior of an Appartment, in which a young lady richly habited is standing by a harpsichord. The sunlight is admitted from a side window, with the effect of De Hooghe. Highly finished. An excellent example of this rare master. 21 in. by 18 in. C. From the collection of E. Solly, Esq.*'

—Sale [J. P. Thom], 2 May 1845, no. 5, for 14½ Gns. to Grey (see *MacLaren*, pp. 437, 438, note 12).

—Coll. Thoré-Bürger, 1866 (*Bürger*).

—Inherited by the Lacroix family (see introduction in sale cat. 1892 and *MacLaren*, p. 437, note 14).

—Sale Thoré-Bürger, Paris (Drouot), 5 December 1892, no. 30, with elaborate description and ill. with wrong number, for 29000 to art dealer Bourgeois (note in sale cat. at R.K.D.) and/or Art gall. Lawrie, London; acquired by the museum in that same month (*MacLaren*, p. 437).

26. *The Lacemaker*
Paris, Louvre
Signed top right.

Canvas, on panel 24.5 × 21 cm. (9¼ × 8 ins.)
Bürger 37. HdG 11. De Vries D : 1664. Bloch: 1665–70. Goldscheider 22 : 1665.
1670–1. See p. 56.
The cushion on the left is a '*naaikussen*' [sewing-cushion]. The red and white strings are bundles of yarn hanging out. Cushions of this type were made of hard material covered with velvet or cloth; they were opened by lifting the top half. Inside were wooden compartments, in which sewing material could be stored. They were taken on the knees to sew on them (see: M. G. A. Schipper-

van Lottum, 'Een naijmantgen met een naijcussen', in: *Antiek* 10, 1975, p. 151).

PROVENANCE: Coll. Dissius, 1682; Sale Amsterdam, 16 May 1696, no. 12: '*Een Juffertje dat speldewerkt. F 28*' ['A needleworking Lady. F 28'] (see document 62).

—Sale Jacob Crammer Simonsz (Amsterdam), Amsterdam (Ph. van der Schley), 25 November 1778, no. 17: '*Jvan der Meer bygenaamt de Delfsche . . . Een bevallige Dame, verbeeldende een speldewerkster, zy zit ter zyde een Tafel, met een Tapytje overdekt, waar op een groen Werkkussen, een Boek en verder bywerk, zeer natuurlyk en sonaghtig beschilderd. Op Paneel, hoog 9½ breed 8 duim*' ['Jvan der Meer nicknamed the Delft one . . . A charming Lady, representing a needle worker, she sits next to a Table covered with a small Rug, on which a green Working-cushion, a Book and other accessories, very naturally and sunnily painted. On Panel, height 9½ width 8 inches'], for F 150 to Nyman.

—* Sale Jan Wubbels, Amsterdam (Ph. van der Schley), 16 July 1792, no. 213: '*J. van der Meer, bygenaamd de Delfsche . . . Dit natuurlyk stukje verbeeld een Dame, zittende neevens een Tafel met een Tapytkleedje bedekt, beezig Kant te werken, ter zyde legt een Boek en Naaikussen; alles zonagtig, fraay, en bevallig gepenceeld, hoog 10, breed 8 duim, P.*' ['J. van der Meer, nicknamed the Delft one . . . This natural painting represents a Lady, sitting next to a Table covered with a small Rug, working Lace, at her side lie a Book and a Sewing-cushion; all painted sunnily, beautifully and pleasingly, height 10, width 8 inches, C.'] for F 210 to J. Spaan.

—Since HdG it has been stated that the painting was in the Schepens sale, Amsterdam, 21 January 1811, no. 5; this, however, was a drawn copy (see below).

—Sale Hendrik Muilman (Amsterdam), Amsterdam (Ph. van der Schley), 12 April 1813, no. 97: '*De Delftsche van der Meer . . . Eene bevallige jonge Dame in oud Hollandsche kleeding; zij is bezig met veel aandacht kant te werken, en is gezeten bij eene Tafel, met een Kleed bedekt, en waarop een Naaikussen, Boek, enz. alles is breed en fiks gepenseeld, en bevallig van kleur. Het voorwerp doet eene treffende uitwerking tegen den witten achtergrond. Hoog 9½, breed 8 duimen. Doek op Paneel*' ['The Delft van der Meer . . . A charming young Lady in old Dutch dress; she is making lace with much attention, and is seated at a Table covered with a Cloth, on which a Sewing-cushion, Book, etc. everything is broadly and vigorously painted, and pleasing in colour. The subject makes a striking effect against the white background. Height 9½, width 8 inches. Canvas on Panel'], for F 84 to Coclers.

—Not in the Amsterdam sale, 24 May 1815 (see below).

—Sale [A.]L[apeyrière], Paris, (Lacoste), 14 April 1817, no. 30: '*Vander Meer de Delft . . . Un tableau peint avec le plus grand art et où le peintre a su, dans une manière large, rendre le fini de la nature, la différence des objets, le soyeux des étoffes, par la justesse de ses teintes et de l'effect. Il représente une jeune femme occupée à faire de la dentelle, et entourée de divers accessoires convenables à cette occupation. Les Tableaux de cet artiste sont extrêmement rares et recherchés . . . Haut. 9 p., Larg. 8 p. Marouflée*' ['Vander Meer of Delft . . . A painting done most artfully and in which the painter has, in a broad way, succeeded in giving the finish of nature, the difference between the objects, the silkiness of the materials, by the accuracy of his colours and of the effect. It represents a young woman busy working lace, and surrounded by several accessories appropriate to this occupation. The Paintings of this artist are extremely rare and sought after . . . Height 9 p. Width 8 p. Canvas laid down on panel'], for fr. 501 to Coclers.

—Sale A. W. C. baron van Nagell van Ampsen (The Hague), The Hague (Jer. de Vries), 5 September 1851, no. 40: '*Jan van der Meer . . . Jeune femme. Elle s'occupe à faire des dentelles, occupation qui paraît attirer toute son attention. h. 23, l. 20 centimètres. Bois*' ['Jan

van der Meer . . . Young Woman. She is busy making lace, an occupation that seems to engage all her attention. h. 23, w. 20 centimetres. Panel'], for F 260 to Lamme.

—Sale D. Vis Blokhuyzen (Rotterdam), Paris (Ch. Pillet), 1 April 1870, no. 484, with elaborate description taken from W. Bürger, as: canvas, 24 × 20 cm., for fr. 6000 to Gauchey '*revendu par Ferral 7500 frs. au Louvre*' ['re-sold by Ferral 7500 frs. to the Louvre'.] At first—in 1870—the complete collection had been offered to the Municipality of Rotterdam for a comparatively small sum, but this was rejected; see: P. Haverkorn van Rijswijk, *Het Museum Boymans te Rotterdam*, The Hague/Amsterdam, 1909, pp. 215–29.

A painted **copy** after the painting is in our view: '*Eene Dame, gezeten aan eene tafel, bezig met speldewerken, bevallig geschilderd*' ['A Lady, seated at a table, doing needlework, pleasingly painted'], by '*De Delftsche Vermeer of zijn manier, hoog 10, breed 7½ duimen, paneel*' ['The Delft Vermeer or in his manner, height 10, width 7½ inches, panel'] (Sale Daniël de Jongh Az., Rotterdam, 26 March, 1810, no. 51, for F 10.5 st. to van Yperen; HdG no. 12a). J. Stolker (1724–85) made a watercolour copy after the painting, which copy is mentioned in sale cat.:

1. Jan Stolker, Rotterdam, 27 March 1786, Portfolio E., no. 193, for F 22 to Van Zante;

2. C. Ploos van Amstel, Amsterdam (Ph. van der Schley), 3 March 1800, Portfolio W, no. 50, for F 22 to Bolten;

3. Sale J. Schepens et al., Amsterdam (van der Schley), 21 January 1811, Portfolio K, no. 5;

4. [J. Kobell?], Amsterdam (H. Vinkeles, Jzn.), 24 May 1813, Portfolio B, no. 12, for F 9 to Gruyter. The sale catalogues say that the scene is seen 'through a niche'. This does not necessarily imply that the painting itself was larger at that time, for Stolker often took great liberties in his copies after old masters.

On two calques published by Van Gelder, probably dating from the eighteenth century, the lacemaker is also seen behind a niche (J. G. van Gelder, in: *La Revue de l'Art* 15, 1972, pp. 111, 112, ill. 5, 6). These were probably made after or in connection with Stolker's copy, not (directly?) after the Vermeer.

27. *Lady writing a Letter with her Maid*
Blessington, Ireland, Sir Alfred Beit, Bt.
Signed on the table, under right hand of the lady writing.
Canvas, 71 × 59 cm. (28 × 23 ins.)
HdG 35. De Vries 16: 1660–62. Bloch: 1665–70. Goldscheider 30: 1670.
1671. See pp. 25, 56.
For the painting in the background see cat. no. 3. The painting was seized on 26 April 1974, with other masterpieces from the Beit Collection, by a group led by thirty-three-year-old Dr Rose Dugdale. The aim was to serve the Irish cause. The paintings were recovered practically undamaged after some ten days. On the subsequent restoration see: A. O'Connor, 'A note on the Beit Vermeer', in, *Burlington Magazine* 119, 1977, pp. 272–3.

PROVENANCE: Pledged by Vermeer's widow on 27 January 1676 to the baker van Buyten a painting by her husband '*vertonende twee personagien waeroff d'een een brief sit te schrijven*' [representing two persons of whom one is sitting writing a letter'] together with cat. no. 28, to settle a debt of F 617. (See document 37).

—Sale Josua van Belle, Heer van St Huybertsgerecht, Rotterdam, 6 September 1730, no. 92: '*Een Juffrouw zittende een Brief te schryven daer de Meid nae staet te wagten, door Vander Meer, h. 2 v. 3d. br. 1 v. 11 en een half d.*' ['A Lady sitting and writing a Letter which the Maid-servant is waiting for by Vander Meer, h. 2 f. 3 inches w. 1 f. 11 and a half inches'], for F 155.

—Coll. Franco van Bleyswyck, Delft, deceased 1734, mentioned in his estate: '*Een stuk, juffer die een brief schrijft en een meid bij haar, van*

J. van der Meer' ['A painting, lady who writes a letter and a maid-servant with her, by J. van der Meer'], valued at F 75, by someone else at F 100; inherited by drawing of lots by Maria Catharina van der Burch, wife of Hendrik van Slingelandt; in the latter's collection in 1752: '*Een Juffrouw die schrijft door J.v.d. Meer van Delft, 27 × 24 d.*' ['A Lady who writes by J.v.d. Meer of Delft, 27 × 24 inches'] (*Hoet* II, p. 408); after the death of this couple valued by A. Schouman in 1761: '*nr. 17, Een schrijvent Vrouwtje door J. van der Meer*' ['no. 17. A writing Woman by J. van der Meer'], F 30; inherited by one of their two daughters, Agatha or Elisabeth Maria (see C. Hofstede de Groot, 'Schilderijenverzamelingen... Slingelandt...', in *Oud-Holland*, X, 1892, p. 229ff).

—Coll. Miller von Aichholz, Vienna; bought by art dealer Sedelmeyer, 6 April 1881; sold to Secrétan, 17 April 1881 for fr. 60 000 (according to hand-written notes by Sedelmeyer in copy at R.K.D. of cat. exh. *300 Pictures ... Sedelmeyer ...*, Paris, 1898, no. 86, with ill.).

—Sale E. Secrétan, Paris (Boussod), 1 July 1889, no. 140, with detailed description, for 62 000 fr. (to Boussod, Valadon & Co, according to a note in author's copy *HdG*).

—Coll. Marinoni, Paris; Art gall. F. Kleinberger, Paris; coll. A. Beit, London (*HdG*).

28. *The Guitar Player*
London, Kenwood, Iveagh Bequest
Signed right on the lower side of the curtain.
Canvas, 53 × 46.3 cm. (20 × 18¼ ins.)
HdG 26. De Vries 26: 1667. Bloch: 1665–70. Goldscheider 32: 1670. 1671–2. See pp. 56–8, 77 n. 48, 78 n. 79.

The painting was taken from the museum at the end of February 1974, apparently for political reasons. It was recovered in May.

PROVENANCE: Pledged by Vermeer's widow on 27 January 1676 to the baker van Buyten a painting by her husband: '*Een personagie spelende op een cyter*' ['A person playing the guitar'], together with cat. no. 27, to settle a debt of F 617 (see document 37).

—Sale Amsterdam, 16 May 1696, no. 4: '*Een Speelende Juffrouw op een Guiteer, heel goet*' ['A Lady playing a Guitar, very well done'] (document 62).

—Coll. 2nd Viscount Palmerston, mentioned in his Travelling Account Book: '1794. Bought at the Hague from Monsr. Nyman ... A woman playing on a Lute, Vandermeer of Delft, 18 Louis d'or'; from the latter to Coll. W. Cowper Temple at Broadland, later Baron Mount Temple, 1871; from him to A. E. Ashley, sold to Art gall. Thos. Agnew, London; purchased by Earl of Iveagh, 1889 (data from: *The Iveagh Bequest, cat. of Paintings*, London, 1960, p. 34).

—N.B. Since the painting was in England from 1794 onwards, it is not—as is always claimed—identical with a piece that was auctioned on 22 December 1817 in Amsterdam. In our opinion that painting is our cat. no. B1.

The provenance of our cat. no. 28 has often been confused with that of an old **copy** after it in the coll. John G. Johnson, Philadelphia (cat. 1972, no. 497). The pedigree of this copy is as follows: ? Sale 1817 (see cat. no. B1); Art gall. Gruyter, Amsterdam; Coll. Cremer, Brussels; Sale Comte C[ornet de Ways Ruart fils Cremer and Georges H. Phillips and W. Bürger], Brussels (Le Roy), 22 April 1868, no. 50, with description, for 2075 to Stevens; Sale William Middleton, 'Collection... received from Brussels', London (Christie), 26 January 1872, no. 192: 'Van der Meer of Delft ... The guitar-player', for £106.1s. to Cox; Coll. H. L. Bisschoffsheim, London; Art gall. Gooden, London. See also: M. W. Brockwell, in *Gazette des Beaux-Arts* 65, 5th period, 1922, pp. 61–2; E. Trautscholdt, in *Burlington Magazine*, LII, no. 300, 1928, p. 146). See also p. 78, note 79.

29. *Allegory of Faith*
New York, Metropolitan Museum
Canvas, 113 × 88 cm. (44 × 34¾ ins.)
Bürger 41. HdG 2. De Vries 29: 1669–70. Bloch: after 1670. Goldscheider 37: 1672.
1672–4. See pp. 10, 58–9, 75 n. 2, 77 n. 48.

The *Crucifixion* on the rear wall is a work by Jacob Jordaens. A version of it is preserved in the Terningh Stichting, Antwerp (*Swillens*, pl. 56). This is probably the '*groote schildery, sijnde Christus aen 't Cruys*' ['large painting, being Christ on the Cross'] in the possession of Vermeer's widow in 1676 (document 40). E. de Jongh observed that the loose piece of gilt leather to the right of the *Crucifixion* and the ebony crucifix on the table may be the objects mentioned in this same inventory (idem, see, E. de Jongh, 'Pearls of Virtue and Pearls of Vice', in *Simiolus* 8, 1975/6 (pp. 69–97), p. 71). According to de Jongh (p. 71, note 9) the same piece of gilt leather is depicted in Plate 22; however, its pattern is clearly different. Beneath the foot of the woman a globe, which can be identified with the second edition, dated 1618, of a globe produced by the Hondius family of cartographers. It is also depicted from another angle in cat. no. 24, (see: *Welu*, pp. 541, 544).

The programme for the *Allegory of Faith*, was mainly taken from Cesare Ripa's book *Iconologia*, as Barnouw noted as early as 1914. The text, on page 147, of Dirck Pers's Dutch translation of that Italian book, published in 1644, reads as follows: '*'t Gelove, wort oock door een Vrouwe afgebeeldt, die sittende en seer aendachtigh siende, een Kelck in de rechter hand hout, rustende met haer slincker op een Boeck, dat op eenen vasten hoecksteen staet, te weten Christo, hebbende de Wereld onder haere voeten. Zij is in Hemels blaeu gekleet met een carmosyne opperkleet. Onder den hoecksteen leyt een Slange verplettert, en de Dood met sijne pijlen verbroocken. Hier by leyt een Appel, waer door de Sonde is veroorsaeckt. Zy is met Lauwerblaeden gekroont, tot een teycken, dat wy door 't Gelove overwinnen. Achter haer hangt een Doorne Kroon aen een spijcker. 't Welck alles door sich selven klaer is, als hebbende weynigh verklaeringe van noode. In't verschiet wort Abraham mede gestelt, alwaer hij sijnen soone wilde offeren.*' ['Faith is also represented by a Woman, who is sitting and watching very attentively, holding a Chalice in her right hand, resting her left on a Book, that stands on a fixed cornerstone, that is to say *Christo*, having the World under her feet. She is dressed in Sky blue with a crimson outer-garment. Beneath the cornerstone a serpent lies crushed, and Death with his arrows broken. Next to this lies an Apple, the cause of Sin. She is crowned with Laurel leaves, which means, that we conquer by Faith. Behind her hangs a Crown of Thorns on a nail. Which all speaks for itself, needing little explanation. In the distance Abraham is also seen, where he was about to sacrifice his son.'] Apart from 'Death with his arrows' and the 'Laurel leaves' all attributes mentioned in this text appear in the painting, though they are arranged differently from Ripa's prescription. That the woman holds her hand on her breast and wears a white dress has been derived from another text in Ripa (p. 148), in which he describes the '*Catholyck of algemeen geloof*' ['Catholic or universal faith']: '*Een vrouwe in 't wit gekleedt, die de rechter hand op de borst hout, en in de slincker een kelck, daer zy aandachtelijck op siet*' ['A woman dressed in white, who holds her right hand on her breast, and in her left a chalice, which she regards intently'] (A. J. Barnouw, 'Vermeer's zoogenaamd Novum Testamentum' in *Oud-Holland* 32, 1914, pp. 50–4).

Details of the painting inconsistent with or not mentioned by Ripa were recently explained by E. de Jongh. Vermeer replaced the Old Testament prototype, Abraham sacrificing Isaac, by its traditional New Testament anti-type, the Crucifixion. The glass sphere hanging from the ceiling and the crucifix on the table were probably derived from a print representing Faith in the Jesuit

Willem Hesius's book *Emblemata Sacra de Fide, Spe, Charitate*, dating from 1636. The print represents a crucifix and a sphere, the latter hanging from the extended hand of a little angel. The text beneath explains the image: the human mind, limited as it may be, is able to contain the vastness of the belief in God, just as a little sphere can reflect the entire universe. Gold and pearls, depicted in cat. 29 in the form of gilt leather and the lady's necklace respectively, figure in many seventeenth-century texts as symbols of Faith (E. de Jongh, op. cit.)

PROVENANCE: Sale Herman van Swoll, Amsterdam, 22 April 1699, no. 25: '*Een zittende Vrouw met meer beteekenisse, verbeeldende het Nieuwe Testament, door Vermeer van Delft, kragtig en gloejent geschildert*' ['A sitting Woman with several meanings, representing the New Testament, by Vermeer of Delft, vigorously and glowingly painted'] for F 400 (*Hoet*, I, p. 48).
—Sale Amsterdam, 13 July 1718, no. 8: '*Een zittende Vrouw, met meerder betekenisse, verbeeldende het Nieuwe Testament, door Vermeer van Delft, kragtig en gloejend geschildert*' ['A sitting Woman, with several meanings, representing the New Testament, by Vermeer of Delft, vigorously and glowingly painted'], for F 500 (*Hoet*, p. 216).
—Sale Amsterdam, 19 April 1735, no. 11: '*Een Kamer, waer in een Vrouwtje, verbeeldende het Nieuwe Testament, konstig en uytvoerig geschildert, door de Delfsche vander Meer*' ['A Room, in which a Woman, representing the New Testament, artfully and elaborately painted, by the Delft vander Meer'], for F 53 (*Hoet*, I, p. 438).
—Sale David Ietswaard, Amsterdam, 22 April 1749, no. 152: '*Een Dame in haar Kamer, in haar devotie, met veel uitvoerig bywerk, door de Delfse van der Meer, zo goed als Eglon van der Neer, h. 4 voet 1 duim, br. 3 voet 3 duim*' ['A Lady in her Room, in her piety, with many elaborate accessories, by the Delft van der Meer, as well done as Eglon van der Neer, h. 4 feet 1 inch, w. 3 feet 3 inches'], for F 70 (*Hoet*, II, p. 248) to Ravensberg (according to note *HdG*).
—Private coll. Austria, 1824, because the painting appears in the background of a portrait of a cartographer and his wife dated 1824 by the Viennese painter F. G. Waldmüller (1793–1865) (*De Vries*; see: B. Grimschitz, *Ferdinand George Waldmüller*, Salzburg, 1957, p. 286, no. 129, with ill.). The painting is now in the Westfälisches Landesmuseum, Münster, cat. 1975, p. 170, with ill.
—Coll. D. Stchoukine, Moscow; from there to Art gall. Wächtler, Berlin, as Eglon van der Neer, but with fake signature of C. Netscher; bought from this gallery by Dr A. Bredius (note *HdG*); on loan to the Mauritshuis, The Hague (cat. 1914 no. 625) 1899–1923; to Boymans Museum, Rotterdam, 1923–8 (*Jaarverslag* of the museum 1923, p. 7 and 1928, p. 9).
—Art gall. F. Kleinberger, Paris; Coll. Colonel M. Friedsam, New York, 1928 (*De Vries*).
—Bequeathed by him to the museum 1931.

30. *Head of a Girl*
New York, Private Collection
Signed top left.
Canvas, 45 × 40 cm. (17 × 15 ins.)
Bürger 2. HdG 42. De Vries 15: 1660. Bloch: 1660–63. Goldscheider 34: 1671.
1672–4. See p. 59.

PROVENANCE: This painting and/or cat. no. 18 may be identical with one of the following paintings at sale Amsterdam, 16 May 1696: '*nr. 38. Een Tronie in Antique Kleederen, ongemeen konstig . . . F 36.—; nr. 39. Nog een dito Vermeer . . . F 17.—; nr. 40. Een weerga van denzelven . . . F 17.—*' ['no. 38. A 'Tronie' in Antique Dress, uncommonly artfull. . . F 36.—; no. 39. Another ditto Vermeer . . .

F 17.—; no. 40. A pendant of the same F 17.'] (see document 62).
—Sale 'un amateur à Rotterdam' / Dr Luchtmans/, Rotterdam (Muys), 20 April 1816, no. 92: '*J. van der Meer de Delft . . . Le portrait d'une jeune personne, haut 17 pouces, large 15 pouces, toile* ['J. van der Meer of Delft . . . the portrait of a young person, height 17 inches, width 15 inches, canvas'] (according to De Vries for F 3.—). N.B. Because of the conformity of the dimensions this painting may also be identical with our cat. no. 18. Since it is called a 'portrait', however, in our opinion it is more likely identical with our cat. no. 30 (cf. p. 59).
—Coll. Prince Auguste d'Arenberg, Brussels, cat. 1829 no. 53: '*Jean van der Meer de Delft . . . Portrait d'une femme affublé d'un manteau bleu, sur toile, hauteur 17 pouces, largeur 14 pouces*' ['Jean van der Meer of Delft . . . Portrait of a woman dressed up in a blue coat, on canvas, height 17 inches, width 14 inches']; cat. Galerie d'Arenberg in Brussels, by W. Bürger, 1859, p. 140, no. 35, with elaborate description and mention of signature.
—Between 1914 and 1948 the whereabouts was kept secret; during World War I, however, the picture remained in the possession of the Duke of Arenberg, was transferred from Brussels to Schloss Nordkirchen, Westphalia (see *De Vries* and cat. exh. *In the light of Vermeer*, Mauritshuis, The Hague, 1966, cat. no. VI; E. Fahy: *The Wrightsman Collection*, V, New York 1973, p. 313 with extensive observations).
—Subsequently in the collection of Mr and Mrs Charles B. Wrightsman, New York/Palm Beach, Florida (Fahy, op. cit.)

31. *Lady seated at a Virginal*
London, National Gallery
Signed on the wall, to the right of the head
Canvas, 51.5 × 45.5 cm. (20⅜ × 17⅞ ins.)
Bürger 30. HdG 25. De Vries 31: after 1670. Bloch: pendant of cat. 25. Goldscheider 36: 1671.
1674–5. See pp. 27, 59, 77 n. 48 and 64.
The overall composition is probably inspired by Gerard Dou's *Woman playing the Virginals* at Dulwich (noticed by K. Boström, op cit. in my n. 38, p. 76). The Dou and the Vermeer are reproduced together in *Walsh and Sonnenburg*, ill. 49, 50). As he had done in the *Lady standing at a Virginal* (cat. no. 25), which is closely related both stylistically and thematically, Vermeer hangs, on the wall behind the main figure, a painting with an erotic content, in this case the *Procuress* by van Baburen, which is also depicted in no. 17 (for the relation between erotica and music see pp. 53ff., 77 n. 73.

PROVENANCE: Possibly in sale Diego Duarte, Antwerp, 1682 and/or sale Amsterdam, 1696, and/or sale Amsterdam, 1714 (see cat. no. 25).
—Coll. Count Schönborn, Pommersfelden (mentioned there from 1746 onwards: see below: sale cat. 1867, and *MacLaren* p. 439, note 7) as: Jacob van der Meer (G. Parthey, *Deutscher Bildersaal*, II, Berlin, 1864, p. 98, no. 2).
—Mentioned as Jan Vermeer of Delft in 1866 by *Bürger*, p. 557.
—Sale Count Schönborn-Pommersfelden, Paris (Pillet), 17 May 1867, no. 78: '*Jan van der Meer ou Vermeer de Delft . . . Jeune femme au clavecin. Assise, de profil, devant le clavecin, elle retourne la tête de trois quarts. Boucles de cheveux blonds; jupon bleu. En avant, sur le parquet, un violoncelle. Signé: I. Meer (l'I en monogr. sur l'M). Nr. 30 du cat. publié par la Gazette des Beaux-Arts, Mentionné dans le Cat. de 1746. No. 60 du Cat. de 1857, sous le nom de Jacob van der Meer. T. H., Om, 50 L Om, 42*' ['Jan van der Meer or Vermeer of Delft . . . Young woman at the clavichord. Seated, in profile, before the clavichord, she turns her head three quarters. Curls of blond hair; blue dress. In front, on the floor, a violincello. Signed: I. Meer (the I in monogram on the M). No. 30 of the cat. published by the Gazette des Beaux-Arts. Mentioned in the 1746 Catalogue. No. 60 of Cat. 1857, under the name of Jacob

van der Meer. C. H. 0.50 m., W. 0.42 m.'] for fr. 2000 to W. Bürger.

—Inherited from the latter by the family Lacroix (see introduction to sale cat. 1892 and *MacLaren*, p. 437, 438, note 12).

—Sale Thoré-Bürger, Paris (Drouot), 5 December 1892, no. 32, with description, for fr. 25 000 to Art gall. Sedelmeyer; cat. *300 Pictures, Sedelmeyer* . . . Paris, 1898, no. 85, with ill.; in Sedelmeyer's handwriting in the copy of this cat. at the R.K.D.: 'Sold by Sedelmeyer to Lawrie & Co. 25.2.93 F. 33.100. who sold it to G. Salting.'

—However, still at Art gall. T. Humphry Ward, 1894 (partners of Lawrie's?) as appears from cat. exh. Royal Academy, London, 1894, no. 93.

—In 1900 in coll. George Salting; bequeathed by him to the gallery in 1910 (*MacLaren*, p. 439).

Paintings now no longer known or identifiable: in chronological order according to the year in which they are first mentioned.

* Translator's note (see below 'tronie'): there is no English word for *tronie* (literally: face) as it was used in the seventeenth century- viz. for all kinds of paintings of a face up to a half-length figure.

32. A '*tronie*' by Vermeer, in the inventory of the estate of Jean Larson, '*in zijn leven beelthouwer in Den Hage . . . gemaeckt ten sterfhuijze, 4 augustus 1664*' [during his lifetime sculptor in The Hague . . . drawn up in the house of the deceased, 4 August 1664]. In the '*Contrabouck*' that goes with the inventory the piece is mentioned again: '*nr. 65. 1 principael van van der Meer F 10-0-0*' [no. 65. 1 original by van der Meer F 10-0-0] (A. Bredius, *Künstler-Inventare*, The Hague, 1915ff., pp. 325, 328). See also cat. no. 18.

Coll. Dissius, Delft; sale Amsterdam, 6 May 1696 (see document 62):

33. *Nr. '3: 't Portrait van Vermeer in een Kamer met verscheyde byiverk ongemeen fraai van hem geschildert . . . 45-0*' [3: The Portrait of Vermeer in a Room with several accessories uncommonly beautifully painted by him . . . 45-0] (see also cat. no. 19) (*HdG* 46).

34. *Nr. '5: Daer een Seigneur zyn handen wast, in een doorsiende Kamer, met beelden, konstig en raer . . . 95-0*' [5: Where a Gentleman washes his hands, in a Room with a through view with figures, artful and rare . . . 95-0] (*Bürger* 39; *HdG* 21).

35. *Nr. '10. Een musicerende Monsr. en Juffr. in een Kamer . . . 81-0*' [10. A Gentleman and a Lady making music in a Room . . . 81-0] (*HdG* 30).

36. *Nr. '33. Een gesicht van eenige Huysen . . . 48-0*' [33: A view of some Houses . . . 48-0] (*HdG* 49). As Hofstede de Groot has already remarked, one of the copies mentioned under cat. no. 9 and 10 may have been a copy after this painting.

37. *Nr. '38. Een Tronie in Antique Klederen, ongemeen konstig . . . 36-0; nr. 39. Nog een dito Vermeer . . . 17-0; nr. 40 Een weerga van denzelven . . . 17-0*' [38. A Tronie in Antique Clothes, uncommonly artful . . . 36-0; no. 39. Another ditto Vermeer . . . 17-0; no. 40. A pendant of the same . . . 17-0] (*HdG* 45). Only two paintings answering this description have been preserved (cat. nos. 18 and 30), so one has disappeared.

37a. * '*Een stuk van Van der Meer, sijnde een juffer in haer kamer*' [A piece by Van der Meer, being a lady in her room] mentioned on 8 October 1703 in the inventory of goods belonging to the paper merchant Paulus Gijsbertsz (Amersfoort, died after 1714), drawn up on behalf of his creditors (Municipal Archives Amsterdam, N.A.A. no. 4719, fol. 414; kindly communicated by Mr S. A. C. Dudok van Heel).

38. Sale Pieter de Klok, Amsterdam, 22 April 1744, no. 87: '*Een Vrouwtje dat bezig is het hair te Kammen door van der Neer van*

Delft, l. 1 v. 3 d. br. 1 v. 1 d., 18-0' [A Woman Combing her hair by van der Neer of Delft, l. 1 f. 3 inches w. 1 f. 1 inch, 18-0] (*Hoet*, II, p. 136; *Bürger* 47; *HdG* 22).
The subject is reminiscent of a much larger, monogrammed painting by C. van Everdingen (*c.* 1620–78), of which the relation between height and width is exactly the same (sale Steengracht, Paris, 9 June 1913, no. 22, with ill., 70.5 × 61.5 cm).

39. * Sale L. Schermer, Rotterdam, 17 August 1758, no. 67: '*Een schilder in zyn Schilderkamer, spelende op de Viool, door Vermeer*' [A painter in his Painting-room, playing on the Violin, by Vermeer]. In our opinion, this is possibly a work by M. van Musscher. Compare also a painting of this subject by G. Coquez, reproduced in W. Bernt, *The Netherlandish Painters* . . . I, London, 1970, pl. 258.

B1. *Woman playing a Lute near a Window*
New York, Metropolitan Museum
Vaguely signed on the wall, below the tablecloth.
Canvas, 52 × 46 cm. (20¼ × 18 ins.)
Dr Vries 20: 1663–64. Bloch: 1665. Goldscheider 19: 1664.
1662–5. See pp. 77 n. 48, 77 n. 61, 77 n. 100.
The painting has been much damaged. On the map: the word EUROPAE is legible. It is a map published by Jodocus Hondius in 1613, of which a new edition was published in 1659 by Joan Blaeu (*Welu*, p. 535).

PROVENANCE: Sale Ph. van der Schley (Amsterdam) and Daniel de Pré, Amsterdam (Roos), 22 December 1817, no. 62: '*Delftsche vander Meer . . . In een gemeubileerd Binnenvertrek zit eene vrouw in Hollandsche Kleeding, op de guitar te spelen. Frappant van licht en fraai gepenceeld, op P., h. 22, br. 18 d.*' ['Delft vander Meer . . . In a furnished Inner-room sits a woman in Dutch Dress, playing on the guitar. Striking of light and beautifully painted, on P., h. 22, w. 18 inches'] for F 65.—to Coclers. N.B. This might be thought to relate to our cat. no. 28. That piece, however, was in England before 1817. Moreover, the description 'furnished Inner-room' is more appropriate for cat. no. B1 than for cat. no. 28; so that the painting is not identical either with the copy mentioned under cat. no. 28.

—Bought in England by Collis B. Huntington, New York; bequeathed to the museum with his complete collection in 1897; transferred to the museum in 1925 (*Goldscheider*).

B2. *Girl interrupted at her Music*
New York, Frick Collection
Canvas, 38.7 × 43.9 cm. (15¼ × 17⅜ ins.)
Bürger 9. HdG 27. De Vries 13: 1658–1660. Bloch: 1655–1660. Goldscheider 12: 1661.
See pp. 77 n. 54, 78 n. 100.
In the background the *Standing Cupid*, also depicted in cat. nos. 4 and 25. The painting has so many weaknesses that when I studied it on the spot I was not able to decide if it is the ruin of an original or a copy. Later on, the latter seemed the more probable since the violin on the wall, mentioned in the sale catalogues of 1810 and 1811, is lacking. However, when Hofstede de Groot described the painting in 1899 he complained of overpainting: '*Zoo zijn er tegen den achterwand een vogelkooi en een viool met strijkstok geheel nieuw ingeschilderd* [On the rear wall, for instance, a bird-cage and a violin with bow have been completely freshly painted in]. The bird-cage is still there now. The violin is not. Also absent now is '*rechts een stuk van een schoorsteen*' [to the right a part of a mantle-piece] which Hofstede de Groot saw there, and did not note as overpainting. He also deplored the fact that the painting (in the old condition) had suffered '*door sterk schoonmaken*' [from vigorous cleaning] (C.

Hofstede de Groot, 'De een en dertigste Vermeer', in *De Nederlandsche Spectator* 1899, p. 224).

PROVENANCE: Sale Mr Pieter de Smeth van Alphen (Amsterdam), Amsterdam (Ph. van der Schley), 12 August 1810, no. 57: '*De Delfsche van der Meer . . . In een Binnenkamer zit eene bevallige Vrouw bij eene Tafel, nevens haar een staand Heer, welke haar in de Toonkunde onderwijst, aan den Wand eene Viool en ander bijwerk, hoog 15½, breed 17 duimen. Doek*' ['The Delft van der Meer . . . In an Inner-room sits an attractive Woman at a Table, next to her a standing Gentleman, who teaches her Music, on the Wall a Violin and other accessories, height 15½, width 17 inches. Canvas'], for F 610 to de Vries (bought in).

—Sale Henry Croese Ez., Amsterdam (Ph. van der Schley), 18 September 1811, no. 45: '*Van der Meer de Delft . . . On voit dans une chambre une femme d'une physionomie agréable; elle est assise, debout à côté d'elle est son maître de musique qui lui donne leçon; un violon pendu au mur et d'autres accessoires terminent cet ensemble. Ce Tableau no. 57 du Catalogue de Mr. P. de Smeth est dans le genre de Terburg: il est d'une touche agréable, d'un coloris clair et d'une action très-expressive. Haut 15½, large 17 pouces. Toile*' ['Van der Meer of Delft . . . One sees in a room a woman of agreeable countenance; she is seated, standing next to her is her music teacher, who instructs her; a violin hanging on the wall and other accessories complete this ensemble. This Painting No. 57 from the Catalogue of Mr P. de Smeth is in the manner of Terburg: it is of pleasant touch, bright colouring and of very expressive action. Height 15½, width 17 inches. Canvas'], for F 399.—to Roos.

—Sale Cornelis Sebille Roos, Amsterdam (Jer. de Vries), 28 August 1820, no. 64: '*Jan van der Meer bijgenaamd de Delfsche . . . In een binnenvertrek ziet men eene jufvrouw, welke in de zangkunst wordt onderwezen door eenen daarbij staanden man, in eene mantel gehuld. Breed van behandeling. Hoog 15, breed 17 duimen. Paneel*' ['Jan van der Meer nicknamed the Delft one . . . In an inner-room one sees a lady, who is being taught singing by a man standing next to her, enveloped in a cloak. Broad of treatment. Height 15, width 17 inches. Panel'], for F 340.—to Brondgeest (*HdG*) or for F 420.—to N.N. (according to the copy of the sale cat. at R.K.D.).

—Sale Samuel Woodburn, London (Christie), 24 June 1853, no. 128: 'Delft van der Meer . . . Interior of an apartment, with a cavalier handing a paper to a lady seated, in a red corset, a guitar and music on a table before her. The light enters from the window with admirable effect', for £42 to Smith (note in the sale cat. R.K.D.), or to: Francis Gibson in Saffron Walden, deceased 1858; inherited by his daughter Mrs Lewis Fry of Clifton near Bristol (according to cat. Frick 1968, p. 294).

—Art gall. Lawrie & Co, London (HdG).

—Art gall. Knoedler; acquired by H. C. Frick in 1901 (Cat. Frick 1968, p. 294).

B3. *Girl with a red Hat*
Washington, National Gallery of Art
Monogram upper left.
Panel, 23 × 18 cm. (9⅛ × 7 ins.)
Bürger 47. HdG 46A. De Vries 22: 1664. Bloch, ill. 56. Goldscheider 25: 1667.
See pp. 73–4, 79 n. 109.

In all monographs on Vermeer it is erroneously stated that the painting is done on canvas. It appears only from *Walsh and Sonnenburg* that it is a panel. The painting sold in 1822 in the Lafontaine sale was also a panel. An X-ray of the piece shows that it has been painted on a turned-over Rembrandtesque portrait of a man (*Walsh and Sonnenburg*, ills. 93, 94). The old particles of paint which a chemical investigation show to be present in no. B3, can be from this portrait (see p. 74).

PROVENANCE: Sale [Lafontaine], Paris, 10 December 1822, no. 28: '*Van der Meer de Delft. Jeune femme représentée un peu plus qu'en buste, la tête couverte d'un chapeau de panne rouge à grand bord, et le corps enveloppé d'un manteau bleu. Un rayon de soleil éclaire en partie sa joue gauche; le reste de son visage se ressent fortement de l'ombre du chapeau. B., h. 9 p., l. 7 p. Il y a dans ce joli tableau tout ce qui fait connaître le véritable peintre; l'exécution en est coulante, la couleur forte, l'effet bien senti*' ['Van der Meer of Delft. Young woman represented a little more than bust-length, her head covered with a red plush hat with large brim, and the body enveloped in a blue coat. A ray of sun partly lights her left cheek; the rest of her face is strongly shaded by the hat. B., h. 9 inches, w. 7 inches. In this pretty painting everything that shows the real painter is present; its execution is fluent, the colour strong, the effect well felt'], for F 200.

—The painting which is now in Washington: Coll. General Baron Atthalin, Colmar; coll. Baron Laurent Atthalin; Art gall. Knoedler & Co, New York, 1925; coll. Andrew W. Mellon, Washington (*De Vries*).

—Since 1937 in the museum (*Preliminary catalogue . . .* Washington, 1941, no. 53).

B4. *Girl with a Flute*
Washington, National Gallery of Art
Panel, 20.2 × 18 cm. (7⅞ × 7 ins.)
HdG 22 d. De Vries: 1664. Bloch, ill. 57. Goldscheider 26: 1667.
See pp. 73–4, 79 n. 109.

PROVENANCE: Coll. Jan Mahie van Boxtel en Liempde, Bois-le-Duc; coll. Maria de Grez-van Boxtel en Liempde, Brussels; coll. Jhr. de Grez, Brussels; discovered there by A. Bredius and exhibited in the Mauritshuis, The Hague, 1906/7; coll. August Janssen, Amsterdam; art gall. J. Goudstikker, Amsterdam (cat. exh. Goudstikker, The Hague, 1919, no. 131); Art gall. Knoedler & Co, New York; coll. JOseph E. Widener, Philadelphia (according to cat. coll. Widener 1931, De Vries and Goldscheider).

—Since 1942 in the museum (*Summary catalogue . . .* Washington, 1962, no. 694).

BLEYSWYCK: D. van Bleyswyck, *Beschryvinge der Stadt Delft*, gedruct by Arnold Bon, Boeckverkooper, op 't Marct-velt, Delft, 1667.

BLOCH: V. Bloch, *Tutta la Pittura di Vermeer di Delft*, Milan, 1954 (English ed.: *All the Paintings of Jan Vermeer*, 1963).

BOOGAARD BOSCH: A. C. Boogaard-Bosch, 'Een onbekende Acte betreffende den Vader van Jan Vermeer', in *Nieuwe Rotterdamsche Courant*, 25 January 1939.

BOURICIUS: L. G. N. Bouricius, 'Vermeeriana', in *Oud-Holland* 42, 1925, p. 271.

BREDIUS 1885: A. Bredius, 'Iets over Johannes Vermeer', in *Oud-Holland* 3, 1885, p. 217 ff.

BREDIUS 1910: A. Bredius, 'Nieuwe bijdragen over Johannes Vermeer', in *Oud-Holland* 28, 1910, p. 61 ff.

BREDIUS 1916: A. Bredius, 'Italiaansche schilderijen in 1672 door Haagsche en Delftsche schilders beoordeeld', in *Oud-Holland* 34, 1916, p. 88 ff.

BREDIUS, SCHILDERIJEN: A. Bredius, 'Schilderijen uit de nalatenschap van den Delftschen Vermeer', in *Oud-Holland* 34, 1916, p. 160 ff.

BÜRGER: W. Bürger, 'Van der Meer de Delft', in *Gazette des Beaux-Arts*, 21, 1866, pp. 297–330, 458–70, 542–75.

VAN GELDER 1956: J. G. van Gelder, 'Diana door Vermeer en C. de Vos', in *Oud-Holland* 71, 1956, p. 245 ff.

VAN GELDER 1958: J. G. van Gelder, met commentaar van J. A. Emmens, *De schilderkunst van Jan Vermeer*, Utrecht, 1958.

GERSON: H. Gerson, 'Johannes Vermeer', in *Encyclopedia of World Art*, New York–Toronto–Londen, XIV, 1967, Col. 739 ff.

GOLDSCHEIDER: L. Goldscheider, *Johannes Vermeer, the Paintings*, London, 1967².

GOWING: L. Gowing, *Vermeer*, London, 1952 (second edition, London, 1971).

GUDLAUGSSON 1959: S. J. Gudlaugsson, *Gerard ter Borch*, 2 volumes, The Hague, 1959.

GUDLAUGSSON 1968: S. J. Gudlaugsson, 'Kanttekeningen bij de ontwikkeling van Metsu', in *Oud-Holland* 83, 1968, p. 13 ff.

GUDLAUGSSON, KINDLER: S. J. Gudlaugsson, 'Johannes Vermeer' in *Kindlers Malerei Lexikon*, V, Zürich, 1968, p. 657 ff.

HOET: G. Hoet, *Catalogus of Naamlijst van Schilderijen*, met derzelver prijzen, 2 vols. The Hague, 1752.

HOFSTEDE DE GROOT: C. Hofstede de Groot, *A Catalogue Raisonné of the Works of the Most Eminent Dutch Painters of the Seventeenth Century*, IX vols., London, 1908 ff. (when no no. of volume is mentioned: vol I, p. 587 ff.).

DE JONGH: E. de Jongh, *Zinne- en minnebeelden in de Schilderkunst van de 17e eeuw*, 1967.

DE JONGH 1976: E. de Jongh *et al.*, exhibition catalogue *Tot Lering en Vermaak*, Rijksmuseum, Amsterdam, 1976.

KOSLOW: S. Koslow, 'De wonderlijke Perspectiefkast; An aspect of seventeenth century Dutch Painting', in *Oud-Holland*, 82, 1967, p. 35 ff.

MACLAREN: N. MacLaren, *National Gallery catalogues, The Dutch School*, London, 1960.

MANKE: I. Manke, *Emanuel de Witte 1617–1692*, Amsterdam, 1963.

NEURDENBURG 1942: E. Neurdenburg, 'Johannes Vermeer, Eenige opmerkingen naar aanleiding van de nieuwste studies over den Delftschen Schilder', in *Oud-Holland*, 59, 1942, p. 65 ff.

NEURDENBURG 1951: E. Neurdenburg, 'Nog enige opmerkingen over Johannes Vermeer van Delft', in *Oud-Holland*, 66, 1951, p. 33–44.

OBREEN: F.D.O. Obreen, *Archief voor Nederlandsche Kunstgeschiedenis*, 7 vols., Rotterdam, 1877–90.

VAN PEER 1946: A. J. J. M. van Peer, 'Was Jan Vermeer von Delft Katholiek?' in *Kath. Cult Tijdschrift* 2, I, pp. 468–70.

VAN PEER 1951: A. J. J. M. van Peer, 'Rondom Jan Vermeer van Delft: de kinderen van Vermeer', in *Kath. Cult. Tijdschr. Streven*, N.R. 4, I no. 6, 1951, p. 615–26.

VAN PEER 1957: A. J. J. M. van Peer, 'Drie collecties schilderijen van Jan Vermeer', in *Oud-Holland* 72, 1957, p. 92 ff.

VAN PEER 1959: A. J. J. M. van Peer, 'Rondom Jan Vermeer van Delft' in *Oud-Holland* 74, 1959, p. 240 ff.

VAN PEER 1968: A. J. J. M. van Peer, 'Jan Vermeer van Delft: drie archiefvondsten', in *Oud-Holland* 83, 1968, p. 220 ff.

ROSENBERG-SLIVE: J. Rosenberg, S. Slive, E. H. ter Kuile, *Dutch Art and Architecture 1600 to 1800*, Harmondsworth, 1966.

SLIVE: S. Slive, ' "Een dronke slapende meyd aen een tafel" by Jan Vermeer', in *Festschrift Ulrich Middeldorf*, Berlin, 1968, p. 452–9.

SWILLENS: P. T. A. Swillens, *Johannes Vermeer, Painter of Delft 1632–1675*, Utrecht / Brussels, 1950.

THIEME-BECKER: U. Thieme, F. Becker, *Allgemeines Lexikon der bildenden Künstler von der Antike bis zur Gegenwart*, 36 vols. Leipzig, 1907–47.

VAN THIENEN: F. van Thienen, *Vermeer*, Amsterdam, s.a.

TRAUTSCHOLDT: E. Trautscholdt, 'Johannes Vermeer', in *Thieme-Becker* XXXIV, 1940, p. 265 ff.

VALENTINER 1932: W. R. Valentiner, 'Zum 300. Geburtstag Jan Vermeers, Oktober 1932, Vermeer und die Meister der Holländischen Genremalerei', in *Pantheon* 10, 1932, p. 305 ff.

DE VRIES: A. B. de Vries, *Jan Vermeer van Delft*, Basel, 1948.²

WALSH AND SONNENBURG: J. Walsh jr., 'Vermeer', in *The Metropolitan Museum of Art Bulletin* 31, no. 4, summer 1973, p. 11 ff.; followed by H. von Sonnenburg, 'Technical Comments'.

WELU: J. A. Welu, 'Vermeer: His cartographic Sources', in *The Art Bulletin* 57, 1975, p. 529–47.

WICHMANN: H. Wichmann, *Leonaert Bramer, sein Leben und seine Kunst*, Leipzig, 1923.

Index